T0231287

MASTERS COLLECTION: VOLUME 1
DIGITAL PAINTING
techniques

DIGITAL PAINTING
techniques

"A stunning visual collection from some of the top talents working in the industry today, who share their techniques and creative processes in what is an informative, inspiring must-have for any artist."

BROM, ILLUSTRATOR, WWW.BROMART.COM

"*Digital Painting Techniques: Volume 1* is a great resource for amateur and professional artists alike! The art is top notch and the insight from the industry's top artists on how they execute their craft is invaluable! I highly recommend this book for any artist's reference library!"

BOBBY CHIU, ILLUSTRATOR, WWW.IMAGINISMSTUDIOS.COM

"I don't know of any other resource that covers such a broad range of digital painting techniques and styles in a single volume. If you are new to digital painting or a seasoned pro, *Digital Painting Techniques* is sure to inspire you and expand your digital painting skills."

TIM WARNOCK, MATTE PAINTER/CONCEPT ARTIST, DOUBLE NEGATIVE VFX, WWW.THENEXTSIDE.COM

"I always love to see what other artists are up to and how they work their magic. *Digital Painting Techniques* is a great collection of tutorials featuring the art of some really cool people working in the industry today."

BENITA WINCKLER, CONCEPT ARTIST AND ILLUSTRATOR, WWW.EEANEE.COM

FEATURED ARTISTS

Alex Broeckel

Anne Pogoda

Brian Recktenwald

Carlos Cabrera

Chee Ming Wong

Chris Thunig

Daarken

Daniel Dociu

Daniel Ljunggren

Daniela Uhlig

David Revoy

Emrah Elmasli

Graven Tung

Jaime Jones

Jan Ditlev Christensen

Jesse van Dijk

John Wallin Liberto

Kai Spannuth

Kieran Yanner

Levente Peterffy

Loïc e338 Zimmermann

Lubos de Gerardo Surzin

Marc Brunet

Marco Bauriedel

Marta Dahlig

Matt Dixon

Mélanie Delon

Michael Kutsche

Mike Corriero

Nathaniel West

Nicolas Oroc

Nykolai Aleksander

Pascal Raimbault

Raphaël Lacoste

Richard Tilbury

Ron Crabb

Serg Souleiman

Sergey Musin

Simon Dominic

Stephanie R. Loftis

Tiberius Viris

Tomasz Jedruszek

3DTOTAL.COM LTD

MASTERS COLLECTION: VOLUME 1

DIGITAL PAINTING
techniques

Routledge
Taylor & Francis Group

LONDON AND NEW YORK

First published 2009 by Focal Press

This edition published 2013 by Focal Press

Published 2017 by Routledge
2 Park Square, Milton Park, Abingdon, Oxon OX14 4RN
711 Third Avenue, New York, NY 10017, USA

First issued in hardback 2017

Routledge is an imprint of the Taylor & Francis Group, an informa business

Library of Congress Control Number: 2009931733

ISBN 13: 978-1-138-41780-9 (hbk)
ISBN 13: 978-0-240-52174-9 (pbk)

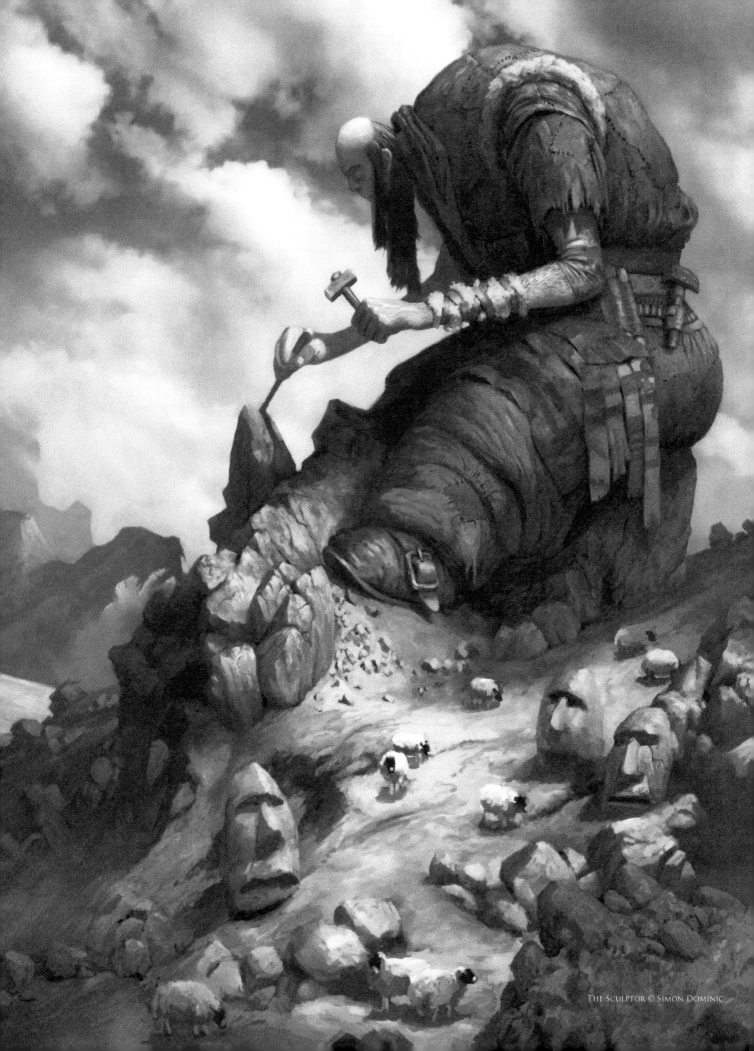

THE SCULPTOR © SIMON DOMINIC

Chapter 05 - Humans

Chapter 06 - Environments

Chapter 07 - Sci-fi & Fantasy

Chapter 08 - Complete Projects

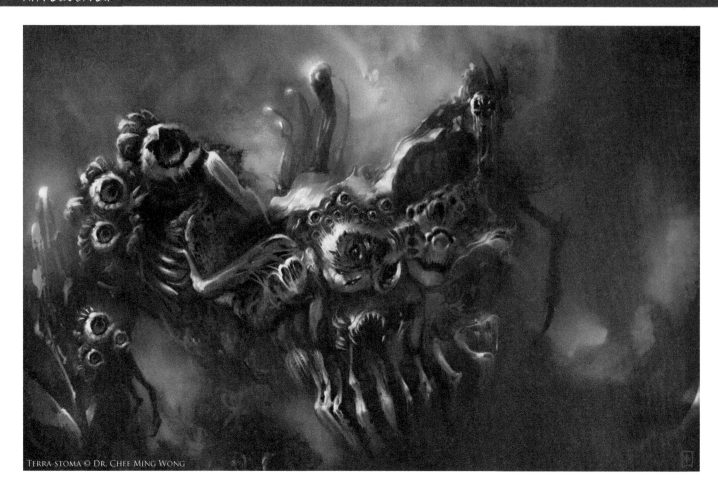

Terra-stoma © Dr. Chee Ming Wong

MASTERS COLLECTION: VOLUME 1

DIGITAL PAINTING
techniques

COMPILED BY THE 3DTotal Team

TOM GREENWAY

LYNETTE CLEE

CHRIS PERRINS

RICHARD TILBURY

MATTHEW LEWIS

3DTotal.com Ltd, 1 Shaw Street, 3rd Floor, Worcester, WR1 3QQ, United Kingdom

INTRODUCTION

Digital painting is huge! It's a modern, creative medium that is growing rapidly and is being used in so many industries and by so many individuals – hobbyists and professionals alike. This book is just a slice of what's out there in the digital painting world, but within this "slice" we aim to offer a comprehensive cross-section of tips and techniques from some of the most accomplished digital artists in the industry today. We cover a wide variety of popular subjects, from aliens, creatures and humans through to robots, cityscapes and natural environments, including

weather effects and many more. The styles we cover vary from speed painting, offering a more traditional impressionistic style, through to setting up the many custom brushes that can provide precise, technical and often time-saving techniques.

Speaking of traditional media, it is important to remember that digital painting is becoming more widely accepted and highly regarded as the techniques and resulting imagery advance. Long gone is the time of sceptics who regarded painting with the aid of hardware and software as cheating; the artist still needs to be just as talented as ever before to produce the breathtaking work you can see throughout these pages. However, with the benefits that digital painting offers, such as increased speed, freedom to experiment, efficient workflows and ease of sharing work with online communities, more and more artists are discovering and embracing this incredible medium. And with guides such as this book, we strive for everyone interested in digital art to be the best they possibly can be by learning from the masters' tutorials, whilst being inspired by their gallery images.

TOM GREENWAY
MANAGING DIRECTOR, 3DTOTAL

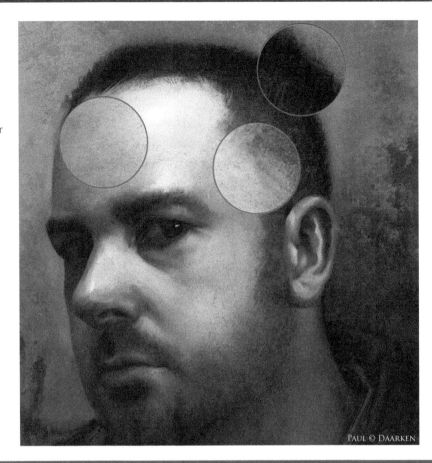

PAUL © DAARKEN

FREE RESOURCES

Some of our *Digital Painting Techniques* tutorial artists have kindly supplied, where appropriate and possible, free resources to accompany their tutorials for you to download to follow along with their teachings. You will find free custom brushes donated by Carlos Cabrera, Mélanie Delon, Mike Corriero, Daarken and Nykolai Aleksander, and on top of these 3DTotal are also providing a base painting to accompany some of our environment tutorials by Carlos Cabrera, as well as a photo (plate) for the matte painting tutorials by Tiberius Viris.

All you need to do to access these free resources is to visit the new 3DTotal micro site at www.focalpress.com/ digitalartmasters, go to the Books section, and there you will find information on how to download the files. Simply look out for the "free resources" logo on articles within this book that have files for you to download from **www.focalpress.com/digitalartmasters!**

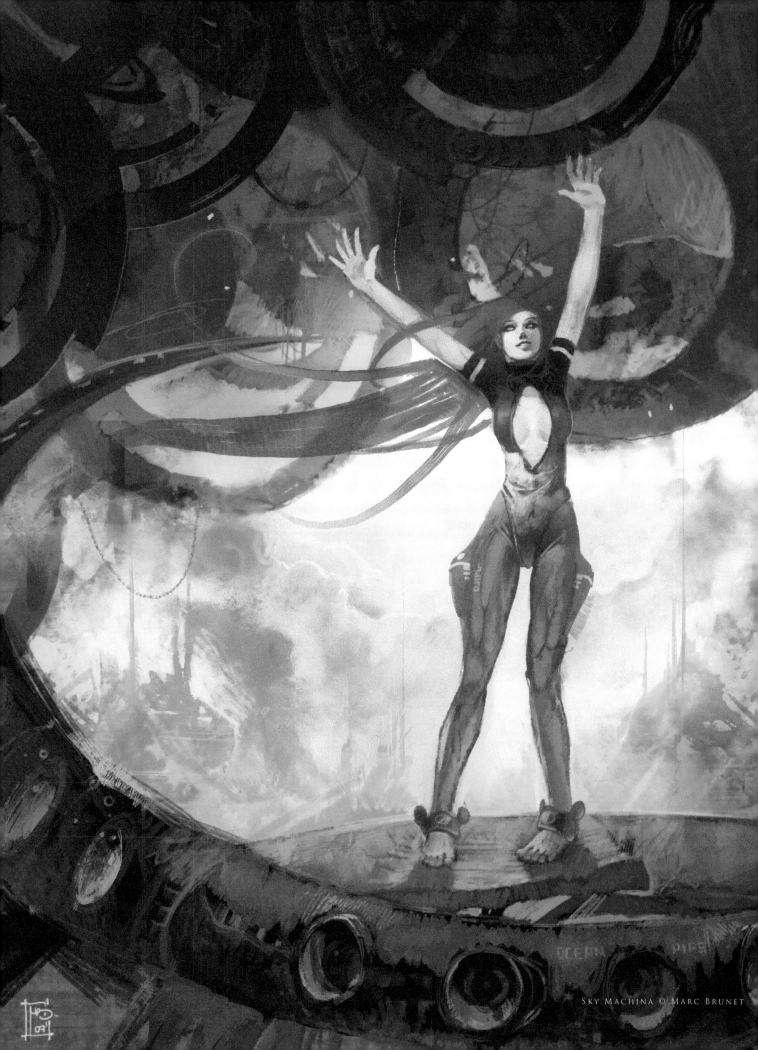

Sky Machina © Marc Brunet

custom brushes

Any artist will tell you that the link between their thoughts and ideas and the actual paintings they produce are the tools they wield. From a traditional standpoint these have been the canvas and in particular the brushes. These are no less important in a digital context; the increasing array of brushes available and the freedom to create customized versions is paramount to the quality of digital painting today. This chapter provides an insight into the value of using custom brushes, and shows how they can be created from scratch and tailored to suit your subject matter.

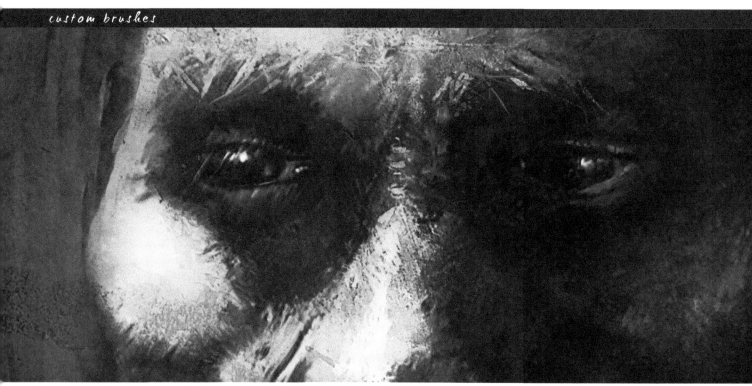

© BRIAN RECKTENWALD

ORGANIC CUSTOM BRUSHES FROM INK, WATER AND SALT EXPERIMENTS

BY BRIAN RECKTENWALD

SOFTWARE USED: PHOTOSHOP

INTRODUCTION

Like a lot of other digital artists out there, creating custom brushes is not only a key step in creating the art, but a heck of a lot of fun all in itself! The default Photoshop brushes are quite awesome, and I use them frequently, especially in the blocking phase, but I always end up integrating one or two custom brushes as well, for control and a personal touch. I've created custom brushes from just about anything I can find, including pictures, textures, doodles and digital scribbles. But my preference is to add an organic feel to my

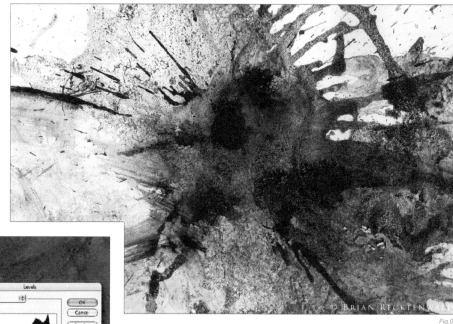

© BRIAN RECKTENWALD

Fig.01

brushes, so 90 percent of my custom brushes come from high-resolution scans made up of crazy experiments with ink, water and salt on drawing paper (**Fig.01**).

STEP 01

Here I pull different selections from the scanned image and mess with them using Levels and Filters and painting over them with other brushes until I get an ideal base image for a new custom brush (**Fig.02**).

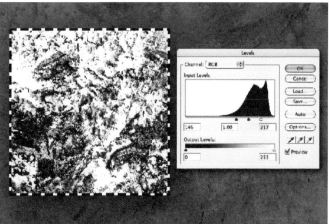

Fig.02

STEP 02

In this example, I'm going to create a brush
for use with the Smudge tool. I want a more
stippled pattern, like a dry brush would give,
to help add texture as I blend. After bringing
contrast into the image by clamping the Levels,
I begin experimenting with some filters to
further pronounce the shapes (**Fig.03**).

STEP 03

Then I duplicate the original texture a few times
and place them on top of the filtered version.
Finally, I play with different blending modes
until there's a good texture/shape balance
(**Fig.04**).

STEP 04

Once I have my base brush, I flatten my layers
and possibly resize the image. It's better to
save your brush at the highest native resolution
possible. However, the higher you go, the
slower the drawing performance. To save this
image off as a brush, go to Edit > Define Brush
Preset, and hit OK after giving it an appropriate
name (**Fig.05**). Now you can access this brush
at any time in the Brushes window.

STEP 05

It's now time to set up the Smudge tool
brush settings for use with our new brush.
We'll be able to pull a lot of mileage from

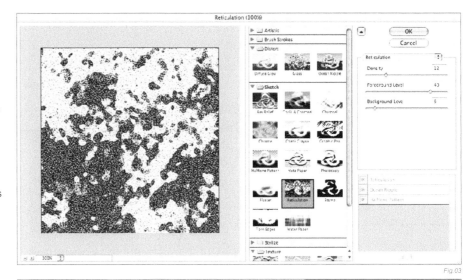

Fig.03

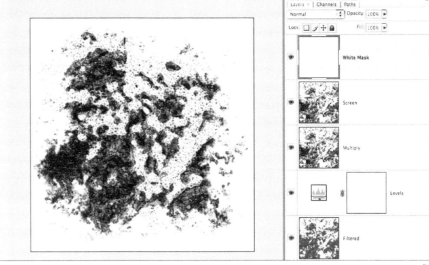

Fig.04

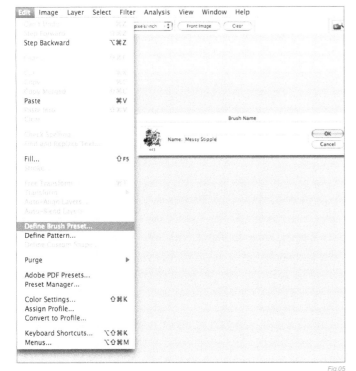

Fig.05

this brush simply by adjusting the Shape Dynamics, Scattering, and
Other Dynamics settings, without having to swap out a new brush
image. Another important value to adjust and tinker with as you go is
the Strength setting. An example of this brush in action starts with a
canvas of broad brush strokes (a default round brush with Strength and
Hardness of 100) and then a Cutout filter applied (**Fig.06**).

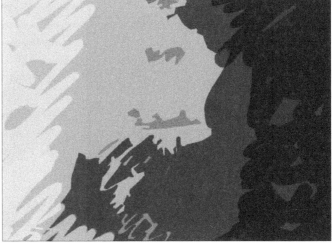

Fig.06

13 CHAPTER 01

Fig.07

Fig.08a

STEP 06

I now select the Smudge tool and load our new brush image (**Fig.07**). For rapid, first pass blending I want speed and spread ability, so at this stage I'll use a smaller brush size with just the Shape Dynamics and Other Dynamics settings adjusted (**Fig.08a – b**).

STEP 07–FINAL

At this stage I'm constantly changing the strength and sometimes turning off the Other Dynamics setting. After some cross-hatching to bring out some tonal gradation, I change my

Fig.08b

Fig.09b

Fig.09a

brush settings to bring a softer, yet still textural, quality to the strokes by turning on the Scattering (**Fig.09a – b**). The rule of thumb here is that the higher the scatter, the softer the blending. Also, the higher the strength, the more the texture will come through. Adjusting the brush accordingly is also important at this stage.

To show you an example of our new brush in action, the custom brush made in this tutorial, and the variations mentioned, have been used exclusively in creating this painting of an old woman (**Fig.10**).

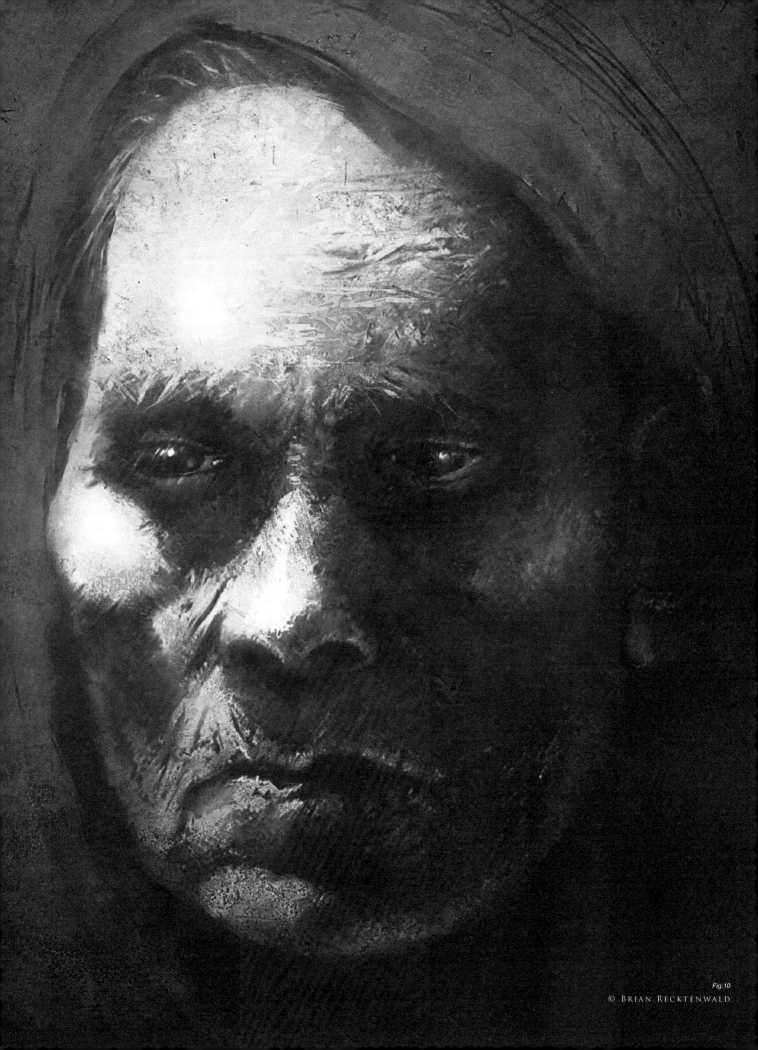

Fig. 10

© CARLOS CABRERA

HOW TO CREATE BRUSHES FROM ANIMAL TEXTURES
BY CARLOS CABRERA

SOFTWARE USED: PHOTOSHOP

The first thing we need for this tutorial is a couple of pictures to create the texture that we will be using in our brush. In this instance, I have chosen to use two photographs of my dog and cat (**Fig.01a – b**).

The next step is to completely desaturate the two pictures. With both images on one layer, we can achieve this simply by going to Image > Adjustments > Desaturate. We now need to place each picture in a different layer. Select the top layer and change the properties of the

Fig.01a

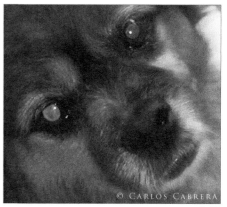
Fig.01b

Fig.02a

Fig.02d

Fig.02b

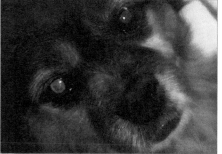
Fig.02c

layer to Difference (**Fig.02a**). By doing this, we will have both layers combined in one to create a new and interesting texture (**Fig.02b – d**).

Now let's flatten the image (Layer > Flatten Image) and search for some original shapes

within the texture to use for our new brush. **Fig.03** shows a unique shape, which I've circled in red. We will need to select it with our Lasso tool (Feather = 20%), and then cut and paste it onto a new document (CTRL + C + N + V).

Fig.03

Fig.04

You will see that the new document that we just created is a potential custom brush. Now, let's duplicate the layer where our brush is (CTRL + J) and rotate it by 90 degrees (CTRL + T) at any angle. We need to change the properties of this new layer, once again to Difference, and then repeat this step two or three times until we manage to create a textured border (**Fig.04**).

Our new brush is now almost done; we just need to tell Photoshop to start using this new image as a brush from now on. So, go to Edit > Define Brush, and voila! We have just created a new custom brush. We can now go ahead and change the settings in order to make it even better (**Fig.05**).

Fig.05

Fig.06

Fig.07

Go to the Brush tab and try out the following settings:

- **Brush Tip Shape** – Spacing 22% (**Fig.06**)
- **Shape Dynamics** – Size Jitter 0% and select Pen Pressure; Angle Jitter 100% and select Pen Pressure (**Fig.07**)

CHAPTER 01

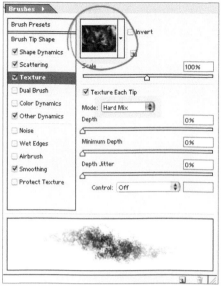

Fig.08

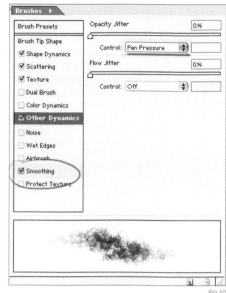

Fig.09

Fig.10

- **Scattering** – Scatter 104% and select Pen Pressure; Count 7, Count Jitter 50% and select Pen Pressure (**Fig.08**)
- **Texture** – Select a random texture and change the mode to Hard Mix (**Fig.09**)
- **Other Dynamics** – Opacity Jitter 0% and select Pen Pressure; Smoothing > On (**Fig.10**)

And that's it–pretty easy, don't you think? Here are a couple of examples of this new brush at work (**Fig.11 – 12**). You now have the skills to create your own custom brushes for your projects, so get creative and have some fun with them!

You can download a custom brush (ABR) file to accompany this tutorial from **www.focalpress.com/digitalartmasters**

© CARLOS CABRERA

Fig.11

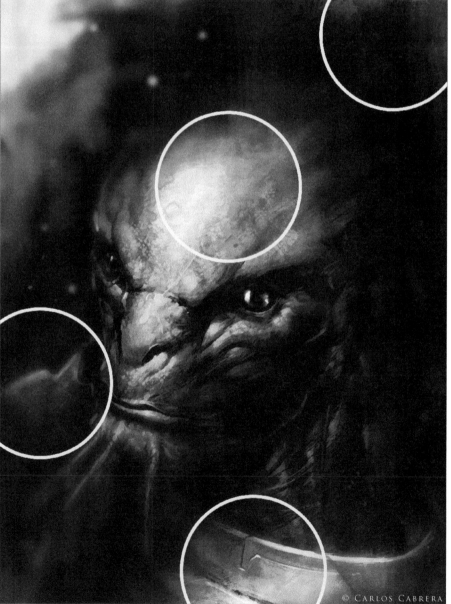

© CARLOS CABRERA

Fig.12

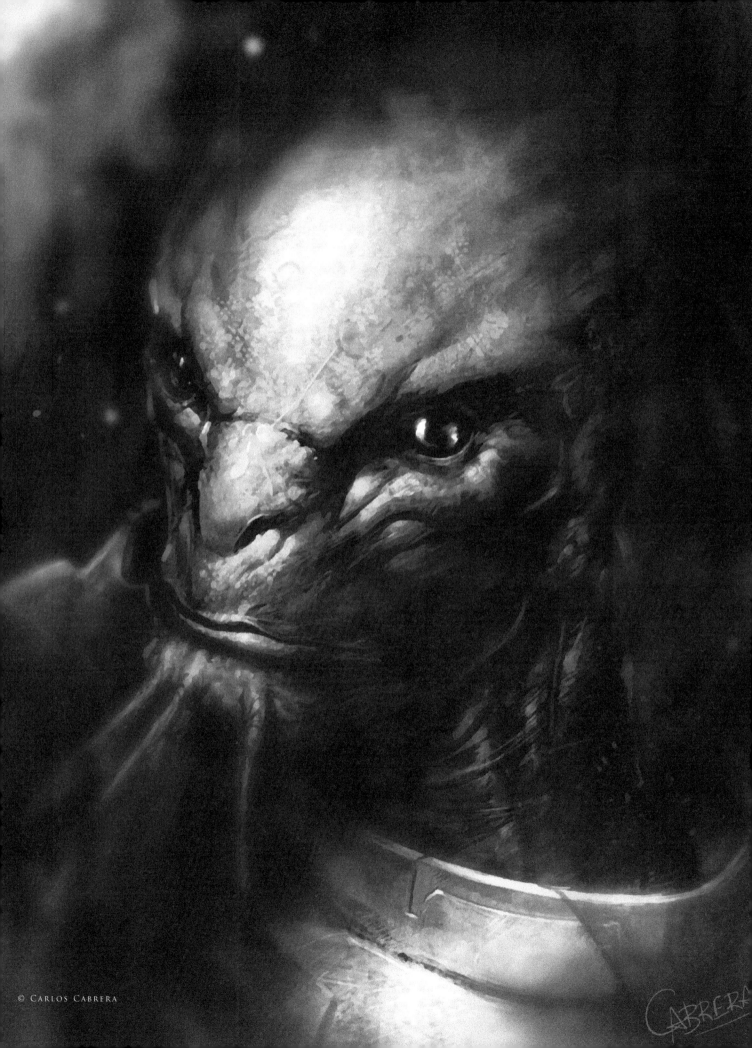

© DAARKEN

CUSTOM BRUSHES
BY DAARKEN
SOFTWARE USED: PHOTOSHOP

A lot of people ask me what kind of brushes
I use and how I make them. Usually, when
I paint, I only use a few brushes, most of
which are just Photoshop presets with a few
tweaks to the brush settings. When painting
a figure I normally use the standard brushes
and save my custom brushes for textures
and backgrounds. These are the brushes I
use, although a majority of all my illustrations
are painted using primarily the two brushes
circled in **Fig.01**. I find that most of the time
there are too many brushes to choose from,
and most of them are just plain gimmicky. I like
to stick with just a few of my favorite brushes
when painting. This also helps to improve your
speed, since you don't have to look around
and try and decide which brush to use next. It
also allows you to learn how to paint different
textures using the same brushes, instead of
relying on a brush to paint a texture for you.

Let's start making a custom brush by putting
down some random shapes and lines. Try not
to make anything too symmetrical, as this will
make your brush look weird and fake (**Fig.02**).
Sometimes what I like to do is use a custom
brush that I have already made as a starting
point. I lay that down and then start drawing

Fig.01

Fig.02

DAARKEN

Fig.03

Fig.04

and erasing on top of it. Now that I am happy with my shapes I am going to open a photo to use as a texture overlay. It doesn't really matter what kind of photo you use (**Fig.03**); you can use any subject matter and still get a cool–looking brush. Once you have a photo, convert it to grayscale and then go to Image > Adjustments > Levels (or Ctrl + I) (**Fig.04**). Drag the sliders around until you get high levels of contrast within the photo, and then click OK when you're ready.

Copy and paste the photo into the document with the brush we started making. On the layer with the photo, change the layer properties to something that looks good. In this case I used Overlay (**Fig.05**). Now you can go back and add another layer on top of the photo and fix any parts that may cause problems or repetition (**Fig.06**). For example, I painted out some of the lines in the top left of the picture.

To create your brush from the image, simply go to Edit > Define Brush Preset; I'm using CS2, so the wording may be different in other versions, but basically anything that says Define Brush will work (**Fig.07**). This brush

Fig.05

Fig.06

Fig.09

Fig.07

Fig.08

will now be at the end of your brush list on the Brush drop down menu. Select your new brush and give it a try. Right now the brush will look really ugly and repetitive (**Fig.08**) – but don't worry, we're about to fix that.

Next we're going to change the brush's settings by opening the Brush Settings window. To do this, either click the Brushes button, or go to Window > Brushes (or simply hit F5 on your keyboard). You'll now be able to get a good-

Fig.10a

Fig.11a

Fig.12a

Fig.10b

Fig.11b

Fig.12b

looking brush by playing around with these settings (**Fig.09**). I would advise you to spend some time dragging all the sliders back and forth so that you can get a feel of what each setting does, and find which ones you like.

For this particular brush, click on the first setting, called "Shape Dynamics". This will bring up different options on the side. By selecting Size and Angle Jitter we can break up some of the repetitive shapes that are found in

the original brush (**Fig.10a – b**). Now click on the second option: Scattering. This will take the basic shape of the brush and spread it out so that you're painting with several instances of the same shape, instead of all of them being in the same line. You can also control the density of the brush here (**Fig.11a – b**). To add some more texture to the brush you can click on the Texture button. Clicking on the picture of the texture brings up a dialog box where you can select which kinds of textures you want to use (**Fig.12a – b**). Finally, click on the Other Dynamics option. This controls the opacity of the brush based on pressure sensitivity. This is a little sample of what the new brush looks like after changing the settings (**Fig.13**).

Here are some examples of other custom brushes in my collection (**Fig.14**):

Brush A & B: This rectangular brush has some nice texture to it that I like to use when painting skin. I usually use this brush as the

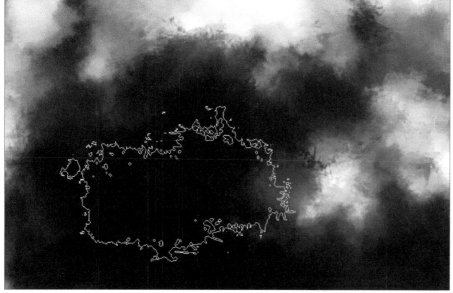

Fig.13

Brush C

Brush A & B

Brush D

Brush E

Brush F

Fig. 14

base layer to get the main shapes in, and then I come in on top of it with other brushes (**Fig.15a**). I use this brush a lot because of its versatility. When used at a very small size, you can get some really sharp lines, while at larger sizes you can get a lot of texture (**Fig.15b – c**).

Brush C: This is another brush that I use mainly for creating texture in the background (**Fig.16a – b**).

Brush D: This speckle brush is really good for painting things like dust, hair, dirt, pores, etc. (**Fig.17a – b**).

Brush E: I usually use this brush for creating texture in the background (**Fig.18a – b**).

Brush F: The brush I use the most is the default round brush. Even though it has no texture attached to it, I can still get a lot of variety with this brush (**Fig.19a – b**).

B R U S H A
Fig.15a

Fig.15c

B R U S H B
Fig.15b

B R U S H C
Fig.16a

Fig.16b

B R U S H D
Fig.17a

Fig.17b

B R U S H E
Fig.18a

Fig.18b

B R U S H F
Fig.19a

Fig.19b

Fig.20

You can also rotate your brush in order to get brushstrokes in different directions. Just go to the Brush Tip Shape options and drag the circular slider around (**Fig.20**).

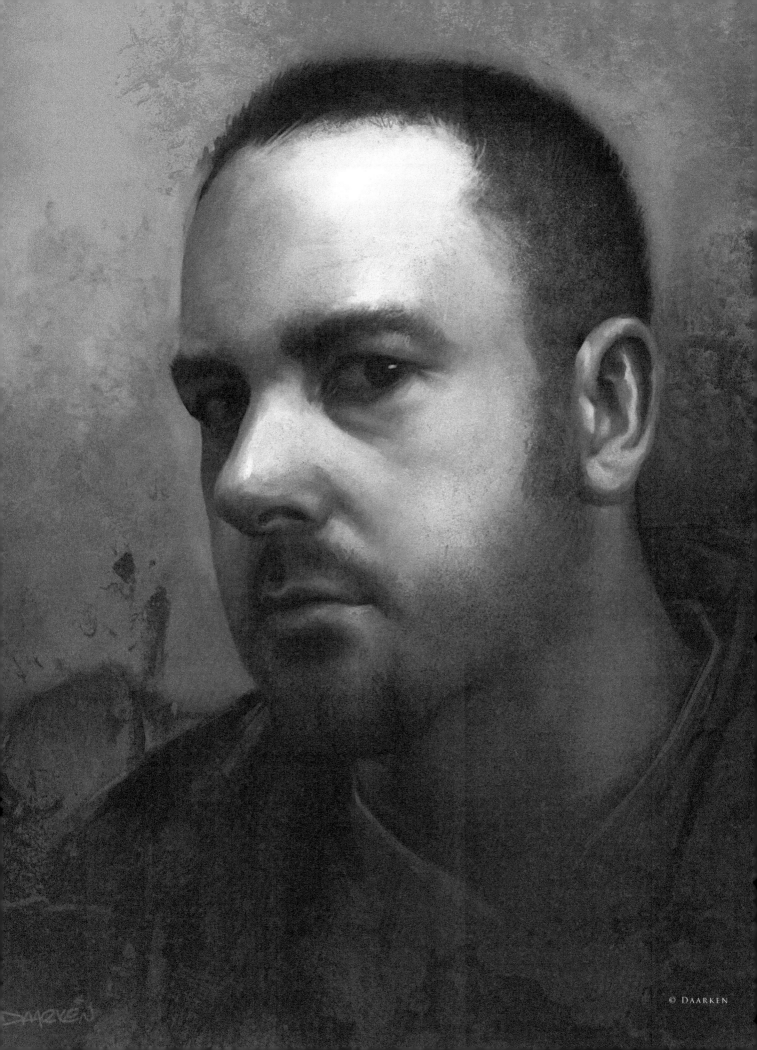

© Daarken

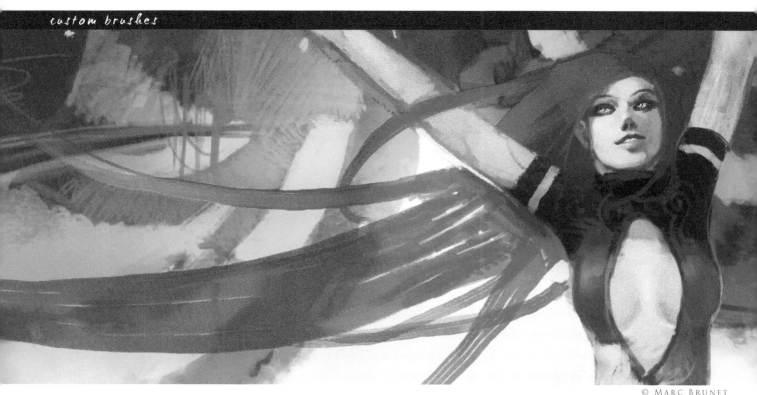

© MARC BRUNET

CREATING CUSTOM BRUSHES TO SAVE TIME
BY MARC BRUNET

SOFTWARE USED: PHOTOSHOP

Using Photoshop, we have all had this thought at one point: "Man, wouldn't it be great if there was a brush that could do all this, instead of me wasting my life on it?!" Well, in this tutorial, I will explain how I create my own custom brushes and how I use them in order to save me an incredible amount of time when I paint.

We will first try to mimic the stroke of a pencil – one of the main brushes I used to paint *Sky Machina*, along with a textured dry brush. At first, the brush creating process seems a bit tedious, but as soon as you get the hang of it you'll pretty much fall in love with it. You can create a brush out of everything you paint! So first, let's open a new file of about 500

Fig.01

Fig.02

Fig.03

Fig.04

by 500 pixels and draw whatever you want (let's draw dots for the sake of this tutorial). Now go to Edit > Define Brush Preset (**Fig.01 – 02**). And that's it! Well, that's not exactly it, but following that the only things left to do are to rename your brush (**Fig.03**) and tweak it to get the effect you want, in the Brushes tab on the top menu.

Opening the Brushes menu, we notice a bunch of options used to customize the basic brush that we just created (**Fig.04**). So, at this point, I suggest you open a new file with a white background to test the brush as you make the tweaks. You don't need to change that much to get a decent result though. There might seem to be a lot of options but they're all very intuitive and you can see the result right away in the Brush Preview window.

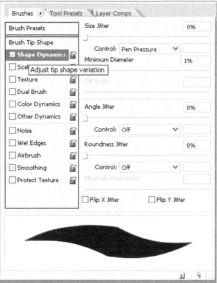

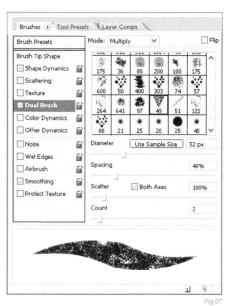

Fig.05

Fig.06

Fig.07

OPACITY DYNAMICS OFF

Fig.08

Fig.09

Here we'll change the brush Spacing, since we want to eliminate the gap between each shape to make it look like a single stroke, so I'll change the spacing from 25 to 5%. Notice how the stroke now feels even and continuous (**Fig.05**). I then check Shape Dynamics so that the lighter I press with the tablet pen, the thinner the stroke will be (**Fig.06**). You can just leave everything else at the default settings. Now skip to Dual Brush – this option is really where the party's at! Here your brush can really become something special. For this brush I'll use the triangular-shaped brush in the Thumbnails menu, which is full of tiny holes so it'll give me the pencil look I'm trying to achieve. Simply change the values, as shown in **Fig.07**.

If I try the brush at this point I already get the result I wanted (**Fig.08**). The only thing left now is to activate the Opacity change with the Pen Pressure so that, if I press lighter on the tablet, the stroke will be lighter too (**Fig.09**). It's just more intuitive and easier to work with this way. Save the newly created brush under something like "Pencil brush" – and that's it! See the difference (**Fig.10**)? Use this new brush as you would use a real pencil to create all the different opacities and brush sizes you need. It's a really nice brush to do line art digitally, or simply to get a little more texture than you would get with a regular round brush for example (**Fig.11**).

The other main brush I use, besides the regular hard-edged round brush found in the default Photoshop brush set, is another custom brush. This one is kind of like the one we just created, as it's based on the same starting shape, but it has a texture associated to it. So let's start with the same previous dots and save it

OPACITY DYNAMICS ON

Fig.10

Fig.11

Fig.12

Fig.13

Fig.14

Fig.15

as something like "Dry brush". Again, in the Brushes tab menu, let's play with a couple of the options ... Firstly, drop the spacing to 5%, just like with the previous one, check Shape Dynamics and Other Dynamics, and leave everything else at default. Then check Texture, and leave everything at default there as well. Let's step back at this point, save the brush we have here, and move on to creating the texture that the brush will use.

Fig.16

Fig.17

Fig.18

There are a bunch of default textures you can find when you click on Textures in the Brushes tab menu, but none of them will help us here. So let's make our own! A very quick and simple way I have found is to take a photo of concrete, or any similar surfaces, take it to Photoshop, play with the Brightness/Contrast until you have a really contrasted and uneven texture, invert the colors (Ctrl + I), desaturate it, and then go to Filter > Brush Strokes and throw an Accented Edges filter on it (**Fig.12 – 15**). This should do! Now all you have to do is go to Edit > Define Pattern, save it under something like Dry Brush Pattern (**Fig.16**), and it should automatically appear in the pattern library.

Let's go back to where we were with our dry brush. In the Texture menu, browse the patterns and find the one we just created (**Fig.17**), adjust the scale to 60% and make sure that Texture Each Tip is checked. Select Subtract as the blending mode and leave

Fig.19

everything else at 100% (**Fig.18**). The brush is now done, so save it and enjoy the texture madness (**Fig.19**)!

To get a little more diversity with the textures, I used the brushes seen in **Fig.20** as well. Everything else, though, was done with the two custom brushes just created (**Fig.21**).

Fig.20

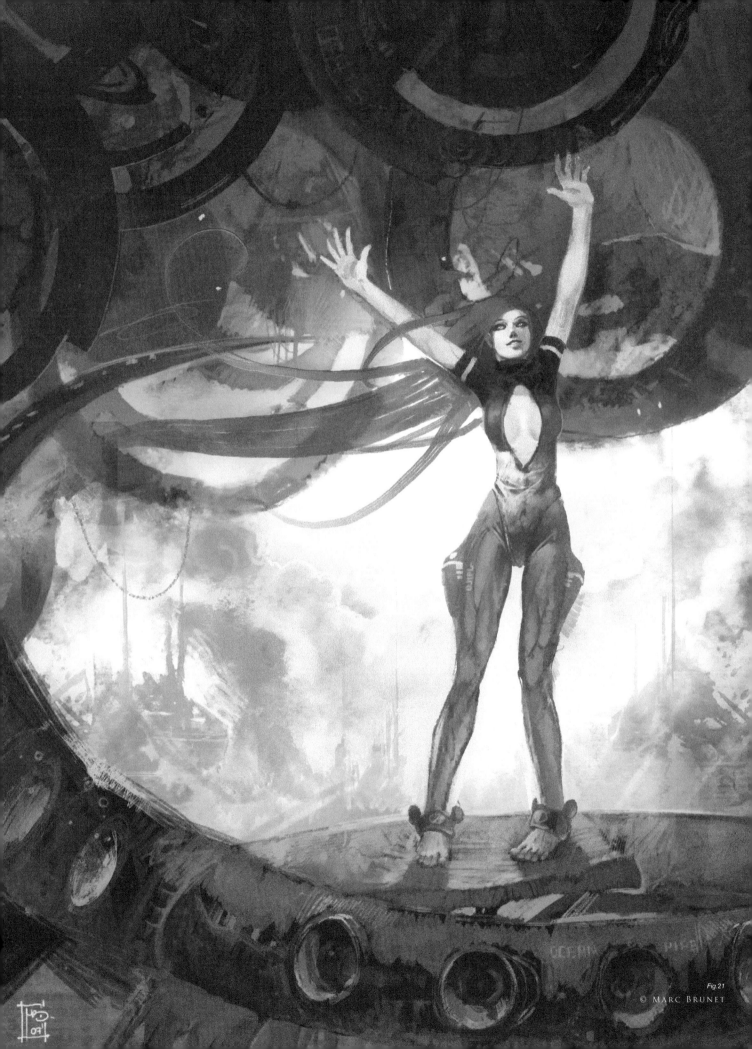

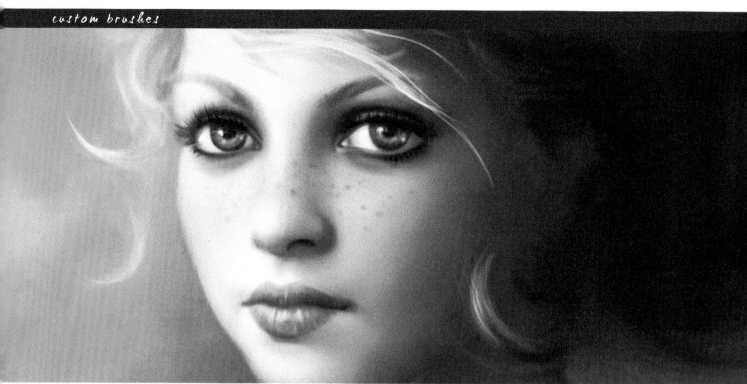

© MÉLANIE DELON

CUSTOM BRUSHES FOR SKIN
BY MÉLANIE DELON

SOFTWARE USED: PHOTOSHOP

THE SPECKLED BRUSH

This brush is the best that I have used so far to achieve a painterly feel, and the great thing about it is that you can use it for everything!

CREATE IT!

The technique is really simple ... On a new white canvas with a basic round–edged brush, I'll paint little random black dots of different shapes and sizes. I usually start without a lot of dots, and I want my brush very low in opacity

Fig.01

Fig.02

Fig.03

Fig.04

Fig.05

(**Fig.01**). I'll then add more dots, but with a very low opacity, just to bring more texture to the future brush (**Fig.02**). Once this step is OK I'll define this image as a brush, by going into the Edit mode and clicking on Define Brush Preset

(**Fig.03**), and then clicking OK in the pop-up. Now I have my new brush in the list, ready to be used.

BRUSH SETTINGS

Now the fun part begins ... As you can see (**Fig.04**), this brush is basically unusable as it is (**Fig.05**), so I now have to tweak it. For this, I go into the brushes palette where I set the control setting under the Opacity Jitter to Pen Pressure (**Fig.06**) and the Spacing to 6% (**Fig.07**). The settings are now OK, and this new brush looks much better (**Fig.08**) so I'll save it (**Fig.09**).

You can make different versions of the same brush, some with more dots or less – just try them! It's good to have several speckled brushes and combine them to create a great texture.

THE BRUSH IN ACTION

Now, how to use it ... This kind of brush is good when you need to bring texture and color variation; you can use it to bring life to a base done with a basic round edge (**Fig.10**), to paint hair (**Fig.11**), or to paint fabric (**Fig.12**). This brush can be used for unlimited purposes!

THE "SMOOTH-TEXTURED" BRUSH

This one is a kind of hybrid brush; it's a mix of a basic round edge and a speckled brush, so let's see how to create it.

Fig.06

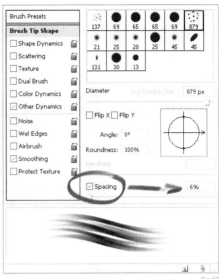
Fig.07

Fig.08

Fig.09

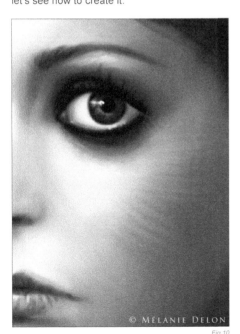
© MÉLANIE DELON
Fig.10

© MÉLANIE DELON
Fig.11

© MÉLANIE DELON
Fig.12

CHAPTER 01

CREATE IT!

For the base (on a white canvas), I'll use a speckled brush and scribble an oval shape softly with a very low opacity (**Fig.13**). Then I'll add more intensity here and there with another speckled brush, or a basic round edge (**Fig.14**). I'm now satisfied with the general shape so I'll define it as a new brush (Edit > Define Brush Preset) (**Fig.15**) and move on to the settings.

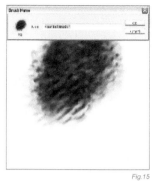

Fig.13

Fig.14

Fig.15

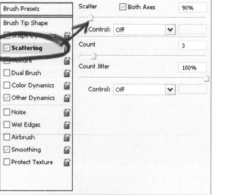

Fig.16

Fig.17

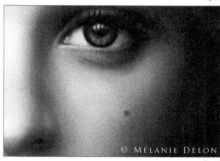

Fig.18

© Melanie Delon

Fig.20

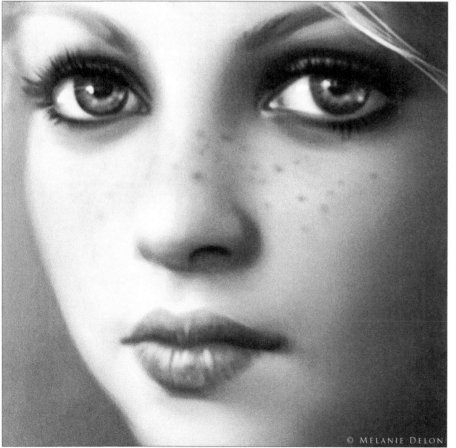

© Melanie Delon

Fig.19

BRUSH SETTINGS

As usual, I set the Opacity Jitter to Pen Pressure and the Spacing to 12%, and then I save the new presets (**Fig.16**). The brush will now look like that shown in **Fig.17**. You can of course play with the different settings to find nice effects, like the Scattering mode (**Fig.18**) which is pretty handy for creating textured brushes.

THE BRUSH IN ACTION

Most of the time, I use this one (see **Fig.17**) after the speckled brush when I want to smooth the skin (**Fig.19**). This brush will not destroy those little color variations obtained previously, so you don't need to worry about that – the only rule is to use it with a very low opacity. This step will bring the last smoothing touches and unify the whole texture (**Fig.20**). You can also use it as a starting point for most textures!

You can download a custom brush (ABR) file to accompany this tutorial from **www.focalpress.com/digitalartmasters**

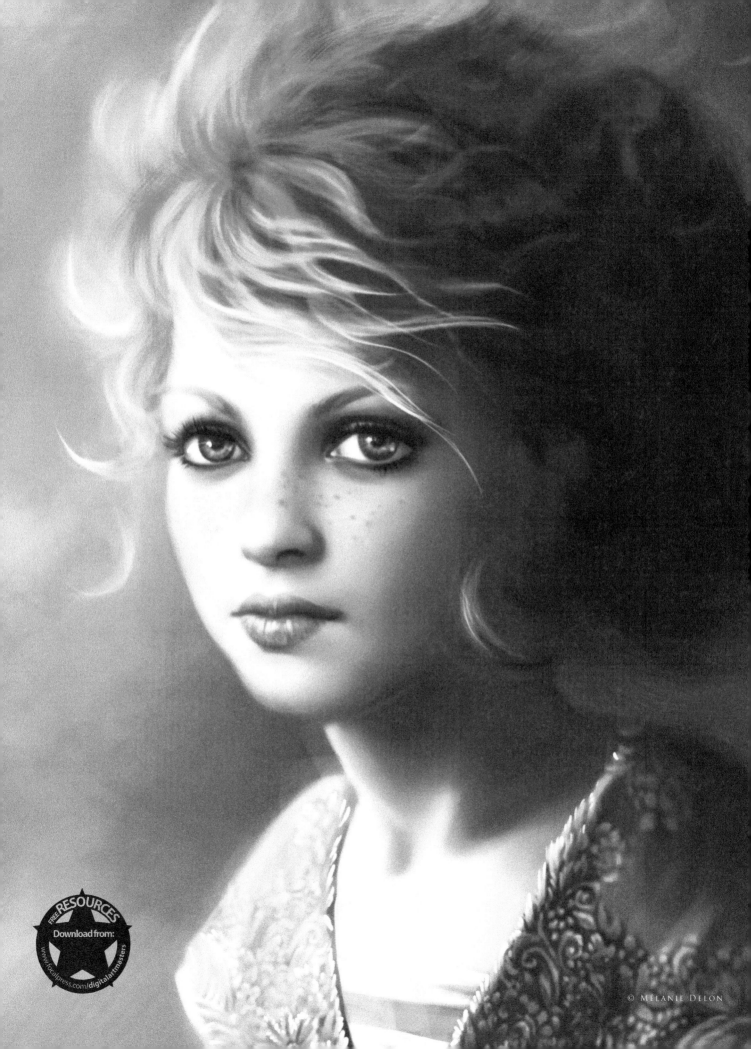

© MELANIE DELON

© MICHAEL CORRIERO

CREATING A BRUSH FROM SCRATCH IN PHOTOSHOP
BY MIKE CORRIERO

SOFTWARE USED: PHOTOSHOP

The first thing to do is create a blank canvas; I usually make sure it's set at 300 dpi resolution, around 500 by 500 pixels, so the brush itself doesn't become pixelated or incapable of scaling to larger sizes when working on a large image.

JAPANESE MAPLE LEAF BRUSH

This first brush design is going to be geared toward foliage, specifically a Japanese Maple Leaf, which will be used to create quick, easy batches of leaves without going through too much rendering trouble. So to begin, grab any of the default brushes supplied by Photoshop and just start to draw out a silhouetted shape, in this case the Japanese Maple Leaf (**Fig.01**). Since we do want a bit of depth to the brush, block in some of

Fig.01

Fig.02

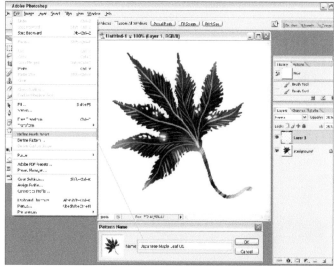

Fig.03

the veins, rips and rugged edges of the leaf. You can also fade some areas so everything isn't on the same level which helps give a bit of variation (**Fig.02**). Now that you've created the brush shape itself, you need to save it. Go to Edit > Define Brush Preset and then choose a name and click OK (**Fig.03**). You'll notice that the new brush, with the name you've chosen, will show up in the brush list at the very bottom.

The next step is to select the new brush you've just created and click the Brushes Option window, located at the top right with a little arrow next to it. This brings down the brush settings you can apply to your custom brush (**Fig.04**). Leaving the brush settings at a default doesn't allow for much control or variation in the strokes, so the first thing to do is allow for some pressure sensitivity; you do this using the Other Dynamics setting (**Fig.05**). Set the Opacity Jitter to approximately 50% and make sure the control setting is set to Pen Pressure. To provide some variation in the direction and scale of the brush, choose the Shape Dynamics settings (**Fig.06**). Set the Size Jitter to 100% and make sure the control settings under Angle Jitter are set to Initial Direction. The control setting under the Roundness Jitter should be set to Pen Tilt, and a minimum roundness of approximately 25% (**Fig.07**). Now that we know where the settings for the brush options are, feel free to test them and play around with different variations, different percentages of control and varying dynamics, including Scatter and Dual Brush modes (**Fig.08**). One of the last settings I adjusted

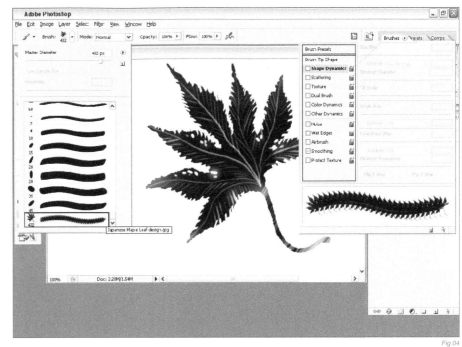

Fig.04

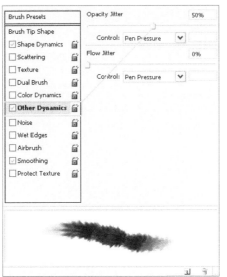

Fig.05

Fig.06

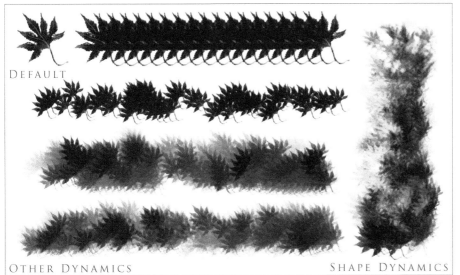

DEFAULT

OTHER DYNAMICS

SHAPE DYNAMICS

Fig.07

before finding the right feel for this custom brush was the Brush Tip Shape (**Fig.09**) where I applied 74% spacing to the separation of the brush flow.

OK, so now our brush settings are complete all that we need to do is save the brush options that have been applied. It's very important throughout this process that you don't choose another brush, or else you may lose all the settings you have applied to your custom brush. Click the Brushes Option window, located at the top right with a little arrow next to it, as previously, and now choose New Brush Preset. Label your new brush, click OK, and the custom brush you created earlier will now

CHAPTER 01

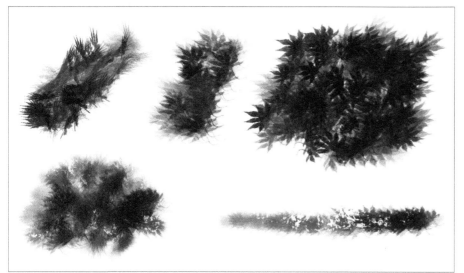

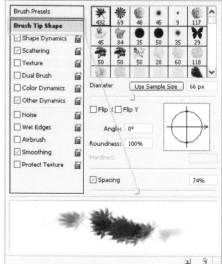

Fig.08

Fig.09

be saved with the new settings you've applied, and located at the bottom of your brush list (**Fig.10**).

A VARIATION ON THE JAPANESE MAPLE LEAF BRUSH

The next step is just as quick and basically a recap of what we just went over. I'm going to create a quick variation of the Japanese Maple Leaf by getting rid of the stem and adjusting the shape of the points. First,

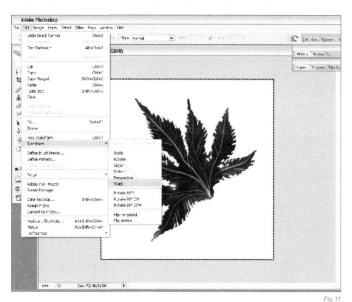

Fig.11

Fig.12

Fig.13

Fig.10

erase the stem of the original brush, then choose Select > All, then Edit > Transform > Warp (**Fig.11**). You'll notice that the entire box has been selected with the dotted lines, and once you choose the Warp transformation option you can choose points on this graphed box to mould and skew the brush shape (**Fig.12**). You can also grab anywhere inside the box and just drag it to transform its original outline, and then apply the transformation to confirm the change (**Fig.13**).

After applying a few of the same brush options as before, such as the Other Dynamics and Shape Dynamics, I've played around with it and I'm happy with this variation on our original brush (**Fig.14**). Save the brush preset, as we did previously, and it will be added to your list. Lastly, now that we have two custom Japanese Maple Leaf brushes, both with the default shape and the brush settings saved as preset brushes, you'll want to save the brush list. On your brush list there is an arrow next to the top right of this box. Click the arrow then Save Brushes and label your brush list; they will be stored and can be used at any time you wish (**Fig.15**). To access your brush list, in the same manner as saving your list, choose Load Brushes and select your brush list file.

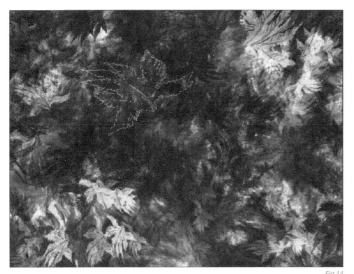

Fig.14

Fig.15

Fig.16

Fig.18

Fig.17

The original version of the custom Japanese Maple Leaf brush can be seen in **Fig.16**. The modified version of the Japanese Maple Leaf brush can be seen in **Fig.17**. See **Figs.18 – 19** for close-up detail showing the two brushes used together in a painting, using them in a few different methods, as a more muted back drop, and applying color dynamics and lighting effects.

You can download a custom brush (ASE) file to accompany this tutorial from **www.focalpress.com/ digitalartmasters**

Fig.19

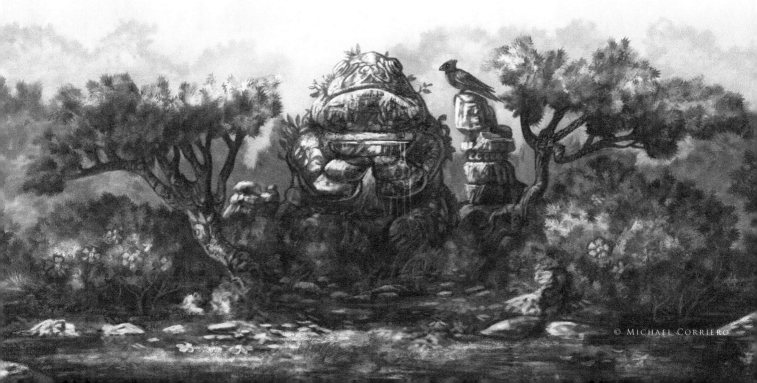

© MICHAEL CORRIERO

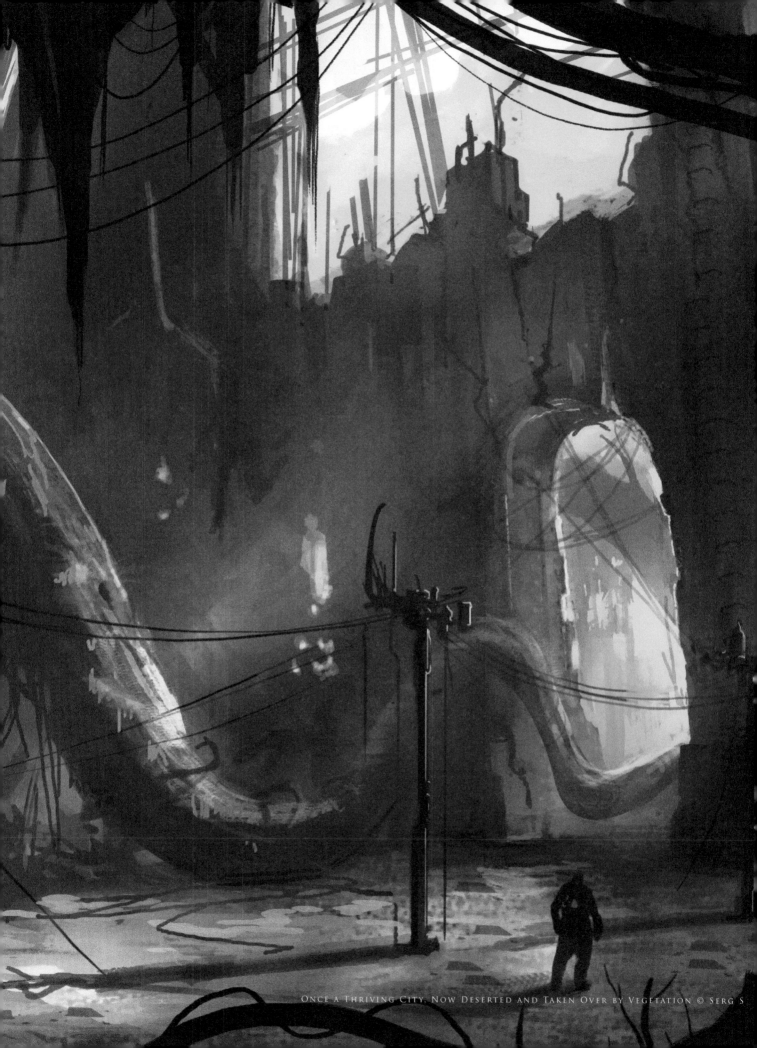

Once a Thriving City, Now Deserted and Taken Over by Vegetation © Serg S

speed painting

In any creative process the task of preliminary work and sketching is a proven way to explore ideas before committing to the final piece. Speed painting has become common practice within digital painting and allows artists to experiment with core themes such as color, mood, lighting and composition. In an industry with an ever-quickening pace, this type of painting has carved a niche for itself within the CG sector and has become widely accepted as an effective way of communicating key ideas before any details are evolved. What follows are some different approaches to tackling a similar problem, but each demonstrating the importance of speed painting in establishing the structural devices behind most paintings.

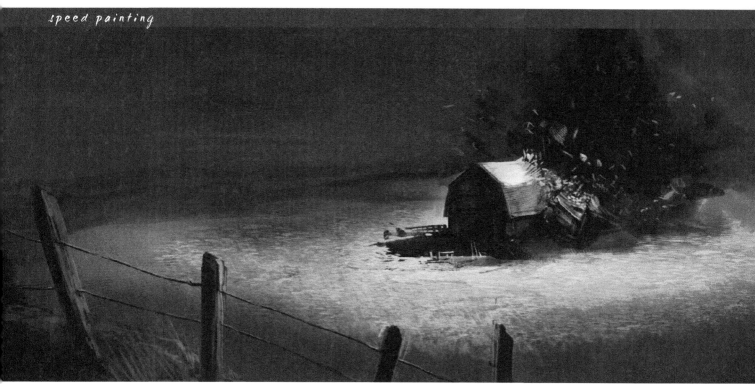

TORNADO MOVING TOWARDS FARMHOUSE
BY CARLOS CABRERA

SOFTWARE USED: PHOTOSHOP

THE SKETCHING PART

I opened a new document of 2000 by 3000 pixels and started the quick sketching phase with a 50% zoom over the whole document. In this particular step I don't like to be held back by little details and prefer to work more on the harmony of the illustration, using quick and simple forms. Drawing in black and white is the quickest way that I know of for obtaining good compositional details without wasting too much time; it almost develops on its own and I always encourage people to try this technique. You can see how the twister and the farmhouse are there in the first view with just a couple of strokes (**Fig.01**). Now it's time to add some gray colors to the sky and to the ground (**Fig.02**).

Fig.01

Fig.02

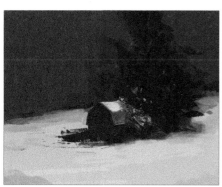

Fig.03

We can start to give the farmhouse a little bit more detail now. For the twister I use black with 50% Opacity; this adds a cloud/smoke effect and allows you to accomplish the effect in a short space of time. After we've finished the gray coloring stage, we can start to add more detail to the farmhouse. You can see the chunks of wood on the house's roof are just

little brush strokes – some of which are darker than others. This creates the effect of small, flying pieces of wood. At this stage it's pretty obvious that you'll need to work the details in 100% zoom, to be more comfortable. We can then add some grass and a fence to the scene, and then we'll be done with the farmhouse – that easy, that quick (**Fig.03**)!

If we compare this step with **Fig.02**, we can see how throwing some dark color at the farm will focus the viewer's attention exactly where we want it: on the farmhouse (**Fig.04**). Now we just need to add some light and shade to complete the drama of our scene. It isn't really that complicated; if you picture it in your mind it will come out naturally. One thing I added in the foreground was some extra detail (the fence), as I felt there was an empty space there to be filled (**Fig.05**). You just need to have fun and play with your illustration. There are a lot of rules of composition, but I think the best one is the eye, imagination and mind of each artist. It's better to be creative and have fun working on your illustration than to work over a pre-established grid.

Now we need to make the twister something scary, and to do this we add a layer on top of

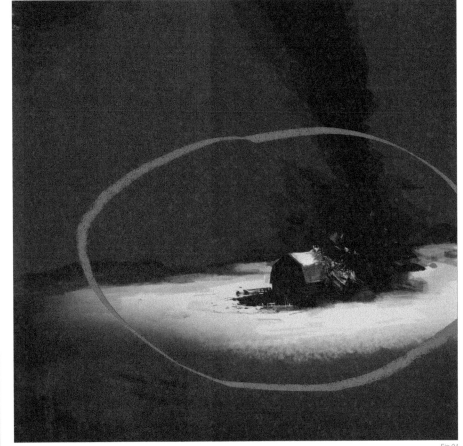

Fig.04

Fig.05

everything and start adding some dust and clouds around the body and base of that mean twister – look how big it is! This particular part is pretty fun, and I bet you will spend quite some time on it (**Fig.06**).

After we've finished our twister, we need to go to the next stage of the illustration, and, to be honest, this is the step I personally enjoy the most. By painting wood and dust flying around the house in a mortal ballet, with just a few small strokes we can easily create the path of horror of this twister, and the fallen debris that it leaves behind (**Fig.07**).

FINALLY, SOME COLOR!
Now we create a new layer and place it above all the others. Press Ctrl + Shift + E on your keyboard to merge all the layers in just one single

Fig.06

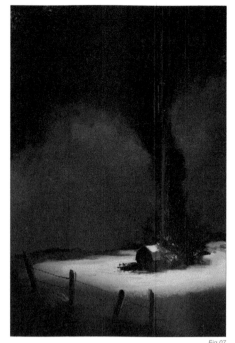

Fig.07

layer, and then rename this layer "color". After this, we press Ctrl + U and the Hue window should pop up. We need to check the Colorize checkbox (it will be unchecked by default), and then set the values to Hue: 54, Saturation: 25, and Lightness: 0 (zero) (**Fig.08**). With these values we will get a nice sepia brown color that we can use for our illustration. We're almost there now!

The initial grayscale painting technique used with this illustration is often used by artists to clear our minds from the color of our subjects, and to cut straight to the chase. On the other

Fig.08

hand it's also good practice to upgrade our rendering skills, and so it's very useful either way.

We now create another layer, above all the existing ones, and paint over the farm and the floor with all the colors that you can see added in **Fig.09**. We switch the layer to Overlay and leave everything at 100%. By doing this we change the floor tint and the farm tint, and finally we have given our illustration a new variety of color and contrast. Lastly, we just need to have some fun applying the last touches, and then we're done (**Fig.10**).

Fig.09

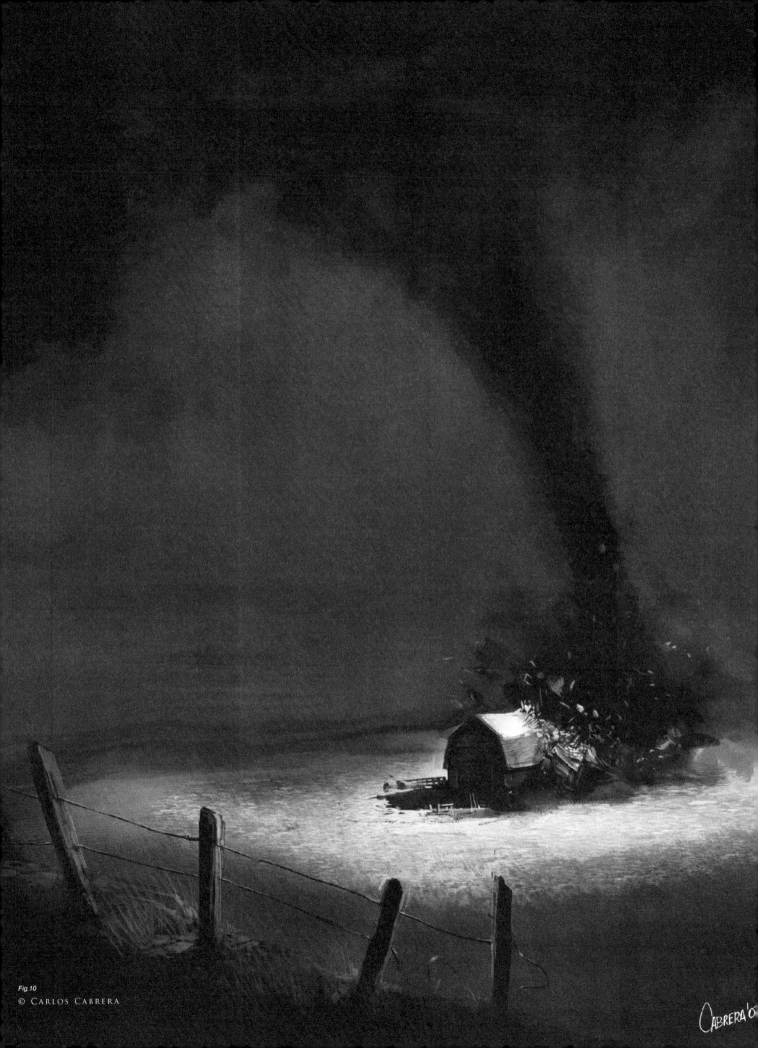

Fig.10
© Carlos Cabrera

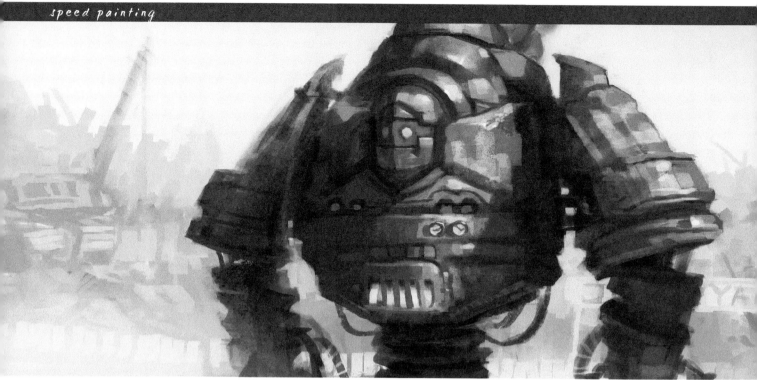

© Daniel Ljunggren

Steam-Powered Mechanical Destroyer
By Daniel Ljunggren

Software Used: Photoshop

Introduction

After thinking about the topic of this speed painting for a while, I started imagining something that would be suitable for a younger audience – perhaps a commercial for toys, with figures you can play with, and one of these toys being the "Steam-Powered Mechanical Destroyer" (or so the description on the back of the box would have you believe). I then thought that it would be more fun if it was a big robot, yet still friendly. The "destroyer" part was the main issue really, meaning I would have to turn it into something not so violent in order to keep the positive mood that I still wanted to achieve.

I could've gone another route towards something more serious, dark and violent, but personally, it wouldn't feel very original. I'm not saying a friendly robot is original either, but perhaps a bit more of an unexpected approach to the subject title. I have interpreted the theme more like a concept artwork than a painting, so please treat it as such.

Step 01

Before starting to draw or paint the full-sized concept with details and all, a great and quick way to find your design is with a few small

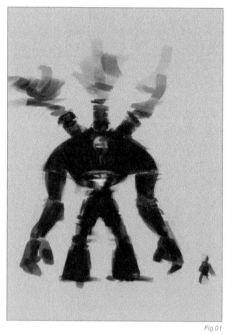

Fig.01

thumbnail sketches. This allows you to focus on the general shape, the silhouette, and the overall feeling of the concept. After a short while of thumbnail sketching, I see something that shows potential (**Fig.01**). I also put in a sloppy human figure to get a feeling of scale. Working a bit further with it I find a design and feel that I want to see a fully rendered version of (**Fig.02**).

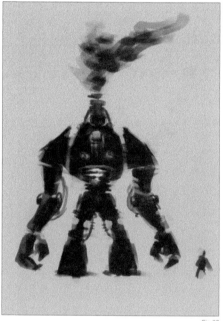

Fig.02

Step 02

Using the thumbnail as a reference image, and keeping the main subject and the background on separate layers, I start to sketch the robot from a more interesting angle and in higher resolution. I'm still working in grayscale because I can focus on what I want to prioritize for the time being: design, proportions, pose and perspective. I find that the main challenge

in this part of the process is to achieve the same feeling in the perspective image as with the thumbnail. If I would go on with the next steps before nailing that feeling, I know I would probably abandon it later on because it didn't turn out the way I wanted, so being persistent in this step pays off (**Fig.03**).

Adding some more volume and details to the robot, and some brushstrokes to the background, I try to find the kind of lighting and contrast I want for this image. I add some highlights just to remind myself where the main light source will be (**Fig.04**).

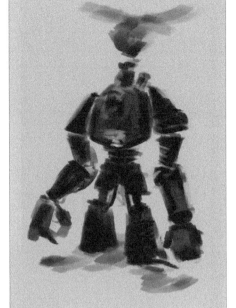

Fig.03

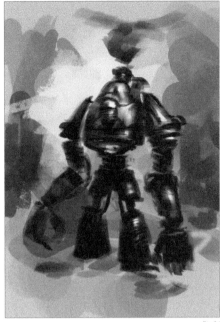

Fig.04

STEP 03

I set my brush to Color mode and paint some big chunks of colors on the background, as well as on the robot (**Fig.05**). Sometimes I don't find the color I'm looking for when using this method, because of the values of the painting underneath, but it's a quick way of deciding what general palette the image will have.

I pause here, thinking about the impression I get from the robot. I figure that I really need to kill those highlights soon, as well as change the color to what I'm looking for. Creating a new layer (Normal mode), I start painting directly with colors, and soon I see something closer to what I had in mind (**Fig.06**).

Fig.05

Fig.06

CHAPTER 02

STEP 04

While developing the concept for this robot I came up with the idea of having it working in a junkyard, where he would be "the destroyer" of metal scraps. This would go well with the overall positive feel I was trying to achieve, and the background would be where I could suggest this (**Fig.07**).

STEP 05

During the previous steps I wasn't quite sure what to make of the robot's left arm and hand, but as I tried a few shapes I knew it would gain visual interest instead of having two similar arms. After a few quick designs I decide to go for some kind of drill (this makes the robot fit better with the description of "destroyer", too). With that done, I feel ready to start working on more detailed shapes and textures (**Fig.08**).

Moving on to adding more details and rendering (**Fig.09**), here I'm trying to make it look a bit more realistic; removing a lot of the black from the underlying sketch, as well as thinking of cast shadows and bounce lights from the ground. I put a few strokes on his head as well, trying to figure out what I want that part to be like.

I do some more work on the background now, making the sky clearer and redesigning some of his firebox and chimneys on his back, as

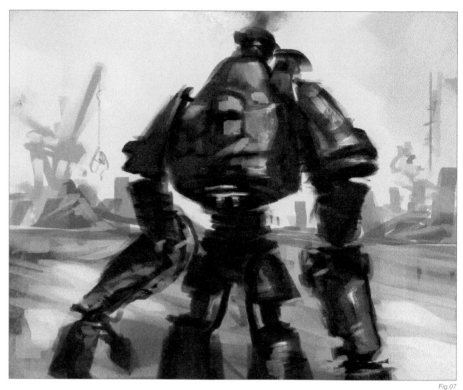
Fig.07

well as giving a warmer ground. I still wasn't sure at this stage what to make of his head (**Fig.10**).

STEP 06 – FINAL

Finally I approach the face of the robot. I considered having the robot being driven by a man for a while (with the head as the cockpit), but with the current scale of things I had trouble making the chauffeur read clearly, so I dropped

Fig.08

that idea and went for a kind robot face instead. This also helps strengthen the overall positive feel. I put down some more work into the firebox, showing more clearly that it is something that could open and hold burning coal. Background details are also added here, as well as some stripes on the robot – and then he's done (**Fig.11**).

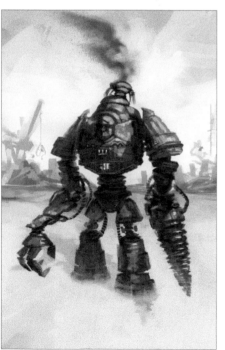
Fig.09

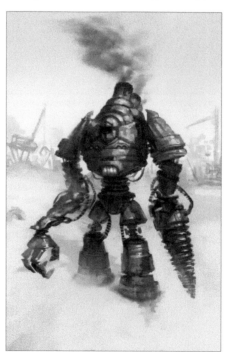
Fig.10

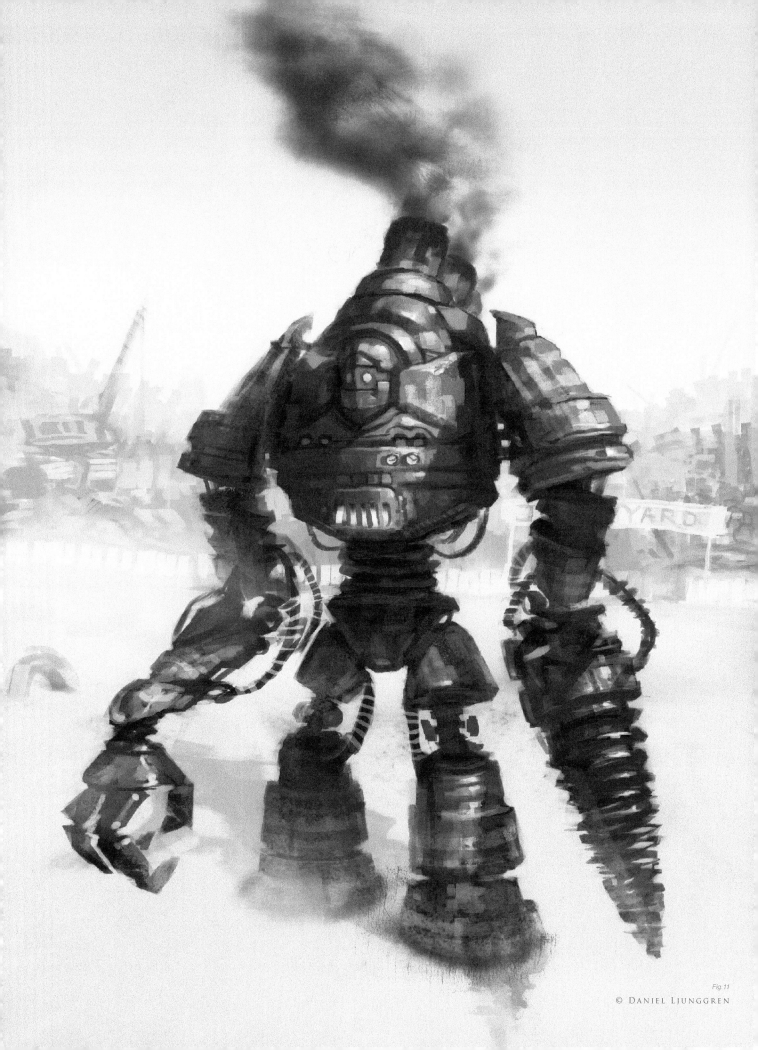

Fig. 11

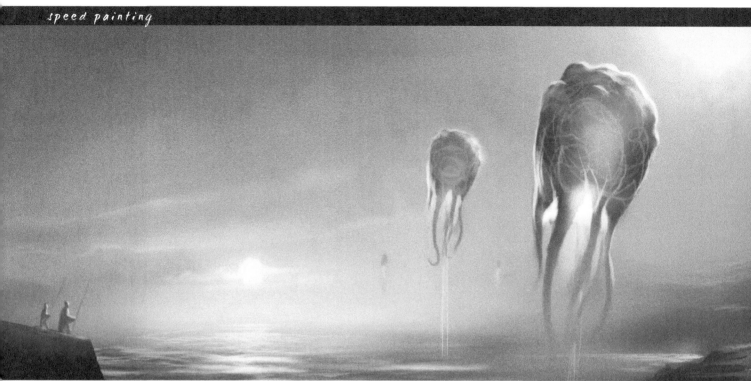

ALIEN HOT AIR BALLOONS
BY EMRAH ELMASLI

SOFTWARE USED: PHOTOSHOP

INTRODUCTION

When the 3DTotal team first told me about this topic, "Alien Hot Air Balloons", the scene that I'm going to paint was already in mind. I therefore feel comfortable about what I'm going to do with this tutorial, and after making some initial thumbnail sketches I have enough to start painting.

STEP 01

I want to finish this painting in 90 minutes – maybe less than that, but no longer – so this is my target goal. Before starting to paint a "speedy", I suggest you set a time limit for yourself. This simply helps you not to overdetail your work and lose time in the process.

I'll use Photoshop CS3 for the entire painting process. I open a new 2200 by 1200 pixel canvas and create a new layer. The scene that I'm going to paint will be an alien world, but I don't want it to be too different

Fig.02

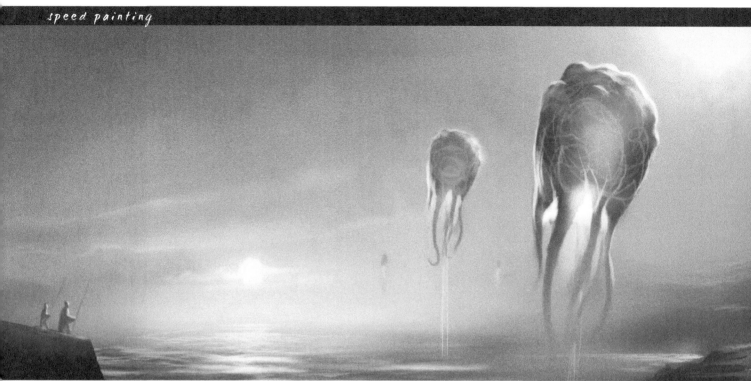
Fig.01

from Earth – some minor changes will do. So the first thing to do is to determine the colors – green and yellow sound cool. Now, let's block them in. I always use large, textured brushes when I'm blocking colors, so I'll do the same this time too. By using yellow, green and gray, I quickly create the background and foreground. I want to have two light sources in the scene so I put two suns into the green, alien sky. So that's it for this step (**Fig.01**) – let's now go into more detail.

STEP 02

I open a new layer and set it to Color Dodge from the blending mode options tab. I grab a soft round brush and glow both of the suns with a saturated, dark orange color. This gives the soft atmosphere I need. I can now start putting some details in. To do this, I use some textured and scattered brushes in order to create the water effect on the background, and some hard brushes for the rocky feel in the foreground (**Fig.02**).

STEP 03

For this third step I continue to add details using my own custom-made brushes. I also need some contrast in my painting, so I open a Curves adjustment layer and bend the curve to gain some contrast. I do this a lot when I'm painting: I always start with light colors and darken them in the process. I also make some changes to the colors by opening a new Color Balance adjustment layer, adding some blue to the shadows, which makes the painting even richer in color (**Fig.03**).

Fig.03

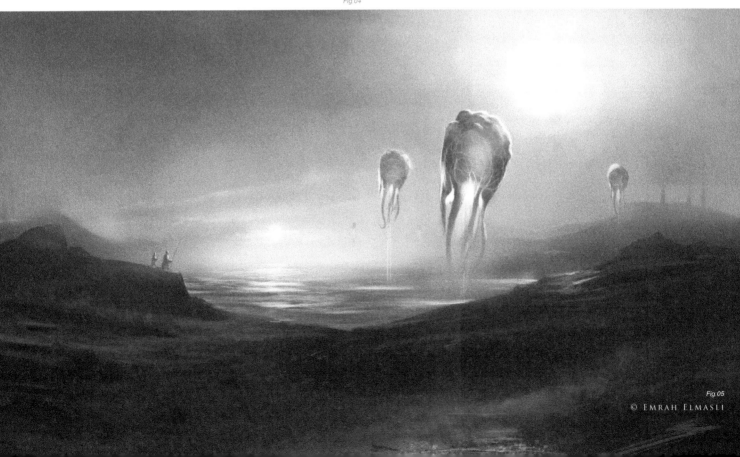
Fig.04

STEP 04

I can hear you asking, "Where is the balloon?" Well, now is the time to add it – or them, in this case. I start painting in the alien balloons with a hard-edged brush. I want them to have arms, like squids, and glowing from inside. Keep in mind that you can always glow anything you want by opening a new layer and setting it to Color Dodge or Linear Dodge, and then paint in with a dark saturated color. My alien balloons are now hovering and glowing (**Fig.04**).

STEP 05 – FINAL

For the final step I simply want to paint in some more details and add more contrast using the Curves again. For the very final touch, I paint two figures with red staffs in their hands into the scene (**Fig.05**). I think they are aliens too, but I don't care really because the speedy is now finished: 90 minutes!

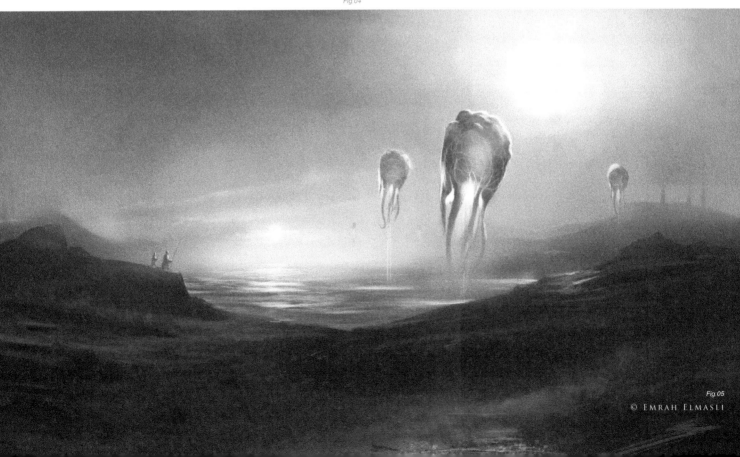
Fig.05

© EMRAH ELMASLI

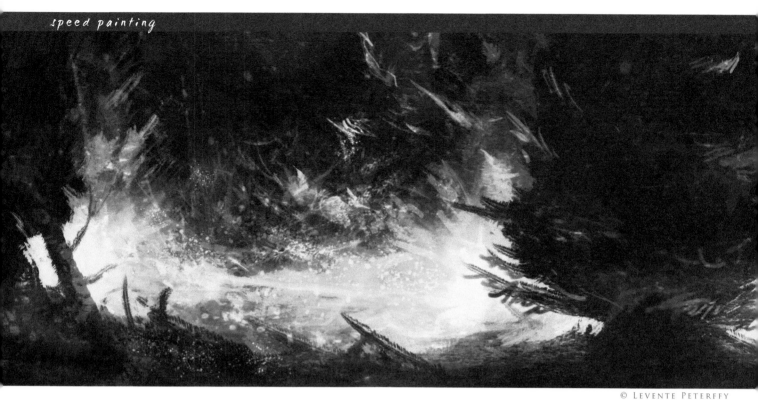

FOREST FIRE
BY LEVENTE PETERFFY

SOFTWARE USED: PHOTOSHOP

LET IT BURN!

In this tutorial I will describe my methods for painting in silhouette, using the theme "Forest Fire".

CHOOSING THE RIGHT COLOR

The first thing to do is to choose the right color scheme for your painting, which can depend on a lot of things. The topic is a common one, so I know that I'm going to need to use a lot of red, yellow and orange tones, representing the warmth and heat of the fire. With this clear

Fig.01

color scheme in mind, I start by selecting a background color. I chose a red brown tone. I find painting with silhouettes easier if I have a dark background and paint with light colors onto it. I scribble with a brighter color on top of the dark background; I don't have an exact idea of what I want to paint, so at this point I'm just scribbling (**Fig.01**).

LIGHT THE TREE

Here you can see the result after some sketching and testing of colors (**Fig.02**). I'm using the same brush as before – for this

Fig.02

Fig.03

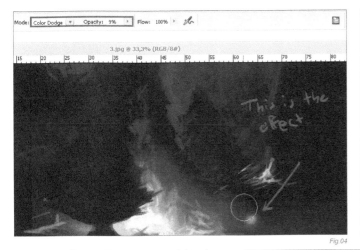

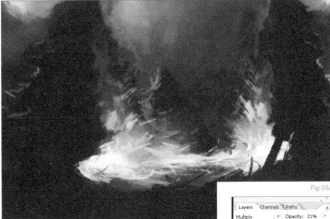

Fig.04

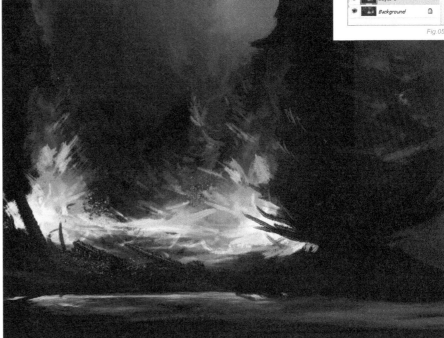

Fig.05a

Fig.05b

first phase of the painting it's a rough brush, suitable for sketching. When sketching in silhouette, it's always important to paint whilst first always considering the light, and secondly the shapes created. For example, I paint the light around the tree and not just the tree itself, as this is a fast way of painting when both light and shape are established. I'm bearing in mind here that I need a dark background, and a lighter color on the brush I'm using.

BURNING, BURNING!

At this point of the painting, the basic colors have already been laid down. So in this next phase you can just reuse those colors to paint more objects, just as I have (**Fig.03**). The use

Fig.06

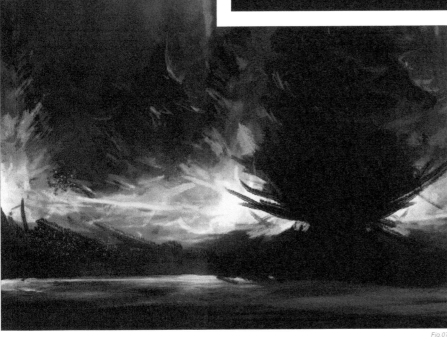

Fig.07

of the Color Dodge layer style in Photoshop is pretty effective, but it's very important to always use very low opacity on it; I always have the Opacity set between 5 and 15%. The lighter tones in the fire are painted with the Dodge mode for the brush (**Fig.04**). I also use a default Photoshop soft-edged brush here to add some of the smoke effects, which have a low opacity on them too. I continue to paint more on the trees, using the same colors as before.

MULTIPLY

This step is simple: I duplicate the painted layer and change the layer mode to Multiply, making the image slightly darker. I also adjust the layer Opacity in order to tone it down a touch (**Fig.05a – b**).

THE LAKE

I felt that the bottom of the painting felt empty at this point, so I decide to add a small lake here. The process of creating this lake is as follows: draw a marquee around the painting; press Ctrl + T to make a Free Transform. Flip the image upside down, basically grabbing the top and pulling it down. You then need to squeeze together the image horizontally so that it looks like a narrow, broad box. Finish the Free Transform by hitting Enter on your keyboard. The last thing to do is to erase the hard edges of this flipped box so that it melts together with the background painting (**Fig.06**).

LAST-MINUTE CONSIDERATION

I'm not totally happy with the background here because I feel I still have some space to be worked on – and also because I want to create more depth in the image. So, I decide to paint in some more trees, using a hard-edged brush for this task – one of the default brushes in Photoshop (**Fig.07**).

TEXTURING

It's time for texturing at this stage, which is good if you have custom-made brushes just for this purpose. I have a custom-made brush (**Fig.08a**) that has a sprinkled effect, which I used to create fire sparks (**Fig.08b**).

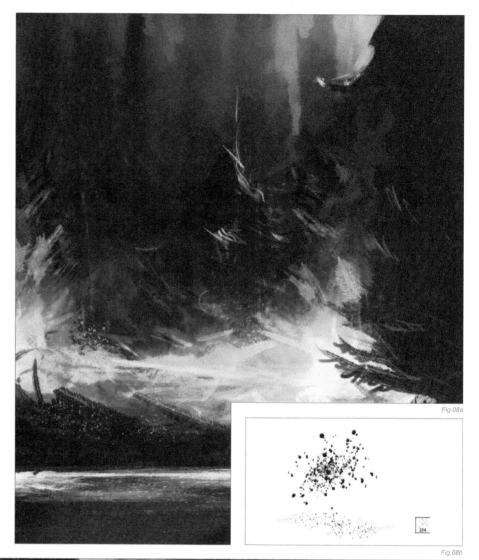

Fig.08a

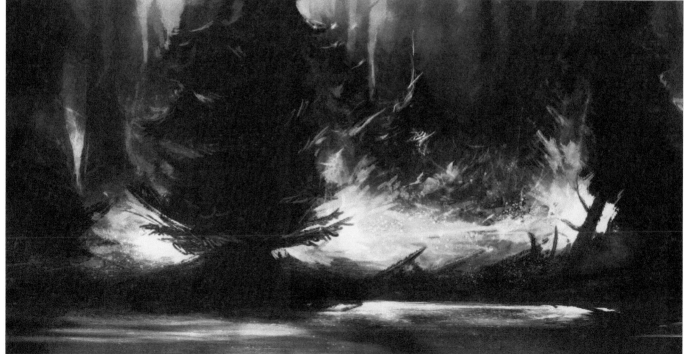

Fig.08b

Fig.09a

FINAL TOUCHES

Alright, so the painting is nearly finished now, but I've decided to play around by adding some more highlights and enhance the light even more on the lake reflection, treetops, leaves, and so on (**Fig.09a – b**). There is also a pretty cool trick you can use to make the illustration look rougher: it involves a flat texture – basically any kind used for 3D purposes. Here it is (**Fig.10a**). I changed the mode of the texture layer to Overlay as well, which was the last thing I did on this painting (**Fig.10b**).

I'm very happy with the final painting – I hope you are equally satisfied with your own forest fire scene after following this tutorial.

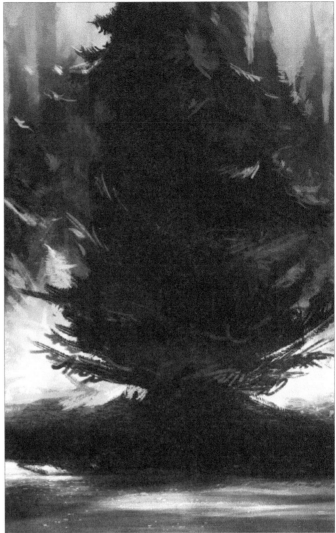

Fig.09b

SOURCE: CGTEXTURES.COM

Fig.10a

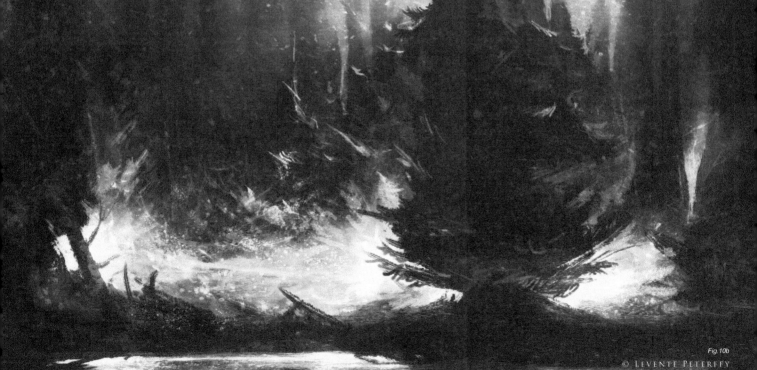

Fig.10b

© LEVENTE PÉTERFFY

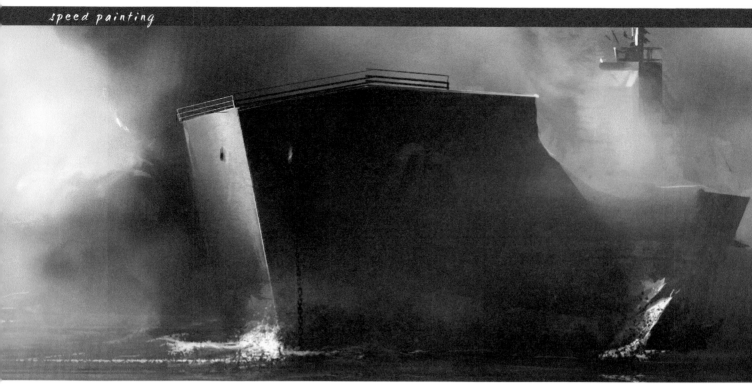

SHIP HIT BY TORPEDO
BY LEVENTE PETERFFY

SOFTWARE USED: PHOTOSHOP

INTRODUCTION

Build your confidence in just an hour: I'm going to show you how to whip-up a "ship hit by a torpedo" with just a few digital strokes! Speed painting is an effective practice used to achieve good composition, color and light-interaction with shapes and forms, and, with the use of brushes – both default and custom-made – you can quickly create and simulate a realistic environment with just a few strokes.

The topic, "Ship Hit by Torpedo", reminds me of World War II; I don't really know why, but I've always been interested in World War II, and so I was therefore quite taken with the topic set for this tutorial. There are probably a million stories to tell about that time period, which would all be very interesting to illustrate, and in this case it's a ship being struck by a torpedo. In this tutorial, the focus will be on the fact that

Fig.02

Fig.01

realistic images – or colors, if you like – can be achieved quickly with the use of custom brushes and blending modes in Photoshop. The software used to create this speed painting is Photoshop CS2, along with a Wacom Intuos 2. So let's begin...

BACKGROUND COLOR

I start off with a colored background, as you can see in **Fig.01**. On this background I start to paint with custom soft-edged brushes, often

with a very low Opacity of between 10 – 20% (**Fig.02**). I work in this way until I can see some shapes evolving (**Fig.03**).

SHIP AND FOG

At this stage I start to develop more of the shapes from the previous image, which were slowly forming. Already, you can see that it shows the shape of a ship in the foggy atmosphere. I use similar kinds of colors to define the shape of the ship more and more.

When I first had my shapes defined I started testing some new colors out. I use a light blue in this case, for the sky, and also define the horizontal sea-line (**Fig.04**). I used a simple gradient to make the ocean; the colors were all picked from the painting – one light color and one dark.

I crop the image at this point, and at this stage I'm able to start going into more detail now. I pick a small, hard-edged brush (**Fig.05**) and start adding details on the ocean, as well as some smoky clouds (**Fig.06**). I like to flip my painting horizontally a lot whilst painting, as it helps to refresh my eyes and allows me to see if there are any flaws (proportions, perspective, and so on).

I continue adding details and also building on the background, trying and testing hues of blue for the sky (**Fig.07**). There is one thing I usually try a lot in my paintings, which is to duplicate the painting layer and then use a Photo Filter on the duplicated layer, increasing the density on the Warming filter to 85. I choose Multiply as the blending mode for the duplicated layer on top. To finish it off, I take the layer Opacity

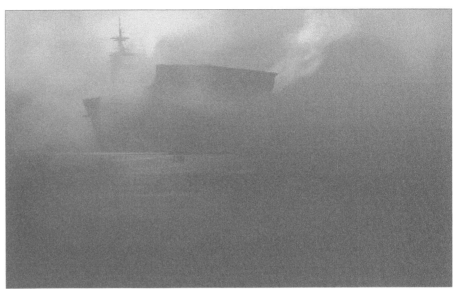

Fig.03

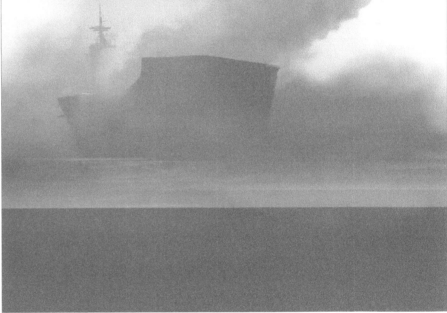

Fig.04

Fig.05

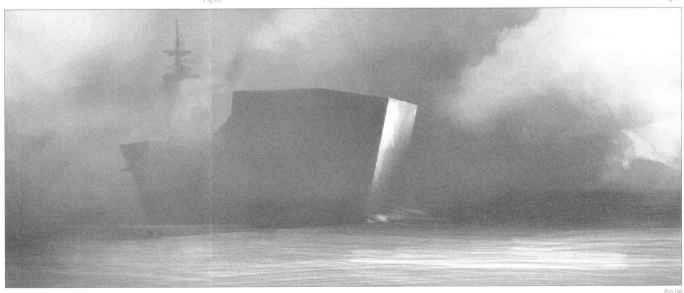

Fig.06

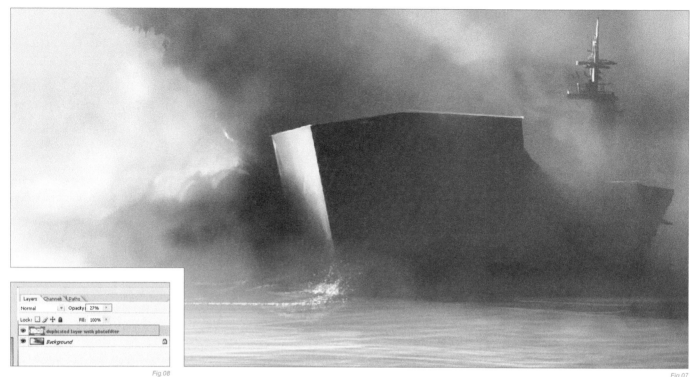

Fig.07

Fig.08

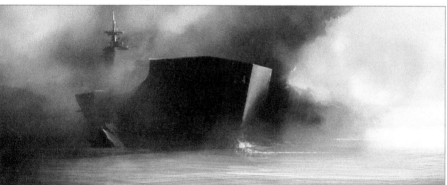

Fig.09

Fig.10

down to a fairly low level, until I feel that the colors are just right (**Fig.08**). If you want more control you can then erase parts of the top layer, as I have done.

At this stage I add some more detail to the ship (**Fig.09**). There is an open crack on the ship's hull, just as if a torpedo tore a hole straight through it (hence the topic for this speed painting).

DETAILING

I like adding details. Adding details is kind of like adding more words to a story – there are certain details that you just have to add, simply because they help the picture to make more sense; for example, breaking waves, reflections on the water, and so on. I paint a silhouette of a bird on the left, because I feel that the sky area in that section is a little empty. Another detail which I think will help is the use of a rusty texture – look at the ship's lower part. I want to create something rusty-looking, so I paint with

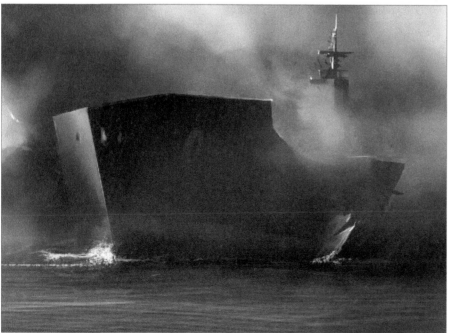

Fig.11

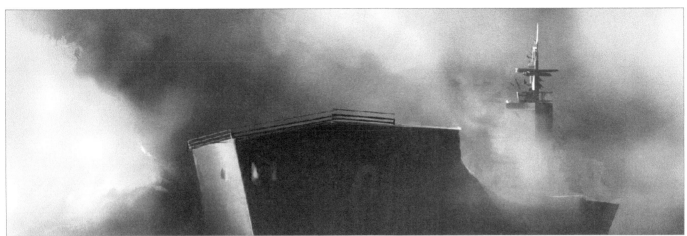

Fig. 12

a custom-made brush, which slightly resembles rust (**Fig.10 – 11**). I also continue adding more brushstrokes to the smoke (**Fig.12**).

COLOR TEST
These last stages of a speed painting are basically to test the colors to see if you can improve them, and add more to the mood (**Fig.13**). Again, I find flipping the canvas always helpful to refresh tired eyes.

FINAL TWEAKS
Adjusting the resolution and adding sharpness are the last things that I do to my paintings. And there we go: speed painting complete (**Fig.14**).

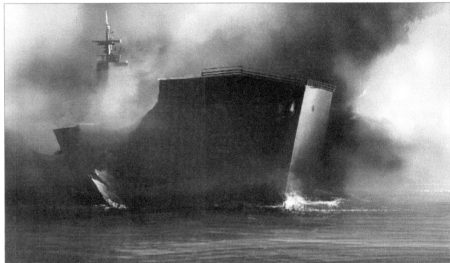

Fig. 13

ARTIST TIPS AND SECRETS
I can't stress this enough: practice and practice more. This is the key to success. Even with cool custom brushes as assets, you still need to train your eye to see shapes and colors interacting with light, in order to evolve a painting. Try not to get too dependent on tutorials; dare to experiment a lot, even if you don't know where to start – just scribble around. There are a lot of forums out there with speed painting threads, so post your work a lot and see what feedback you get. There are people out there willing to help you so use their advice wisely. However, do try to think about the problem for yourself, and try to solve it as best as you can. If you have a hard time starting to paint, then make studies from paintings by some of the Masters, or of screen shots from movies – that should help you to get started, at least.

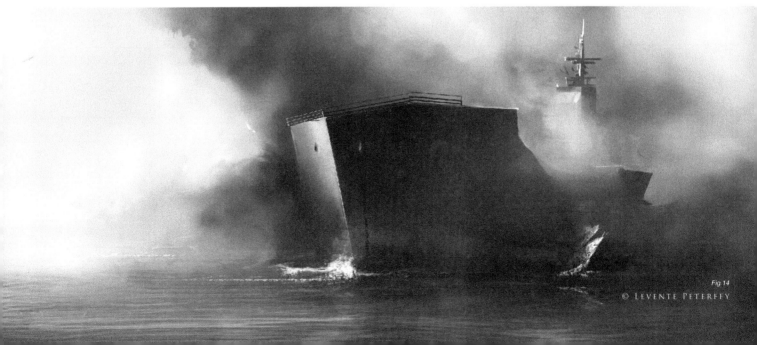

Fig. 14

© LEVENTE PETERFFY

© NATHANIEL WEST

ALIEN HOT AIR BALLOONS
BY NATHANIEL WEST

SOFTWARE USED: PHOTOSHOP

STEP 01

For this speed painting I start off sketching freely, with no preconceived notions, and wait to see what will come out about. After a short time of messing around with different shapes and values, I begin to see a vision of a large balloon coming towards a foreground destination. In my mind, I view air balloons as very tranquil, and so the scene began to take on that quality.

Fig.01

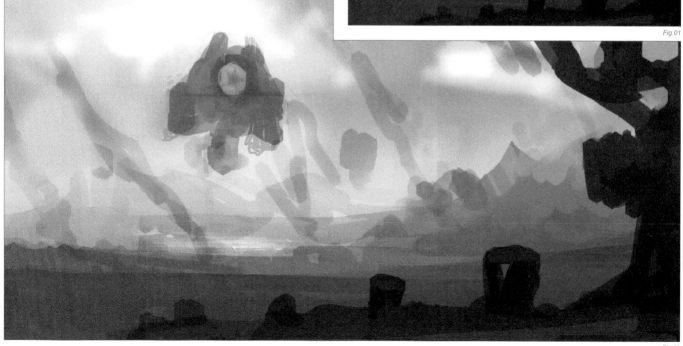

Fig.02

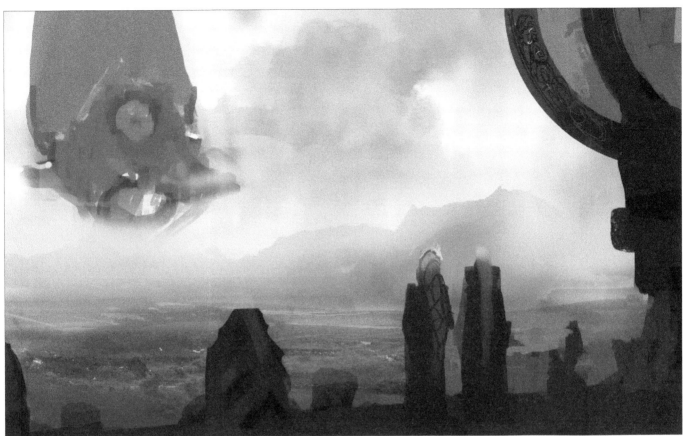

Fig.03

When first starting a piece I begin by laying down a rough grayscale sketch (**Fig.01**). It is very important to have a good value structure first and foremost, with values grouped together to create a graphic and dynamic piece. I would say that this is the single most important stage in a painting, and should be

worked out before beginning with color. If your value structure works, then the rest of the painting will follow easily. But, if your value structure is off, then you will find the next stages of the painting to be hopeless efforts until the value structure has been corrected. Often, a painting is not dynamic

simply because the lights and darks have not been pushed enough, thus resulting in a "flat" appearance.

STEP 02

Now that my values are worked out, I proceed on to glazing color over the entire painting. This

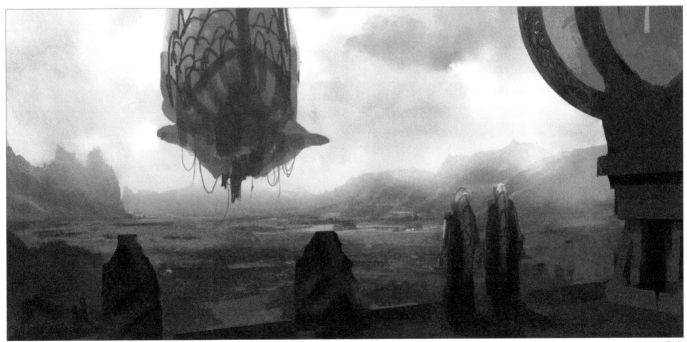

Fig.04

CHAPTER 02

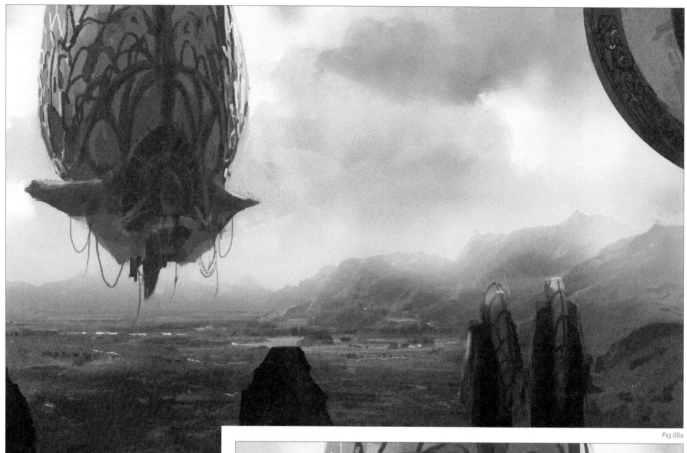

Fig.05a

can be subtle or extreme, but either way I glaze the whole painting with one color to keep the palette unified. I then begin to add additional color variations and levels of saturation to develop the piece further. I'm always careful to maintain the value structure throughout this stage of the painting process (**Fig.02**).

STEP 03

With the overall palette of the painting established, I can now begin to further develop some details. I add in the balloon portion of the hot air balloon, and then mirror it with the same color and shape in the upper right corner. I also add a couple of figures and decide to give them the same color and shape language (**Fig.03**). This is all in an effort to tie the balloon and the foreground together, from a story point of view. I had indicated some trails of smoke coming off of the ground, but I decide at this stage to get rid of them, so as not to disrupt the landscape too much. The sky begins to get tightened up now, along with the mountains.

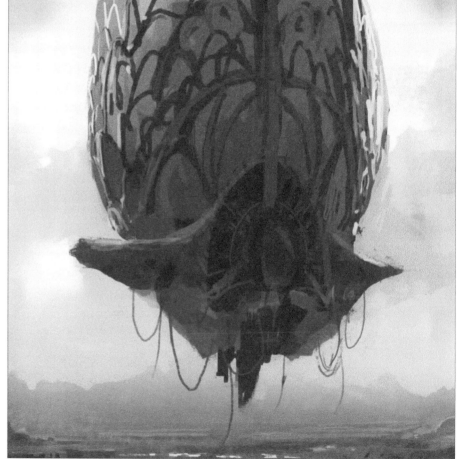

Fig.05b

STEP 04

I continue detailing the landscape further, introducing textures and color washes to achieve the desired effect. The air balloon has changed quite a bit, and its design has started to take shape. I'm also introducing additional color shifts into the sky as well (**Fig.04**).

STEP 05

I'm now going to focus solely on the balloon, as that is our main subject matter. I give some loose detail to it, and then blend it into the environment with some ambient lighting on the outer edges of the balloon (**Fig.05a – b**).

STEP 06 – FINAL

I now add in additional details to the landscape and foreground. Once done with all the

Fig.06a

Fig.06b

detailing, I put some rays of light coming through the clouds, hitting a couple of areas with some highlights, and push the contrast in some areas to make the scene a touch more dramatic. I add in some highlights on the edge of the foreground to help separate it from the landscape, and then happily call the painting done (**Fig.06a – c**).

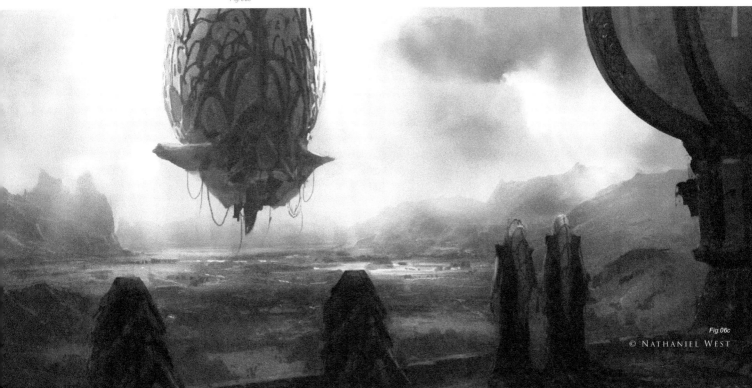
Fig.06c
© NATHANIEL WEST

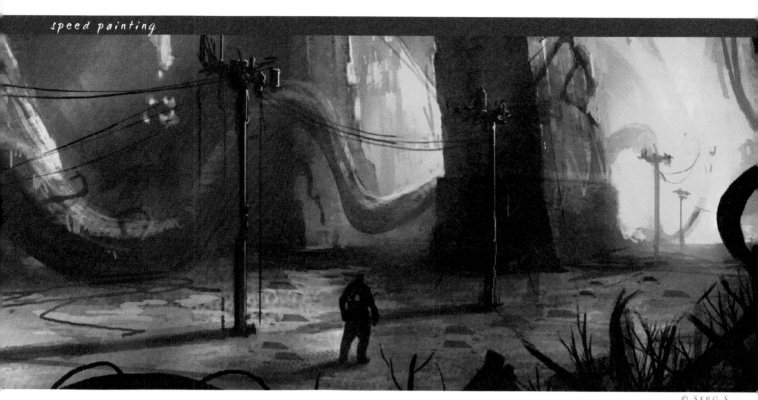

© SERG S

ONCE A THRIVING CITY, NOW DESERTED AND TAKEN OVER BY VEGETATION
BY SERG SOULEIMAN

SOFTWARE USED: PHOTOSHOP

INTRODUCTION

The outcome of a painting cannot be determined in the first stages of its creation; an image usually evolves with the artist over time. The process that I used to approach this brief started out with some research into interesting shapes. It's always a good idea to have some kind of reference for whatever you're drawing, but this time around I wanted to see what I could achieve from a two-hour speed painting without using any specific references. So here we go...

Fig.01

Fig.02

STEP 01

For this painting, I start off with a standard round brush, size 13, with Pressure Dynamics turned off and Opacity set to 75%. The colors I went for, with the theme of an overgrown city in mind, were all neutral and earthy tones (**Fig.01**)

Fig.03

STEP 02

In the beginning stages I try to focus on shapes and the negative space of the image, and aim to not let the perspective of the piece hinder my search for these shapes. At one point I had a cityscape, but it then turned into an interior shot once I put in the three vertical structures, and so I'm going to follow that path instead. I try not to put in perspective lines when starting an image, as I like to be able to search for shapes with the greatest freedom. At this point I decide on the composition and that the space I am painting is going to become the base of a building that has been taken over by vegetation, as the brief suggests (**Fig.02**).

STEP 03

Once the composition has been decided upon, I start to think about the lighting and shadows. Adding a complementary light source from the bottom left helps with the color contrast, and I use red to indicate rubble and to introduce some warmer color to the shadows (**Fig.03**).

STEP 04

At this stage, adding some perspective lines helps me out with the repetition of objects, and in defining the shapes discovered in Step 01. At this point it's a good idea for me to check the values in the image. The order of values I used were: a value of 10 for the foreground, a value of 4 for the mid-ground (the area where the light hits the floor), and 6 for the background (**Fig.04**). A good way of thinking about this is: light, dark, light, dark – it's never ending! When

Fig.04

Fig.05

you have dark next to dark, you lose the edge (although sometimes you may want that).

STEP 05

After adding a figure to set the scale, I decide that I want to create an uneasy feeling for the character. Having verticals in your image creates stability, and so angling them to the left and darkening the values of the image seems to help create the illusion that I'm aiming for. I then paint out one of the center pillars of the image in order to give the feeling of more hope, and to lose some of the repetitiveness (**Fig.05**).

STEP 06

At this stage I start bringing it all together. I add more detail using a standard brush with the

texture option checked, and I angle the brush to the perspective of the image (**Fig.06**). The main change here is to separate the values of the atmospheric perspective of the image where the objects seem to become closer in value as they recede into the space (**Fig.07**).

FINAL THOUGHTS

At this point I was happy with the image because it conveyed the mood, environment and scale I had initially hoped for. If this image was to be used as a piece of concept art, it would give the 3D artist a good starting point to work from. If it was a matte painting then the use of photographic textures would be the next step, as well as cleaner edges and greater use of the Selection tool.

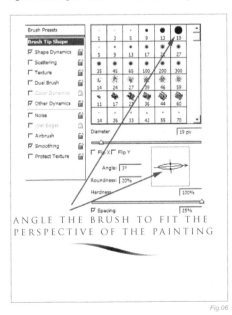
ANGLE THE BRUSH TO FIT THE PERSPECTIVE OF THE PAINTING
Fig.06

Fig.07

© Serg S

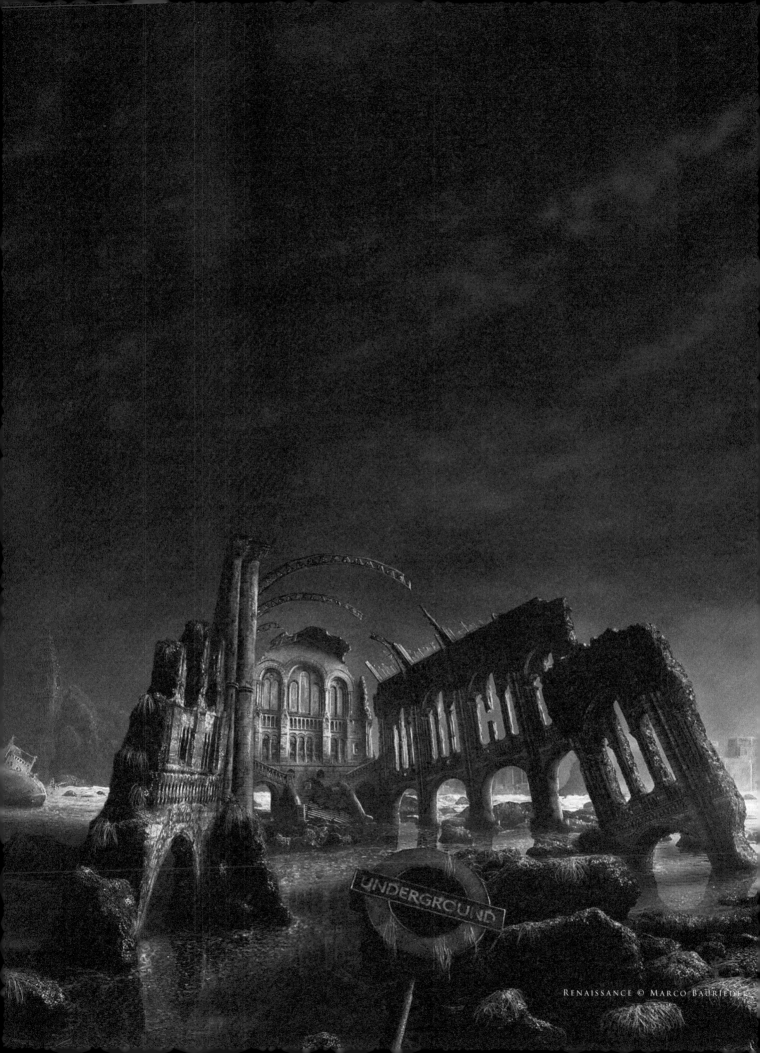

matte painting

What was once a traditional art form has now adapted to become a purely digital practice. This very particular discipline allows film makers to create scenes that would prove either too expensive or impossible to film, and has become one of the staple ingredients in this industry. This chapter looks at the techniques behind matte painting and explores the value of photography and painting skills to seamlessly blend two distinct attitudes.

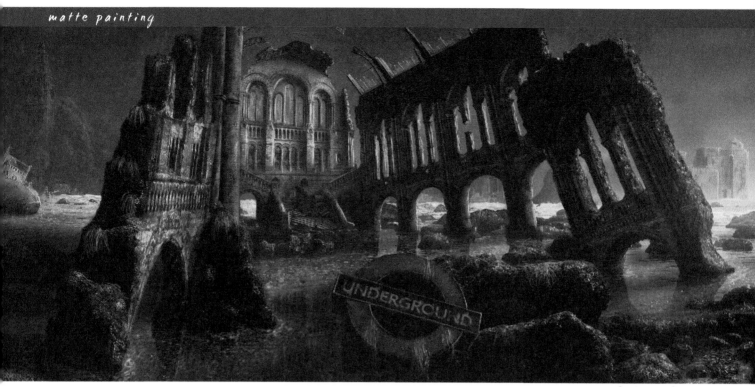

THE MAKING OF "RENAISSANCE"
BY MARCO BAURIEDEL
SOFTWARE USED: PHOTOSHOP

The base image needed to be cleaned up first before anything else (**Fig.01a**). The second stage was to create an extension of the image, following the concept of leading onto a matte painting in which the National History Museum would be set in a natural environment, as if in existence sometime in the future. I started off by taking the base image of the National History Museum and painting/Clone Stamping the people out of it (**Fig.01b**). The Lasso tool

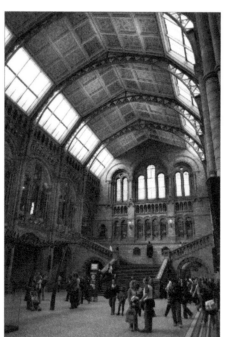

Fig.01a

Fig.01b

Fig.01c

Fig.01d

was used to select parts of the image, which were then copied, rotated, flipped and scaled to fit into another location (**Fig.01c**). Making selections of a shape by guessing how it would continue in a covered/extended area, then Clone Stamping in some noise from a similar part of the image and color correcting it, is another nice way to work (**Fig.01d**).

Fig.02

It is important to give some visual variation to duplicated parts. You can easily achieve this by painting some dirt, erasing things, or using the Sharpen brush. The idea is to imitate the colors, and the overall sharpness and grain of photography. After cleaning up the image, perspective lines were used to extend the image (**Fig.02 – 03**).

I created some concepts in order to get an idea about how to put the museum into a natural environment. Clone Stamping some photography into your painted concepts might also help to imagine the desired look very early on in the process. For the concept to work

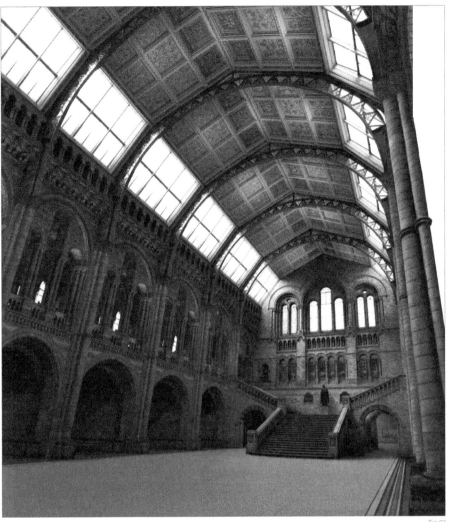
Fig.03

it was important to color correct the building in a way that it could be integrated into the background scene (**Fig.04**). To be honest I should have spent more time thinking about perspective issues in the concept phase. As you can see here, I didn't take a lot of care with the rocky shore concept (**Fig.05**); I wanted to sort of zoom out of the building to give the viewer a glimpse of the surrounding landscape, although I did expect to encounter a lot of problems with the lens distortion of the original photograph with this idea.

I decided to continue with the rocky water landscape concept, because of the drama that it expressed to me. And so I started by extending a rocky shore photograph (**Fig.06**). Sharpness, shapes and colors were imitated, without copying elements one-to-one from the landscape image, by painting and Clone Stamping. After extending and color correcting the image, a sky and several objects were

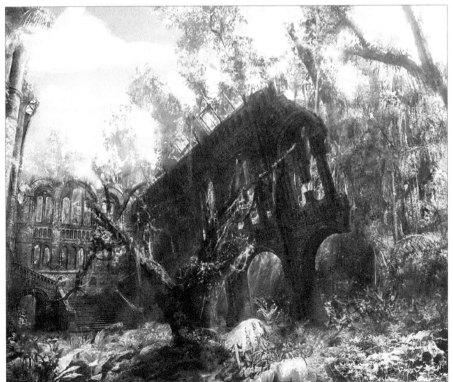
Fig.04

　　　　CHAPTER 03

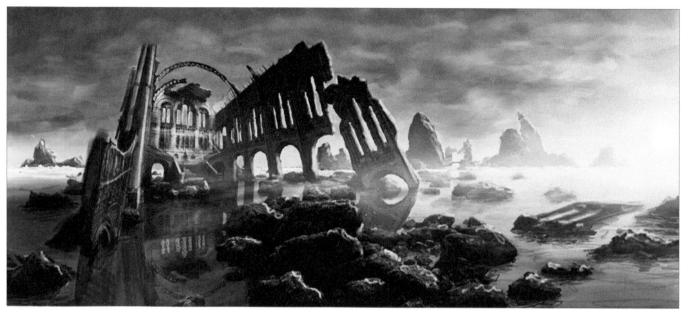

Fig.05

Fig.06

then added. The National History Museum was roughly adjusted into perspective and shaped to match the look of the concept. Adding some rough reflections and shadows helped me to tie the image together at this stage, and allowed me to spot any problems (**Fig.07**).

I chose to get away from the dark mood and went for a warmer color instead. Adding the sun and lighting, the whole scene was done by painting light on different layers, with some set to Dodge blending mode. To achieve the glossy look of the stones, I painted sharp highlights, such as on the water's surface. I used a custom brush that scattered the tint depending on the pen pressure, and used a

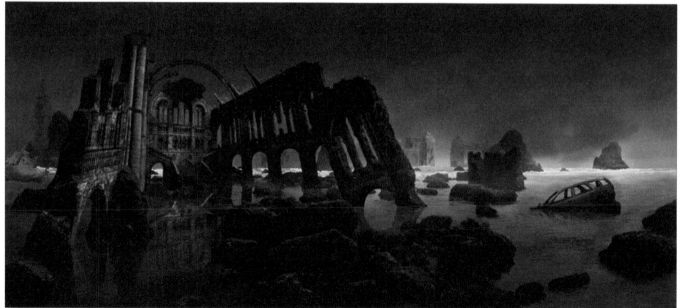

Fig.07

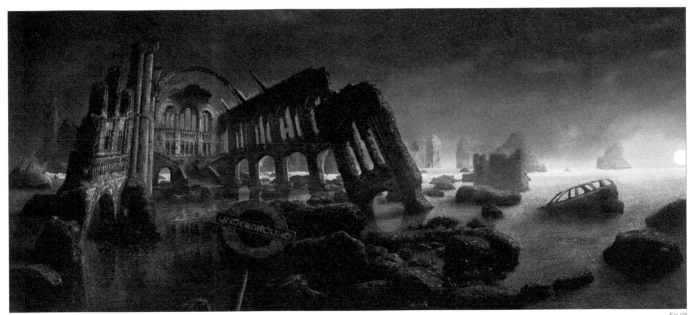

Fig.08

motion-blurred noise layer for most highlights (**Fig.08**). I was then able to add all of the really fun details.

Finally, some more perspective correction of the building was done, without destroying the drama of its alignment in the whole image. Seaweed and water movement were painted around the foreground rocks to get some more variation in the whole piece. The cityscape on the right was also added at this point, and the background rock beside Big Ben was given a more realistic, hazy look to set it further into the distance. The stairs of the National History Museum were then broken down into pieces, and the lighting was adjusted accordingly (**Fig.09 – 10**).

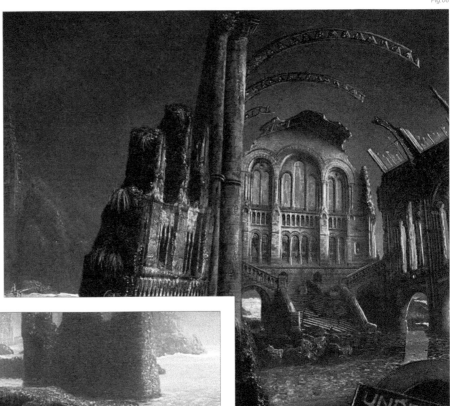

Fig.09

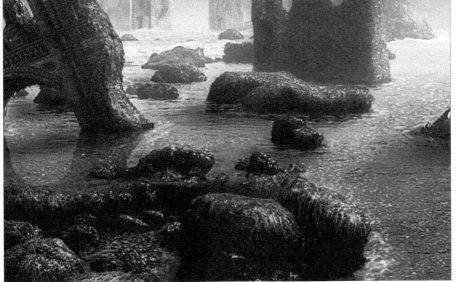

Fig.10

And here is the final image. Sometimes it's hard to keep photorealism in photographic parts when color correcting and painting. Of course, the perfection of those skills comes with time, and I'm always personally learning and trying to improve and hone my techniques. I'd like to thank Dave Edwards for providing the photo for this matte painting; I hope this tutorial can give you an interesting insight into how an image such as this can be created.

CHAPTER 03

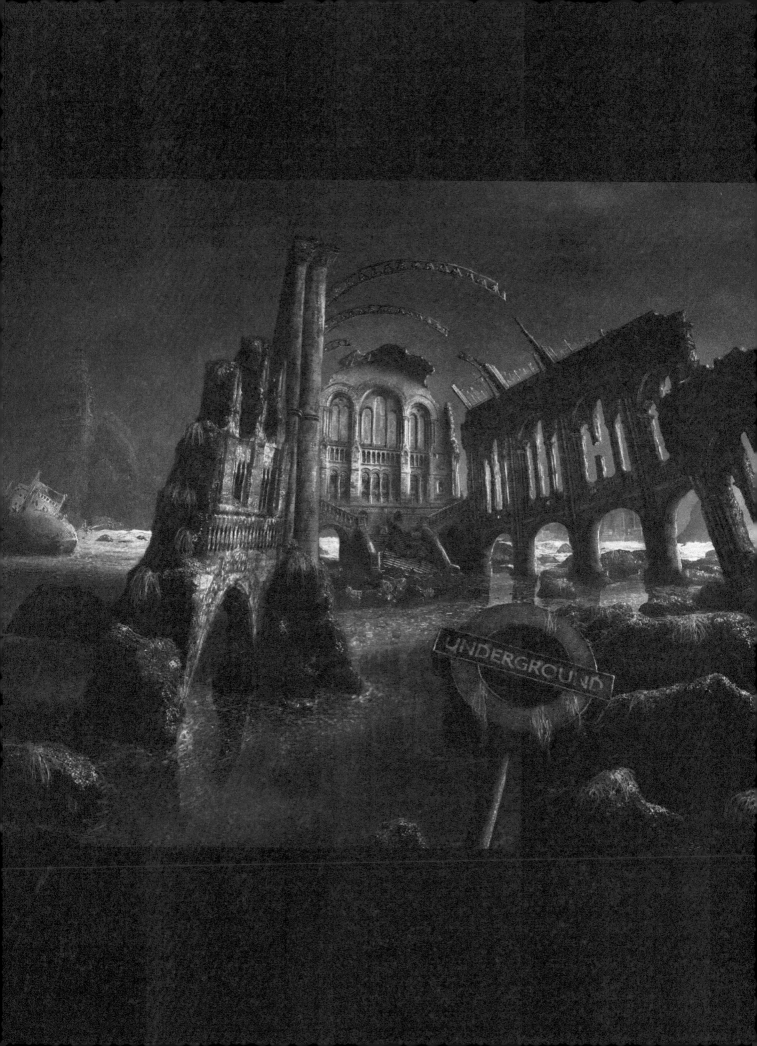

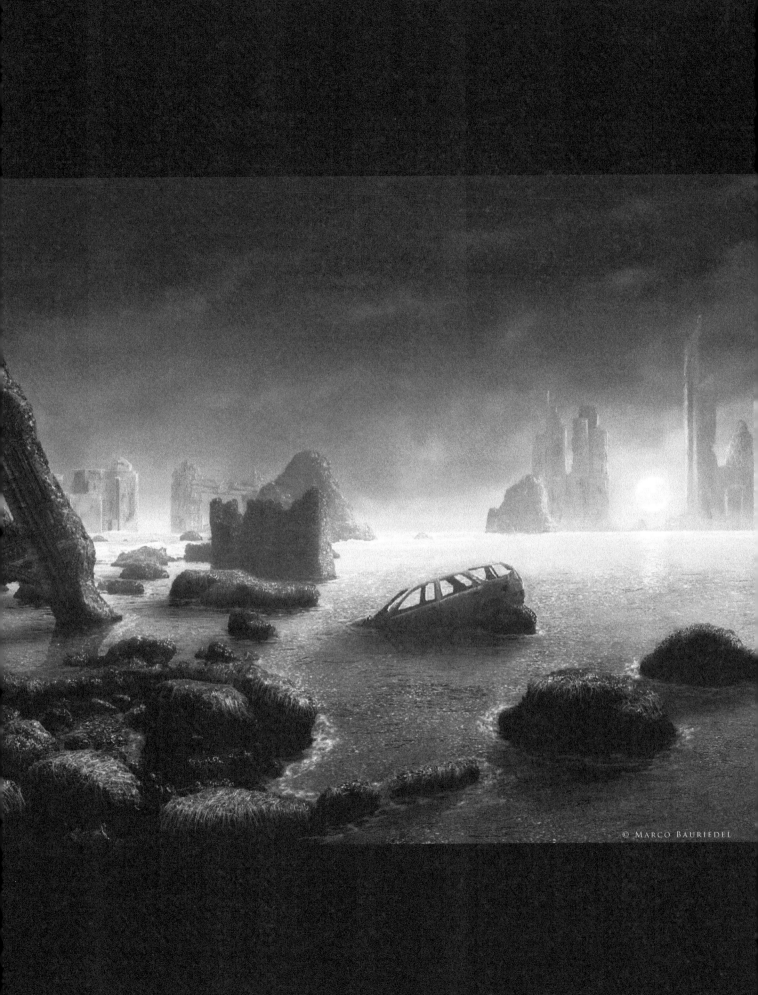

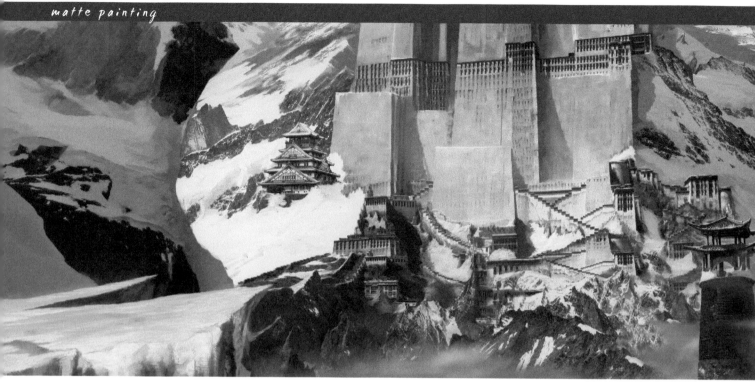

© SERGEY MUSIN

THE MAKING OF "FINDING UNKNOWN KADATH"
BY SERGEY MUSIN

SOFTWARE USED: PHOTOSHOP

The Dream-Quest of Unknown Kadath is considered a combination of several Lovecraft stories. It features Randolph Carter, a mystic whose unique gifts allow him to walk through dreams. He uses these talents to locate Kadath, a fortress of the Gods. Carter's adventures include traveling to good and evil dimensions, talking to cats, and sailing on the seas. After reading this novella by H.P. Lovecraft I was mostly interested in the idea about *The Dream-Quest of Unknown Kadath*. Before starting, I searched the internet for reference images to free my imagination and

SOURCE: CORBIS

Fig.01

to ensure that I would get the right idea for the concept (**Fig.01 – 02**). I wanted the scene to be set in a snowy climate, so I also searched for reference images of snow (**Fig.03 – 05**).

The concept sketch was drawn on white paper (**Fig.06**). I then turned the horizon line in order to achieve an effect similar to that of a film camera. I scanned the sketch and opened the file up in Photoshop CS2. The black and white picture was showing, and on top of that I built up a layer of color using the Multiply blending mode (**Fig.07**).

SOURCE: CORBIS

Fig.02

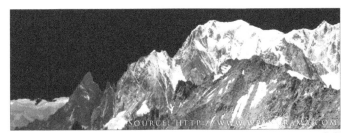
Fig.04

Fig.03

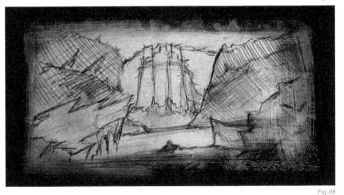
SOURCE: CORBIS
Fig.05

I created a new layer under the sketch to use as the fundamental color draft, with the Opacity set to 60%. I removed the original black and white sketch at this point as I no longer needed it and was happy working with the blocked-out colors as a guide. I started building up my scene using the photos that I found as reference, layering them up following my concept (**Fig.08 – 09**). I found the main object in the sketch looked too clear at this point, and Kadath's fortress was being "squeezed" by the two iceberg cliffs, so I decided to move them apart to open up the scene a bit (**Fig.10**).

You'll notice that, for this piece, I was using photo references of mountains without skies. I removed the sky from the mountains by looking at the color channels from the original image and selecting the

Fig.06

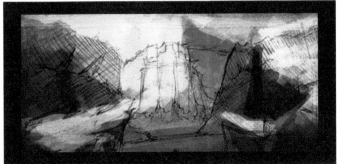
Fig.07

one with the most contrast between the sky and the rest of the image. I duplicated the blue channel and used the Curves to increase the contrast until the black and white image separated the sky from the foreground. To create texture on the mountain on the right, I used a

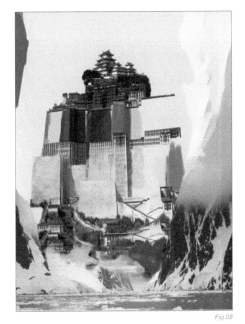
Fig.08

Fig.09

CHAPTER 03

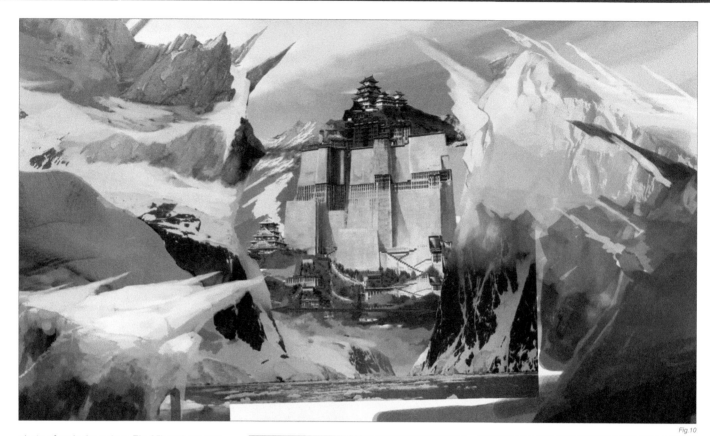

Fig.10

photo of an iceberg (see Fig.05) and created
a clipping mask layer (Alt + click between two
layers) on the layer of painted ice. I changed
the upper layer's Opacity to 60%, and then
cleaned things up using the Eraser tool. On the
left, I used another photograph of a mountain
(**Fig.11**) and rotated it. I painted out the forest
from the icy mountain in Fig.11.

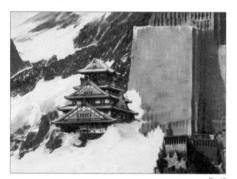

Fig.13

Fig.14

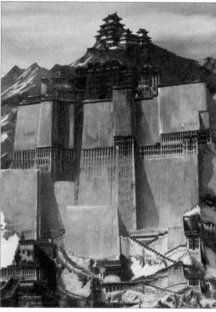

Fig.11

Fig.12

To paint Kadath itself, I used a clear-cut,
jitter brush, and the Clone Stamp tool, taking
reference from the photographs which I cut
up into three parts (**Fig.12 – 13**). I painted the
walls and lengthened them. I hand-painted
and copied the stairs several times to increase
the imposing height. Painting the snow and
ice was very tedious. Most parts of this piece
were painted using a hard brush (between 1
and 4 pixels in size). The block of ice in the

foreground (**Fig.14**) was painted thoroughly
using a small standard brush (sometimes as
little as 1 pixel), and custom brushes with 50%
Opacity to achieve cross movement (**Fig.15**).
The picture was finished off with lots of mist
to achieve good depth of field. I also decided
to add an observation tower to increase the
interesting features of the composition (**Fig.16**).
The man in the boat was also hand-painted
(**Fig.17**).

To finish off the painting, I created a new layer for the shadows set to 50% Opacity. I used a firm brush, and with the Opacity set to 35% I painted in the areas that needed some attention – in the lower right area and on the mountains on the left – because the sunlight could not reach there. I then created some adjustments layers with alpha masks, that is, Hue/Saturation and Brightness/Contrast, to achieve a single gamma. I painted onto the adjustment layers on the mask, to create the different

Fig.15

tones and contrast areas on various sections of the picture. Here you can see a breakdown of the final set of layers used to complete the image (**Fig.18**). With all layers combined, the final image was complete, as can be seen in **Fig.19** (5600 by 5200 pixels in size).

Fig.16

Fig 17

Fig.18

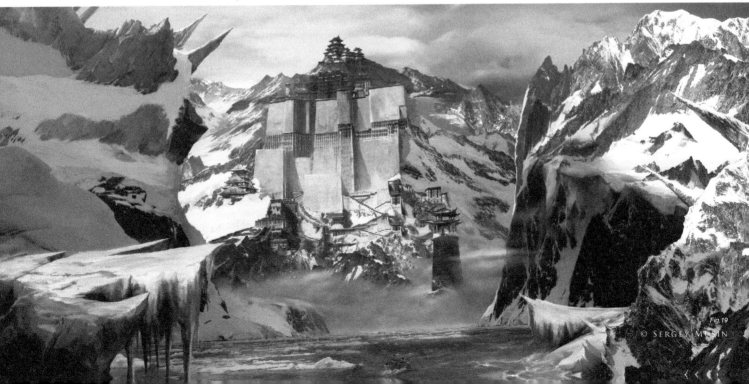

© SERGEY MUSIN

Fig.19

SEASON CHANGE: A WINTER SCENE MATTE PAINTING
BY TIBERIUS VIRIS

SOFTWARE USED: PHOTOSHOP

This tutorial is aimed at beginners to matte painting, as well as those who already have some experience; however, please note that advanced knowledge of Photoshop is required in both cases. If you are not familiar with adjustment layers, layer masks or channels (RGB), you should read about these topics prior to starting this tutorial.

INTRODUCTION
We will start with a common transformation: season change. More specifically, we'll be turning our base image into a winter scene. While the process itself is not hard, the difficult part is in finding the right shapes, shades and places for the snow, as well as finding a cool (literally) yet realistic color palette.

In **Fig.01** you can see the before and after results of this tutorial, so let's get to work.

WHAT ARE WE AFTER?
So, we are after a winter scene. We have been provided with a raw photo which, as you can see (left of Fig.01), was taken most likely during the summer, and we want to see how it will look six months later. The problem with this photo is that it's full of green trees that

Fig.01

will lose their leaves in winter; however, we have no information of what's behind them and we can't recreate that information from other parts of the image (we are not going to change architecture, so no Clone Stamping!). This case is perfect tutorial material, because we will do more than just the average summer to winter; we will see how to get a little creative, even if limited by certain restrictions.

I'm going to try to show you a good working habit that can be applied anywhere – not just in matte painting – which will save you a lot of time and nervousness. The key is to think and

plan your image. Sure, as artists we often tend to rush ahead under the heat of passion, but as professionals we should first of all learn how to tame that fire, and to make it last as long as we need it to, especially when we work on big and long-term projects.

So, the first step is to think about what you are after. See what you have and, more importantly, what you don't have. See what you need to get for the project (maybe you have to ask your team mates for a 3D render or a cloud formation). When you feel like you have everything you need, plan your creation steps

so that you don't work chaotically and lose precious time.

In this case, we are after a summer-to-winter transition. We have a raw photo (see left of **Fig.01**) which shouldn't be altered too much in terms of elements, so this is pretty straightforward as far as material is concerned. So let's plan out the creation steps and see what we are supposed to do. Let's say we have two major restrictions:

• We must not make major alterations to the castle architecture
• We should keep the size and placement of all the major elements (such as the river, position of the trees, and so on).

So with all this in mind, I'll start by planning the steps I will need to take:

• Firstly, I should begin by changing the color palette into a colder, less saturated one. I also want to reduce the contrast
• I want to "move" this castle to somewhere in the mountains, which will contribute to the overall cold feel and will give more depth. So for this next step, I will need to replace the sky and the background, and add some nice mountain peaks. I will also want to remove the large tree in the foreground on the left
• I should consider recreating the mid-areas, especially the group of trees on the left and right of the castle. I should also connect these areas with the background, probably with an in-between forest and some mist. This is a process often referred to as "surgery"
• Then it's time to adjust the front lake/river, give it a frosty look, paint some snow over

Fig.04

it and then paint some snow in front of the castle
• When all this is done we should start painting in the snow on the castle itself; firstly on the basic parts, then onto the more obscure/hidden parts
• After I'm done with the snow painting I should refine the atmosphere and light. I don't like the fact that the original plate is so uniformly lit, so I'll want to change that as well.

BASIC STEPS

In any matte painting, the key is to work with many layers and use adjustment layers for transformation in order to achieve a lot of flexibility. By painting the layer's mask, you can select which areas to affect and you can discard/modify any layer at any time.

Everything begins with the preparation of our working area. In this case we are going for a cold atmosphere, yet not too overcast, so we must do a series of adjustments, amongst which will involve reducing the contrast and desaturating and moving the hues towards colder values, like cyan and blue. Depending on your base image, it might take some time to create the proper feel, so have patience and experiment with various adjustment layers. There's no recipe for this, but I'll try to point out the most important changes that you should make:

REDUCE THE SATURATION & CONTRAST

This is usually done with a Hue/Saturation adjustment layer; in our case I've used -26 for Saturation (**Fig.02**) and I've also slightly increased the brightness. You can also use this layer to shift the hues a little, but don't go too wild – a plus/minus 4 maximum will do.

Fig.02

Fig.03

As for reducing the contrast, there are tons of ways of doing this, amongst which are: using a Curves adjustment layer; using a Brightness/Contrast layer and reducing the contrast (not as accurate as Levels/Curves); using layer transitions, and so on. (I always use Curves and Color Balance adjustment layers to create moods because, from my experience, it creates better results than using just one of them alone.)

MOVE THE HUES TOWARDS COLDER VALUES

This is generally done with a Color Balance adjustment layer using a combination of Cyan/Blue sliders, where needed. The amount and size depends on the hues of your base image. In **Fig.03** you can see my values for the shadow part. Note that the values are quite small, but they produce very visible effects, so don't go too wild. Also note that while this effect is applied to the entire image, it alters the hue by keeping the contrast with its neighbors, which means that for low values the effect is subtle and suitable for in-detail hue changes. Don't forget that if you have more areas which need different adjustments, you can use several layers and paint into their mask.

CHANGE THE OVERALL MOOD WITH A CURVES ADJUSTMENT LAYER

We will use the red channel of a Curves adjustment layer to pull the levels towards Cyan. Some people prefer to use just Color Balance, whilst others will tell you anything but Curves is wrong. However, I have found that using both (with smaller intensities) produces much better results. In the end, it doesn't matter what tool you use as long as you produce good results, so feel free to experiment (**Fig.04**).

Fig.05

After applying all the changes I have ended up with what you can see in **Fig05**. It doesn't seem very "cold" right now, but that's just because there's a lot of greenery in the scene which affects the overall mood. However, if you look at the original image you'll see the difference already (see left of Fig.01 for reference).

CHANGING THE BACKGROUND

Luckily for us, the original image has a clear sky which means changing the background should be pretty easy. First of all, find a nice mountain stock photo that suits the image, and

which also doesn't load the image too much. We already have a lot of positive space so we need as much sky as possible to compensate. The general process of replacing the background involves the following steps:

• Creating a mask for the new background layer
• Selecting the sky (and other areas you want to replace) from the original layer
• Going into the mask, inverting the selection and filling it with black (which will render those parts invisible while keeping the rest of the layer) (**Fig.06**). What is more or less difficult, depending on the base image,

is the extraction of the area(s). There are several methods to do this. In our case, which is one of the simplest, we can simply use the Magic Wand tool to quickly select the sky. Moderate problems arrive when the area you want to replace has many ungrouped hue values, or, on the contrary, the whole image has shades of the same hue (think of sepia) and/or the separation edge contains many small details (like a tree, for instance). In this case the most common method is channel, extraction, generally using the blue channel, which has the best contrast. Lastly, the hardest cases are those which combine all of the above and, in addition, have also about the same brightness levels, or their distribution is random. These require hand work, combining the Lasso tool with painting into their mask. Here's what I get after roughly replacing the background (**Fig.07**).

ADJUSTING THE MIDDLE GROUND AND FOREGROUND

Now that we have moved the castle it's time to adjust the rest of the elements to fit their new location. We will start by recreating the left middle-ground part, which was in the original

Fig.06

Fig.07

photo behind the big tree in the foreground. Since we don't know exactly what was there, we have a lot of freedom for this step (unless we are given specific instructions, of course), so it's up to us to choose what to place in there. For this tutorial, I've decided to replace this part with some pine trees, obviously covered with snow. The fastest way to do this is to find a nice stock photo; it doesn't have to be a full forest – two trees are enough. You can then duplicate them all around and modify their edges for variety. However, do pay attention

to the scale. In this image, one of those front towers has the height of a two-to-three story building, so the pine trees should be scaled accordingly.

Now we're done with the last step, I feel the need to connect the group of trees with the distant mountain for more natural depth. This is achieved by adding a distant forest in between and painting some mist over it to help integration. I also enhance the mist at this point by adding more details to it (**Fig.08**).

It is now time to powder some snow over the two trees inside the castle ground, to match in with the rest of the scene. This is done with a hard round brush with a Scattering effect applied. In the end, I roughly paint some snow in front of the castle as well, to get a better idea as to whether I am on the right path, and also to spot any flaws (**Fig.09**).

Finally, we need to adjust the water in order to give it a frosty, cold, wintry look. What contributes the most to this effect is some

Fig.08

CHAPTER 03

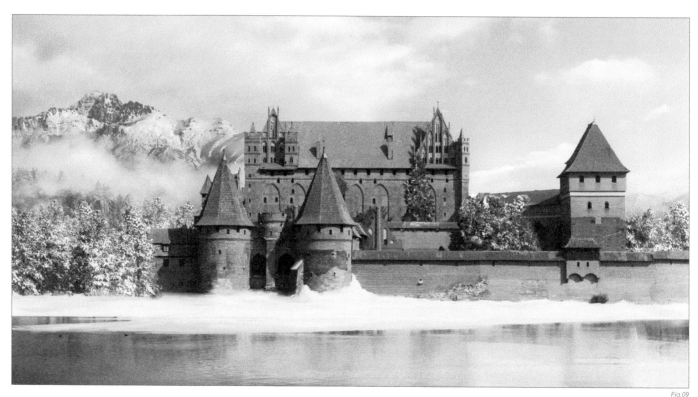

Fig.09

drastic desaturation and snow painting on the places where the lake meets the shore. And don't forget about reflections! Once it's been frosted over in places it will reflect much more detail than in the original photo (**Fig.10**).

STARTING TO LOOK COLD...?

One thing that I don't like at this point, which is a heritage from the original photo, is the fact that the whole image is quite uniformly lit. There's nothing wrong with this in terms of realism but since the subject is so big and centered, the eye gets lost in the image. One way to correct this, at least partially, is to create a gradually increasing brightness from left to right, but we'll address this later.

PAINTING THE SNOW

At last, we get to take care of our castle. For some, this might prove to be a boring step because it involves a lot of thinking and detail painting. You have to go in and check every spot where snow would naturally fall; a high quality original will help the process a lot. When painting snow, use a rough brush to create irregular shapes. Choose two colors: one for the regular snow (a white) and one for

the shadowed parts (a gray or a slightly blue-tinted white). Painting snow involves working alternatively with these two colors. In **Fig.11** you can see a suggested palette for painting snow and ice with realistic shades (not too saturated).

Begin by adding snow on the edges and small parts where the snow would naturally fall. Then move on to the roofs and bigger areas (always do this afterwards because it will be easier to spot details before you do it). The hardest part of this process is to think about how the snow would actually look on the structure and not

Fig.10

Fig.11

just mindlessly spray it everywhere. If in doubt, reference photos will help. Don't be ashamed to type "castle in winter" into Google and look at some photos.

Don't forget to paint in at least 1.5 times higher resolution – double resolution is recommended. Here's a close-up of the painting (**Fig.12a – b**). And after all the painting work is complete, this is what I end up with (**Fig.13**).

REFINING THE ATMOSPHERE

Finally, when we have everything ready, it's time to create that gradual transition I was talking about. Using two Levels adjustment layers – one that makes everything darker and one that makes everything brighter – I paint in (using their mask) shadows and highlights to break up the monotony and make the image more interesting; darker to the left, brighter to the right. I've also move the highlights a little towards yellow to match the sun's natural color for this kind of setting (**Fig.14**).

You can download the photo (JPG) used as a plate in this matte painting tutorial from **www.focalpress.com/ digitalartmasters**

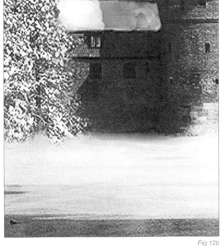

Fig.12a

Fig.12b

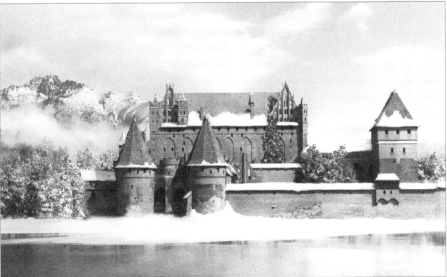

Fig.13

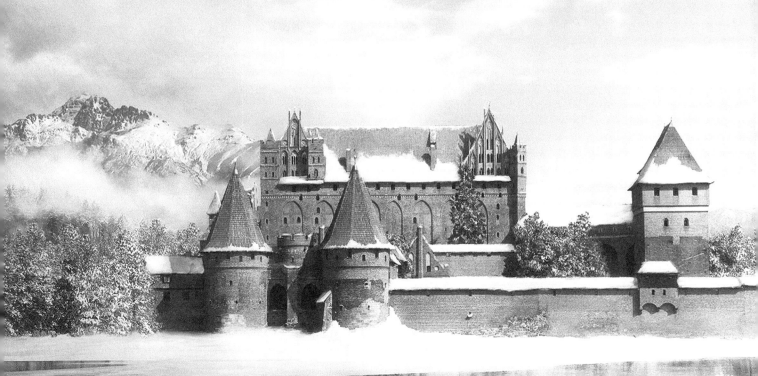

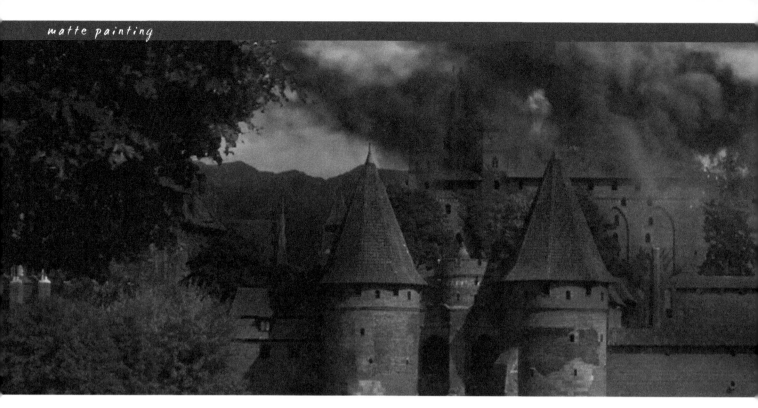

PYROTECHNICS: FIRE AND SMOKE
BY TIBERIUS VIRIS
SOFTWARE USED: PHOTOSHOP

Again, this tutorial is aimed at beginners to matte painting, as well as those who already have some experience; however, please note that advanced knowledge of Photoshop is required in both cases. If you are not familiar with adjustment layers, layer masks or channels (RGB), you should read about these topics prior to starting this tutorial.

INTRODUCTION
Here we go with our next matte painting workshop. This time we will tackle some pyrotechnic effects as we will try to set our nice castle on fire. What?! Well, at least we're not doing it for real!

I must say from the beginning that fire and smoke have an illustrative character and are not the subject of classical matte paintings,

Fig.01

which are supposed to be "invisible art" and not contain any moving elements such as smoke, water and birds, and so on (which are later added to the live plate by means of compositing). However, as before, we will assume that this is an establishing shot or an illustration of some sort and carry on tackling this brief. So let's get started!

In **Fig.01** you can see the before and after results of what we're going to do.

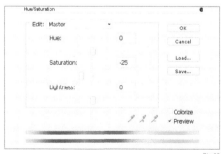

Fig.02

WHAT ARE WE AFTER?
So we've taken our sunny castle and subjected it to the wrath of winter ... Now let's see how it will handle fire! We will assume that some heavy explosion took place just 15-minutes ago in the upper part of the castle. So, with that in mind, we will focus less on adjusting the rest of the scene and more on how to create the pyrotechnic effects. Let's start as we should do by thinking things through.

Fig.03

Fig.04

SCENE PREPARATION

As mentioned at the beginning of this tutorial, we'll consider this to be an illustrative piece. It is therefore very important that we sell the subject using appropriate moods and lighting to emphasize the feeling. For this very reason I choose to replace the sky with an overcast one, in order to bring more heaviness upon the scene.

The process of replacing the sky by using a mask is the same as in the previous article on the winter scene, so I won't go into too much detail on this again here. Now we need to tone down the rest of the scene to match both the sky and the scenario. We will have to bring down the saturation and also darken it. We will bring down the saturation using a Hue/Saturation layer and we'll darken it using two identical Levels layers, half valued (**Fig.02 – 03**). The reason I used two layers is because I wanted to simulate hints of light passing through the clouds by painting in the second one's mask, and I thought this would give me better control. The result of my adjustments can be seen in **Fig.04**.

Fig.05

Next we will break the monotony of the highlights in the original photo by creating scarce cloud shadows. We will do this by simulating random cast shadows by painting into the mask of a Solid Color layer with a fairly dark color set to about 65% Opacity (**Fig.05**). Note that because the distance between the clouds and the land is relatively high, the shadows cast are always going to be blurry and rather diffused. If the clouds are quite small, or the sun manages to peak through, you will see those typical cloud shadowed areas on the land.

You can control the shadow intensity by various means, like a gray shade used in the mask, overall Opacity value, or the transfer mode, but pay attention never to exceed the 60 – 70% of the value of direct shadows (which you can reference from the original photo). For our scene I choose a pretty light and diffused shadow for more subtlety (**Fig.06**).

LET IT BURN!

Fire and smoke have always been considered pretty tough elements to paint if you're aiming for realism in your work. In matte painting, you have the optional choice of finding a stock photo that fits your needs (although these are rare), or to use a smoke or gas simulation software (but the result is not always so good with this option). However, shockingly enough, we won't talk about either of these here. Instead, I'll show you how you can paint realistic smoke using custom brushes and some good old thinking!

CREATING THE BRUSH

When creating the custom brush we have to consider the various smoke properties and think how they can be translated into brush properties. The most important aspects that should be taken into account are shape, opacity and variation.

GENERAL CONSIDERATIONS:

Although smoke has a structure that resembles a cloud formation, its composition is different from a chemical point of view, and that affects the expansion pattern and speed. Smoke disperses a lot faster than a cloud. Another important difference is that smoke is generated; hence it's thicker near the source and breaks up as it goes farther.

BRUSH PARAMETERS:

- **Shape** – Smoke has a typical shape with irregular edges and resembles a cloud structure. The basic brush shape can be sampled from an existing cloud texture – almost any would do. The element should be around 120 to 200 pixels in size. See **Fig.07** for an example.
- **Shape Dynamics** – Smoke tends to gather in clusters of various sizes, which disperse faster or slower depending on their densities and composition. We can mimic this by using a Shape Dynamics modifier set to Pen Pressure (**Fig.08**).
- **Scattering** – This completes the above effect by scattering around the groups within a certain limit. Use both axes at about 120 to 130%

Fig.06

• **Color Dynamics –** This assures a variation in shades. Apply a darker color to the foreground and a lighter one to the background, and then set the foreground/ Background Jitter to around 30% (**Fig.09**)

Fig.07

• **Other Dynamics –** Finally, we also have to simulate the gaseous nature. The smoke is thicker if the density is higher, and it gets less opaque as the volume increases and the particles scatter around. We will set the Flow Jitter to Pen Pressure and that should do it. If you need better control for some areas you can also set the Opacity Jitter to Pen Pressure.

APPLYING THE BRUSH

Now that we have our brush we can go ahead and paint the fire and smoke. Because fire will be painted in the same manner, I usually start with the smoke, but if it helps you to visualize better you can start with a quick fire placeholder – the choice is yours.

Before starting it's good to take into consideration wind direction and speed, because this will affect the way the smoke evolves, how fast it disperses, and its trajectory. Most of the time, considering a good smoke source and the strongest wind, the farthest smoke reaches without dissolving too much, which translates into a smaller occupied volume and higher density (a.k.a. higher opacity). In opposition to this, when there's almost no wind, smoke evolves on a vertical

trajectory and expands quickly, reaching large volumes in the upper parts with lower densities. If the scene already has a predefined wind (either from a story or existing elements), you should be consistent with it; otherwise pick one before starting and try to stick with it.

With your new custom brush and all these factors in mind, you can now start creating the smoke. Since this is not a video tutorial I am rather limited to what I can show you in process images, but I can at least talk you through the process. It is important to be patient and to not expect immediate results, as this is a long and tedious process that often requires plenty of trial and error. Like with any painting, you should start by blocking down the basic shape of the smoke with a neutral color.

Fig.08

Fig.09

At this point you are after two things: shape and opacity. Take your time refining them as it will be harder to do this later on. I have made a quick example to show you what I mean, but normally you would want to spend more time on this than I have done here (**Fig.10**).

The next step is to lock the layer (including Opacity) and start adding different shades. For the beginning choose only two – one for highlights and one for shadows – which should of course match your scene's lighting scenario, as well as smoke composition. Use fairly large sizes for the brush at this point (**Fig.11**).

After you lay down the basic shading you can then get into the details (painting with smaller brush sizes) and additional shades. Remember that you'll have lighter shades on the parts exposed to light, and darker shades in shadows and near the fire source. Again, don't expect immediate results; keep doing this until you're satisfied. You can also pick slightly colored smoke – it doesn't have to be grayish, and it will of course depend on your scene. For the particular scene that I'm working with, it took me about 1 to 2 hours to paint the smoke. You can see the result here (**Fig.12**).

Fig.10

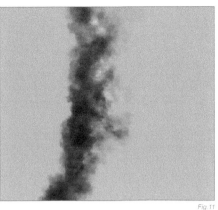

Fig.11

Fire is very simple to paint if you start with the smoke. The fastest and easiest trick is to pick a middle-toned orange, set the brush transfer mode to Color Dodge, and paint over the smoke. Or, use an extra layer and set it to Color Dodge transfer mode. The latter offers you better control as you can later apply filters to just the fire alone, without affecting the smoke. With smoke, it takes a while to achieve the desired effects, so be patient and experiment!

Additional Steps

You can also enhance your smoke by adding subtle motion blur to it; this can often add a great deal of realism because smoke tends

to evolve a bit faster than the camera shutter, plus it's a moving element of course. For this, use Filters > Blur > Motion Blur and choose the direction of your smoke. The intensity should be around 10 to 15, depending on the size.

You can download the photo (JPG) used as a plate in this matte painting tutorial from **www.focalpress.com/digitalartmasters** You can also download Fig.07 as a JPG file so you can use it as a sample for your own cloud/smoke brush experiments.

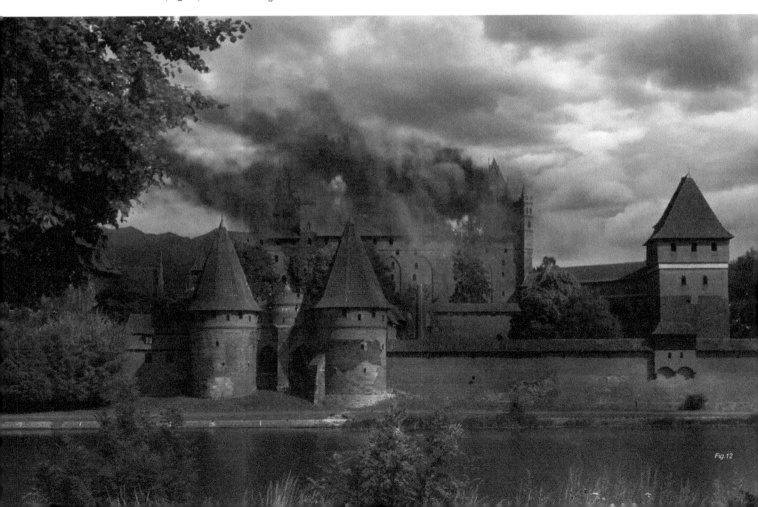

Fig.12

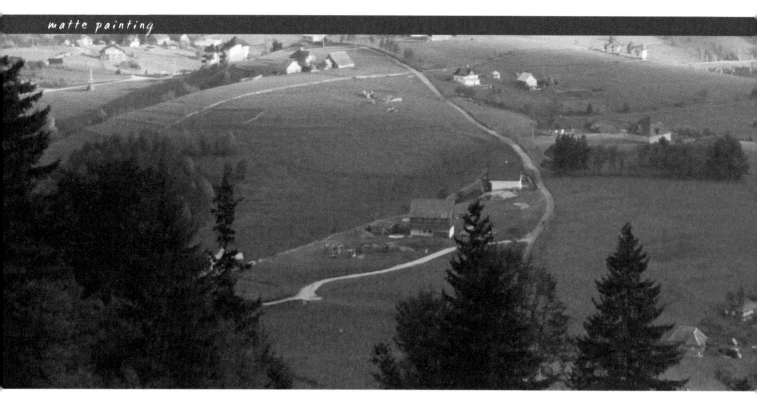

MATTE PAINTING TIPS AND TRICKS
BY TIBERIUS VIRIS

SOFTWARE USED: PHOTOSHOP

INTRODUCTION

You've seen how Photoshop can be a great tool and how, with only an average knowledge of it, you can achieve some pretty nice effects. But matte painting isn't actually just about Photoshop, and all that I have shown you so far have just been the basics, which are meant to give you a taste and to get your attention. You are now standing at the beginning of a wonderful road, but you should know that matte painting is much more than photo manipulation and, as the name suggests, involves a lot of art theory and real world understanding, too. That's why in this tutorial, we will try to understand these aspects and see what matte painting is really all about.

ORIGINS

Matte painting is all about mimicking photography. We don't try to reproduce how the human eye sees environments, but rather how the camera captures them. Traditional matte painting was developed initially

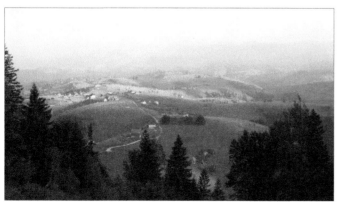

Fig. 01

in around 1959 for the movies and was done optically, by painting (literally) on top of a piece of glass to be composited with the original footage – hence the name "matte painting" (painting done on glass with a mask = matte). Nowadays, digital matte painting is less about painting and more about virtual set creation, yet it retains its old name because it shares the same goal with its grandfather. Matte paintings are used widely for any kind of application that requires a virtual set. But, of course, movies are still where they are used the most; the goal being to produce realistic environments (sets) where actors can perform naturally, as if they were really there.

PLAYING BY THE RULES

All the rules from traditional art are transferred here and, in addition, a matte painter has the difficult task of making everything photorealistic. There are several elements that tell the eye it's watching something that exists (even if it doesn't):

- **Depth** – This is the natural progression of colors and focus that you see in nature. In the distance, elements have less saturation and contrast and details are harder to spot. In the extreme distance you will only notice two shades (highlights and shadows), while the objects tend to have a bluish tone, due to the heavy atmosphere filtering. On the other hand, the foreground (meaning the objects that are close to you) has normal saturation and contrast, full black levels, and you can see all the details in them.
- **Lighting** – While this is obvious in nature, one has to be careful when creating a matte painting so that all the highlights and shadows match the source light and direction.

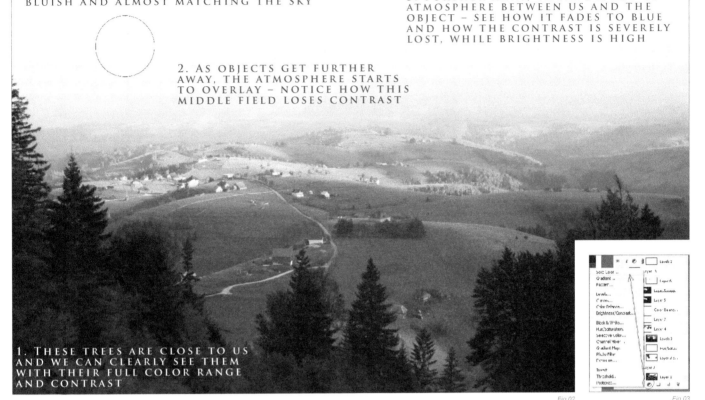

WATCH HOW IN THIS EXTREME DISTANCE MOUNTAINS HAVE ONLY TWO SHADES: HIGHLIGHT AND SHADOW – BOTH VERY BLUISH AND ALMOST MATCHING THE SKY

3. FURTHER AWAY, THERE'S A LOT OF ATMOSPHERE BETWEEN US AND THE OBJECT – SEE HOW IT FADES TO BLUE AND HOW THE CONTRAST IS SEVERELY LOST, WHILE BRIGHTNESS IS HIGH

2. AS OBJECTS GET FURTHER AWAY, THE ATMOSPHERE STARTS TO OVERLAY – NOTICE HOW THIS MIDDLE FIELD LOSES CONTRAST

1. THESE TREES ARE CLOSE TO US AND WE CAN CLEARLY SEE THEM WITH THEIR FULL COLOR RANGE AND CONTRAST

Fig.02 *Fig.03*

• **Scale** – Again, it's very important to match the scale of every element. You don't want a tree to be as tall as mountain, even if it might sound cool in a fantasy setting!

DEPTH: IN THE REAL WORLD
Depth, or better said "the way an object behaves with distance", is one of the most essential aspects of realism. This includes two sub-aspects:

• How sharpness is affected
• How color and contrast recede/fade.

The first is of less importance for us (but not unimportant). It's the classic photographic depth of field: on normal shutter settings, objects that are further away are blurred. How much or how less varies from scene to scene. The second one is more delicate and it's the main issue we are interested in (**Fig.01**). In a normally lit environment, the objects in the foreground have a high contrast, high levels of black and high saturation, while the objects

in the distance tend to fade towards the color of the atmosphere because there's more "air" between our eye and them, which acts as a filter and only lets certain light frequencies pass through (light is an electromagnetic wave, by the way). This translates into low contrast, high brightness and low saturation. You'll tend to know this effect as "haze".

Take a look at **Fig.02**. Notice how in the extreme distance the mountains have only two shades: highlights and shadows (both are very bluish and almost match the sky). The pine tree in the foreground is close to us and can be clearly seen in its full color range and with full contrast. As objects get further away, the atmosphere starts to overlay – notice how the forest starts to lose contrast. Even further away still, there's a lot of atmosphere between us and the objects, and they start to fade into blue – contrast is severely lost here, whilst the brightness is high. Of course, this is something that applies to Earth and our atmospheric observation. If you create an alien world matte painting then you'd have to take

into consideration how the atmosphere on the planet would behave when deciding upon how much haze you should have.

DEPTH: MIMICKING THE REAL WORLD
Creating haze is quite easy, and there are many ways to do it. Out of these ways, two seem to suit almost every situation.

Method 1 – If you have many different layers (e.g., a layer for a mountain on the left, another for the mid-range one, and another for the far right cliff, and so on), which is the best way to work? Simply select each layer and apply a Solid Color adjustment layer on top. Choose the color of the sky (use the color picker – it's the fastest way to do it) and reduce the Opacity according to the distance (e.g., for a very distant mountain you may use 50 – 60%, but for a mid one you might use 20 – 30%). Don't forget to link this solid layer to the layer that you wish to affect, otherwise it will affect everything (press Alt and click between the layers) (**Fig.03**).

CHAPTER 03

matte painting

Method 2 – If you don't have everything on individual layers then it's time to clean your tablet and start painting haze. Use a soft-edged round brush set to Pen Pressure on both Opacity and fading, and gently paint haze, more onto distant elements and less onto close ones. Use a layer mask to brush out if you paint too much. As before, choose a color for the sky using the color picker and try to paint evenly.

Regardless of the method you use, you may also want to adjust the individual levels if they still don't fit, even after the haze. For that, use a Levels adjustment layer beneath the solid one and ever so slightly move the black levels towards the right or the white levels towards the left, as you need – less shadow intensity or less highlight intensity.

SCALE: IN THE REAL WORLD
Scale seems natural and quite a trivial thing for many people. Yet, together with perspective, it's the main source of errors for many new artists (and not only them). It is important to have a good understanding of these aspects because, together with depth, they are the main elements which create the illusion of distance. The human eye and the brain relate to objects in the scene versus already known sizes in order to determine how big another one is (or in our case to spot errors). It's all contextual and relative. For instance, we all know how big an average house is from our daily life experience. Seeing it in an image next to a pine tree which is half as small and with no

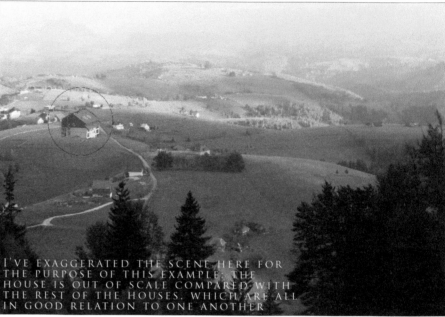

I'VE EXAGGERATED THE SCENE HERE FOR THE PURPOSE OF THIS EXAMPLE; THE HOUSE IS OUT OF SCALE COMPARED WITH THE REST OF THE HOUSES, WHICH ARE ALL IN GOOD RELATION TO ONE ANOTHER

Fig.04

other reference objects around it would make us believe the pine tree is still young (because we know an adult pine tree should be much bigger). However, take the same house and put it next to a whole forest which isn't taller than half of the house, and you'd know something was out of whack! The one that is wrong – forest or house – will depend on the other elements that are in the scene. See **Fig.04** for an example (which is exaggerated for the purpose of this tutorial).

SCALE: MIMICKING THE REAL WORLD
Obviously, making the right scale is easy, tool-wise. Simply use the Transform tool to scale down. It's a good idea to have the object rendered very big and scale it down, rather

than scale it up and paint to compensate for lost quality. The trick is to choose the right scale. Look around the area where you want to place the object, see what else is there, and then scale it in relation to the surrounding objects.

PERSPECTIVE
When it comes to matte paintings, the most common error you see is that of the angle of views. With this technique, the artist uses samples and objects from many different sources, so it is important that all of them share the (almost) same perspective. The second aspect of perspective is that of camera distortion. Because we try to mimic photography and not the real world we should "copy" the way camera lenses affect an image.

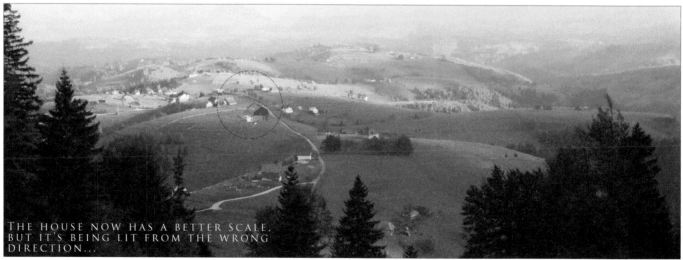

THE HOUSE NOW HAS A BETTER SCALE, BUT IT'S BEING LIT FROM THE WRONG DIRECTION...

Fig.05

CHAPTER 03 90

Finally, a matte painting may be required to have unusual perspectives, like 1-, 2- or 3-point perspective, or special ones like cycloramas (take a look at *Star Wars* cyclorama matte paintings – those that have been made public, anyway).

To achieve all of this, you have to plan your elements well and use your references wisely. Don't torture your photograph by stretching it until it breaks – you won't solve anything with that. Instead, try to paint and imply the right perspective; use another reference or make a 3D object and pose it at the right angle.

LIGHT: IN THE REAL WORLD

Last but not least, another important element of a successful matte painting is light – that is the way that objects are illuminated and shadows form; something that is so natural, yet, as before, can also be a great source of errors. Light can be your friend, but also your enemy. Use it properly and it can make your scene dramatic while at the same time hiding imperfections (in fact this is the main "trick" used by matte painters: hiding imperfections in shadows or mist). However, use it improperly and it will destroy your scene. The main mistake that you can see among new artists is having objects lit from different directions, like one from the left, another one from the right, and another one from the top (**Fig.05**). You can immediately spot that there's something wrong with the house in Fig.05. In this case, a simple flip would solve the problem … but what happens when that's not enough?

LIGHT: MIMICKING THE REAL WORLD

Creating the proper light is often the most time-consuming step of a matte painting. Usually it's impossible to find references that fit together and which are also lit from the same direction (unless you are provided with plate shots), and so you must spend a considerable amount of time correcting the light and making everything match. There are three main difficulty levels, which are as follows:

Level 1 – If the image you want to use is lit from the same azimuth/pitch but opposite direction, then a horizontal flip usually works. However, while this is OK for landscapes, it doesn't work so well on architecture or recognizable patterns.

Level 2 – The second difficulty level is when light doesn't match, but the shadows are not too hard-edged (either overcast or with low intensity/blurred). In this case, the typical process of correcting the element is as follows:

• Apply a Solid Color adjustment layer (see **Fig.03**) with a dark color (that obviously matches the hue/shade of shadows from the rest of the scene), and set the Opacity to around 50 – 70%, depending on your needs

• Duplicate the object layer, dramatically increase its contrast, and then set it to Screen with Opacity 60 – 100% – again, all depending on your scene's needs

• Create a mask for this layer and brush out the parts that are in the shade (hence you will see the dark layer below), leaving only the parts that you want to be lit.

Level 3 – The hardest situation is when the shadows are many and hard-edged (think of some sort of a cliff). For this, either find another reference or start painting in shadows and highlights based on the colors you pick from the original plate.

CONCLUSION

Matte painting is all about creating the illusion of reality. Depth, scale, perspective and light are the most important elements that trick the eye into believing. And, besides having them right, you can also use light and scale to your advantage in order to bring drama to your images and make your scenes epic (**Fig.06**)!

Fig.06

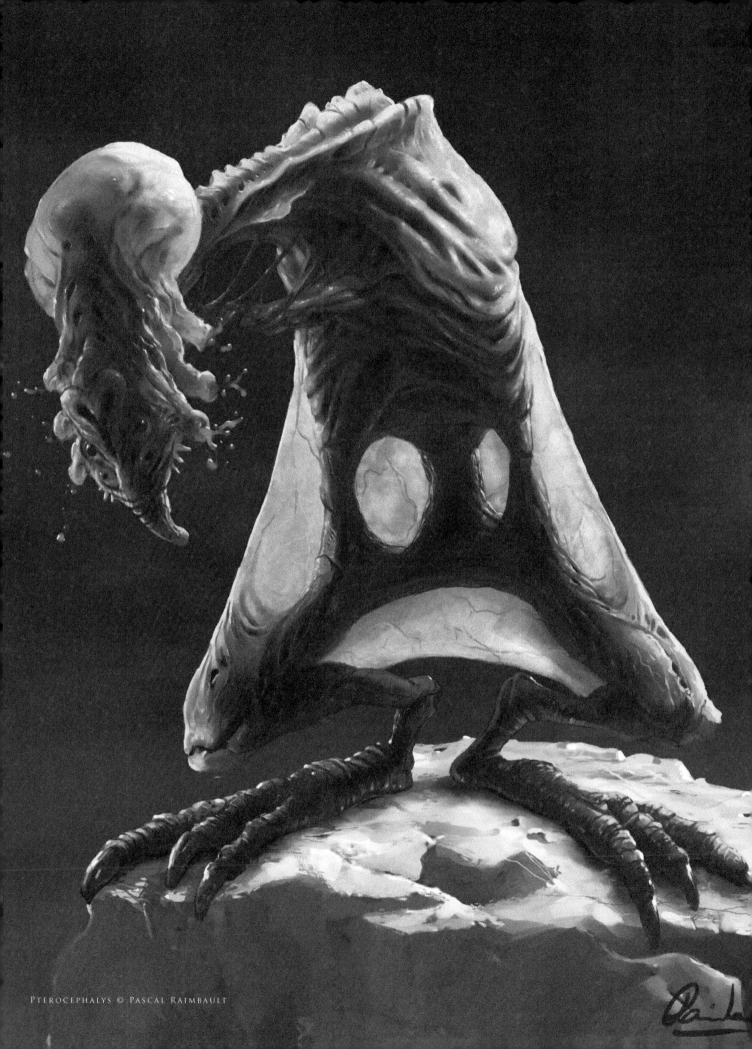

Pterocephalys © Pascal Raimbault

creatures

Similar to being an environment artist, many find themselves dedicating their time to character and creature design which involves a very different set of skills, namely knowledge of anatomy. Creature design forms a huge part of many projects stretching from video games to film and TV, and covers both animals existing in the real world through to aliens – think of films such as *Jumanji* and the *Star Wars* saga. This chapter will offer a vision of the issues to consider not only when painting animals but also in the creation of original designs.

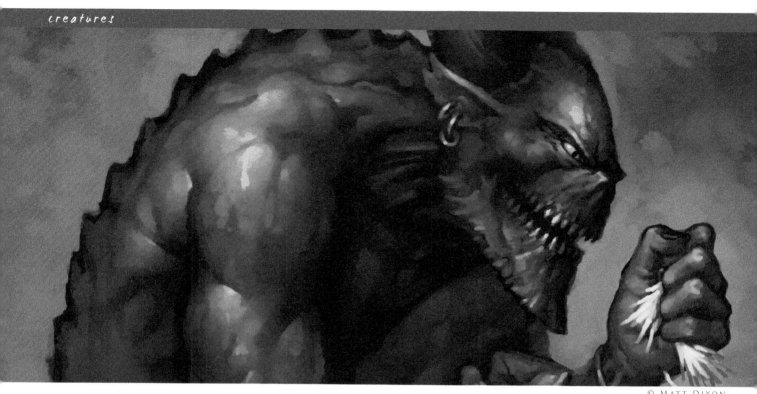

© MATT DIXON

THE MAKING OF "BIRD CATCHER"
BY MATT DIXON

SOFTWARE USED: PHOTOSHOP

Here I'm going to try to explain my Photoshop painting process, from the first doodle through to a finished painting. As I go along, I'll detail both what's happening on the canvas and what's going around my head. I'll be working on a 2480 by 3508 pixel canvas (A4 at 300 dpi). This is high enough resolution, should I ever want to print or publish the image in the future, and also fits nicely on my monitor at 25% magnification which allows me to see the whole image as I work; except where stated in the text, the painting is being worked on at this magnification throughout.

A NOTE ON BRUSHES

I use my own custom brushes for all my paintings, though I'm not going to go into any detail on brush creation during this walkthrough. There are two reasons for this: firstly, there are plenty of excellent brush tutorials already and I don't feel that I have much to add to the information already available; secondly, Photoshop's brush engine is very easy to use and I hope anyone with an interest in custom brushes will take the time to experiment with the settings on offer to find their own custom brush settings – it really is a lot of fun, and certainly the best way to learn!

Fig.01

The brushes I use fall into three basic categories: soft edged, hard edged and texture. I'll mention which I'm using as I go along and it really doesn't matter exactly what brush is being used as long as they fit into those basic categories. The standard Airbrush, Dense Stipple 56 (Natural Brushes set), and Rolled Rag – Terry 120 (Faux Finish set) Photoshop

Fig.02

defaults will do just as good a job as any fancy custom creation if used correctly. Whatever brush I'm using, I have my graphic tablet set up the same; stylus pressure controls opacity and nothing else. I use the square bracket keyboard shortcuts to control the size of my brush while I work, and I vary this regularly to break up the marks I'm making.

One final brush setting to be aware of is Texture. I use this a lot to help break up my brush marks, and it's worth spending some time experimenting with this area of the brushes palette to see what kind of effects can be had. Again, the Photoshop defaults are perfectly acceptable in most situations, particularly the Texture Fill and Rock Pattern sets.

SKETCH

I begin by sketching out a rough idea for my image (**Fig.01**). I've decided to paint something fun for myself, so I've chosen a fantasy demon

Fig.06a

Fig.03

character, but that's as far as my concept goes at this stage so I just doodle around for a while. The hunched-over pose was suggested by imagining the character's spiteful, covetous personality; I find it really helps to try and get into the spirit of the image I'm working on so there's a fair amount of face-pulling and growling going on while I scribble away. As you can probably see, I'm not that fond of working with lines, so as soon as I have something that feels right, however rough, I'm ready to move on.

VALUE

Here's where the painting begins. I'm much happier here than with a sketch, and I'll often begin a piece by jumping straight into this stage. I create a new layer, filled with a mid-gray, and proceed to block in a tighter version of the image working mostly with a large, hard-edged brush (**Fig.02**). I'll click my working layer off to reference the sketch every once in a while, but I'm not concerned with tracing any part of it – I'm looking here to refine the idea into a strong composition. Ideally, I'm trying to compose an image that can be read by silhouette alone for maximum impact, so I'm working with just two or three mid-to-dark tones. I think I'd consider this stage the most important part of the painting process – these basic values are the "bones" of the image and if it doesn't work here, no amount of work with color or detail will rescue it.

Fig.04

Once I'm happy with the placement of values in the composition, I'll begin to define the significant forms a little, again working with just a couple of tones to keep things bold (**Fig.03**). I take the opportunity to tweak the position of the demon's hand here, so he appears to be looking more directly at its contents. What is he holding? It needs to be something bright to draw the viewer's eye to that point, but I still haven't decided quite what it should be. I often leave trivial elements like this undecided as I find it helps to keep me interested in the picture as it progresses. Generally speaking though, this is bad practice and I'd recommend working things like this out thoroughly at this stage.

UNDER-PAINTING

Next, I duplicate the painting onto a new layer which I then set to Multiply, with the Opacity dropped to around 70%. On the layer beneath, I begin to lay down some basic colors (**Fig.04**). I want the overall color scheme to be quite cool, but with some warm tones in the demon's flesh to pull him out of the background, so I begin by filling the base layer with a gray-green color. On top of this, I work some lighter tones into the background with a large, soft brush to strengthen the character's silhouette – I'm adding some bluish hues here to cool off the green base. Now it's time to work on the demon, so I roughly block in the character's form with a desaturated purple to give a little contrast with the green/blue background,

before adding pink and orange flesh tones on top. Essentially, all I'm doing here is coloring in the value sketch – I'm not concerned with adding any extra definition to the painting just yet, as you can see from the rough-and-ready state of the base layer (**Fig.05**). When I'm done here, I flatten the image. That's the last time I'll use layers on this painting until the very final stages.

A NOTE ON LAYERS

As far as possible, I like to work on a single layer when I paint. This allows me to focus simply on the painting process and not layer management – I always seem to end up painting on the wrong one if I have more than two layers, anyway. There's very little in the way I work that actually requires layers – if I make a mistake I'll paint it out, or use the history palette to undo that stroke.

RENDERING

With the basic colors established, I can start rendering (**Fig.06a**). I find it easier to gradually build up the rendering from dark to light – this first pass will define the forms with mid-tones. Hopefully the detail shots will help to show how I approach this stage (**Fig.06b – d**).

I begin by color picking from the area of the painting that I intend to work on (the shoulder and upper arm in this case), then shift that color to be slightly brighter to provide me with my mid-tone, perhaps also shifting the hue to make it slightly warmer depending on where I'm working. I'll then use a soft brush to dab this color back onto the area I want to

Fig.06b

Fig.06c *Fig.06d*

render up, working very gently to keep the opacity low. This lifts the general brightness in the area, without obscuring too much of the under-painting. Now I'll swap to a hard-edged brush and begin to slowly work up the forms I approach this very much as if I were using pencil crayons, or scumbling with oils, gradually building up the color with a series of light, repeated strokes. Using a texture on your brush (see "A Note on Brushes") really helps here. In some places (veins and around the chin and eye) I may use a heavier stroke to introduce some hard edges, working back over them with soft strokes if necessary. I'm mostly adding lighter tones here, just occasionally color picking a dark color to add a hard edge here and there.

This process continues around the image, taking care to work within the overall pattern of values laid out at the beginning (**Fig.07**). For the most part I'll remain at 25% magnification for this stage, though I'll zoom in to 50% here and there where I want to tighten things a little further.

BACKGROUND

Now it's time to throw in a background (**Fig.08a**). I follow a very similar pattern here to the rendering process above – color picking in the area that I intend to work in, shifting the color to provide me with the hue I want, then dabbing with soft and texture brushes before finally working in around the character with hard-edged brushes. I choose quite a strong green here as I like the way it contrasts with the red flesh, and then introduce some blues around the bottom.

An abstracted background such as this can be very useful in balancing out the composition. The flow of the picture up to this point is very much on the diagonal, from bottom left to mid-right, through the angle of the rock and the placement of the demon's limbs (**Fig.08b**). I'm hoping to balance this by introducing a contrasting flow in the background (white arrow). If I've done it right, the flow should converge on the demon's open hand, reinforcing it as the principal focus in the image.

Fig.07

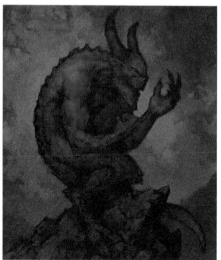
Fig.08a

Fig.08b

DETAILS

I can't put off tackling the contents of that hand any longer. Several ideas have come to me while I've been working – a captive fantasy damsel, a kitten, the remains of a brave warrior … None of them seem right somehow, so I decide to play safe and go for a skull, with a few other skulls scattered on the rock (**Fig.09**). I build up the skulls in the same way as the rest of the image – painting in dark base tones first, and then layering lighter colors on top until they're at the same mid-tone rendered level as everything else.

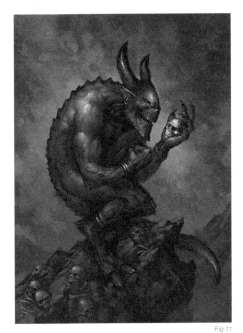

Fig. 11

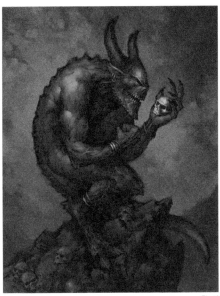

Fig. 09

Fig. 10

FINAL RENDER

Time for a final render pass! I follow the same technique as before, dabbing with a soft brush and refining with a hard-edged brush, but with progressively lighter tones (**Fig.10**). I don't want to overload the painting with details, so I'm treading very lightly and trying to pick out only what's necessary – the shoulder, arm and fist, the demon's face and the skull in the hand. I know I still have highlights to come, so I'm not taking things too far. I also added a few simple pieces of jewelry to help add some interest in those secondary areas not picked up in this render pass. Again, I'll jump to 50% zoom here and there for the more detailed work.

HIGHLIGHTS

Less is definitely more when it comes to highlights (**Fig.11**). If the rendering has been handled carefully, all that should be necessary here is a few well placed strokes. Bright highlights will draw the eye, so it's particularly important not to spread them into areas where I don't want the viewer's eye to settle. I use a hard-edged brush to accent the same principal elements as before – the arm, face and skull, with a few carefully placed marks on the horns, hoof and jewelry to help communicate their hard, shiny surface properties.

I add the highlights on a separate layer, so I can quickly swoop in with the Eraser if I feel like I'm overdoing them. I'm also balancing a few other areas of the image, adding some more bones and details to the rock, and

Fig. 12

working into the background with some brighter tones, trying to up the contrast around the demon's face and hand to hold the focus in that area. I think I'm just about done at this point, so I leave the painting to rest overnight so I can look at it with fresh eyes in the morning.

FRESH EYES

Spending a few hours away from an image can really give you a different perspective – the skulls just aren't working now I look at it again. I said that leaving certain elements undecided was bad practice; I should listen to my own advice! At least digital paintings are easy to adjust, so I paint out the hand and rock and prepare to begin again (**Fig.12**).

REWORKING

I paint the rock back in, this time with a more neutral color as I think the blue I used before was oversaturated (**Fig.13**). The previous rock had lost its flow (see **Fig.08b**) as I added details, so I'm careful to try and reemphasize that as I work. Elsewhere, I'm working from broad, soft strokes and refining with smaller, harder marks. The basic rock is painted against the dark base color using just two tones.

Now I have to tackle the problem of what the demon is doing up there on the rock again. The skulls didn't work because they didn't add anything to the picture – I want something that will help communicate the character's evil personality and suggest some kind of narrative. Perhaps wanton destruction of something

beautiful, delicate and innocent? The idea of a spiteful child pulling the wings off insects pops into my head, so I decide to have him perched up there catching birds, and I paint the hand back in as a fist.

BIRDS

Here I'm painting in the birds – following the same technique of working from dark to light, first roughly defining the shape of the dead birds on the rock with a dark color (**Fig.14**), then laying down a mid-tone to add some form with a final round of highlights on top (**Fig.15**). I want them to stay quite loosely rendered so as not to pull focus from the demon's face and hand. I've purposely hidden most of that unlucky bird inside the demon's fist so as not to make the painting too graphic, and hopefully lend a little ambiguity to the scene – the idea being that the image will reveal itself more slowly if the viewer has to notice the other more obvious birds in the scene before realizing that the bunches of feathers protruding from the hand belong to an unfortunate dove being crushed within the fist.

Fig.13

Fig.14

TIDYING UP

Almost done! I'm much happier with the birds than I was with the skulls, so I'm just working around the painting picking away at any areas that still bother me. I paint in the flying birds in the background, keeping them very simple, add a few highlights to the demon's fist and work into the rock a little more (**Fig.16**).

FINAL TOUCHES

I really hated that glowing eye from the earlier version so I paint in a more conventional eye here, choosing a yellow/green hue that will hopefully stand out from the blue/green in the background (**Fig.17**). I also feel that the background is a little unbalanced, so I use a soft brush to stroke across some of the textures around the edge of the painting to reduce their contrast, which should draw the focus more towards the center, and touch some of the blue from the horizon into the top of the picture in an attempt to balance the distribution of colors a little better.

CONCLUSION AND CRITIQUE

The painting feels complete, so I add my signature and give it a gentle pull with the Levels tool in Photoshop to add a little extra punch (**Fig.18**). Done! Now is a good time to look back and see if the image is a success. It's often interesting to compare the final product against those early value sketches to see what's changed – I think that comparison holds up well, with the composition and basic distribution of values remaining consistent throughout. I like the way the demon's flesh has ended up, though some more variation in hue across his body would be an improvement, in my opinion. The jewelry does its job connecting the less well defined areas of the character's body, but looks a little like an afterthought – perhaps some more significant metalwork, maybe a belt or ornamentation on the horns would help to solve this? There are always lots of little niggles like this that I try to remember for the next time. The big one this time around is to make sure I have the contents of demon's hand worked out well before I start to paint!

Fig.15

Fig.16

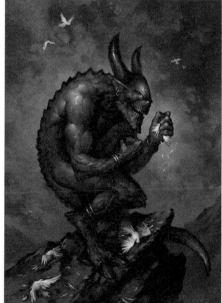

Fig.17

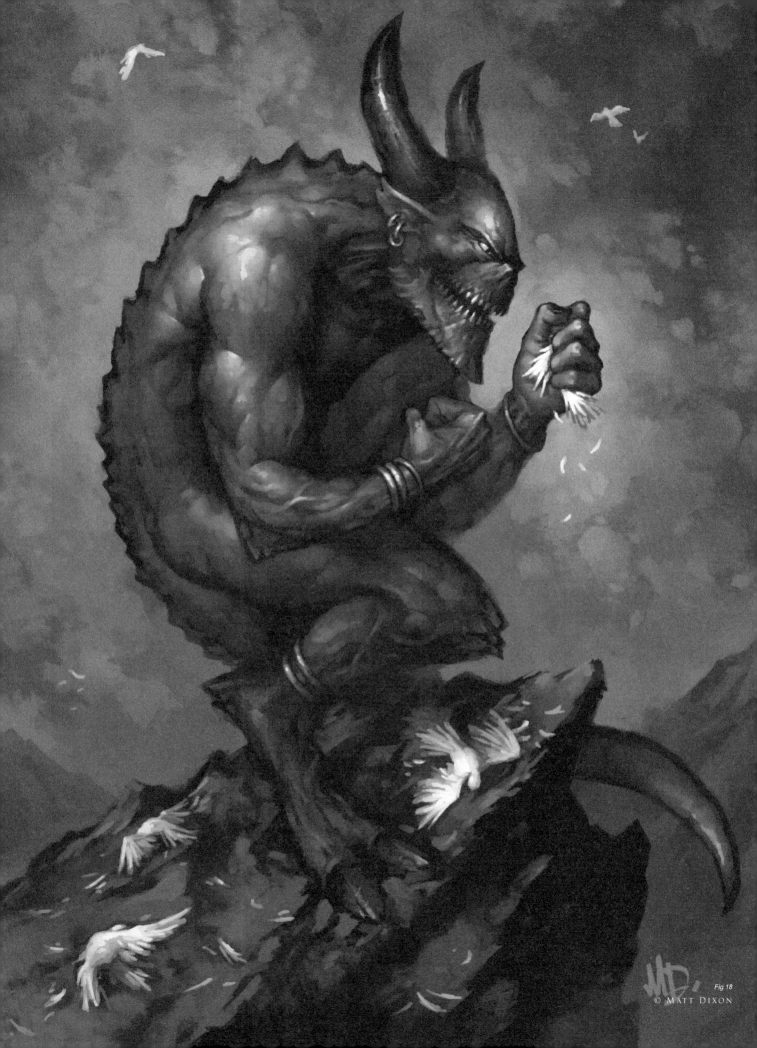

Fig. 18

CREATURE CONCEPT DESIGN 101
BY MIKE CORRIERO

SOFTWARE USED: PHOTOSHOP

In this tutorial I'll provide you with the necessary information to create your own unique concepts – from scratch. This series will discuss verbally and visually the philosophy behind the make-up of a conceptual creature. Throughout this tutorial you'll gradually obtain a reference library stretching from the basics in animal anatomy to much more complex ways of exploring what is actually possible and plausible, or what would be considered thinking "outside the box". There really are no limits to what's considered a conceptual creature!

PART 1: A STARTING BASE FOR YOUR DESIGNS: REFERENCE LIBRARY
RELATION TO REAL WORLD LIFE FORMS

All creature designs come from a mix and match of existing biology. Whether it's the biological make-up of a tiny flea or the structure of a

Fig.01

massive Sauropod, all creature designs are made up of what an artist has researched and studied in life and history.

A group of lizard hipped dinosaurs were the largest living land animals in history, known as "Sauropods" (**Fig.01** – Brachiosaurus – Vertebrate – Dinosaur).

Fig.02

Descendants of the largest of all land animals, lizards still roam the Earth today. Dinosaurs were once just as distinct from species to species as reptiles and birds remain today (**Fig.02** – Anole – Vertebrate – Reptile).

DISCUSSING SPECIES

There are literally millions of different species on Earth. Land based animals alone can range from limbless animals like gastropods and annelids, to bipeds, tetrapods, quadrupeds and arthropods. The ostrich is the largest living flightless bird. There are approximately 9000 species of birds (**Fig.03** – Ostrich – Vertebrate – Bird).

Mammals largely fall into the quadruped and tetrapod group. Arthropods make up a large range of species including insects, crustaceans, arachnids and myriapods. Crabs have four pairs of walking legs and two pinching limbs (**Fig.04** – Ghost Crab – Invertebrate – Crustacean). Arthropods are characterized by segmented bodies, jointed limbs and hard exoskeletons protecting their inner organs. Invertebrates make up approximately 97% of the Earth's entire species!

Fig 03

Fig 04

Fig.05

Amphibians range from frogs to newts, salamanders, toads and caecilians (**Fig.05** – Axolotl – Vertebrate – Amphibian). They are capable of living both below and above water with both swimming and terrestrial traits.

ADJUSTING EXISTING ANATOMY WITH PLAUSIBLE JUSTIFICATIONS

I lengthened the neck, the forearm and hind legs of a water buffalo while taking away some of the weight in the stomach (**Fig.06** – Manipulated – Mammal – Water Buffalo). I also adjusted the shoulder hump. I removed the horns and extended the mandible to be utilized as tusks for foraging. These variations on the anatomy of the original animal really make a big difference in the overall nature behind the habits of this creature. There should always be reasons for the changes you make!

Fig.06

CHAPTER 04

PART 2: TAKING THE NEXT STEP INTO IMAGINARY CREATURE ANATOMY

In this design you'll notice that the overall body shape resembles something of a warthog; although in all areas this design was conceived through the understanding of how animal anatomy works, it was not referenced (**Fig. 07**). The spiked vertebrae protect the back of the neck from predators (**01**). The tufts of fur on its forearms could be a distinction between male and female (**02**). The tail (**03**) is there to help balance during running while it also serves to cool the body down. **04** shows why the lower jaw is constructed the way it is, in order for the upper incisors to fit properly in the mouth when closed.

Fig 07

Amphibians lay clusters of tiny soft eggs stuck together in clumps (**Fig.08**) (**01**). A large sack of loose skin under the lower jaw allows the creature to create a distinctive vocal call (**02**). The reason the eyes are located at the top of the head is so that only the nostrils and eyes need to breech the surface of the water (**03**). This creature has some modified differences that set it apart from any known amphibians. It has a heavier, sturdier jaw lined with rows of sharp teeth. A pair of fin-like appendages is found on the rear to act as rudders for quick maneuvering underwater (**04**).

The long thin tube on the face contains a proboscis, much like that of a butterfly (**Fig.09**). When the creature is startled or feels threatened, it will quickly fill this membrane which is capable of stretching to an enormous size until it bursts, releasing a noxious gas inside (**01**).

Fig.08

Fig.10 shows a large carnivorous bird containing talons on the ankles of its feet and a deadly fork pronged beak (**01**). Like its ancestors and the inspiration for its design, it is an egg laying creature. (**02**) It creates a nest underground that is lightly covered with dirt. (**03**) It is also equipped with rear facing horns to defend and protect the back of its head and neck during attack. (**04**) Adding yet another means of attack and defense I've given it a tail with a split spiked tip.

Setting it apart from modern day lizards, this creature has a body structure similar to that of a mammal (**Fig.11**). It has long legs designed

Fig.09

Fig.10

for an upright running cycle. Its nasal cavity is split into three sets of nostrils (**01**). A pair of long thin antenna acts as extra sensory appendages (**02**). The back is lined with an extremely tough, scaled hump leading down to a thick powerful tail (**03**). To set the creature apart from any reptile it contains a pair of mammal-like ears and fur under the neck (**04**).

PART 3: DESIGN PROCESS, BONE STRUCTURE AND SKIN TEXTURE
INSTALLATION OF RESEARCH

This concept is a combined mixture of my knowledge and memory of insects I've come across in life or viewed pictures of in books and on the internet (**Fig.12**). Unlike most insects it has more than one set of eyes, which would put it somewhere in the class of arachnid; however, it only has three pairs of legs, two of which are for walking. So you see how this creature can resemble an insect, but it doesn't contain the specific traits insects or arachnids are made up of.

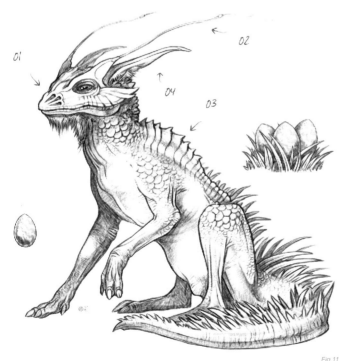

Fig.11

Fig.12

CHAPTER 04

WEIGHT DISTRIBUTION AND SIZE

The size of a creature needs to factor in a lot of rules in regards to how its weight is handled, and how it is distributed and supported. When you look at nature, you'll notice the smaller an animal or insect is the less gravity affects its weight, which in turn affects the construction of its body type. A very large creature needs to take into account how the massive body fat, muscle and large bones will be held up. An animal like that is not likely to run with long strides and would certainly not be capable of jumping. It's just more plausible to think of these things in terms of real world animals first, and then go on a creative spree.

CLASSES COMBINED

In order to create a believable fictional creature from skeleton to fully rendered color and skin texture, it's sometimes very helpful to base the bones on what you know (**Fig.13**). The design of this fictional skeleton is based on the head of an iguana, although modified in various ways of length, thickness and boney spikes on the skull. The body is modified slightly from that of a cow and given the addition of a dinosaur-like

Fig.13

11 ft

5 ft 9''

Fig.14

Fig.15

tail, while the vertebrae were modified to fit the new back structure of this creature and its tail. There are aspects, such as the fins on the back, that you could never expect to see just from observing the bones. That kind of thing is where you get to be creative and remember, this is a concept so have some fun.

COLOR AND SKIN TEXTURE

Something that is important to remember when applying any type of texture is that it's a texture, not a pattern (**Fig.14**). Applying complimentary colors, even in a subdued form such as this, helps to provide a nice flow from the front to the back in color scheme. You can follow the hints of red and warmer tones from the head to the tail. The imperfections in textures are the key to making them more believable (**Fig.15**). This insect-like creature contains elements of birds, beetles and even a bit of crustaceans, so the textures vary throughout.

TEXTURE CHART

You can see here that, although I've only touched upon two different creature designs, I came out of it with quite a few varying surface textures (**Fig.16**). Imperfections and variations in size and shape are what help sell a texture. They show the viewer that it's a texture of a living creature, not a repeated pattern.

Fig.16

CHAPTER 04

Fig.17

PART 4: HEAD DESIGN, EYES AND CONSTRUCTION OF THE MOUTH
WARMING UP

A simple way to effectively produce some warm up sketches without wracking your brain too hard is to use the mirrored effect of a front view (**Fig.17**). It's possible that you can sometimes find a great design this way.

HERBIVORE WITH ITS JAW CLOSED

Mammals have lips (**Fig.18**) (**04**) which help with the intake of food; it's the soft organ covering the bridge of the mouth and the teeth, and it also aids in vocal sounds. The cheek bone here is very visible (**01**). In creatures you can use this to give them a unique appearance. It surrounds the eye socket (**06**). You can add multiple nasal cavities to provide a more interesting nose or lack thereof (**05**). The additional pairs could each be used for separate purposes. Leading up toward the forehead from the nostrils is the bridge of the nose (**02**). The bridge of the nose is an extension of the nasal cavity that leads back down into the mouth, which allows a creature to intake air. A prehensile split upper lip helps grasp foliage, twigs and other food sources (**03**).

FRONT VIEW OF THE OPENED MOUTH

The gums are visible and showing the tooth as it continues to the root (**Fig.19**) (**01**). I decided for this creature I wanted one large incisor that is split, but connected close to the root (**02**). Molars are unique to many

Fig.18

different species of animal so they can appear in many different shapes and sizes (**03**). Taste buds found on the top of the tongue are used to distinguish what's edible (**04**). A set of small rear incisors were given to the creature (**05**), as well as a secondary set of incisors located in the usual place towards the front of the mouth (**06**). You'll also notice a gap between the prehensile lips where it splits (**07**). The inner muscle of the cheek connects the upper and lower jaw, which is stretched with the mouth open wide (**08**). The tongue is a muscular organ used for the ability of speech along with the lips (**09**). An empty space of gum in between the incisors allows the upper incisors to fit comfortably (**10**). A common set of four small incisors for sheering of various food sources are not meant for grinding like the molars (**11**). Finally, the large lower lip is capable of a flexible amount of movement (**12**).

PUPIL DESIGN OF THE EYE

This is a generic pupil shape, as seen in many humans and other mammals (**Fig.20**): a perfectly round iris and round pupil (**01**). A horizontal pupil can really provide a strange look, often found in mammals like goats or amphibians (**02**). What is unusual about this

Fig.19

type of eye is the black sclera (**03**); this can be seen in animals such as horses. Quite the opposite, here we have an eye design containing no iris, and a very small pupil can also produce an eerie effect (**04**). Here is a typical reptilian eye, usually found in snakes and some lizards or frogs (**05**). Just to show you how you can take the pupil in any direction you like, with this one I split the iris up into three separate points all connected by a randomly shaped iris (**06**).

The eye is made up of a few simple parts (**07**). There is the black portion called the "pupil". Then there is the iris which contracts and opens the pupil. The soft tissue found around the edge and corner of the eye is the ciliary muscle holding the eyeball in place within the eye socket. The sclera is the fibrous membrane and often white portion of the eye that can also be black in coloration. It, along with the cornea, forms the external covering of the eyeball.

PUPIL

IRIS

TISSUE AND CILIARY MUSCLES

SCLERA

Fig.20

PART 5: BODY STRUCTURE AND BODY VARIATIONS

LOW-BACKED CREATURES

This type of creature tends not to be capable of running fast because the lower back and short legs do not allow for long strides (**Fig.21**); its back is constructed of large bone plates to prevent rear attacks. This type of body, where the front shoulders are higher in proportion to the hind legs, gives the animal the appearance of a strong upper body and forward attack motion. Considering it would be incapable of running at high speeds, it may be more of a scavenger.

LOWERED HEADS AND SHOULDER BLADES

This creature's lowered head allows it to charge, making good use of its horns (**Fig.22**). The eyes and ears are conveniently located atop the head where the vision isn't obstructed by the horns. If you decide to design something like this, understand that the weight of those horns

Fig.21

and its head need to be counter balanced by a stronger neck and short strong legs to distribute the weight toward the rear.

OBESE CREATURES

You'll notice that creating an obese creature that is both wide in girth, and surrounded by body fat overall, restricts the design to shorter legs (**Fig.23**). You could provide it with longer legs but then it may not seem as obese, as it would seem just big in general.

Fig.22

Fig.23

LONG-NECKED DESIGNS

This is a slim version of a long-necked creature with a streamline body and flexible neck (**Fig.24**); its overall body design is built more for speed. A longer neck might suggest it feeds off leaves on high trees.

BIPED CREATURE

Here you'll notice a conceptual bird-like creature. It has two legs, a neck, a head and vestigial wings (**Fig.25**). What is stopping it from appearing humanoid is the lack of an upright torso and human arms. In **Fig.26**, you can see that I've given this creature a humanoid torso. This shows you two variations with a similar color scheme on two biped designs.

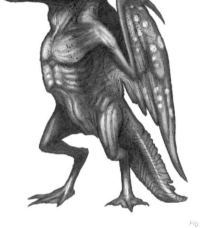

Fig 24

Fig 25

Fig 27

Fig 26

ORIGINAL INVERTEBRATE DESIGNS

This design does not follow a specific body plan found in nature; it breaks a rule by including traits that come from multiple orders or phylum (**Fig.27**). This design jumps past classification due to modified skin texture and its body plan. It's more closely related to the arachnid order, but it's only a quadruped with two feeding appendages and two sets of eyes. Its body is actually a variation of skin and bone with portions of exoskeleton make-up. This is how you begin to step outside that box – an insect body structure that's made up of skin and bone, not an exoskeleton.

CHAPTER 04

PART 6: COLORS, PATTERNS AND FINAL RENDERINGS

BASE COLOR

Using all the prior discussed information, at this point you can set out and begin a rough sketch for a unique creature design (**Fig.28**). Once you refine the design, set the sketch layer to Multiply so you can easily select the negative space, invert it, and then fill in a dark neutral color to begin painting on top of (this will serve as the base tone). You can see here that even below the sketch I started working out some of the main colors and a bit of pattern. In this base color, areas around the mouth, eyes, chest, elbows and armpit are a warmer pinkish red. Overall I'm keeping the base colors close to the mid-value range before applying any real highlights. The light source can change what happens to the colors and shapes.

Fig.28

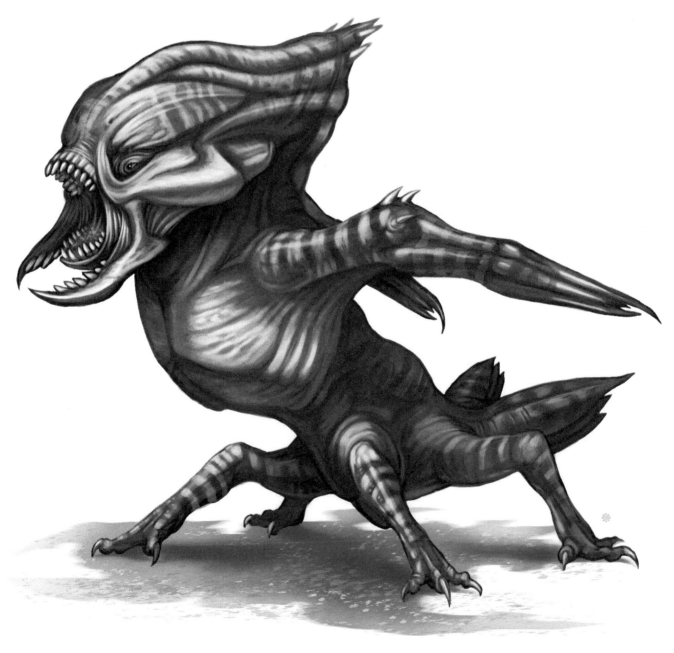

Fig.29

FINAL COLOR RENDITION

Once the design of the creature is laid out and the base color is defined, the next step is to start working out the light source and strengthening the forms (**Fig.29**). The form of the creature is determined by how you lay down the light and dark values of your color scheme in order to explain to the viewer visually how thick a body part is or how the shape is formed. Painting in the direction of the form, providing wrinkles, imperfections in the skin, variations and changes in the local skin tone and texture, will strengthen the overall design. Patterns can help reveal the shape of the forms (the stripes in this design, for example).

The posture and pose of the creature I've designed, along with the shapes and sharp nails, teeth and spikes, suggest the predatory nature of its character. The design of the mouth with the inclusion of beetle-like pinchers also suggests that it's a carnivore and equipped with deadly instruments meant for ripping flesh and killing its prey.

Fig.30

BASE COLOR BLUE

The local color of this creature is blue (**Fig.30**); however, red is applied to areas of the design meant for harming prey or protecting against predators as well as joints and sensory appendages. Working from dark to light, and not the other way around, it is easier to define a shape by applying a highlight, especially when working on a white background.

FINAL COLOR RENDITION

If you take a look you'll notice here that I fixed the top of the skull from the work in progress (**Fig.31**). I started laying down highlights of soft blue and highlighting areas of the limbs where light would create a shiny streak following the shape of the form. An important aspect of a "focal point" is that areas falling in shadow will lack detail, whereas the highlighted portions will contain more detail. This concept focuses on cooler tones as the highlighted portions and the shadows fade to a darker red or purple. When you're ready to call a design complete, go back and ask the question why once more, look it over, and then call it a rap!

Fig.31

CHAPTER 04

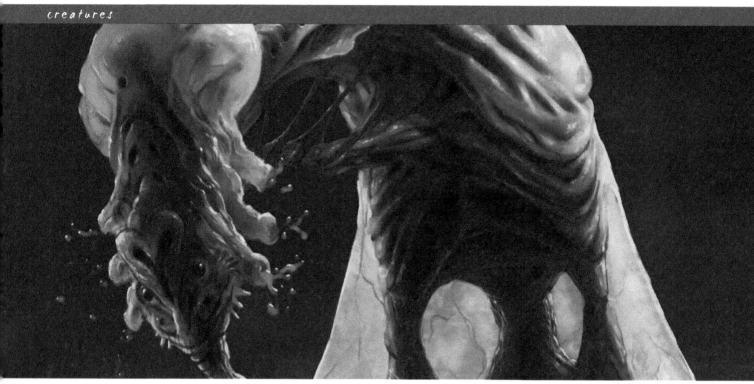

CREATURE DESIGN FOR LOW ATMOSPHERIC CONDITIONS
BY PASCAL RAIMBAULT

SOFTWARE USED: PAINTER

First of all, let's try to find real animals that could live in this very specific environmental condition. It's always good to reference nature – it's the best source of inspiration to me, personally. The higher the altitude, the lower the pressure and atmosphere should become. Existing animals that live in high mountains, like llamas and deer mice, have adapted their physiology in order to survive in such extreme conditions. This could therefore be a good starting point to find design ideas for our

Fig.02

Fig.01a

Fig.01b

creature. These animals have to get more oxygen into their blood to transfer it to their bodies' tissues. This means that our creature could have a reddish skin color. They also need less food, so our creature could be skinny. The depth of respiration increases, which means the creature could also have a large rib cage.

"Pressure in pulmonary arteries is increased, 'forcing' blood into portions of the lung which are normally not used during sea level breathing. The body produces more red blood

cells to carry oxygen. The body produces more of a particular enzyme that facilitates the release of oxygen from hemoglobin to the body tissues."
(**Source: http://www.himadventures.net/ articles/highaltitudehealth.txt**)

For humans, high altitude can cause some dangerous side effects, which can also give us ideas for the design – headaches, dizziness, fatigue, shortness of breath, loss of appetite, nausea, disturbed sleep, and a general feeling

of malaise. The illness referred to as "HAPE" (High Altitude Pulmonary Edema) results from the build-up of fluid in the lungs, so let's add holes to the rib cage. HACE (High Altitude Cerebral Edema), another illness associated with high altitude, is the result of swelling of brain tissue from fluid leakage. The creature can therefore also have holes in its head, to excrete such fluids. We should also consider adding large nostrils to our creature, in order for it to get more air into its lungs. We could possibly even add nostrils all over the body? I think it would be a good idea for him to also have two necks in order to double the volume of air coming in from the nostrils on his head.

The name I have chosen for my creature is "Pterocephalys"; "ptero" means flying and "cephalys" refers to the head. Most of the time, when the atmosphere is low on a planet, the gravity is also low. Our creature could therefore be adapted to this condition, as well. He could be jumping very high into the sky and may even fly using membranes, just like flying squirrels! The Pterocephalys will therefore need strong thigh muscles to be able to do this.

I am going to use Painter X and a Wacom tablet Intuos 3 to draw and paint this creature, as follows.

STEP 01

First of all, let's make a very quick sketch of this creature and see how he could move (**Fig.01a**). This gives us an indication on the proportions of the Pterocephalys. It could be something between a bird and a squirrel,

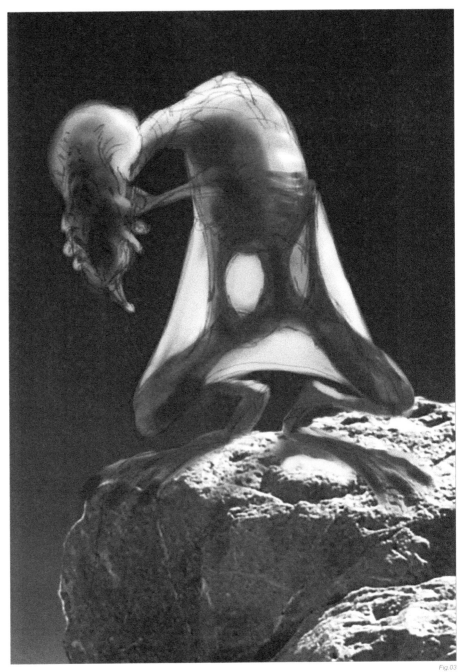
Fig.03

Fig.04

Fig.05

for the legs. So let's now make a quick sketch just to get started with the global shapes and proportions. Sometimes I scan a traditional sketch done with pencil and put color on it with Painter. In this case I will start directly in Painter using the Pencil brush. The Pterocephalys will be able to walk and jump, but he will not be a good runner at all (**Fig.01b**).

STEP 02

I am going to refine the sketch a little bit now, focusing on the head a little more. I have added holes to the head; the purpose of these holes

is to excrete liquid that could cause a cerebral edema. Huge nostrils and smaller ones are added to the face. I also add a quick rock form to the sketch in order to encourage me think about the environment as well (**Fig.02**).

STEP 03

Here I am adding rough colors and reusing rocks from a photo I took in New Zealand, in order to get a sense of the lighting and environment. This rock was actually a small one, but it's a good base for a paint-over. I am using three layers at this stage: character, rocks and sky. I use Painter's Airbrush for the sky and the round oil pastel with low opacity to add color over the character. If we look at the rock's lighting, the main light (which is the sun) is coming from behind, and we also get an ambient blue light coming from the sky (**Fig.03**).

STEP 04

I want to focus on the head again now, to help me figure out this creature's personality. I don't want him to look too aggressive as he doesn't need to eat very often; he is not a predator and probably just needs to eat some rare flowers once a week (**Fig.04**).

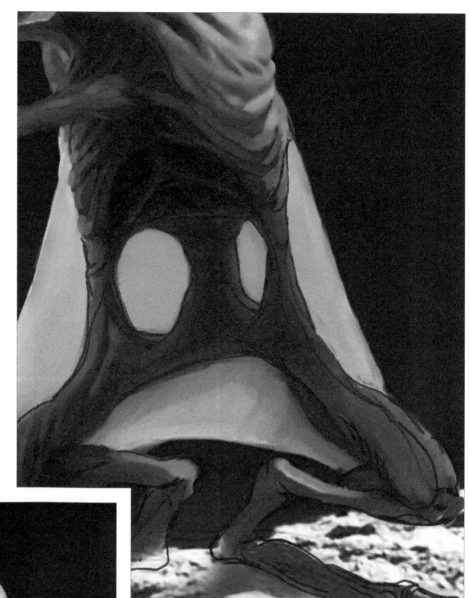

Fig.06

STEP 05

I am pretty much detailing the body by going down the neck and rib cage at this stage, mainly using the Oil Pastel for details and the Airbrush to get more of the volumes. I want this creature to have holes all over its body and a fleshy feel to the skin. It has to be skinny also, as mentioned previously. I am using featherless chicken and furless cat photos as a reference, to get ideas about skin rendering and skin folds (**Fig.05**).

STEP 06

Now let's work on the lower body area. I need to rework the lines to get a clearer idea of his anatomy before adding details. I could have focused on the lines first and just done a black and white first pass on the whole thing, but I am more used to playing with the colors very early on in the process (**Fig.06**).

Fig.07

STEP 07

Here I am adding volume and details to the legs using the same tools, as well as using the Glow tool to get a warmer highlight color from the sun (**Fig.07**).

STEP 08

Now I am painting over the rock photograph element so that it blends in more with the rest of the painting; this will also allow me to tweak the rock more easily later on (**Fig.08**).

STEP 09

Here I am just adding shadows under the feet and details on the lower part of the body. Cerebral fluid has also been added, escaping from his head; it's kind of floating about in the air because of the low gravity present (**Fig.09**).

STEP 10

Now let's focus on the highlights and the shape of the second neck. Because this creature has holes all over its body to excrete liquids, it

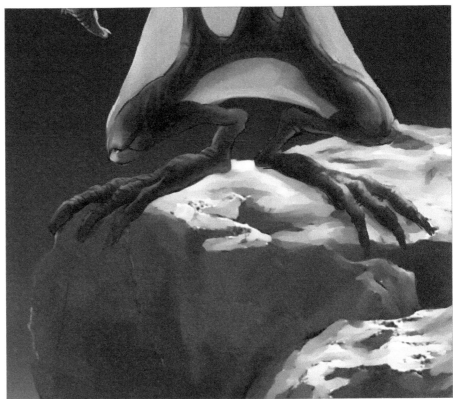
Fig.08

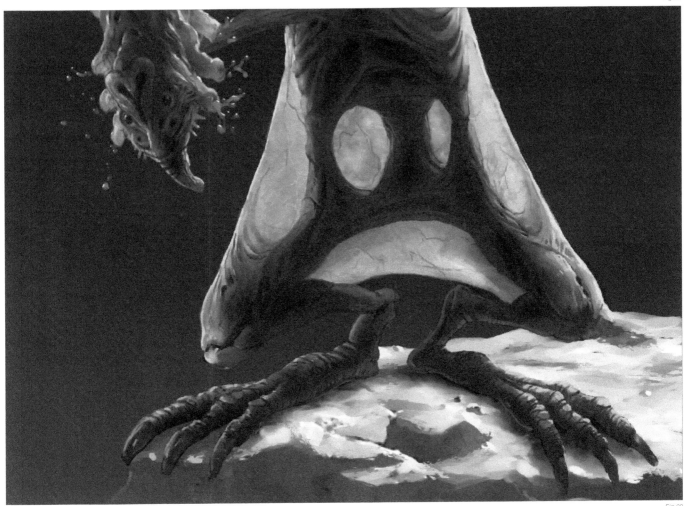
Fig.09

Fig.10a

makes sense to add more of a wet skin effect to it. The neck shape was a bit too straight for my liking as well – it was not looking organic enough – and so I changed it a little here. The creature has so many holes on it that I wanted the lower neck to look almost like an external organ. This makes him look a little more fragile,

but it's OK as he has adapted to escape most dangers by jumping very high (**Fig.10a – b**).

STEP 11
I cropped the image in this final stage so that we could get a closer look at the creature. I also removed some of the rock underneath

the right knee to improve the composition. The middle toes are now also smaller on the creature, which was done to break up the uniformity of them and the rather boring proportions. As the final finishing touch, I add more contrast to the image, and that's it – done (**Fig.11**)!

Fig.10b

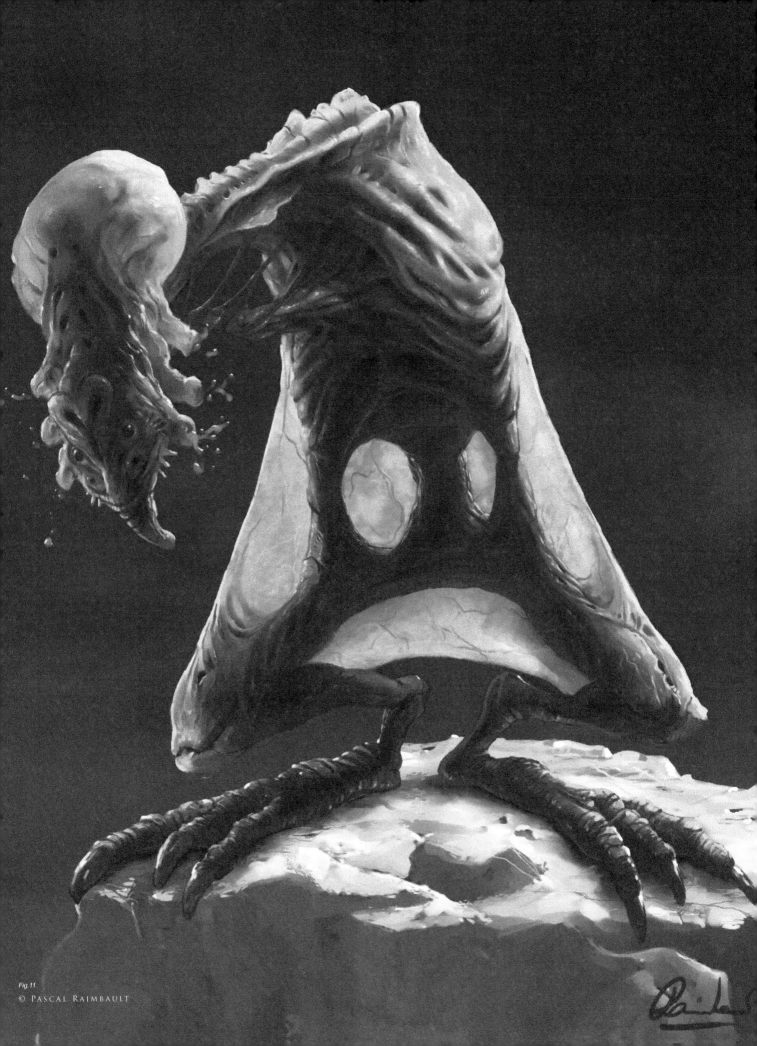

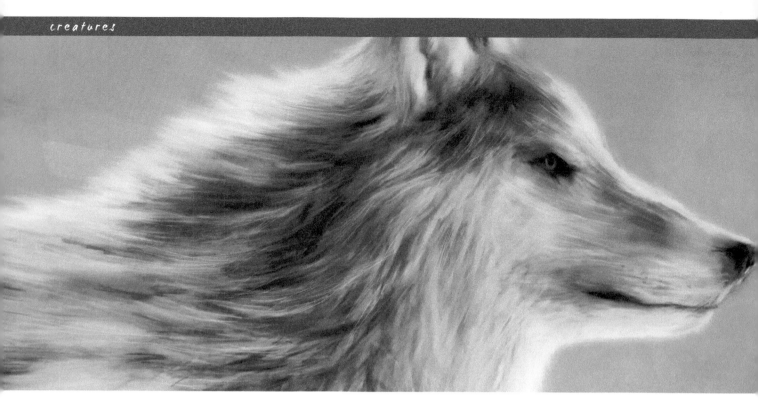

PAINTING FUR
BY RICHARD TILBURY
SOFTWARE USED: PHOTOSHOP

In this tutorial I will be attempting to paint fur, and for this exercise I will be using a wolf as a context to create the image, in order for it to make sense and not appear just as a semi-abstract picture. Before starting to paint, I search the internet for various references and photographs to help guide me in the creation of a convincing representation of fur. When you begin to look at your subject, which in this case is a wolf, you will realize how varied it is, not only from animal to animal but also in the types of fur evident in a single type of creature, such as our wolf. When I began researching the subject I soon discovered how wolves vary in color and how their fur changes in length across their bodies. For example, the fur around their legs is quite short and looks almost matted, similar to a bear, and yet around the shoulders it is longer and shaggier in appearance. So with our research done and references gathered, let's paint!

STEP 01

Once you have enough reference material at hand it is time to make a start, which I will do by filling in the background color of a blank canvas with a non-descript warm gray, over which I can create a new layer for my drawing of a simple outline of a wolf (**Fig.01**). I always like to get rid of the white early on – any tertiary color is suitable really, and this is only a personal preference.

STEP 02

On a new layer I start to paint in the key colors, which compose mainly of warm browns and yellows in this instance. As there will be no definitive shadows and highlights I have sketched everything in on one layer. In **Fig.02** you will notice that I have made some

Fig.01

provisional rough marks below the shoulder to denote some of the thicker fur that appears darker beneath the surface, similar to a husky. I use a paler color along the edges to show where the light manages to show through, and basically paint in the main areas. You will also notice that the brush marks also roughly follow the direction that the fur has grown, as indicated by the arrows.

STEP 03

The next stage involves using a custom brush in conjunction with the Smudge tool so that the edges may be softened somewhat and create the appearance of numerous strands of hair. In **Fig.03** you can see the shape of the brush in the upper left corner along with the marks it produces, and in **Fig.04** you can see the settings used, which are simple enough. Notice that the Spacing is turned down in order

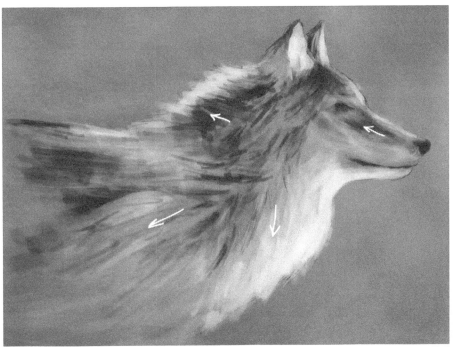

Fig.02

Fig.03

CHAPTER 04

that the brush leaves uninterrupted lines when used. With the brush size set quite small, select the Smudge tool and start dragging outwards from the edges – you may wish to alter the strength on the toolbar to around 55%. You can see how this has made a difference in the latest version. I also use a standard Airbrush set to between 1 and 3 pixels wide and add in some more hair to help blend the sections. Remember that you do not really need to illustrate every strand of hair, but rather just a few here and there to suggest the illusion of fur.

In the case of the head, I paint in some lighter areas using various tonal ranges and omit any real detail. I place a few random lines around the neck line to help blend the head and body and suggest some longer fur, but do not labor on this. The eye, nose and mouth areas are darkened to help the overall impression, but you can see that the picture is much improved from just a minimal amount of detail.

STEP 04

So far I have tried to create the impression of fur using tonal ranges, a small amount of smudging, and with as little attention to painting actual individual hairs as possible. What I have essentially aimed for is a good and general impression with as much economy as I can muster, so that I have a clear target

Fig 04

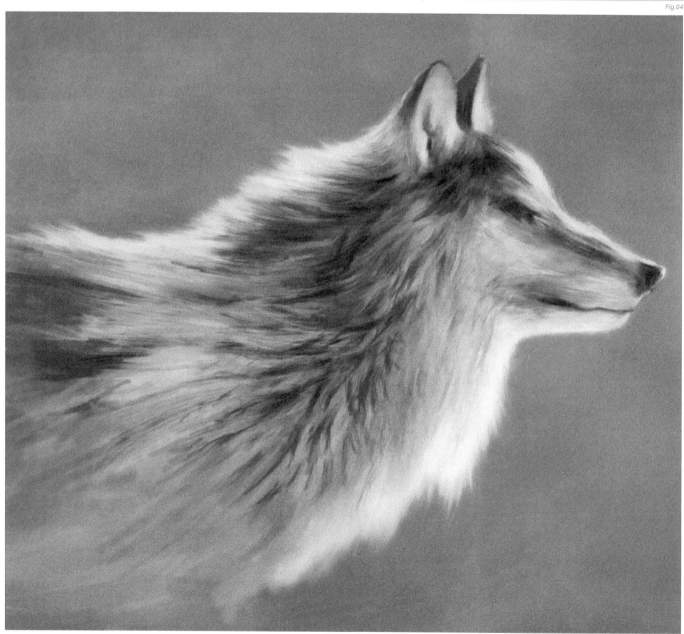

Fig 05

for finishing the picture. Now that I have established the key areas I will begin the process of refinement.

In **Fig.05** I use the same Airbrush as in the previous section to paint in a series of fine strokes that help blend the various tonal passages and show actual strands of fur. These range from the neck to the top of the back and follow the rough direction of the body, but keep mindful to draw in random directions in order to add a natural feel. You can see, particularly on the shoulder area, that the dark sections flow towards the back as well as the chest, and some of the lighter hairs on the neck are almost at right angles to the general flow.

STEP 05

We now reach the final phase of the tutorial which proceeds along the same lines. I add in more fine strokes as well as a few that are a bit wider, to resemble some clumps of fur. Remember to vary your strokes in direction and width as well as the color. So, for example, in darker areas add in some lighter strokes, and vice versa.

In the final version (**Fig.06a – b**) you will notice that I have left rougher and wider strokes along the shoulder to portray the thicker fur, and kept the finer strokes to areas towards the outer edges and head. The crucial thing to remember is randomness. The last areas to be completed are the eyes, a few facial details, and a color change to the background.

Fig 06a

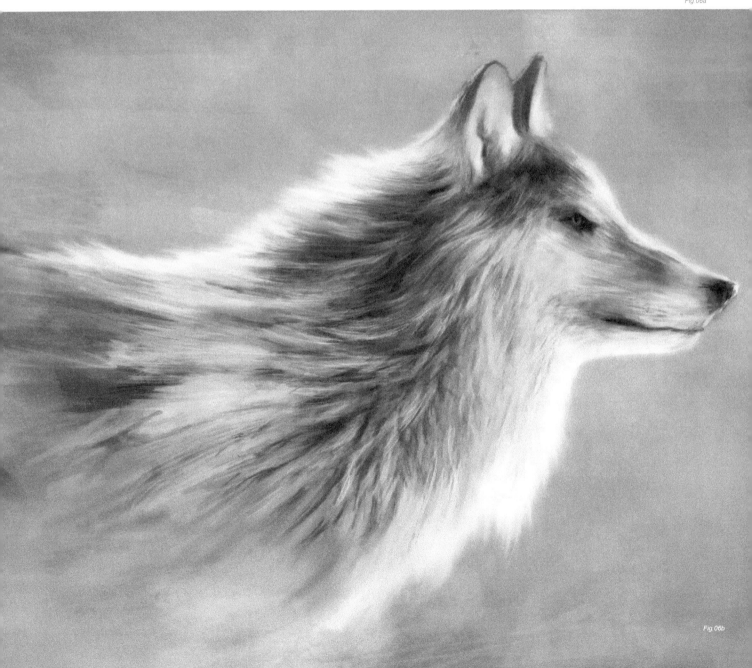
Fig.06b

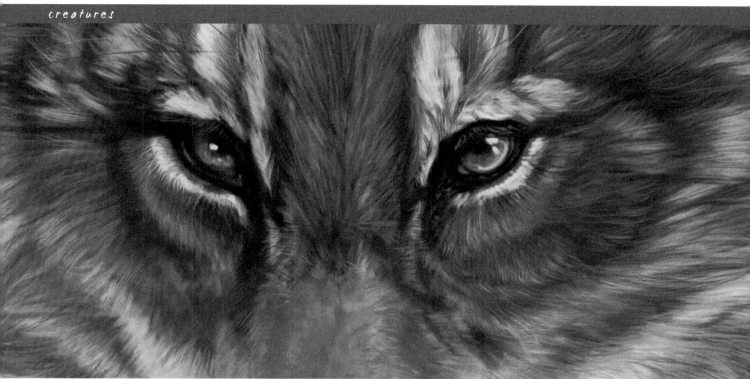

PAINTING ANIMAL EYES
BY STEPHANIE R. LOFTIS

SOFTWARE USED: PHOTOSHOP

This is a tutorial for coloring/painting animal eyes in Photoshop 7, but you should be able to follow it with Photoshop CS and most other versions of PS and similar programs. I will also be using a graphics tablet for the pen pressure sensitivity.

STEP 01

It's always nice to start with a sketch. I like to use a neutral colored background and a large black brush to sketch with, keeping the sketch and background on separate layers (**Fig.01**). My brush of choice is the Airbrush Pen Opacity

Fig.01

Flow brush that comes with Photoshop by default. I like to go into the Brushes Presets and check the Wet Edges box, as this gives the brush a nice watery effect that is easy to blend. Throughout this tutorial this is the only brush I'm going to use, though I have made many variations of it for different purposes (you may want to save variations made to your brush as separate brushes, so that you don't have to always mess with the settings every time you want to use them). You don't want to paint in 100% brush Opacity; the pressure sensitivity and low opacity will help with blending.

I tend to draw my eyes as sort of an upside-down, obtuse triangular-type shape, and I make them generally all black with a small outline of where

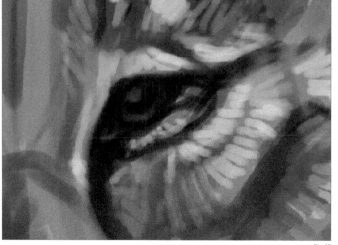

Fig.02

I think I'll want the highlight to be. I also either enlarge my sketch or draw big; the bigger your image, the more detail you can add, and also the better quality the image will be. I'm pretty much comfortable going as small as 2400 by 3000 pixels.

STEP 02

This is usually when I start adding the base fur on another layer. Often, I don't work on the eye until most of the fur work is done. The eye is a very important feature on a face and the fur around the eye is also very important in giving the eye that three-dimensional look. It also makes the eye looks like it "belongs" there (**Fig.02**).

STEP 03

To start the eye, zoom into 100% and create a new layer. What I have done here is taken a neutral color and colored the shape of the iris. I've also tried to further define the shape of the eye and pupil with a black brush. The color in the center of the pupil was placed there in order to help me figure out where I thought the pupil should be (**Fig.03**).

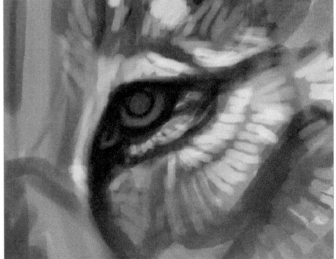

Fig.03

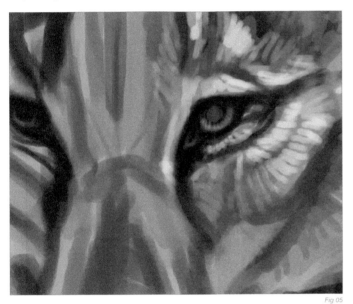

Fig 05

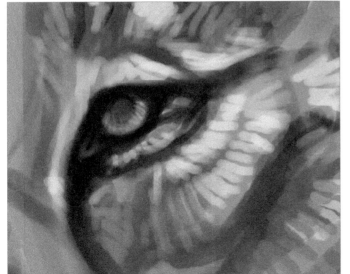

Fig 06

Fig.04

STEP 04

Here comes the fun part of painting an eye! This can very easily go wrong though, so you can make a new layer if you want to feel safe. I basically follow a star-shaped pattern with the pupil being the center. I first take a dark colored, very tiny brush and draw from the center downwards, in quick strokes (**Fig.04**).

STEP 05

Then, on top of that, I take a lighter colored brush of about the same shape and do the same thing around it – not necessarily on top; we're trying to get different segments of color. I then like to try and redefine the roundness of the iris with a quick swoop of the same color (**Fig.05**). I repeat dark color, bright color, dark color, bright color. You don't need to use the same colors; I used black, a dark burnt orange, a bright orange and some orangey yellows, followed by some swoops to redefine the circle of the iris at the bottom (**Fig.06**).

You may need to zoom in and out of the eye to make sure you aren't making a mess of your painting. I also recommend that you paint both eyes at the same time, so that they have the same colors and look like a pair.

STEP 06

You should now re-add your pupil with a large black brush in the center (**Fig.07**). I feel pretty good about my colors at this point so I continue to work by adding some of the final touches. This time I take a small black brush and, instead of dragging it to the bottom of the iris, just go about halfway – this really emphasizes the pupil (**Fig.08**). I then add my final swoop of color which acts as a reflection of light on the eye (**Fig.09**).

STEP 07

Now you can start working on the other details associated with a convincing pair of eyes: the dots of light reflection, the eye lids, and tear ducts. It's basically all just about taking much lighter colors that stand out in order to give the illusion that the eye looks moist. You can also add eye lashes, too – I can't think of a furry creature that doesn't have eye lashes!

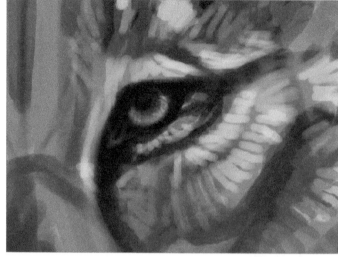

Fig.07

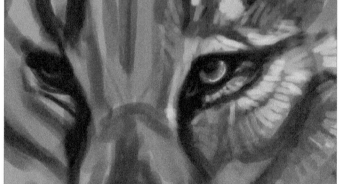

Fig.09

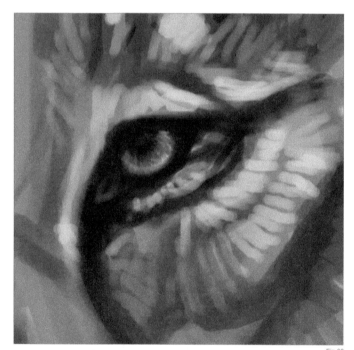

Fig.08

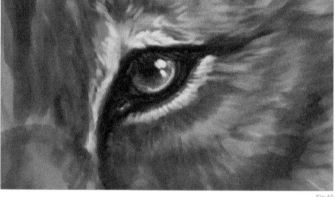

Fig.10

To paint the eyelashes I take a light brown color – I don't want them to be bright white because they'll cross over the eyeball just painted and will stand out more than I want them to. You just need to paint quick strokes for your eyelashes, and then outline them in black so that they don't get lost in the other colors of the eye (**Fig.10**).

STEP 08

And that's basically it for the eye itself, but the surrounding area is also pretty important. When you've finished detailing your eye, zoom out and take a look at your creation. With my painting I had to edit them a little to fit the head and to make sure both eyes worked together convincingly in the creature portrait. I could then continue rendering the creature's fur until I was satisfied with the illustration (**Fig.11 – 12**).

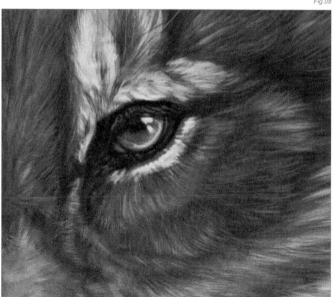

Fig.11

Fig. 12

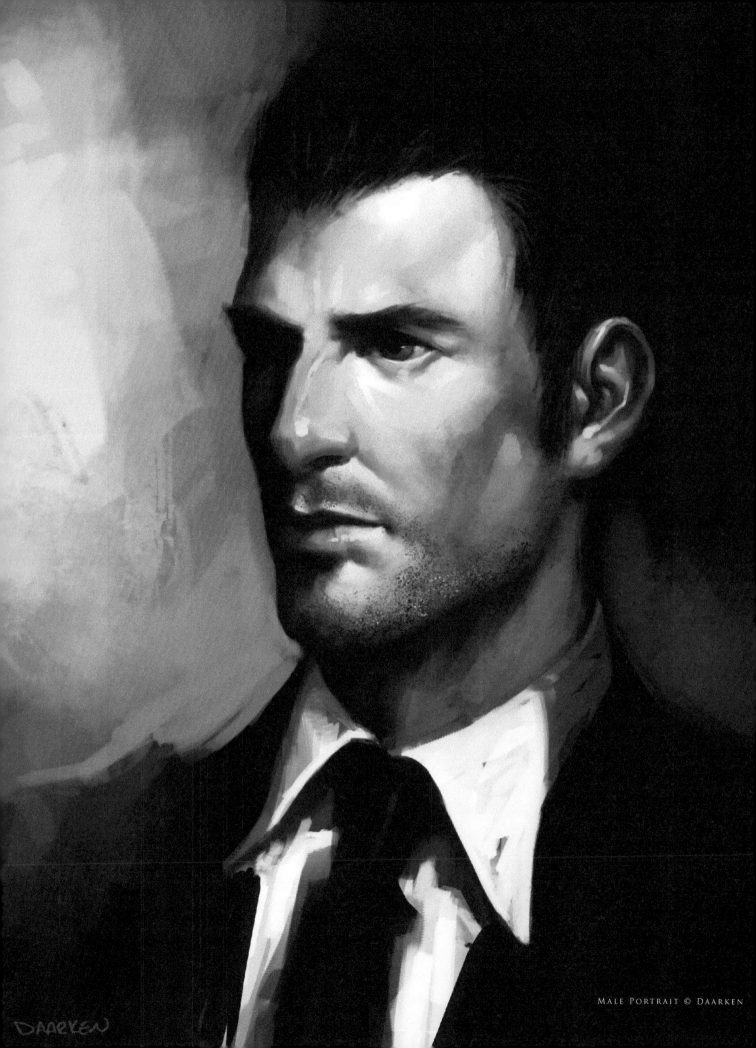

Male Portrait © Daarken

humans

This is a subject that has preoccupied artists for centuries and is essentially a vehicle for studying the human condition, and as such forms a necessary part of this book. As opposed to focusing on the subjective aspects of painting people, this chapter chooses rather to deal with the technical issues related to painting human characteristics. I think it was Miro that once said that one cannot jump into the air without ones feet being firmly on the ground. It is with this sentiment in mind that our chapter aims to show how to go about painting the human body, and thus enabling artists to use it as a form of expression.

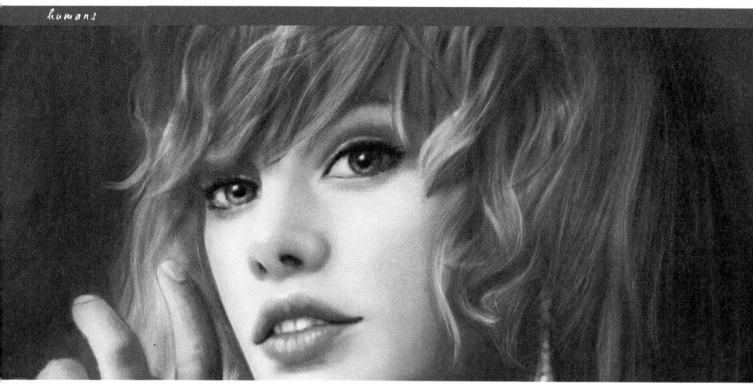

How to Paint Blonde and Red Hair
By Anne Pogoda

Software Used: Painter and Photoshop

The question is: Why is red and blonde hair more complex than painting dark hair? Well, to be honest, it's not that easy to explain, but let's try it like this: When you have dark hair, you just have to set up a basic "black" pattern in which you start to give some "white" highlights, and finally you might add a colorful shimmer of red or blue to the whole thing to make it appear more lively – and then you're done! When you want to paint blonde hair, the result you want to come up with has to appear anything but dark or black. So you have to work with more colors at once. If you want to have a nice blondish

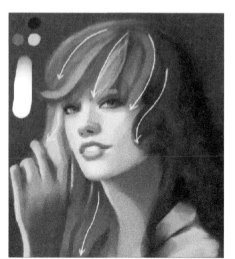

Fig.01

palette, you have to work with a variety of reds and yellows (to mention just the basic colors). When trying to paint hair, you will see that getting a good handling of color is actually harder than just lightening something up, as it is with the case of dark hair. So let's start by getting directly into the color blocking stage of painting blonde hair.

The painting in this example is a picture of a lovely woman which I created not too long ago for a client. I was given Courtney Cox as a main reference, which also resulted in references of Olivia Wilde, Hayden Panietere, Calista Flockart, and one of Enayla's (http://www.furiae.com) paintings called "Ailil". When you have a customer and he is unsure as to how he wants the look of his/her desired character to be, then it is good to ask them for celebrities or fine art paintings which seem to impersonate their imagined figure. Without this information, it is nearly impossible to come up with a result that the customer will like or can feel connected to. Having said that, and collected all your references, you can always come up with a concept to show to your customer and ask whether he likes what you have in mind, or not. So let's continue.

Step 01 – Setting Up the Base by Blocking First Color In

This can be seen in **Fig.01**. When you are planning a figure it works best to pick your desired colors and block them in quickly. In this case, you can use an Airbrush with hard edges and have the Spacing set to 5%. I have also drawn in the colors which I used for the basic hair pattern in the upper left corner so that you can get a better understanding of how I worked here. As you can see, we have several reddish and yellowish tones in a range from light to dark. This is because the goal was to show not just the basic hairstyle, but also a basic lighting pattern. I use the darkest color for the hair as a base – a dark brown. Above this color all of the other – three – lighter colors are applied, which means we define the actual lighting situation after we have painted in the dark base. I have kept the back of the head mostly unnoticed at this stage of work, and simply painted some large, dark red strands in. The important part of this stage is how to define the "bangs". These should always make their way around the head of the figure, or else they will look oddly misplaced or wig-like. Having the darkest color as the base mostly helps at the parts where the

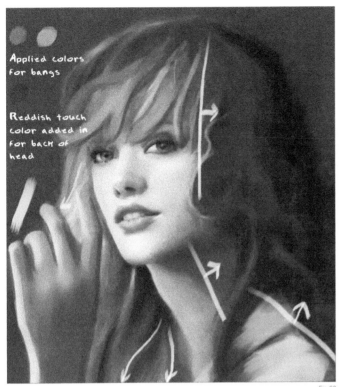

Applied colors for bangs

Reddish touch color added in for back of head

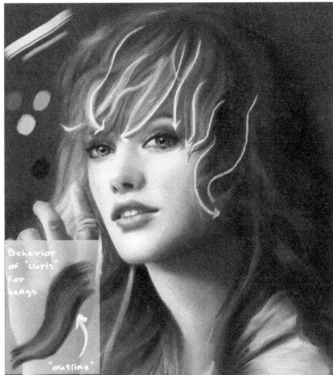

Behavior of "curls" for bangs

"outline"

Fig.02

Fig.03

yellowish highlight tones are applied. Because the darkest color shines through, or makes its way between the yellow strands, it gives the hair more depth and also makes it appear livelier because more than one base color (yellow and red) is applied.

STEP 02 – IT'S ALL ABOUT DEFINITION

In the next step (**Fig.02**), it's all about further definition. I had actually planned some curls here for the back of her head (which I later changed). OK, so what is the meaning of all those arrows? Well, it's not all as confusing as it seems; looking at how the lighting situation

appears in this artwork we could generally split the image into two halves. On one we work with the lighter colors, and on the other we work with the darker colors. This makes it much easier to stick with the mood you are looking for, without losing it. So, while on the left side we can continue working on the bangs by adding some highlighted strands with our speckled brush, we can give some reddish tones to the right side of the image, such as the back of her head, to give it all a more lifelike appearance. We keep the reddish tones only applied to the parts of the head which are nearest to the border lines (the lines drawn on the image with arrows). I leave the very back

of her head unnoticeable, so that it stays in the dark base color that we applied earlier. This also helps us to see the head – and so the hair connected to it – as a three-dimensional object.

STEP 03 – FINDING A CONNECTION

So let's continue to step 3, where it's all about connecting what we had so carefully split with our "border" earlier on. It is vital to work with a rather small, speckled brush now – take a look at **Fig.03** for the directional arrows which show the further definition of the bangs. To give the bangs better definition, we basically need all colors from our palette again, which also make the connection between the two parts we had separated in steps 1 and 2. The trick is to paint in curls with a rather small, speckled brush using the lighter colors from our palette. Then we simply pick the darker colors and define the borders between two curls with them, for example, if we want to draw an outline (see Fig.03 for the little panel which explains the meaning and behavior of the "outline").

STEP 04 – THE BACK OF THE HEAD

OK, so now we finally want to focus on the back of her head. As mentioned earlier, I initially wanted to go with a curly look, but later

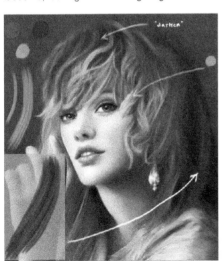

"darken"

Fig.04

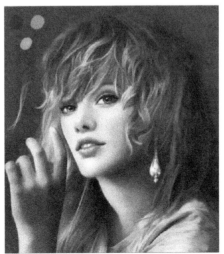

Fig.05

scrapped the idea due to the working process. So, for the new look of the back of the head, pick a rather large, speckled brush and the dark brown base color to paint the new basic shape in. Then pick one of the lighter colors and apply the highlights to the new base, as seen in **Fig.04**. We'll leave it at this stage (for now) and go back to the bangs.

Taking a small, speckled brush and the highlight color marked on the right side of Fig.04, continue to paint more shape in. Be careful with this very strong highlight color as it works best when applied to the "peaks" of the strands to give the hair more volume and a lively effect. Once that's done, pick the dark red to darken the strands at the top of her head some more. This gives the viewer more understanding of the head as a three-dimensional object. The darkening of the hair works best when you handle it as I have explained in step 3.

STEP 05 – PAINTING STRANDS OF HAIR

Step 5 continues on top of what we have done in step 4 – we are just getting into more detail now. Pick your speckled brush and set it to a very small size. We will now paint in many tiny hairs and since we clearly defined the shape of the bangs and the back of her head earlier, this should be easy! It really is exactly like in step 4, just with a very tiny brush to define all the unique strands of hair (**Fig.05**).

STEP 06 – MERGING THE FIGURE WITH THE BACKGROUND

Now we will pick the color of the background and a soft-edged Airbrush, and set the Opacity to no more than 30%. The brush should be a large one, as shown in **Fig.06** (simply follow the arrow), and we will now carefully apply the background color to the "borders" of her head. This will connect the figure better with the background, and again makes it all the more colorful and lively. In theory, you are done now, but just in case you own Painter there is a little nice addition you can apply to the hair once finished...

Fig.06

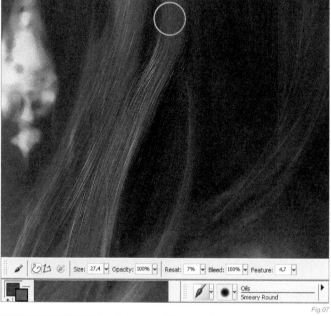
Fig.07

Fig.08a

Fig.08b

Fig.08c

STEP 07 – GOING ADVANCED WITH PAINTER

To give the hair some extra highlights there is a nice little trick you can add using Painter. What's so cool about Painter is that the brushes can interact with color that has already been applied, which means that if we duplicate (Photoshop: right-click > Duplicate) the hair layer and carefully apply oils to it in Painter, the oils will react with the hair pattern we have already painted and therefore create a lovely texture. In this case, I used the Smeary Round brush from the oil brushes palette. Don't worry about the intensity of the brush strokes that will be created since we have made a copy of the hair layer on which we now paint, so it'll all be fine. In Painter and Photoshop, press the Alt key on your keyboard when you would like

to grab a color whilst painting, as this makes it possible to quickly get the color you would like to work with. By the way, in **Fig.07** you can see the colors that I have worked with for the oily hair texture. Since the new color reacts with the color which is already applied, it will merge all together automatically so you don't need to work it over with an Airbrush afterwards to soften it up. After you have applied as much oil as you would like, which hopefully created a lovely fuzzy pattern to the hair you have already painted, you can save the document, close Painter and reopen the document in

Photoshop. Or, you can pick the Eraser (in Painter), set its Opacity to 20% and carefully erase the parts of the oily pattern that you don't like.

STEP 08 – OVERWORKING PAINTER WORK IN PHOTOSHOP

Back in Photoshop, we are now going to erase areas of the attached oil hair copy that we don't like. This basically works almost the same as in Painter, but in Photoshop it doesn't make much difference as to how much pressure you give

Fig.09a

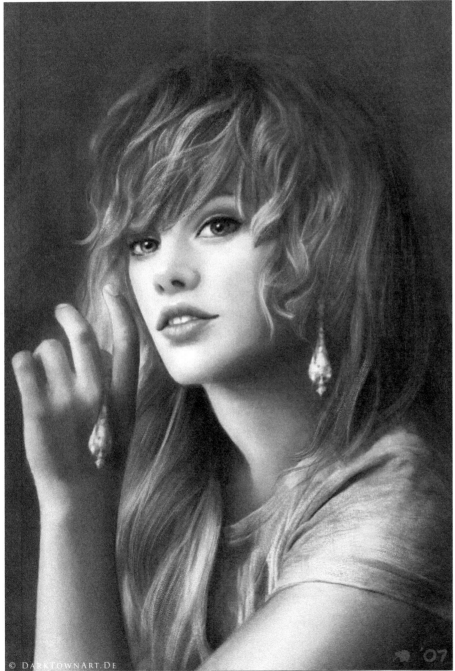

© DARKTOWNART.DE

Fig.09c

Fig.09b

to the pen after you have set the brush Opacity of the Eraser to 30%. In Painter, setting the brush Opacity of the Eraser to 20 or 30% only makes sense if you handle the pen of your graphics tablet very carefully. That's why I'm mostly doing the erasing part with Photoshop because it gives me a feeling of better control over the whole thing. **Fig.08a – c** shows three examples of oily Painter patterns which have been overworked with the Eraser. And here we have the final image (**Fig.09a – c**).

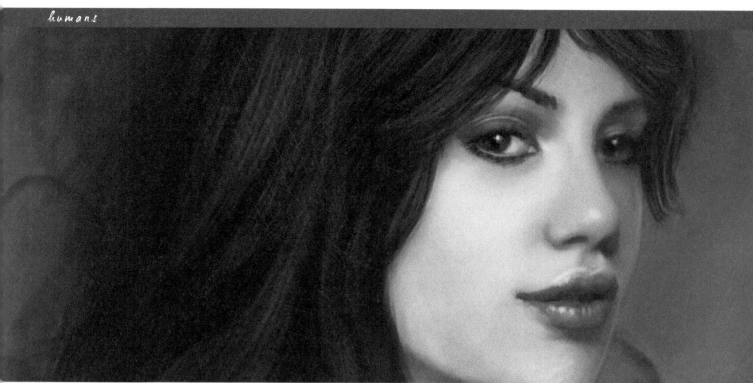

How to Paint Luscious Lips
By Anne Pogoda

Software Used: Photoshop

So you have painted this lovely woman with beautiful eyes and an even
lovelier face, have maybe even used the other tutorial in this book to
attach some wonderful hair to her, and now you come to the part that
you have so patiently avoided ... the lips. The lips are what really make
a female illustration, especially when you're looking for the kind of "kiss
me" pop-out lips which drive men crazy. To learn how to paint lips at their
best, I have decided to work up two examples for you in two different
color schemes and from different angles, so that you have the best base
for your future female paintings.

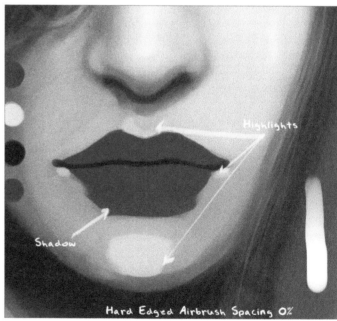

Fig.01

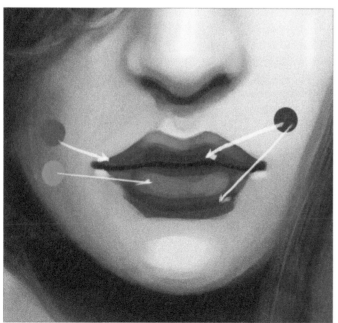

Fig.02

Example 01
Step 01 – A Base for the Lips

Alright, let's begin. Pick the red color of your desire and a hard-edged
Airbrush – Spacing 0%, Opacity 100%, and the size of your desire – to
block in a basic lip shape, which you will then separate with a curved
line of dark red. So you have an upper and lower lip now, in a very basic
shape. To give the lips an illusion of depth, it works best to make them
cast a shadow (**Fig.01**) and to add some highlights to the surrounding
skin.

STEP 02 – HIGHLIGHTS

Stick with the hard-edged Airbrush – Opacity can be between 90% and 100% – and paint the first highlights to the lips with a bright red or a soft pink. You can also pick a red which is slightly darker than the basic reddish color of the lips to apply some at the lower side of the upper lip and at the lower side of the lower lip (**Fig.02**).

STEP 03 – MORE HIGHLIGHTS

Now we're going to add some "pop-out" highlights. Still using the hard-edged Airbrush, but of a smaller size, choose one part of the lips to which you will give a very bright white highlight, and then randomly spread some other highlights on the upper and lower lip. We will merge the lip layers 1, 2 and 3 now to save working capacity. Simply press Ctrl + E whilst you are on the lips layer 3 and it will merge layer 3 with layer 2. Whilst you're on layer 2, press Ctrl + E again to merge it with layer 1 (**Fig.03**).

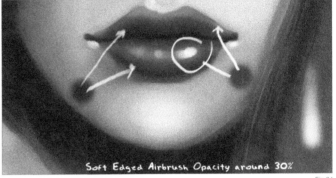

Fig.03

STEP 04 – SOFTEN UP

In step 4 we will create a new layer (Ctrl + Shift + N or Layer > New > Layer) and pick the soft-edged Airbrush with an Opacity of 30% to soften the "edgy" borders between each color which were caused by the hard-edged Airbrush. Pick your basic red again to work near all highlighted areas of the lips. The darker red is for the lower part of the lower lip which is closest to the shadow, and for the lower part of the upper lip which is closest to the line between both lips (**Fig.04**).

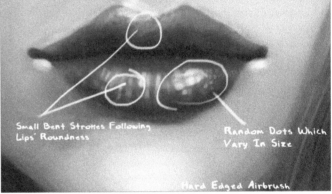

Soft Edged Airbrush Opacity around 30%

Fig.04

STEP 05 – DETAILS

Now it's detail time! Pick the hard-edged Airbrush again and set it to a rather small size of your desire. Create a new layer and attach many

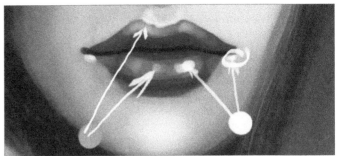

Small Bent Strokes Following Lips' Roundness

Random Dots Which Vary In Size

Hard Edged Airbrush

Fig.05

little white dots and strokes to the lips. The strokes should be bent so that they follow the roundness of the lips. It also works best if you paint dots which vary in size, to avoid the lip structure looking boring (**Fig.05**).

STEP 06 – SOFTEN UP AGAIN

Create another new layer and pick the soft-edged Airbrush again. The size should be as seen in my example (**Fig.06**) compared to the size of the lips; the Opacity should be no more than 30%. Carefully work over the lower part of the highlighted areas. You can compare it with step 5 if you want – can you see how the little strokes and dots seem to form a clearer lip structure now?

STEP 07 – MORE DETAIL

If you want, you can merge the layers from steps 5 and 6 now by pressing Ctrl + E to avoid being overwhelmed by layers. Don't forget to create a new layer for the detail which we will be adding now. You can take a small, hard-edged Airbrush or a small, speckled brush and paint lots of little whitish strokes and dots on the lips. As you can see, I did this very randomly in **Fig.07**. Don't worry; it'll look good in the end. You can also add some small highlights to the lips.

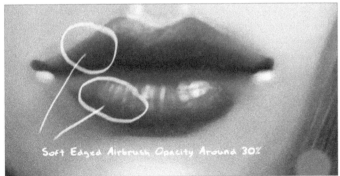

Soft Edged Airbrush Opacity Around 30%

Fig.06

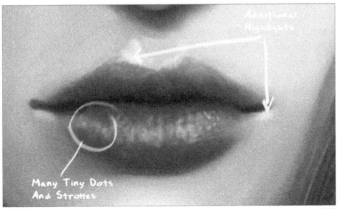

Additional Highlights

Many Tiny Dots And Strokes

Fig.07

STEP 08 – FINAL TOUCH-UPS

Pick the soft-edged Airbrush again – Opacity set to no more than 30% - and set it to a size which is the same as in my example compared to the size of the lips. Now pick a reddish tone that is slightly brighter than the basic red which you have used for the first shape of the lips, and carefully work over the lower part of the lower lip. Now pick a whitish tone and carefully add a few more highlights to the top of the lower lip. And you're done (**Fig.08a**). Here are the lips in the finished illustration (**Fig.08b**).

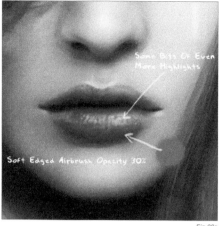

Fig.08a

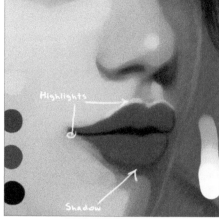

Fig.09

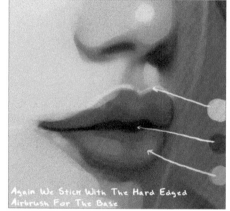

Fig.10

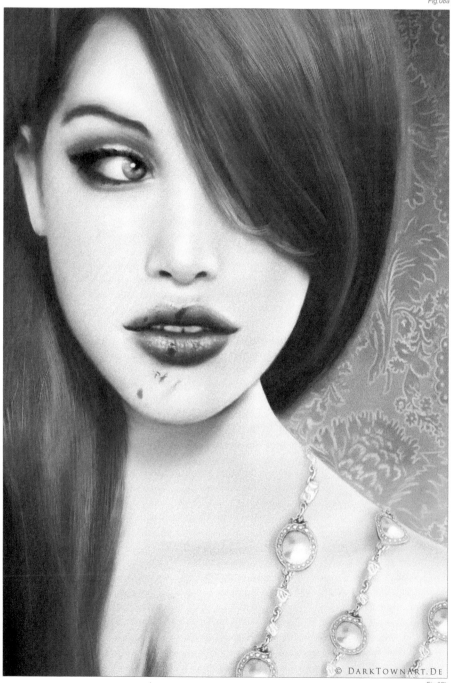

Fig.08b

EXAMPLE 02
STEP 01 – A BASE FOR THE LIPS

Let's continue with example 2, now. This time we want to paint lips in a three-quarter view. Unlike the first example which was basically done in reddish tones, the current example works on bluish background tones which hold a contrast to the pinkish lips and skin tones. So the lips will be set up from a basic pinkish color scheme this time, again separated with a rather dark red, curved line to divide them into an upper and lower lip. The brush of choice is, again, the hard-edged Airbrush – Opacity 100% and Spacing 0% (**Fig.09**).

STEP 02 – ADDING HIGHLIGHTS

Stick with the hard-edged Airbrush again to add some highlights to the lips. I have marked which colors were used for which area on **Fig.10**. You can also see that I painted some teeth in; they are basically just two big strokes in a red which is a little brighter than the red that was used to separate the upper and lower lips.

STEP 03 – ADDING STROKES AND DOTS

What we'll do now is add some strokes and a few dots to the lips, which is quite simple but will make them "pop out" more. Adding some dabs of highlight will make the lips look glossy. Also, picking a dark red to carefully work on the lips with curved lines which follow the shape adds detail and makes them seem more realistic. You can also feel free to add a few lines of highlights to the lower lip to add more detail to it, too (**Fig.11**).

STEP 04 – GET BLENDING

Now, since we have so nicely worked in some detail into the lips, it is time to soften the whole thing up again. But first of all, you can merge

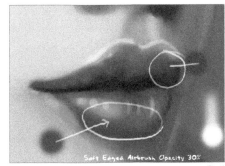

Fig.11

Fig.12

Fig.13

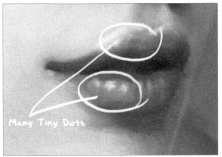

Fig.14a

© DarkTownArt.De

Fig.14b

all current lips layers to save working capacity again. Then you can create a new layer to work over the lips with the soft-edged Airbrush – Opacity 30%. This merges the colors together and you will get away from the edgy vector look. It will also take away some of the detail but don't worry, we'll bring that back in steps 5 and 6 (**Fig.12**).

STEP 05 – APPLYING MORE STROKES TO PUSH THE DETAIL

If you want you can merge the layers again now by pressing Ctrl + E. Like in example 1, you can either take a small, hard-edged Airbrush, or a small, speckled brush to paint many little whitish strokes on the lips. You can also add some additional highlights to get the lips popping out effectively again (**Fig.13**).

STEP 06 – FINISHING UP

You can now use the speckled brush – or pretty much any hard-edged brush of a very small size – to paint many little dots in your highlight color of choice on the lips, to finish them up. This was a quick one, wasn't it? That is the good thing about lips: as soon as you give lots of highlights to them, like in example 2, you will get such a great "pop-out" effect that the viewer's eye gets tricked and doesn't recognize the actual lack of detail in them (**Fig.14a**). Finally, here are the lips in the finished illustration (**Fig.14b**).

© DAARKEN

MALE PORTRAIT
BY DAARKEN

SOFTWARE USED: PHOTOSHOP

GETTING READY

For this tutorial I decided I would approach this
portrait from more of a traditional standpoint,
and not do something that was fantasy or
sci-fi. It is good to learn the basics first before
going and breaking all the rules and creating
something crazy. If you need photo references,
I would recommend shooting the reference
material for yourself. That way you don't have
to worry about any copyright issues, and if you
want to sell it later on then you can.

Fig.01

Fig.02

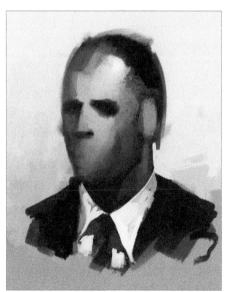

Fig.03

When taking photo references, make sure you
do not use the flash, because it will wash out
your picture and flatten out the planes. Make
sure you have some good, strong lighting –
preferably from one main light source. Position
your model so that you get interesting shadow

shapes. I am not working from any photo
references so we will see how this turns out.

A lot of people ask me how many layers I paint
on; most of the time I try to keep things simple
by painting on one layer. I have a lot of layers

CHAPTER 05 136

in this tutorial because it is easier to show the process that way. Recently I have started working with more layers for my conceptual work because clients like to be able to turn different things on and off or change things, like clothing and hair, for example.

THE BLOCK-IN

When I start a painting I usually have no idea what I'm going to do or what it will look like, and this time is no different. I have a basic idea of the angle that I want to paint, but that's about it. As you will see, I make a lot of changes throughout my painting. Not starting out with a tight drawing allows me to try different things more freely and to let "happy accidents" happen.

I always start out with a dark silhouette for the shape of the head (**Fig.01**). I then come in with a basic skin tone and put in where the face will be. I can then come in and put in the shadow shapes for the eyes and nose. At this point I can also begin to set up my color scheme. A general rule when painting faces is that they are more yellow around the forehead and more blue/green around the mouth. One thing to keep in mind is that you do not have to pick a blue color in order to make something look bluish. For the area around his mouth, for example, I picked a desaturated orange (**Fig.02**). I knew that this color would look bluish due to the colors surrounding it. If you place the same color against different

Fig.04

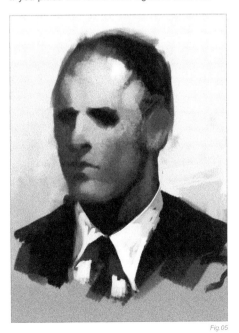

Fig.05

Fig.06

Fig.07

backgrounds you can see how different each one looks, even though it is still the same color.

"FOLLOW THROUGH WITH YOUR SHAPES"

I heard this so many times at school. Following through with your shapes simply means you continue the shapes of the body through their clothing. This will help you keep things in the correct place. Whenever I'm painting faces I always paint them without their hair (**Fig.03 –**

05), and then later on paint the hair on top of the head. This helps me get the position of the hair in the right place.

ADDING THE DETAIL

Even though I start out with a basic color scheme, I tend to change the colors a lot throughout the painting. Sometimes I will completely change the color scheme, whilst other times I will just fix the color balance. An easy way to fix the color balance without

actually changing the color of the painting is to click on the little circle that is half black and half white (**Fig.06 – 07**). When you click this, a menu will come up with many different options for you to choose from. From this menu you can change the Color, Levels, Hue/Saturation, and so on.

Now that I have all of the basic shapes in place I can start going into more detail (**Fig.08**). The first part I wanted to work on was the eye. Since eyes are usually the focal point in any portrait, it's necessary to be able to paint them correctly and understand how they work. A common mistake I see in a lot of people's painted eyes is that they look very flat. One reason is because most people don't really understand the planes of the eye. The eye is a sphere, and that sphere has an effect on the masses around the eye, like the eyelids. The

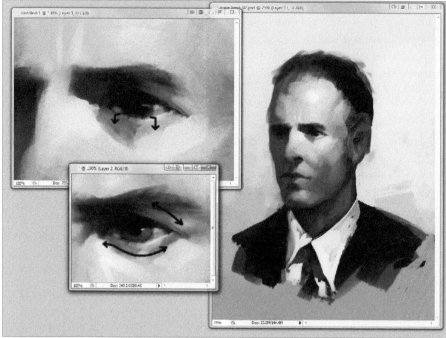

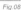
Fig.08

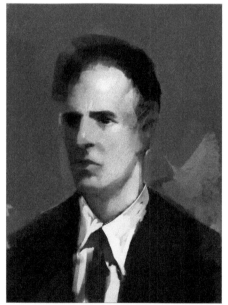
Fig.09

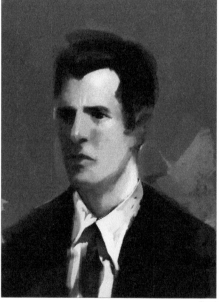
Fig.10

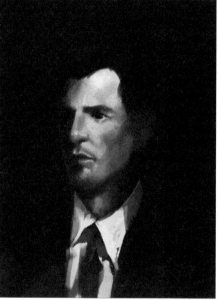
Fig.11

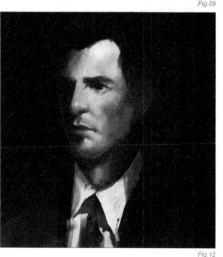
Fig.12

eyelids should wrap around that sphere. Not only does the eyelid wrap around, but it also has thickness. Think of these planes kind of like a box; since my lighting is from the top, the top plane will catch more light, whilst the side is darker. Another error that a lot of people make is that they make the eyes too white and they forget the shadows to help the eye wrap around. Again, the eye is a sphere; the top will catch more light, and as you move around the sphere the light falls off and gets darker. If you study the Masters, like Sargent, you will see that their eyes are not white but red, yellow, and orange.

So far I'm not really happy with where this portrait is going so I start making changes (**Fig.09 – 10**). Now, all of a sudden, he kind of looks like Norrington from *Pirates of the Caribbean*, so I decide to change it again (**Fig.11 – 14**) by adding a black background and changing his features. The great thing about working digitally is that I can make these changes easily. If I don't like something I can change it in a few seconds, instead of having to repaint entire areas. This medium also allows me to make more daring decisions than I normally would if I were painting in a traditional medium.

Fig.13

Something about the face is still bothering me here, so I change it again (**Fig.15 – 16**). By cutting off more of the right side of his face and moving his ear back, I can change the angle of his face (**Fig.17**). He was getting a little lost in the darkness, so I threw some light in the background (**Fig.18**). The traditional painting trick for portraits is to put the dark side of the face against a light background, and the light side of the face against a dark background.

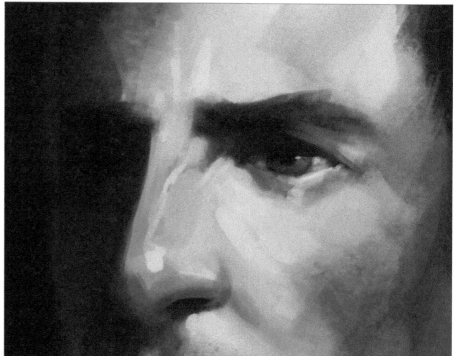
Fig.14

Fig.15

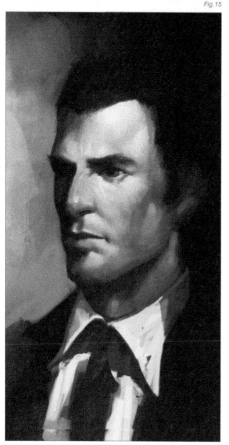
Fig.18

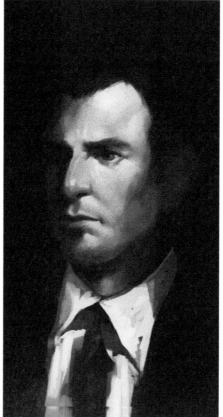
Fig.16

Fig.17

FINAL TOUCHES

Now comes one of my favorite parts: the ear (**Fig.19 – 20**). I have no idea why, but I really enjoy painting ears. It's weird, I know. I think the thing I like about them is that they have a lot of very unique shapes and structures, and

a lot of people tend to overlook them. Within such a confined area you can still find tons of plane and color changes.

I wanted to make him look more like a rough and tough kind of guy, so adding some more

facial hair is an easy way to do that (**Fig.21**). For the stubble I use a custom brush. You can easily make your own brush for this purpose by painting some random dots and then going to Edit > Define Brush Preset. The new brush will be in your brush library at the end. After you make your brush, don't forget to change the settings, like Scattering, Size, and Opacity.

I am nearing the end of the painting now and making some minor adjustments to the face

Fig.19

Fig.20

Fig.22

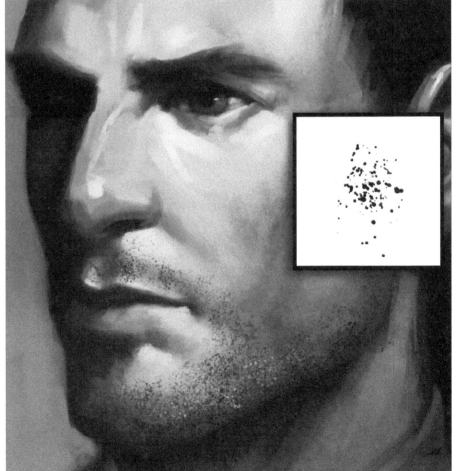

Fig.21

(**Fig.22 – 24**). I felt like his nose was a little too short (usually the width of the eye is the same distance from the corner of the eye to the top of the wing of the nostril), so I selected the nose and went to Edit > Transform > Distort, and pulled the nose down a bit.

CHAPTER 05

Fig.23

Fig.24

Something was still bothering me about the face but I couldn't put my finger on it. I asked my girlfriend about it and she thought that his hairline was a little too high (**Fig.25**). This can easily be changed by selecting the area that you want to move, and then going to Edit > Transform > Warp. The Warp and Distort tools are one of the hidden gems of Photoshop. These two tools have made my life a lot easier. The Warp tool allows you to pull and push different parts of the selection, and can actually make things turn without having to repaint them. Once you hit Warp, a grid will pop up on the screen where your selection was (**Fig.26**). If you click and drag different points of the grid, your image will move according to the direction that you pull. Once you have everything in place, you can apply the changes by hitting Enter on your keyboard.

Fig.25

As you can see, this painting went through many different changes before I knew where it was going (**Fig.27**). With the help of my knowledge of anatomy and some tools in Photoshop, I was able to come to a complete illustration.

You can download a custom brush (ABR) file to accompany this tutorial from www.focalpress.com/digitalartmasters

Fig.26

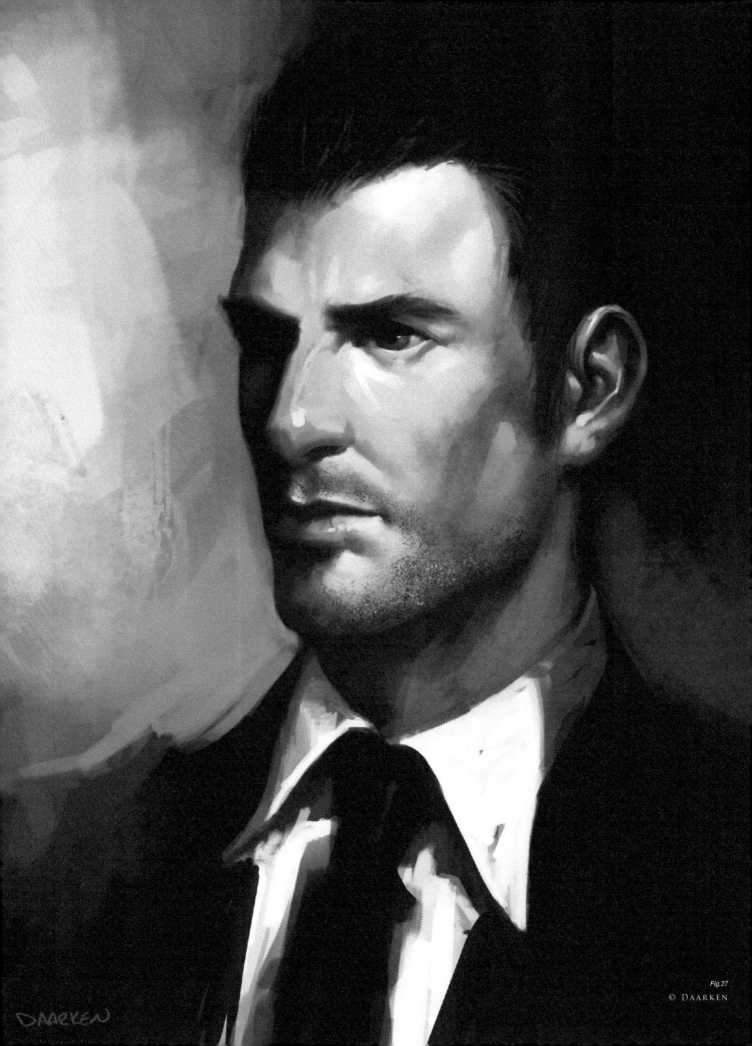

Fig.27

© DAARKEN

DAARKEN

© EMRAH ELMASLI

PAINTING REALISTIC SKIN
BY EMRAH ELMASLI

SOFTWARE USED: PHOTOSHOP

In this tutorial I'll try to explain the painting process of a realistic human skin texture. I'll use the upper torso of a male body as my subject, which is a very good surface to apply light, form and detail. It's always good to use a reference in subjects like this – a photograph or a life model will do.

I begin my painting process by creating a new A4 document in Photoshop CS2. The first step is drawing the lines of the torso. I start by drawing the main sketch on a new layer with

Fig.01

Fig.02

a simple brush (**Fig.01**), by looking at a torso reference in an anatomy book. To begin, it's always useful to draw a basic sketch which indicates the main forms of the subject. By doing this, our painting will be better and correct (**Fig.02**). Upon finishing my sketch and being happy with it, I change the layer properties to Multiply and open up a new layer underneath it. I fill this new layer with a medium skin tone (R = 219, G = 190, B = 156), which

Fig.03

I'm thinking of using in my painting, using the Fill tool (**Fig.03**).

As we know, skin tones vary by race and the country we live in. The skin that I'm going to paint belongs to a white man, with a medium-toned skin. I continue by opening a new layer between the sketch and the medium skin tone layer. I start to determine general forms with the soft brush that you will see detailed

in **Fig.04**. The colors that I use while painting the forms are the darker and warmer tones of the medium skin tone that I used before. I pay more attention to the general "stain" values, then go more into the details, trying to figure out the form of the skin, the curves of the muscles and the color of the final skin tone (**Fig.05**).

For the next step I can start to apply the highlights by considering the angle of the light source. I use the yellowish and lighter tones of the skin for this so that the form starts to slowly become more defined (**Fig.06**). Once happy with the highlights and the shadows of the form, I start to paint over the lines and try to make the painting look more realistic (**Fig.07**).

Fig.06

Fig.07

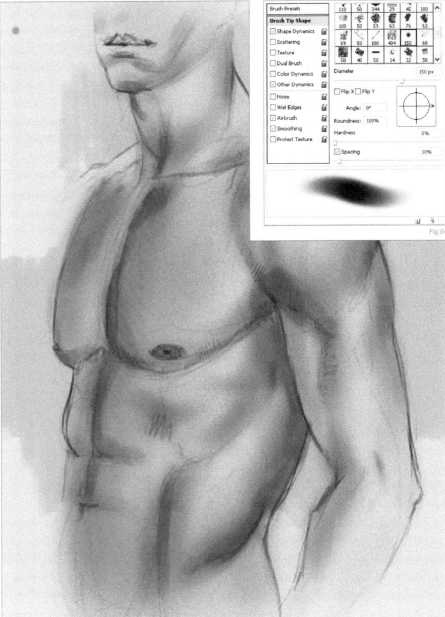

Fig.05

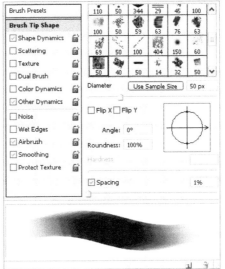

Fig.08

The brushes I use while painting over the lines are the airbrushes that I use frequently, and the hard-edged brushes which I use to paint the sharp edges (**Fig.08**). When painting skin, remember that it takes the form of the muscles and wraps it like cloth.

One of the most important things that we should pay attention to whilst painting a realistic skin texture is successfully applying the curves of the muscles. If we take a look at the shoulder muscles, we can see the harmony between the skin and the muscles under it (**Fig.09**). Human skin is a reflective surface, despite its matte appearance. If we look at the area between the bicep muscle on

the upper arm and the ribs (**Fig.10**), we can see the bouncing light affecting the bicep area. We call this "radiosity". This reflection changes depending on the color and the density of the light. It is important to get the reflections right whilst painting a realistic skin texture.

After painting over the lines (**Fig.11**) I can start the detailing process. The best way is to examine our own skin to see what kind and amount of detail it has. Skin has details like freckles, hair and spots. I'll now try to apply these details to my painting. I can start with the freckles and spots. One of the best ways to produce freckles is to create them traditionally by using a brush and watercolors. All you need to do is to spatter some watercolor paint onto white paper. After creating the spattered effect, you scan it and make it ready to use digitally. Using Photoshop, I desaturate the spatter texture and adjust the Levels until it becomes pure black and white (**Fig.12**). I then copy this texture onto my painting and apply it to the suitable places.

To integrate the freckles with the skin I change the layer properties of the layer to Color Burn, and to make it less dominant I decrease its Opacity to 50% (**Fig.13**). To make it look more homogeneous, I erase some of the spots. I also apply some brown colored spots to make the skin texture richer (**Fig.14**). The other way

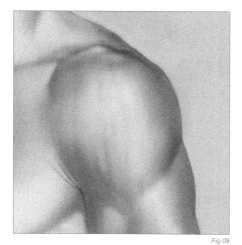

Fig.09

Fig.10

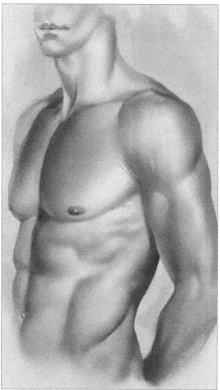

Fig.11

Fig.12

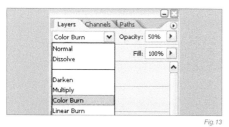

Fig.13

Fig.14

Fig.15

of making the texture look more detailed is to add some hair to it. I paint these hairs on the lower arm with a thin, hard brush, one by one (**Fig.15**). The color of the hair I chose is a lighter tone of the skin color (R = 199, G = 154, B = 116) (**Fig.16**).

Another detail which is revealed under the surface of the skin is veins. I add some bluish-gray colored vein details on the bicep muscle with a soft and calligraphic brush, without overdoing them. To make them "pop out" more I add some highlights to them with a lighter tone of the skin color (**Fig.17**).

After adding all these details, I've almost finished the painting. There are just some color and contrast adjustments left to be made. Over all my layers I open some adjustment layers, like Brightness/Contrast, Color Balance and Hue/Saturation. You can find these by going to the Layer menu and clicking on New Adjustment Layer. I increase the contrast and decrease the saturation a bit. Also, I adjust

the colors with the help of Color Balance and make them look more accurate. As a last step I will add a noise effect over the skin to make it look rougher. I open a new layer and fill it with a grayish tone of the skin color (for example: R = 180, G = 170, B = 150). After this, I go to the Filter menu, click on Noise and select Add Noise effect, and then make these adjustments: Amount = 400%, Distribution = Uniform (**Fig.18**). I then use the Spatter effect

Fig.16

Fig.17

Fig.18

Fig.19

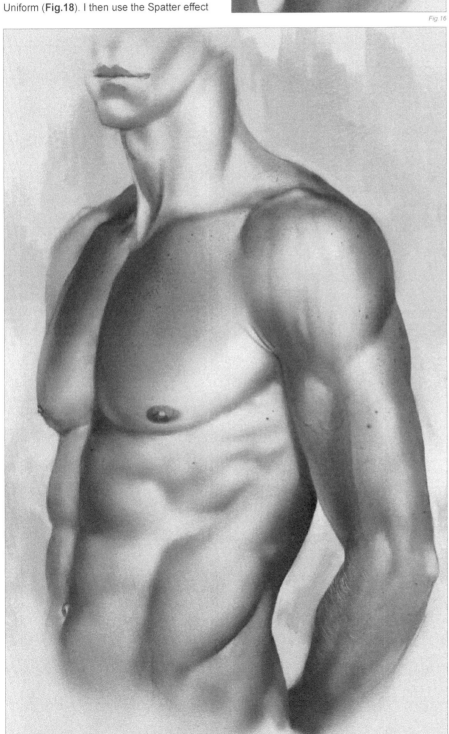

Fig.20

to make the noise look messy and unbalanced (Filter > Brush Strokes > Spatter). I apply Blur on the same layer twice (Filter > Blur > Blur) (**Fig.19**). And lastly, I decrease the Opacity of the layer to 4%.

Finally, my skin painting is complete (**Fig.20**). This is the method I use to paint realistic skin textures, and I hope it will be useful for you too.

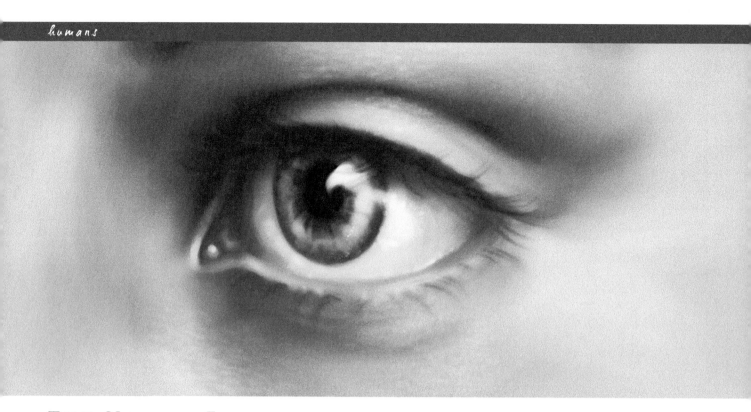

THE HUMAN FACE
BY NYKOLAI ALEKSANDER

SOFTWARE USED: PHOTOSHOP

Let's face it, it's not easy to draw or paint a human face, especially not without some practice. When painting a realistic face, everything has to be in the right place or else it will look quite grotesque and wrong. And not just that ... each facial feature has its own unique anatomy that one needs to stick to – at

least as a base to build upon. In this tutorial, I'll be showing you how to paint separate facial features, with some tips and tricks on how to achieve skin texture. This should not only be useful for beginners, but also for those of you who are already pretty good at painting but would like to learn a bit more and push your

skills to the next level – or perhaps just do something different.

EYES – INTRODUCTION
The eyes are said to be the window to the soul, and undoubtedly they are the most expressive part of a face. I've heard it said that if you get them right then you're halfway to a good portrait, and it's certainly true to some extent. Eyes are also the part of the face that most often makes a portrait look strange or lifeless, and this usually happens when their anatomy is not fully taken into account. So, to get you started on a realistic eye, let's have a look at a line drawing of what an eye actually looks like (**Fig.01**).

Eyes come in different shapes and sizes, but the general shape will always be the same. The eyeball is called an eyeball for a reason, because it's a sphere, and the curve of it is visible even when we don't see the entire eyeball. In a side view of an eye it's even more apparent. Then there is the tear duct in the inner corner of the eye, and of course the eyelids – top and bottom. Omitting any of these things will make the eye look flat and quite simply wrong. To make things more

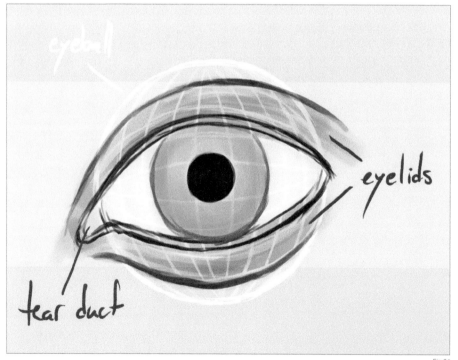

Fig.01

comprehensive, I'll show you how to paint an eye from two different perspectives – front and three-quarter view, as these are the most common ones for portraits.

Let's Paint!

To begin, open a new file and choose a skin color for your background – something in the mid-range, not too light or dark. We add a new layer and sketch the eye, remembering all those things mentioned earlier. Our light source will be on the right, so we can already add a reflection into the sketch (**Fig.02**).

First, let's give some shape to the surrounding area of the eye. I suggest you paint beneath the sketch layer, either directly on the background, or (more conveniently if painting an actual portrait) add another layer beneath the sketch layer. Choose a default round Paintbrush with the Opacity Jitter set to Pen Pressure, and pick an orange-brown tone for the shadows and a yellow beige for the highlights to start with the shading. Keep it light: let the background color work for you! We also want our brushstrokes to follow the natural curves of the eye socket and lids (**Fig.03**).

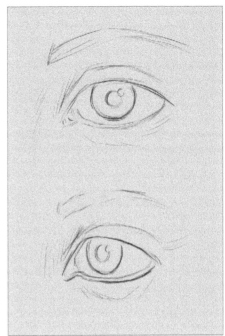

Fig.02

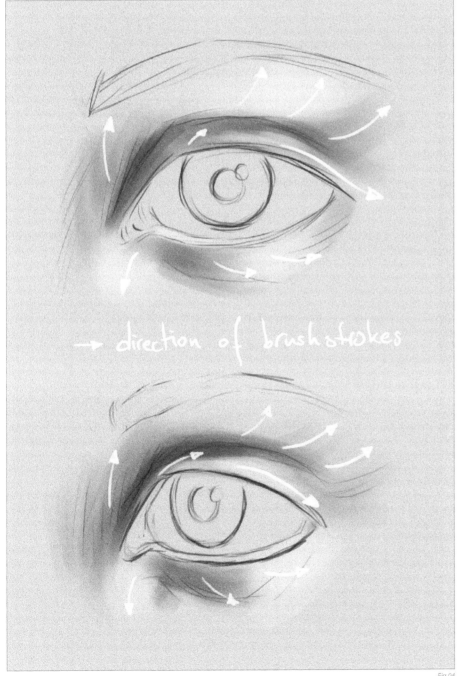

→ direction of brushstrokes

Fig.04

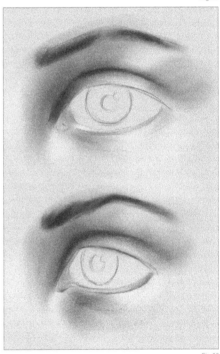

Fig.03

Continuing with the round brush, we refine and blend the shadows and highlights and we add some gray-purple and orange to the top lid for some variation, even though it may not be instantly noticeable. We can also hint at the eyebrows (**Fig04**). To smooth the brush strokes out a bit, I tend to use the Smudge tool set to Finger Painting, with a speckled brush tip set to Scatter and the Opacity Jitter set to Pen Pressure. Experiment with this; these are the settings that work best for me, but it may be different for you.

CHAPTER 05

To get a more solid idea of what the eye will look like, let's paint the white of the eye. A common mistake to make is painting the white in pure white. Remember that we have to take the curve of the eyeball into consideration, as well as the reflections of the light source. Using a grayish color works best, its lightness depending on the overall light of the painting. Mixing in a little of the surrounding skin tone (or color of lighting if appropriate) helps in making it look real. And for the tear duct, we can use a beige pink base (**Fig.05**).

Now let's add color to the iris. I choose a medium-to-dark color for this as a base, and then add a slightly lighter shade on top. This already gives the impression of a little depth. Now add the pupil. Note how in the three-quarter view it doesn't appear rounded, but slightly oval; this is due to the perspective (**Fig.06**). Don't forget the little bright dot of reflected light as this will help you in the next few stages of building up the detail of the iris!

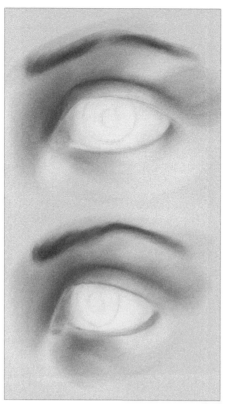

Fig.05

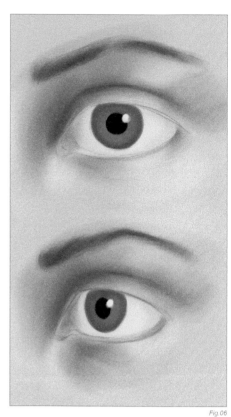

Fig.06

We already have a recognizable eye now, even though it's still quite rough and a lot of details are still missing. For now though, we want to refine the general shape of the eye and lend it some depth. Sticking with the round Paintbrush, I choose a rather saturated orange-brown for the deep shadows between the upper eyelid and brow. I also use this to add a light shadow to the upper lid's ridge, and on the inside of the bottom lid. The tear duct receives some nicely saturated orange, which is repeated ever so slightly in the outer corner of the eye. To enhance the highlights a bit, both very light beige and gray-green for parts of the lids work well. The shadows on the eyeball itself are worked over again, too (**Fig.07**).

From here on, it really is all about refining everything and adding details, working with the round Paintbrush at varying (manual) opacity settings and sizes. I always feel as though it's a bit like sculpting the features, rather than painting them; pulling them out of the canvas by adding deeper shadows and brighter highlights as I go along. So that's exactly what we'll do: deepen and refine the shadows. Adding a soft but substantial shadow to the upper lid's edge helps with getting an idea of what effect the eyelashes will have on the overall picture, and softens the edges of where the eyeball disappears under the lid (**Fig.08**). The iris's color is accentuated with a pale green, and intensified with a very lush, dark turquoise where the lid casts the shadow.

Sticking with the iris, pick a small brush – either the round Paintbrush or a speckled custom brush – and we can begin to paint the line pattern. Every eye has this pattern, but sometimes the color can be so dark that it's not truly visible. However, the lines that go from the pupil to the outer edge of the iris are always there. In this case, we want them nice and

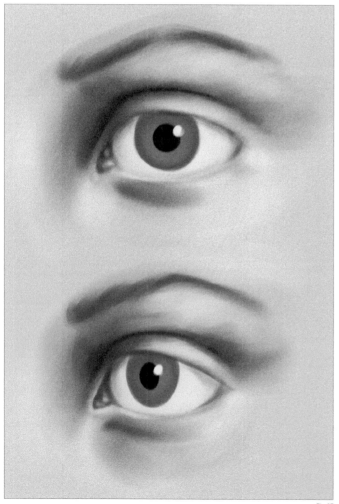

Fig.07

visible with some vivid color variations. We'll stick with the pale green and turquoise but choose lighter or darker shades of the same or a similar hue (**Fig.09**). Sit back sometimes and just look at what you've been painting as you may very well notice some parts that you want to touch up. Here, more highlights are added to the outer edge of the brow, the edge of the bottom eyelid and skin around the tear duct, and I can then start to hint at hairs of the eyebrows, too.

Selecting the Smudge tool (set to Finger Painting, as before) with a speckled brush tip, we carefully render the iris. Make sure you keep your smudge strokes going from pupil to iris edge: we don't want all the lines to disappear! Once that's done, we pick a very bright but almost desaturated pale green and go over the iris where the light hits it: on the right and a small area at the bottom left, where there would be a feint secondary reflection. To enhance the curve of the eyeball, we now pick an almost white-blue and work on the actual reflection in the eye. Notice how I paint it in an arch, going up and then back down again, extending across the side of the iris onto the eyeball. This aids in giving the illusion of a curved glossy surface (**Fig.10**).

Using a small round Paintbrush with Opacity and Size Jitter set to Pen Pressure, we can now paint in the eyebrow. Pick a nice deep brown, as well as a medium brown for this. Smudge the hairs ever so lightly. Pick color from the surrounding skin and use it to break up the brow a little.

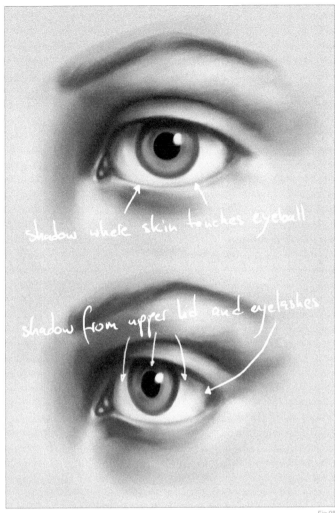

shadow where skin touches eyeball

shadow from upper lid and eyelashes

Fig 08

Accentuate the skin around it with some more highlights, especially on the outside where the light would hit the strongest. Once that is done it's time to think about the eyelashes. We'll add a new layer for them as it's easier to paint them that way without fear of ruining your eye. Choose a small round brush with Opacity and Size Jitter set to Pen Pressure, and start painting in the lashes with flicking motions. Unless caked in mascara and tortured with a lash curler, eyelashes don't usually curl upwards all that much (**Fig.11**).

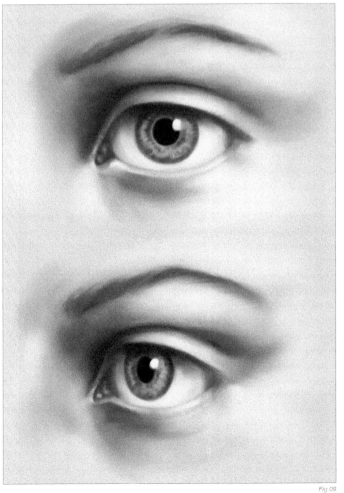

Fig. 09

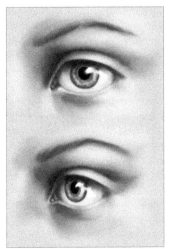

Fig. 10

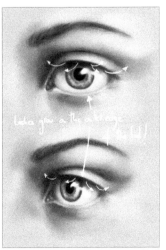

Fig. 11

CHAPTER 05

You can either keep painting on that one layer or add new layers for more layers of eyelashes, building up the density. You can also duplicate the layer your lashes are on and move it a little to either the left or right, and then reduce its Opacity and erase some parts of the lashes and smudge others. Once happy with the eyelashes, we gently smudge the ends

here and there (**Fig.12**). Adding a few dots of highlight in between the lashes on the lower lid gives a nice impression of glossiness.

The last step of every painting always consists of adding all those tiny details that make it "pop"; that make it look realistic even when it retains a painterly quality. Using separate

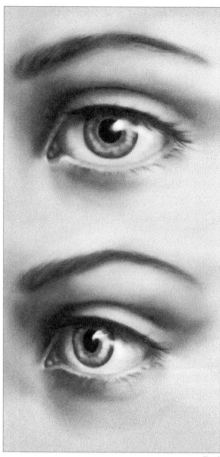

Fig.12

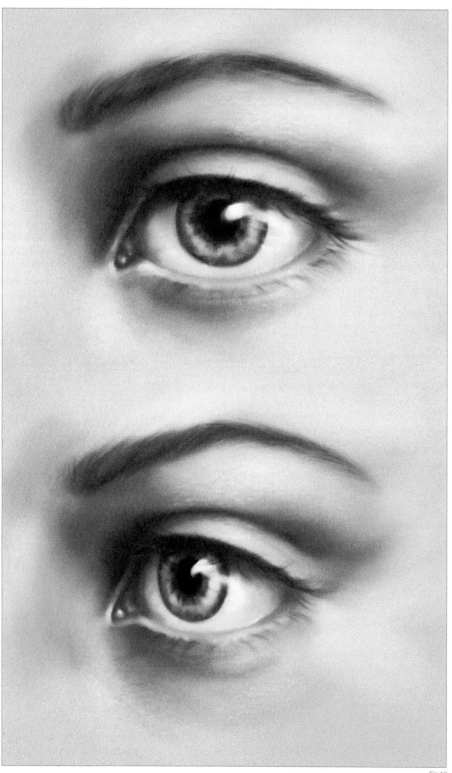

layers for these details is often a good idea as you can adjust and experiment with them to your liking, without ruining your painting. Before we do this though, we want to finalize the iris a bit more. Picking the darkest turquoise we draw a ring of lines extending from the pupil – some stronger and longer, some weaker and shorter. This instantly intensifies the green and the apparent glow of the eye. Now that is done, we add some more highlights to the eyeball with a custom speckled brush, and then smudge them lightly. Choosing a much finer speckled brush we set its Angle Jitter to 50% and carefully use it on the brow, both eyelids and in the corner of the eye with a very bright white-yellow. Do all this on a new layer. Smudge it slightly, but only so much as to take the edge off the obvious dots. You may also want to erase some parts of it to let it blend in better with the surrounding skin tone. Now duplicate that layer and set it to Overlay, and then nudge it a few pixels to either side to create a fine skin texture (**Fig.13**). All that is left now is to look your painting over, see if you want to add a few more lines on the lower lid or in the corner of the eye, or adjust any highlights or shadows – and that's it!

Fig.13

EARS – INTRODUCTION

Ears are funny things, or at least I think so when I look at them for a while! They appear intricate too, which is something often overlooked unless properly studied. And it is their deceivingly simple shape that causes the most problems. Again, let's check out what an ear actually looks like (**Fig.14**). Indeed, a simple shape! When painted though, people sometimes like to forget about everything besides the earlobe and the helix, and maybe even the tragus, which makes the resulting ear look kind of bizarre. Others just paint some random squiggles into the ear to resemble the antihelix, and that doesn't really work either. Without the little "bump" that is the antitragus, it looks slightly odd too. As before, I'll show how to paint an ear from both frontal and three-quarter view, and you'll be surprised that it really won't take long at all.

LET'S PAINT!

Open a new file and add a new layer for the sketch. I choose a medium gray-blue for the background color, rather than a skin tone, as it will make painting the front-view ear easier (in reality it wouldn't be surrounded by skin, either). Pick a small round brush, with the Opacity and Size Jitter set to Pen Pressure, and draw your line work. If you need references, don't hesitate to use them to get it right (**Fig.15**).

Let's block in some colors, sticking with the round Paintbrush. I tend to switch off the Size Jitter for this to get good coverage, whilst still keeping the benefits of the Pen Pressure Opacity. Pick a medium flesh tone

Fig.14

Fig.15

and use this as your base color for the ears. Once you've filled them in (remembering to paint beneath the sketch!), pick a red-brown color – not too saturated – and block-in the shadow areas, bearing your light source in mind (**Fig.16**). I've also hinted at the hairline a little.

When painting fair-colored skin, the ears tend to be slightly redder or pinker than the rest of the face due to the amount of blood vessels running through them. If light shines through them from behind, it becomes even more apparent. Bearing this in mind, I now choose a warm orange to refine the shadow areas, and a light pink to bring out the highlights (**Fig.17**).

Even at this stage, it's already pretty discernible as a realistic human ear. From this point on, it really is all about placing shadows and highlights in the right places, careful blending, and paying attention to the shape of the ear and the shapes that make up the ear. To blend the colors we've already laid down, we'll use the Smudge tool, as before, with a speckled brush tip set to Scatter and with the Opacity set to Pen Pressure. Refine the shadows and highlights a little and blend as needed (**Fig.18**).

Fig.16

Fig.17

Fig.18

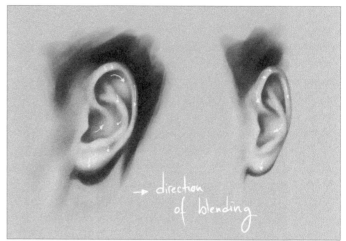

direction
of blending

Fig.19

Fig.20

Now is the time to clean up the edges of the front view ear a bit and also to fix a few things that in this case have nothing to do with the ear, namely the neck and hairline. We'll also work on blending the colors a bit more and smoothing out any rough brush strokes that may have been left over. Try blending with the contours of the ear's shape, rather than by random smudge strokes (**Fig.19**).

It already looks pretty good now, and there really isn't that much left to do, unless of course you want to paint every skin pore. As a matter of fact, ears tend to not get too much attention in most portraits, and even less so in full-body character paintings. Often they are just hinted at, as it is enough for our brain to recognize the correct shape of an ear to imagine the rest. In any case, we should now add some more pronounced highlights, as well as enhance the orange-peach tint of the skin, as it got a bit washed-out by all the blending. For the latter, add

another layer and very lightly paint over the areas that need it. You can adjust the Opacity of the layer, or erase wherever you do not want the peach color to be too strong, before merging the layers (**Fig.20**).

Now to the highlights – quite literally! Let's add another new layer, pick a very bright yellow and a soft round brush, and lightly paint over the areas where the light would hit (and reflect) the strongest. This will be mainly the antihelix, but also the lobe and antitragus, and maybe add a few scattered highlights on the helix, too. Set the layer to Overlay and adjust its Opacity until you cannot really see the brush strokes anymore – just a "glow". Merge the layers. You can add some skin texture if you like (as explained for the eye), but ears tend to not show it as much as the skin on a person's face, so it's not quite necessary (**Fig.21**). And you're done!

Fig.21

LIPS – INTRODUCTION

The lips are probably the second most important feature in a face, and not only because they can look so pretty. Whilst eyes make a quiet show of emotions, our lips are far more supple and capable of many more visible nuances of expression. Aside from that, lips are also the part of the human face that seems to have a reputation for being difficult to draw or paint, despite their rather simple appearance. This is mainly to do with the myriad of movements a mouth can make, and the movements of muscles that change the look of a face accordingly. But even a neutral expression can often seem to cause some problems, and the results can look quite wrong. Let's look at what a generic pair of lips actually look like (**Fig.22**). The common mistakes made are numerous, from pointed corners of the mouth to a straight line separating the lips, and harsh, exact lines and changes of color between lips and surrounding skin – something that only happens when you wear meticulously applied lipstick. Again, I'll be showing you this time how to paint lips from two different perspectives – front and three-quarter view.

LET'S PAINT!

Open a new file. Choose a medium flesh tone for the background. Add a new layer, and using the hard round Paintbrush with Opacity and Size Jitter set to Pen Pressure, sketch the lips (**Fig.23**). For the three-quarter view, you will have to think "3D" – the lips follow the predetermined shape of the skull while keeping their own curved shape, and often this is what causes problems.

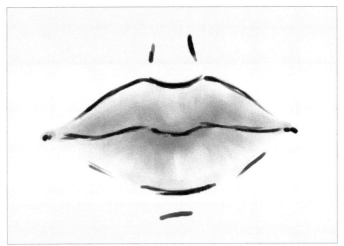
Fig 22

Fig 23

Fig 24a

Direction of brush strokes
Fig 24b

Now add a new layer underneath the sketch and stick with the round Paintbrush, though you may want to switch off the Size Jitter option. Pick a slightly lighter color than your flesh-toned background, and add a few highlights around the lips – this will help you to determine the light source and keep it steady. Use a slightly darker reddish tone for some carefully placed shadows. Then pick a brownish-red color and vaguely fill in the shape of the lips. Try and place your brush strokes to follow the curve of the lips, as this will add some instant volume (**Fig.24a – b**).

The basic form of the lips and surrounding tissue is laid down with this, and we'll start building on it. So choose a couple of slightly more saturated reddish-brown and pinkish colors and keep working on the lips, applying them more intensely where the upper and lower lips touch, and letting them fade out towards the "outline" of the lips (**Fig.25**). This is usually the point where I start reducing the Opacity and Flow of the brush manually, as well as keeping the Pen Pressure Opacity switched on. To smooth things out a little, you can blend the brush strokes by picking the Smudge tool, set to Finger Painting, with a speckled brush set to Scatter, and Strength to Pen Pressure. Don't smudge it too much though, as we still want some distinct lines on the lips, as these will aid us later with the texturing.

We keep working on the lips' volume at this stage, adding a variety of reds and pinks – all very close together, and all in the brown color range. Always make sure you work with the curve of the lips, be it when applying the colors, or when blending them. Gently blend the colors using the Smudge tool, as before (**Fig.26**). This is a good point to add some first hints of texture and definition. A round medium soft Paintbrush with Size Jitter set to Pen Pressure works perfectly for this, loosely adding lines and dots. Again, carefully blend certain areas while leaving focal points untouched (**Fig.27**).

From here on, it's all about shaping and details. In my case, I wasn't quite happy with the lips' shape, and altered it a little. It's easier to change things before adding lots of detail, so make sure you are happy with your work before you dive into the last phase. Using the same brushes as before, we soften as well as refine the lips. Pay attention to the fact that the "line" that separates upper and lower lip is not really a line, but a shadow. Therefore, soften it – enough to not make it look like an actual line, and not so much that it blends in with the rest (**Fig.28**).

Fig.25

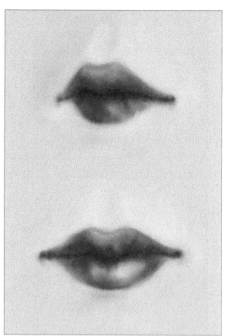

Fig.26

Fig.27

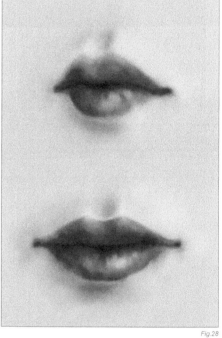

Fig.28

Fig.29

Now we come to the fun part – we're going to go a bit crazy with the brush! Select a small round brush, set the Size Jitter to Pen Pressure and switch off the Opacity Jitter. Add a new layer, pick a light color that works with your lips – in this case I used very light pink and very light yellow – and dot the brush around randomly. Don't worry about going over the edges of the lips; you can erase what you don't want later. Alternatively, you can choose a speckled brush and just stamp it over the lips a few times. Not as much fun, but this gives you the same result. Now set the layer to Overlay or Soft Light, and reduce the Opacity as much or little as you see fit. Erase those bits of the dots that you don't want, or lightly erase what you don't want to show too strongly. You can also smudge the dots a little, or apply the Median or Gaussian Blur filter. Repeat this procedure on more layers with both light and dark colors to get the best results. As a last step, pick one of the darker colors from the lips, and using a round Paintbrush with Opacity and Size Jitter set to Pen Pressure add a few more refining lines. Blend as needed, and ... there are you lips (**Fig.29**)!

NOSE – INTRODUCTION

The nose is inarguably the focal point of any face. When someone has a big or crooked nose, this is what we notice before we take in anything else (even if we don't want to admit it). Noses come in many shapes and sizes, and what is interesting about this is that their shape and size influences, and is influenced by, the shape of the rest of the facial features. Also, the shape and size of the underlying bone and cartilage (the bridge) dictates what size and shape the tip of the nose will be. Sounds complex? It's not, really. If you have a straight, wide nose bridge, you simply won't have a thin, pointed tip. If the bridge of your nose is high, you won't have a flat tip, unless the bridge is also severely crooked. The problems people seem to face when painting noses range from the angle of the nose in accordance with the rest of the face, to the general shape of one. Even some drawing books show noses as if they are comprised of lots of knobbly bits, making them look very bulbous. Since most of us seem to like straight and pretty noses, the general shape should be something like this (**Fig.30**).

LET'S PAINT!

Start as before with a clean canvas, and make the background color a neutral tone. Add a new layer, and draw your sketch using a small round Paintbrush, with Size and Opacity Jitter set to Pen Pressure. It is usually a bit easier drawing or painting noses when you have a

Fig. 30

Fig. 31

face to paint them into, so you can do just that if you like. I will, for the purpose of this tutorial, stick to a blank canvas (**Fig.31**).

Add another layer beneath the sketch layer, pick a medium skin tone and block in the nose using a round Paintbrush, with Size Jitter switched off, and the Opacity set to Pen Pressure. Then choose your shadow color and gently add it where you need it (**Fig.32**). It's always quite nice to use a somewhat saturated orange-brown for your shadows, as well as a muted purple, as the skin around the tip of the nose is usually slightly redder. Also, try to avoid black or very dark brown for your deep shadows, unless you are painting a very dark portrait, as it always looks slightly flat.

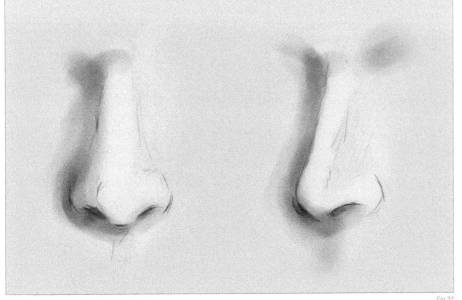

Fig. 32

Smooth your colors out using the Smudge tool, just as before set to Finger Painting, with a speckled brush tip and Strength Jitter set to Pen Pressure. Once you've done that, refine your general nose shape a little by adding more subtle shadows – the tones in the mid-range, meaning neither in full light nor in full shadow (**Fig.33a – b**). You'll be pleasantly surprised to find that if you were to remove your sketch layer now, you'd see a rather distinct nose already.

So from here on we shall refine the nose, working with what we've already got, using the standard round Paintbrush and the Smudge tool set to Finger Painting, as before. You can of course make alterations if you are not really happy with what you've done. You may want to start with refining the nostrils. Refrain from painting any sharp lines here; rather, make use of a softer Paintbrush and paint shadowy blobs. The same goes for the "outlines" of the nostril where it curves in on the surrounding skin. Blend these areas with care: you don't

Fig.33a

want sharp lines, but neither do you want everything to be completely smudged (**Fig.34**). Once you've got all that, choose a nice, light color and add the first proper highlights, namely on the tip of the nose and down the bridge, and some also around the nostril.

There is not much left to do now other than more refining. If you are going for a soft and dreamy kind of portrait, leaving everything slightly blurred with just a few focal parts is just fine. If you're going for something more photorealistic or graphical, bringing out the

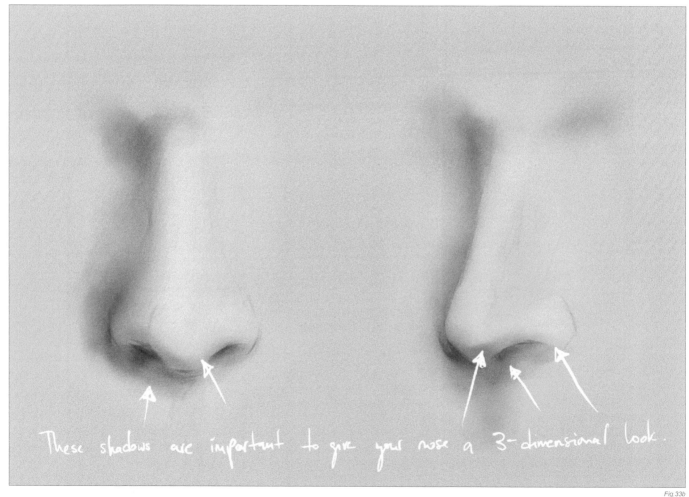

These shadows are important to give your nose a 3-dimensional look.

Fig.33b

Fig.34

Fig.35

features more works best. I am going to refine the nostrils a bit more, and add some more saturated shadows (**Fig.35**).

Your nose is done at this point. Now, if you wish, you can add some texture or freckles. For freckles, add a new layer, select a speckled brush, set it to Angle Jitter, and, choosing a light color, stamp it over the nose. Now set the layer to Overlay and reduce the Opacity as much or little as you like. Add another layer and repeat the stamping with a darker color, and preferably a different speckled brush. Again,

set it to Overlay or Soft Light, and reduce the Opacity as needed. You can repeat this as often as you like or want. You can do the same thing with a Texture brush to simply add some skin texture. And there you have your nose (**Fig.36**).

Now you're all set to start painting faces!

You can download a custom brush (ABR) file to accompany this tutorial from **www.focalpress.com/digitalartmasters**

Fig.36

CHAPTER 05

PAINTING THE HUMAN EYE
BY RICHARD TILBURY

SOFTWARE USED: PHOTOSHOP

In this tutorial we will be painting a human eye. The first thing to do is
to gather as many reference pictures as you can – including a mirror!
You will notice that all eyes are unique in both color and shape, and
that the skin will vary in every image. Lighting also plays a key role in
determining how reflective the lens looks, as well as the skin itself.

STEP 01

Once you have enough references at hand, start by deciding on a light
source and then putting down some very rough shapes and colors using
a standard Chalk brush. In **Fig.01** you can see that I have laid down a

Fig.01

basic template to build upon. I created the skin tones on a single layer
and then added the white of the eye (or sclera), the iris, and the pupil all
on separate layers. I added some Gaussian Blur to the three eye layers
to avoid any sharp lines. It is good practice to keep these layers intact for
now to ease the process of making any color alterations as we progress.

STEP 02

In **Fig.02a** I have added some provisional detail to the eye on the same
layer as the iris – just a few random squiggles that emanate outwards
from the pupil, as well as a darker outline. You can also use the Smudge
tool to soften the edge of the iris, as well as to destroy the perfect

Fig.02a

symmetry. I added an extra layer on which I painted in some more flesh tones to soften the image.

In **Fig.02b** you can see some of the darker paint strokes that define the eyelid, as well as some pinker shades that run around the sclera. There are also some lighter accents that help form the bottom lid. Try and vary the colors across your painting, whilst keeping them within a similar tonal range. You can select pale reds through to yellows, browns and even some cooler bluish tones. Remember that variety is the key to creating a convincing look!

Fig.02b

Fig.03

STEP 03

In **Fig.03** I have refined the corner of the eye where the eyeball curves inwards, and have softened the surrounding skin area. More crucially, I have added a new Shadows layer set to Multiply and painted in some gray/brown tones under the eyebrow and top of the eye itself, to help refine the form.

STEP 04

I then created a new layer to add in the eyelashes using a fine Airbrush, as seen in **Fig.04**. I also painted in some grayish tones under the upper lid to denote some shadows

Fig.04

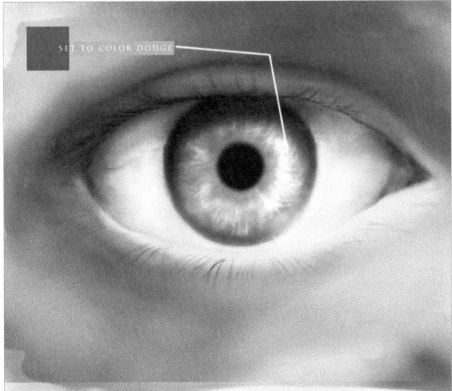

SET TO COLOR DODGE

Fig.05

which are also being cast across the top of the eye. You will notice that I have also used the Smudge tool to add an inconsistent edge to the iris, as well as painting in some small blood vessels and subtle pink tones towards the corners of the eye. One other layer has been added to inject some light into the eye. Here I have used a pale blue and green color and made some random shapes around the pupil, and then set the blending mode to Screen which helps bring it more to life.

STEP 05

To further enhance the eye I selected a dull green and on a new layer set to Color Dodge, painted a random shape covering most of the lower right side of the iris to create some highlights, as seen in **Fig.05**.

STEP 06

The one vital aspect still missing from the
image is a reflective highlight across the
cornea. This will add a necessary touch and
breathe life into the image. This is done using
a pure white on a new layer with the Opacity
turned down to around 80%. It is up to you
where you paint the highlight and the type
of shape you choose as it is very subjective
anyway. I have chosen a window shape using
some sharp lines to describe a framework, and
faded the edges somewhat (**Fig.06**). Reserve
a pure white only for a small section of the
highlight. I have also painted in some small
highlights in the corner of the eye and along
the bottom lid. At this stage it may be a good
idea to flatten the painting if you are happy with
things.

Fig.06

Fig.07a

Fig.07b

STEP 07

We are almost finished now, apart from some
subtle color overlays which will be used to
improve the skin tones. In **Fig.07a** you can
see that I have masked out the actual eye, and
then on a new layer applied a gradient across
the image from corner to corner using a pale
pink and yellow. I then repeated this process
but this time using a much grayer denomination
of the previous colors, as seen in **Fig.07b**. Set
the blending mode of both these layers to Soft
Light at 100% Opacity and see the results in
Fig.07c (compared with **Fig.06**). The tones are
now much warmer, and the shading softer.

STEP 08

One last thing which we can do is use a
Spatter brush with a little scattering to help
break up the skin tones and show some
highlights around the pores. You can either do
this on a new layer or paint onto the flattened
version. Select a Spatter brush and reduce
the size down to between 7 and 12 (**Fig.08a**),
and begin painting in lighter marks below the
bottom lid to create a textured surface. You
can also increase the scattering from within
the brushes palette to paint in some varied
tones which are just visible above the eye area
(**Fig.08b**).

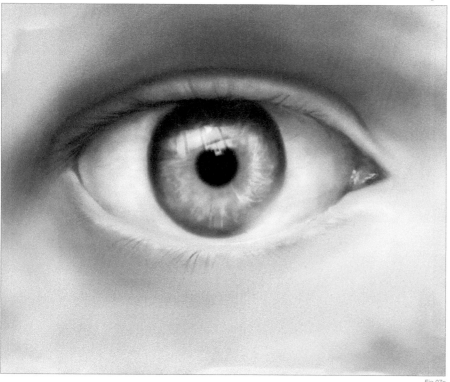

Fig.07c

I used a standard dry brush to begin with and combined this with the Dual Brush function and some scattering for this area (**Fig.08c**). To finish off the image I added one final

layer using a pinky purple color (171, 112, 126) set to Overlay, which just increases the redness around the eye to suggest the blood vessels beneath the surface. Then, using the

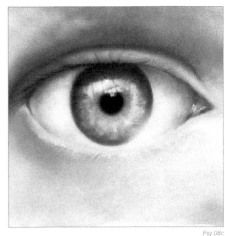

Fig.08c

circular Marquee tool with some feathering, I altered the color of the eye through Image > Adjustments > Hue/Saturation. I increased the Hue slider to create some brown around the pupil, and gave the eye a greener, gray color.

Fig.08a

Fig.08b

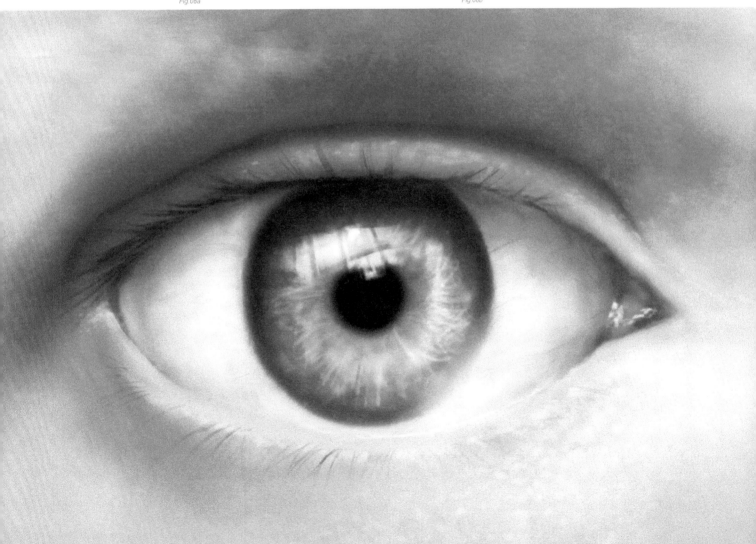

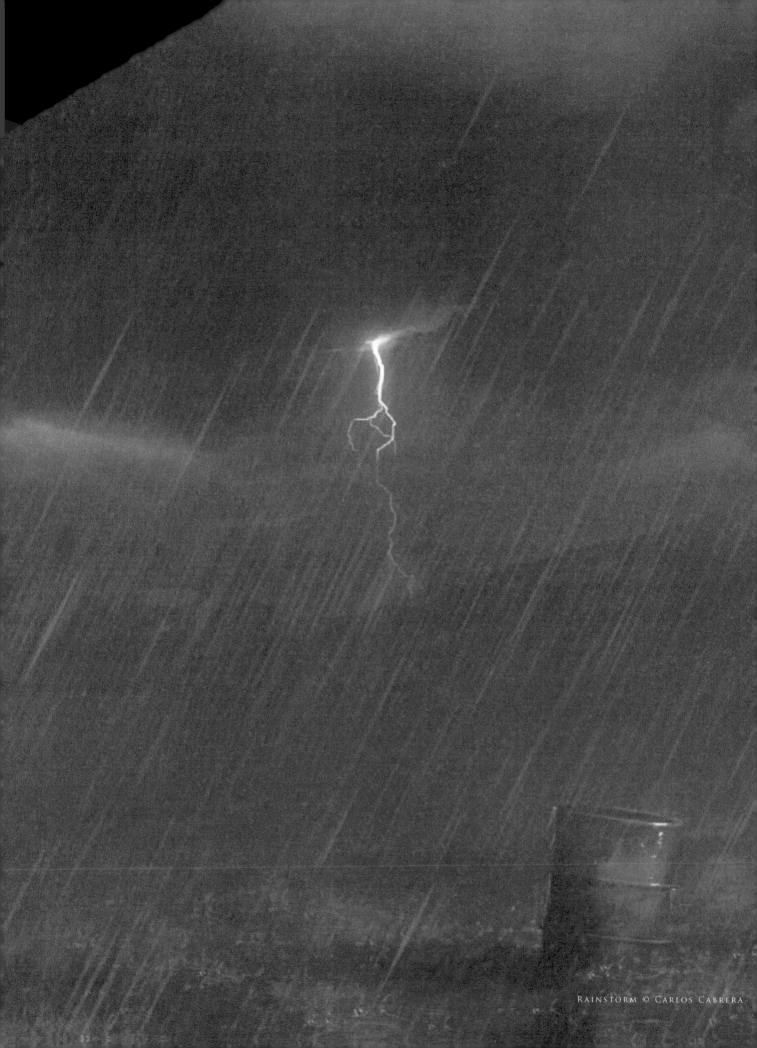

Rainstorm © Carlos Cabrera

environments

In today's world of ever-increased specialization, many artists have adopted roles specific to certain areas of expertise. One of these is an environment artist, and, as well as creating original designs, it often involves adjusting an established scene and creating variations. This chapter looks primarily at how a base image can be manipulated to reflect different weather conditions, and shows how the same scene can be transformed dramatically to convey a diverse range of moods.

SANDSTORM
BY CARLOS CABRERA
SOFTWARE USED: PHOTOSHOP

In this first of five tutorials, we will learn how to transform a basic given scene into the five different weather conditions. In this first tutorial we'll be tackling a sandstorm! This tutorial is perfect for anyone who is looking to create a sandstorm effect in any landscape painting (**Fig.00** – base image).

First of all, open the image you want the sandstorm to be added to, and then change the Color Balance of the entire image to something similar to the following settings: Shadows -2, +11, +18; Midtones +85, 0, -62; Highlights +23, 0, -4. With these settings you should achieve an orange atmosphere (**Fig.01**). Alright, now

Fig.00

you're ready to create a new layer and paint the shape of your sandstorm with a brown color (RGB 196, 147, 81). I decided to paint a triangular shape in order to increase the size of the effect over the other objects in the scene (**Fig.02**). Now go to Filter > Distort > Wave and apply a nice distortion to your shape. Pay close attention to this step; when you finish applying the Wave effect, press Shift + Ctrl + F (Fade), change the Opacity to 50%, and you

Fig.01

Fig.02

will see your last Wave effect duplicated with a nice opacity. Repeat this step three or four more times and you will create a perfect cloud shape. These effects have much better results if you change the parameters of the Wave filter before applying the Fade effect (Shift + Ctrl + F) (**Fig.03 – 04**).

Well, we now have a good cloud shape; the color is okay and the shape is perfect, but it needs more detail. You can now either search through your personal collection of

Fig.03

textures to find a good photographic image of a mammatus cloud, or you can search the internet for some good images. We need this photograph to add a realistic touch to our sandstorm shape. Select your chosen mammatus cloud photograph and search for a good shape within it. When you find what you're looking for, select it with the Lasso tool and paste it into a new layer. Change the layer's blend mode to Overlay and move your mammatus cloud into your sandstorm shape (**Fig.05**).

Fig.04

CHAPTER 06

As you can see, the pasted photograph looks good but we don't yet have the quality that we need. Remember that we are using this photograph only as a base from which to paint our own clouds. Now create another layer and change the blend mode of it to Overlay, and set it to 80% Opacity; select a gray color and start painting your own clouds. (**Note**: Don't use white in Overlay blend mode for the clouds because the white color will burn the image below, and we don't want a shiny cloud; we need a matte brown one.) So, paint the highlights using gray on your sandstorm cloud, and then – with black or a dark gray color – start painting in some shadows. Play around with the opacity of your brush to achieve some interesting shapes. **Tip:** If you use the numbers on your keyboard whilst painting then you can quickly and easily change the opacity of your brush – try it! This short cut is very helpful.

Let's now go back to our cloud to smooth the edges. For this you can either use the Smudge tool (R) or paint several strokes using a low opacity brush (I always use the latter technique). When you finish you should have an image such as **Fig.06**. It looks good but it

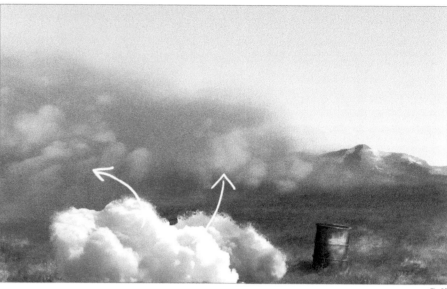

Fig.05

needs more light and shading work, don't you think? Check the bottom of the cloud: it doesn't have a great amount of shadows at the base, and so to fix this simply create a new layer in Multiply blend mode, and paint using a brown color at the base of your cloud. When done, change the Opacity of the layer to around 40%. Now create another layer in Overlay blend mode, and paint with a big soft brush at the bottom of the cloud. (**Note**: Remember not to

paint using a high opacity brush – always use 50% or less when painting clouds or smooth surfaces.)

The shadows are okay now, so let's start work on the highlights. Repeat the same procedure that we used for the shadows: create a new layer in Overlay mode and paint in the highlights using gray. Try to follow the direction of the clouds to create volume (**Fig.07**). The

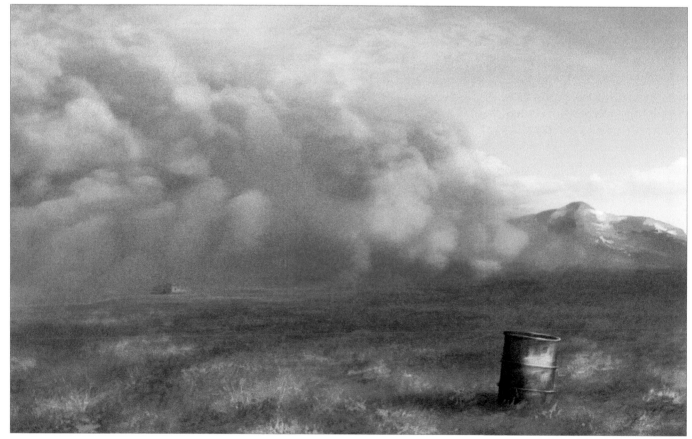

Fig.06

cloud is now perfect ... but where is the farm? We now need to show the farm again because it's an important object in this scene. Simply go to the background layer (the one that holds the base painting) and select the farm using the Lasso tool (it doesn't have to be a perfect selection). Press Ctrl + J to duplicate the selection you just made into a new layer, and move it over the top of the Cloud layer. Change the blend mode of this new farm layer to Luminosity, and move the Opacity slider to about 10% (**Fig.08**).

If you want, you can leave the painting at this stage, but if we go on to tweak the colors a little you will see just how much better it can look! To do this, create a new adjustment layer (from the black and white icon positioned at the bottom of the Layer window) and select Color Balance. Click on the Shadows option (Color Adjustment > Tone Balance) and move the sliders to Cyan -22, Green +12 and Blue +7. Then click on the Highlights button and move just the Yellow slider to -13. If you check

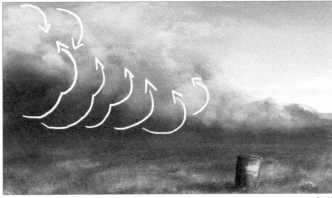
Fig.07

your image now, the shadow changes into a greenish-gray (**Fig.09**). This shadow color stands out the Sandstorm effect. You can then create another new adjustment layer and play with the Curves. I always use these last few steps to tweak my paintings, and it's also a good way to check if everything is okay or needs to be changed at the end.

The best way to learn Photoshop is simply to experiment with it. Try every tool, read tutorials and books – anything which will help you to learn this program. And practice; practice all the time!

You can download a custom brush (ABR) file to accompany this tutorial from **www.focalpress.com/digitalartmasters**, along with the base painting (JPG) that Carlos starts from so you can take greatest advantage of this tutorial.

Fig.08

Fig.09

© CARLOS CABRERA

© CARLOS CABRERA

TWISTER
BY CARLOS CABRERA
SOFTWARE USED: PHOTOSHOP

Are you prepared to transform a calm landscape base image into a scene featuring a dramatic twister? Okay, well let's begin!

If you don't have too much of an idea about what a particular scene looks like, then I always recommend you use the internet to find some photographs that can help you in your work. Years ago, artists needed to have hundreds of books in their studios to help them find good reference images for their works, but now, with the internet, we have the opportunity to instantly find the images that we are looking for. So, find some good reference images of what you need, and study the colors and atmosphere of them. You can learn a lot if you look at and study any images, not just

Fig.01

artists' works. You can learn lots of things from photographs, too.

Fig.00 shows the base image that I will use for this demonstration. So, let's see the first step in transforming the scene and adding a twister. First of all, we need to change the light of this image a little. Go to Image > Adjustments > Curves and make a curve, similar to the one you can see in **Fig.01**.

Fig.00

It's not a huge change of color, but this is just the first step. Now we have to work hard on the clouds. This may be both the hardest and most enjoyable part of the painting, as we have to create a cool twister mixed in with the clouds. For the dark color of the twister pick a dark blue color (RGB 93, 117, 130), and for the brighter area of the twister select a sky blue color (RGB 137, 163, 179). With these two colors we are going to create a cool-looking twister...

DARK COLOR

LIGHT COLOR

SMOOTH

Fig.02

Fig.03

To create the effect of the clouds and twister, I use a custom brush. First, I will show you how you can paint clouds easily using this brush. The first thing we need is a base color, so let's use the dark blue color that we picked before, and paint an irregular cloud shape. This brush has the pressure Opacity turned on, so you can create some nice and interesting effects with it. The next step is adding light to this cloud shape, so pick the light color and paint on the area of the cloud where the light hits. Use the pressure of your pen to smooth between the dark and bright area of the cloud (**Fig.02**).

A simple way to smooth two colors is using a brush with a low opacity, so let's try using 30% or 40% for this image. Pick the brighter color and paint over the darker color with a low opacity. Then select the Eyedropper tool (press the Alt key) and pick this freshly mixed color. Continue doing this a couple of times and you'll see how the edges of your cloud begin to smooth, without the help of the Smudge tool.

Fig.03 shows the path of my brush strokes when creating these cloud formations. It's easy, don't you think? Try doing a couple of extra

clouds in a new document before you continue with the twister.

Ready? Okay, so now let's paint the twister ... With the dark color (RGB 93, 117, 130), paint the twister's body and mix it in with the clouds. Spend some time painting and smoothing the clouds as this is the most important part of this illustration, so do your best here. Now, with the light color (RGB: 137, 163, 179), paint the edge of the twister's body. With this last step you are going to separate the twister from the background. Pick an earth color and paint the

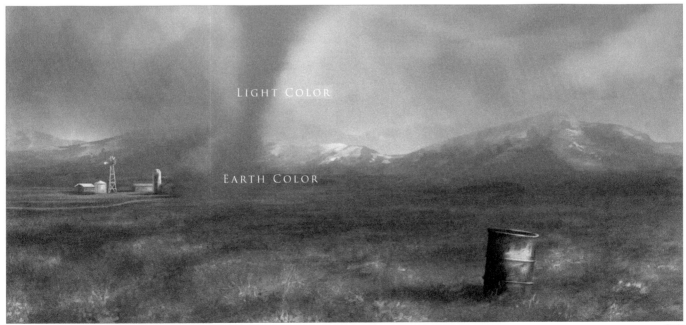

LIGHT COLOR

EARTH COLOR

Fig.04

base of the twister with this color. Try to paint something like what you can see in **Fig.04**.

We now have to darken the sky, so pick a green color (RGB 121, 166, 151) and paint on a new layer using the Gradient tool (Foreground to Transparent) from top to bottom. Change the properties of the layer to Multiply and change the Opacity to 91%. This will change the sky to a green/gray color (**Fig.05**), although it's still much too bright at this stage.

Now create another layer and change the properties to Color Burn. We need the Opacity to be lowered here, too, so change it to around 80%. Again, select the Gradient tool and paint

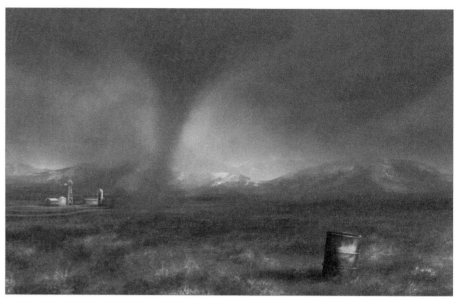

Fig.05

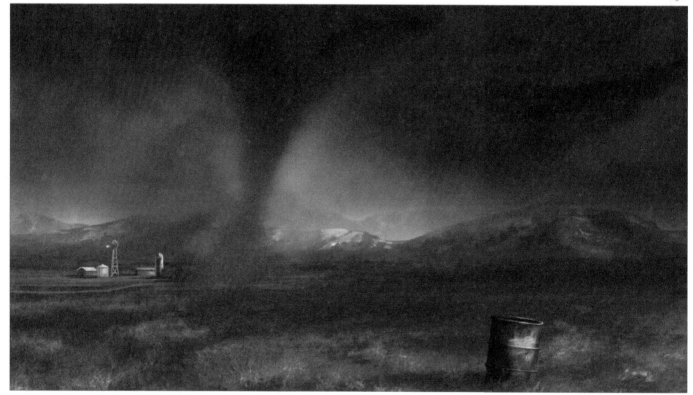

Fig.06

Fig.07

over the clouds with this green/gray color (RGB 164, 178, 170). Now it is dark; you can see just how dramatically the image has changed from this adjustment (**Fig.06**).

It's now time to destroy the farm. Create a new layer and paint – using a hard round brush – the trash, earth and wood that will be flying around the base of the twister. This is a fun part, so spend some time putting the details in here (**Fig.07**). You can paint cows flying around the tornado too if you like – or maybe even a farmer?

The farm is ready and the tornado looks scary now, but we still need to add the Wind effect to the entire scene. Create another layer and paint

some random dots on it – any place is okay. We will transform these dots into a foreground of flying trash. Pick any bright color from the image to paint these dots, and when you've finished go to Filters > Motion Blur and apply these settings: Angle 8; Distance 40 pixels (**Fig.08**).

We are almost finished with this image at this stage. Let's now create the last layer. This layer is very important, so take your time on it. I'm going to show you what I did but it's not a technique as such, just a final tweak of the image. You can continue modifying the image until you personally feel that the illustration is finished. Remember that only you know when a painting is finished! Some artists flip the entire image to see errors; others zoom in and out of the image to see and feel what is wrong. Try to find your own way. So in this last layer we'll change the properties to Overlay (Opacity 52%) and paint with browns, greens and yellows over

Fig.08

the image, in order to enhance the different areas. In **Fig.09** you can see the layer without the Overlay properties. Compare this with the final image (**Fig.10**).

And this is the end of the tutorial. Try to apply these steps to any image you create, and learn to feel comfortable with what you do.

You can download a custom brush (ABR) file to accompany this tutorial from **www.focalpress.com/digitalartmasters**, along with the base painting (JPG) that Carlos starts from so you can take greatest advantage of this tutorial.

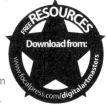

FREE RESOURCES
Download from:
www.focalpress.com/digitalartmasters

Fig.09

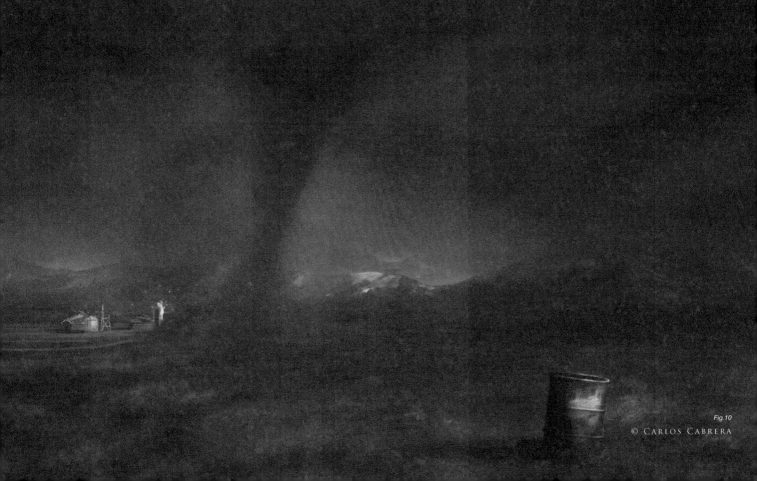

Fig.10

© CARLOS CABRERA

© CARLOS CABRERA

RAINSTORM
BY CARLOS CABRERA

SOFTWARE USED: PHOTOSHOP

The first thing we need to do is to grab reference images (I always use Google Images to search) in order to understand how the colors change in different weather conditions. Remember that we are only using the reference photographs as a color guide for our painting. In this tutorial I will show you the steps that I followed in order to transform a base illustration into a stormy scene, but it is essential that you also practice and create your own techniques, too.

Our first step is to change the ambient color of the entire scene. Let's pick a gray/brown color

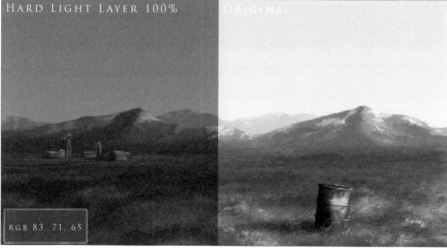

Fig.01

(RGB 83, 71, 65); this color is going to give us the stormy, ambient color that we are looking for. Create a new layer (Hard Light 100%) and fill it with our ambient color. Do you see how it changes with only one color (**Fig.01**)? And this is only the first step! Let's continue.

Now we need some clouds. In this step, if you have a cool cloud picture to hand then you can use that. If you don't have one that you can use, simply do a search for some interesting cloud images, or take some of your own photographs. Create a new layer (Overlay 100%) and paste your cloud picture onto it. Or, if you're feeling confident, then try doing it like me and paint your own clouds! Remember that we must only paint with this gray color on this layer because we don't want to dramatically change the brown ambient color (**Fig.02**).

Fig.02

Create another new layer (Normal 100%) now in order to add some fog to the mountains in the distance. In a storm scene such as this then fog is really important. The image still looks too bright for a stormy day, so let's darken it a little more. Create another new layer (Overlay 100%), select a Gradient tool (Foreground to Transparent) and paint the layer with a dark color (RGB 59, 56, 53). Now it's looking like a stormy day (**Fig.03**), don't you think? We need to add more fog in the distance now, so select a soft round brush (Size 300; Opacity 50%) and paint on the horizon line (**Fig.04**).

Fig.03

Now it's time to add the rain. To paint the rain I created a simple custom brush. Select a bright rain color (RGB 100, 97, 96) and paint over the entire scene using your Rain brush, trying to put more rain on the horizon line (**Fig.05**). In a new layer we are now going to add a Wet effect to the trash can in the foreground. With just a few white strokes in the area where the light hits the trash can, and a simple reflection/backlight on the back of it, we will achieve a nice wet-look effect (**Fig.06**). To increase the wet/rain effect we have to add water splashes, too. I created another simple brush for this effect, as well (this brush doesn't have any special configurations). So, select the brush, create another new layer and paint in the little rain splashes around the trash can.

Fig.04

Fig.05

CHAPTER 06

HIGHLIGHTS

REFLECTIONS/BACKLIGHT

Fig.06

SELECT THE FARM AND THE TRASH CAN

Fig.07

We still need to add the reflection from the farm and the trash can over our wet floor. This step is very important so pay attention here. Create a new layer and merge the visible layers (Shift + Ctrl + Alt + E). Now you have all the painting in one unique layer, but you can still see that other layers are there, too. Select the farm and the trash can with the Lasso tool, (Ctrl + J), and we will automatically obtain a copy of our selection in a new layer (**Fig.07**). Now go to Edit > Transform > Flip Vertical, move the duplicates below the original farm and trash can, and erase the edges with a soft round brush. You should obtain a similar result to what can be seen in **Fig.08**. To increase the

Fig.08

SMOOTH

IRREGULAR SHAPE

reflection, change the layer properties to Overlay; this will create the Reflection effect on the floor.

Let's now add our lightning to this storm scene. First of all, we have to darken the top of our painting a little more, because the lightning needs some contrast. Create another new layer, pick a darker color (RGB 65, 61, 59) and paint again using the Gradient tool over this new layer. Change the properties of the layer to Overlay and reduce the Opacity to 50%. Now we can easily paint a couple of highlights over this dark sky. To create the lightning in this storm you'll have to paint an irregular shape in a bright color; you can then smooth the top of the lightning, as if it is coming from inside the clouds (**Fig.09**). Create another new layer (Normal) and add the first lightning glow (yes, we will add another one in just a couple of minutes) with a soft round brush. To increase the Light effect, add a reflection to the base of the clouds. Create an Overlay layer and paint the second glow Effect with white over the lightning. You can see the difference of some lightning with a glow and without in **Fig.10**.

Fig.09

And for the final step we are going to add a technique that I always use to add texture to a painting and increase the shadows. Create a new layer and merge all the visible layers again. Do you remember how to do this? Simply press Shift + Ctrl + Alt + E. Now we have the entire scene merged, go to Image > Adjustments > Threshold and play with it until you obtain a result similar to **Fig.11**. Do you see how it looks as an old ink drawing? Well this technique is a good one to use in order to check whether your painting has good light and shadow work. Now select this new black and white layer and change its layer properties to Multiply. We have to reduce the Opacity to 5% in this particular case, but remember that if you use this technique then the maximum Opacity is something like 15%, because you don't want to cover all of your cool paintings.

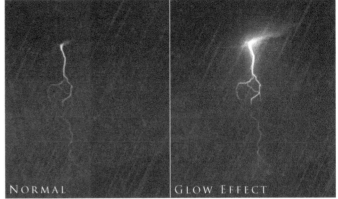

NORMAL GLOW EFFECT

Fig.10

Fig.11

Well I think we can now say that this image is finished (**Fig.12**). I hope this tutorial has helped you to try some of these steps or techniques in your images. Practice every day and force yourself to speed up your skills, because in this business speed and quality are very important!

You can download a custom brush (ABR) file to accompany this tutorial from **www.focalpress.com/digitalartmasters**, along with the base painting (JPG) that Carlos starts from so you can take greatest advantage of this tutorial.

Fig.12

© CARLOS CABRERA

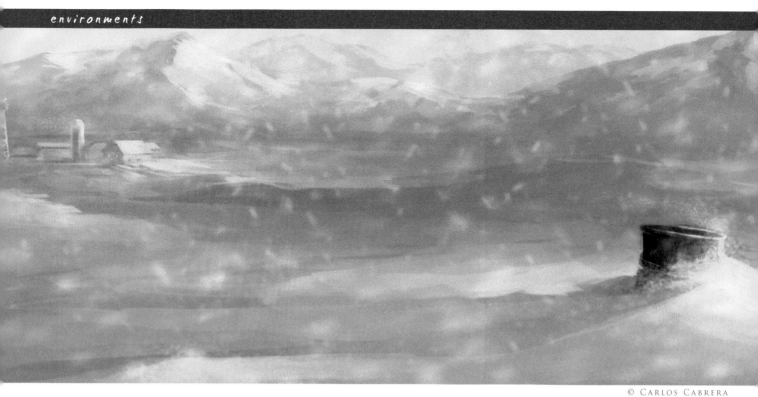

© CARLOS CABRERA

SNOWSTORM
BY CARLOS CABRERA

SOFTWARE USED: PHOTOSHOP

In this tutorial I will show you how to create
a snowstorm from the first to the last stroke.
We need some specific steps to transform
this painting (**Fig.00**); one of these steps is
to add the snow – a lot of it! The next step
is to change the Color Balance to blue, and
finally add some fog. You can follow these
steps or you can create your own, unique way.
Please use this method only as a guide or
for reference, rather than a rigid way of doing
things.

Fig.00

Fig.01

Create a new layer and start painting the snow.
Use a blue/gray color for the snow. I used
these colors: RGB 84, 112, 126 for shadows
and RGB 113, 140, 157 for the highlights.
Please try your own palette – you can even use
a photograph of some snow for reference, if
you like. Paint – with fast strokes – the shape
of the snow and cover all the grass that you
see in the picture (**Fig.01**). This is a quick step,
so don't waste too much time on it – we will
add more details later on.

Change the Brightness and Contrast of the whole image. I used these settings: Brightness +16, Contrast -48 (**Fig.02**). Can you see how the atmosphere in the whole image changed with just a few color tweaks? Well this is just the beginning. The next step is to change the atmospheric color to blue. To do this, create a new layer and fill it with this color: RGB 161, 173, 197. Change the layer's properties to Color 100% and check your new atmospheric color.

Now let's smooth the snow a little bit, on the ground. Create another layer and start painting with a soft round brush at 50% Opacity. Try to use the Eyedropper tool a lot – this is very important – and please do

Fig.02

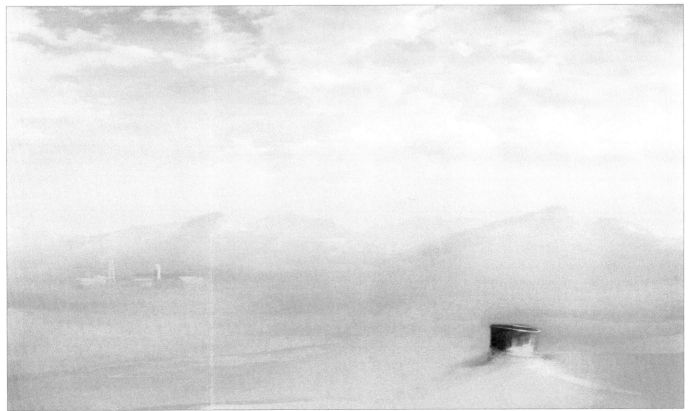

Fig.03

not use the Smudge tool in this case. Create another layer and paint the fog on the horizon, with a brighter blue color. Use a soft round brush at 30% Opacity for this (**Fig.03**). Let's put more fog in the sky now. On another layer (Normal layer, 82% Opacity), paint with this blue color (RGB 127, 184, 208) and try to merge the mountains with the sky. The new atmosphere looks very good, don't you think? With a good brush, you can now paint some more detailed snow. You should spend a lot of time on this step because we need a good-looking snow environment!

On another new layer, paint the clouds using shades of gray, and change the properties of this layer to Overlay at 85% Opacity (**Fig.04**).

Fig.04

CHAPTER 06

FOREGROUND TO TRANSPARENT GRADIENT

Fig.05

You can use a photograph for the clouds, but remember that the photograph must be grayscale, because we don't want to change the blue/gray color of our own sky. But now we have a problem … The sky is too bright to be a stormy sky. So let's fix this really quickly. Create another layer and fill it with a gradient. Use the color RGB 81, 91, 103, and change the layer's Opacity to 48%. Don't fill the whole image with the gradient, just the upper middle section (**Fig.05**).

Now is the time to add some snowflakes. Create a new layer and fill it with black paint. Paint random dots onto it in a gray color (RGB 128, 128, 128). You can paint the snowflakes one by one, you can make a custom brush, or you can duplicate the layer (Ctrl + J) and change the Opacity to simulate distant snowflakes. When you paint the dots use different sizes of brushes, too (**Fig.06**). And pay attention! Change the properties of the layer to Color Dodge and find a good opacity level – I used 78% Opacity, but see what is better for your own painting. You can see how the black is gone now, with the Color Dodge property, and the white is now there. Well, those white dots are our snowflakes. But they

still need some adjustments. The snowflakes need Motion Blur, so go to Filter > Motion Blur and set these parameters: Angle 20, Distance 25 pixels, and then add a Gaussian Blur (3%), too. To increment the Snowflake effect, you can duplicate the layer and transform it a couple of times and obtain an image such as **Fig.07**.

Now it's time to add some little tweaks and the image is then done. We need to draw more

attention to the trash can in the foreground, and the farm in the background. To do this, create another layer (Overlay, Opacity 77%) and fill it again with the Gradient tool and the color RGB 58, 60, 66, from the top right corner to the left corner. Now, on another layer, paint the windows from the farm in orange. Add another layer with Soft Light properties, and set the Opacity to 68%. Play with this last layer to change the amount of light coming from

Fig.06

the windows. In this final step you can add whatever you want – use your imagination.

For the final layer I painted, using a soft round brush, some more fog onto the horizon, and the final color tweak was a Curves adjustment. So, open the Curves pop-up menu (Ctrl + M) and enter these settings: Input 172, Output 120 (**Fig.08**). If you want to, you can paint more snow on the trash can and maybe add some more snowflakes to the scene. Use all of

Fig.07

Fig.08

your skills in this final step and add more details. When you feel that the image is done, save it and upload it to your portfolio! You can see how I added more snow detail on the ground and mountains in the final image (**Fig.09**); I did this with several low opacity strokes in the dark area of the snow.

You can download a custom brush (ABR) file to accompany this tutorial from **www.focalpress.com/digitalartmasters**, along with the base painting (JPG) that Carlos starts from so you can take greatest advantage of this tutorial.

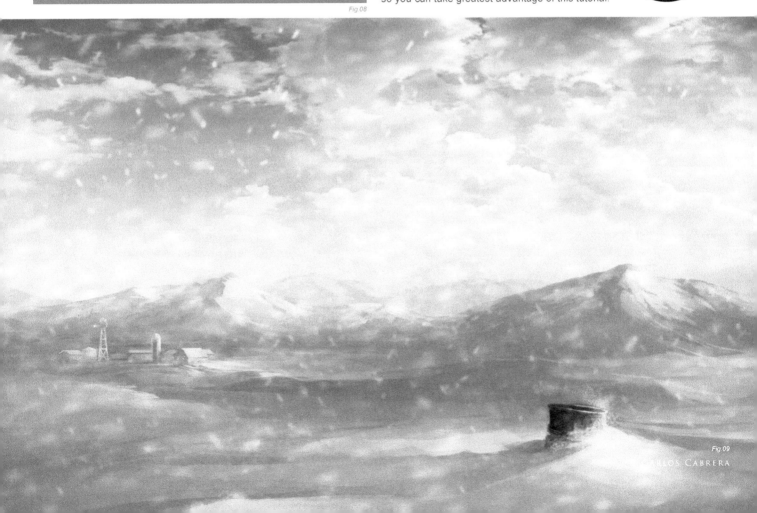

Fig.09

CARLOS CABRERA

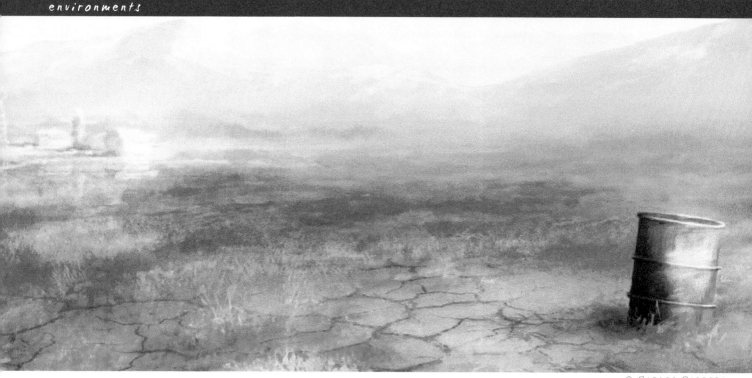

© Carlos Cabrera

Heat Waves
By Carlos Cabrera

Software Used: Photoshop

Before we begin painting we need more information about the subject. In this case we have to transform this image (**Fig.00**) into a warm desert. The first thing you have to do is find all the material you can get from internet about the subject: images, photographs, references, and so on. From this material, check the type of color schemes that usually have a desert-like, warm environment. If you check one of your reference images you will see that the colors are usually warm orange hues in this type of environment. One of the perfect examples of this kind of weather would be a photo from Africa, where you would see how the horizon line disappears because of the hot weather, and you'll find that the heat waves distort distant objects. Well, this is exactly the weather effect we need, so let's begin.

Open your base painting and check if you have something to modify. This particular base image is perfect for this brief: the grass is short, the sky is clean, and the solitary trash can in the foreground is ideal for this subject. The first thing we have to do is change the color scheme of the entire image to orange. Go to the little round icon in the bottom of your Layer window; create a new adjustment layer, then

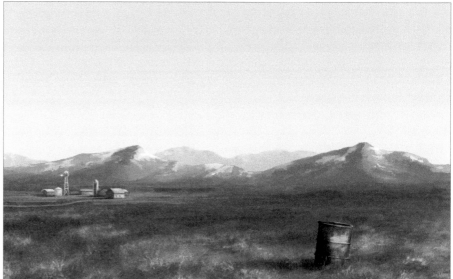

Fig.00

select Color Balance. Adjustment layers can be used for making many types of adjustments to your work, without actually doing anything to the original layer. This is perfect if you have to do modifications to your final image, so remember that these kinds of layers allow you to make non-destructive corrections to your images. For example, if you create a Curves adjustment layer, you can go back to the Curves dialog box later and change the settings at any time.

In the Color Balance dialog box, select Shadows and move the Cyan value sliders to -23, the Yellow values to -10, and leave the Magenta and Green values at zero. Now go to Midtones and move the value sliders to Red +9, Green +3 and Yellow -70. Now we have the shadows and midtones finished, so it's time to change the highlights. Click on Highlights and move the value sliders to Red +100, Yellow -44, and leave the Magenta and Green values at zero. What do you think (**Fig.01**)?

The image is orange now, but it doesn't look like a desert, so we'll have to desaturate the image a little. Let's create another adjustment layer. Go to the little black and white round icon and select Levels. Into the three Level boxes input the values: 0, 1.62 and 244. The image looks really good now (**Fig.02**).

Now it's time to add a simple sky. You can find one of these on the internet, or – even better – create one yourself. I painted this sky using the default Photoshop round brush with a low opacity (something like 30%). I painted the sky on the right-hand side because I felt that the image was going to be too heavy on the left side. When you paint the sky in a new layer, change the blend mode to Hard Light and move it below the adjustment layers. This step is very important because the sky must have the same color balance as the image (**Fig.03**).

Fig.01

We've finished with the sky and the color scheme of this scene now, so it's time to change the ground a little. Create a new layer and move it below the sky and the adjustment layers; select the default round brush and paint a cracked, dry earth near the trash can. If you prefer, paste a texture instead of paint, but remember to change the blend mode of this layer to Pin Light or Hard Light, with low opacity (**Fig.04**).

Fig 02

Fig.03

Fig.04

Now we are going to create a heat reflection on the horizon, so go to Image > Duplicate and click on Duplicate Merged Layers Only. In this new merged image, select the Lasso tool and draw a selection over the farm, as you can see in the next image (**Fig.05**). Press Ctrl + C to copy the selected image and paste

it (Ctrl + V) onto your original painting. Now, on this new farm layer, go to Edit > Transform > Flip Vertical, and position it as a reflection of the original farm. With the Eraser tool (E), erase – with a soft round brush – the contours of this flipped farm. If you change the blend mode of this layer to Overlay you can see how

the reflection looks more real. We've almost finished the painting now, so let's move on to the final step.

In this last step we're going to use the mask mode to do a smooth selection. So press the Quick Mask mode icon in the tools palette (or

Fig.05

Fig.06

press Q on your keyboard), select the Gradient tool and select a Foreground to Transparent gradient. Change the gradient from Linear gradient to Reflected gradient and paint – with black – the horizon line, as you can see in **Fig06**. Now go back to Standard mode again (Q). Create a new layer and press Shift + Ctrl + Alt + E and merge all the visible layers in this new clean layer. You still have the selection from your Quick Mask mode, so press Delete and erase the selection.

Why do we make all this mess? Well, it's because we have to create the heat weaves. Rename this layer "heat waves", then go to Filter > Distort > Wave and select a good value for your heat weaves. When you've finished it, you'll have an image like **Fig.07a – b**. And viola – we're done!

You can download a custom brush (ABR) file to accompany this tutorial from **www.focalpress. com/digitalartmasters**, along with the base painting (JPG) that Carlos starts from so you can take greatest advantage of this tutorial.

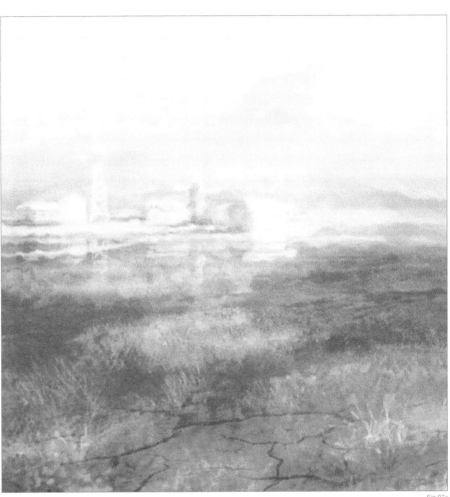
Fig 07a

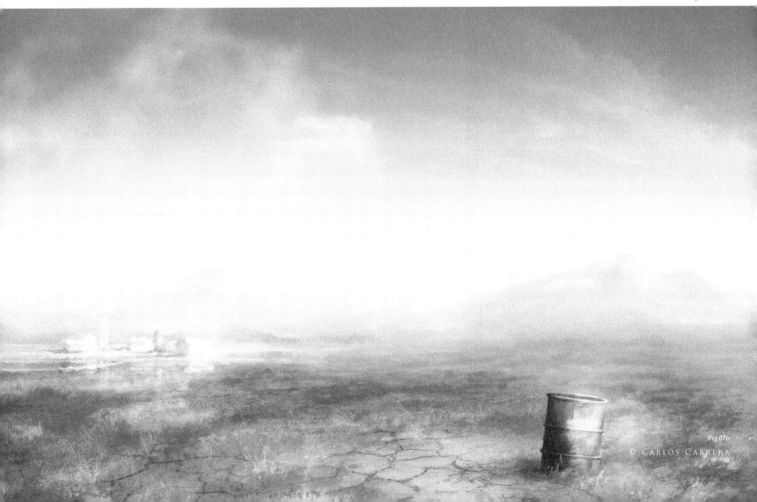
Fig 07b

© CARLOS CARRERA

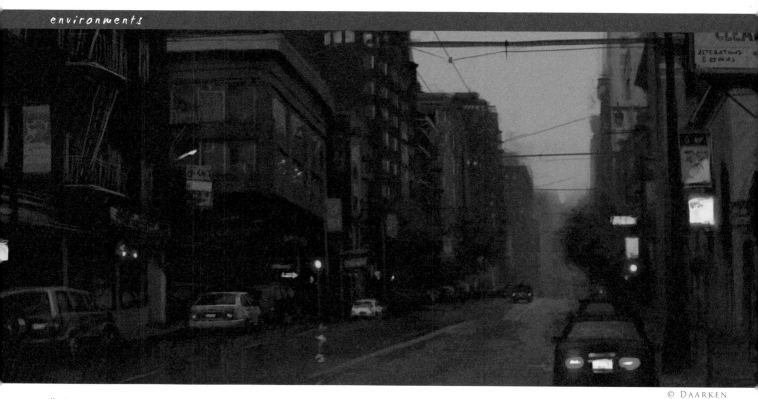

"ANOTHER RAINY DAY": PAINTING A CITYSCAPE
BY DAARKEN

SOFTWARE USED: PHOTOSHOP

CONCEPT

In this tutorial I will be showing you how to paint a rainy day scene without having to paint any weather effects, but rather the feeling will be conveyed purely based around color, mood, and some reflections on the street. I took the reference photograph for this image myself, a long time ago (**Fig.00**). It is a good idea to always shoot your own reference material, because that way you don't have to worry about any copyright issues, especially if you want to sell your painting. When you are taking your reference, be sure not to use the flash. Using the flash will destroy any kind of lighting scheme you wanted and will also wash out the subject.

Fig.00

THE BLOCK-IN

For the most part of this tutorial I will just be using two different brushes for this painting; a round brush and a rectangular brush. When I am painting from reference material I open the reference and place it next to my canvas (**Fig.01**). This way I can always look over at the reference while I am painting. I start out by painting in the color of the sky, and then block in the main silhouettes of the buildings in a dark color, but not pure black. Right now I am using the natural, rectangular brush. I like using

Fig.01

Fig.02

Fig.03

this brush because it is very versatile in the fact that you can get soft shapes as well as hard edges. You can also rotate the brush to get brush strokes in different directions.

After I have all the main shapes in place I need to put in the base color of the buildings (**Fig.02 – 03**). Using the same brush I paint the buildings in the background with less pressure, as opposed to the buildings in the foreground. Usually things further away are softer, and things closer are sharper. Even when I know a building isn't going to be dark in color, I will still block in the silhouette as a dark color because that way I can get some of the dark color to show through (**Fig.04**). This will give the surface some more texture and depth; otherwise it will look too flat.

I continue to work all around the canvas and try not to focus on any one particular element (**Fig.05**). This will allow me to get a greater

Fig.04

Fig.05

feel for the image as a whole and not to worry about spending too much time on something, only to have it be out of place or in the wrong perspective.

ADDING THE DETAIL

One of the really cool elements in painting a cityscape is the lights. The red tail lights of the cars act as a directional element that lead the viewer's eye throughout the piece. Adding lights will also give your illustration a livelier feel to it, almost as if it were alive itself (**Fig.06 – 07**).

The brush I used to simulate rain droplets on the rear window of the car is a type of speckled brush (**Fig.08**) (I also use this brush a lot when I am painting facial hair on men). The red tail lights look okay right now, but I really wanted them to feel like they were glowing. An easy

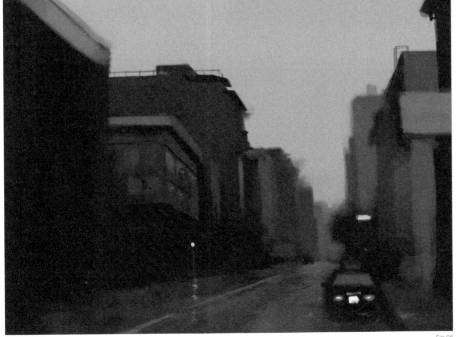
Fig.06

CHAPTER 06

way to do this is the use the Color Dodge setting on the brush (**Fig.09**). Do not use the actual Dodge tool because this will desaturate and wash out your painting, but instead use the Brush tool, and from the drop down menu select Color Dodge. Using this setting will preserve color in your painting and will make it glow. I usually pick a darker color than what I want, because otherwise you will risk over-exposing your image. In order for this to work you will need to use this brush on a layer that has your entire illustration on one layer. If you are working in layers just hit the Ctrl + A hot keys to select the entire canvas, and then again hit Ctrl + Shift + C to copy all layers. Now just hit Ctrl + V to paste the illustration into a new layer. Now you can use the Color Dodge brush on this layer.

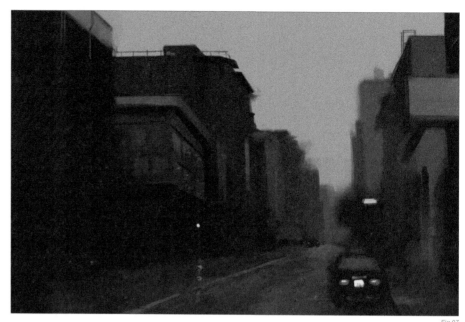

Fig.07

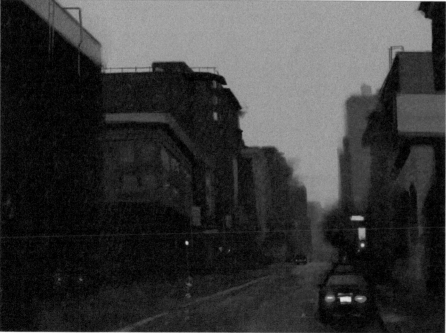

Fig.08

Fig.09

Fig.11

The other brush that I used a lot in this illustration was just a Photoshop default, round brush, with the Opacity set to Pressure. Using this brush will give me some harder edges than the rectangular brush I used for blocking in the main shapes (**Fig10 – 12**). Edge control is a very important aspect of a painting, and can

Fig.10

cause an illustration to either succeed or fail. Most of the time I use the hard round brush for when I am painting elements such as railings, poles, and wires. I try not to use the Shift key for drawing straight lines, but instead I just do them freehand. Doing this will give more life to your painting and it won't look so mechanical. Some of the lines look pretty straight, but that is only because I will keep redrawing the same line over and over until I am satisfied with the way it looks. Remember that the Ctrl + Z (Undo) hot keys are your friends.

For many of the colors I have been picking color directly from the photo, simply because it saves a lot of time. I would actually advise against doing this because it doesn't require any thought. In time you will start to lose the

Fig.12

Fig.13

Fig.14

Fig.15

understanding of color and you will not be able to identify which color is which. You will begin to catch yourself thinking, "Is that color more blue or yellow?" It is good practice to look at a color in a photo and try to pick the color yourself just by looking at it. Also, picking colors from a photo is generally bad practice simply because colors in photos are usually not very accurate, and can be washed out or dull. But anyway, I am being bad and color-picking here.

I wanted some more color harmony in my piece, so I decided to change the Color Balance of the illustration (**Fig.13**). An easy way to do this without actually changing your painting is by clicking on the half-black, half-white circle at the bottom of your layers palette; doing this will open up a window in which you can choose different options to change. I chose Color Balance. The Color Balance

CHAPTER 06

Fig.16

Fig.17

dialog box will open, and it is here that you
can change your colors. I pulled the sliders
towards more Yellow, Magenta, and Cyan. You
can also change the tonal balance by selecting
Shadows, Midtones, and Highlights. It is fun to
play around with these different settings.

THE FINAL TOUCHES

All that is left now is to add in some of the final
details to the buildings, like the windows, signs,
and railings (**Fig.14 – 17**). I am also adding
in the rest of the cars on the left-hand side.
These steps only take a few minutes because
I am painting pretty loosely. One of the things I
always battle with is how refined I should make
an illustration. For this painting I wanted a more

Fig.18

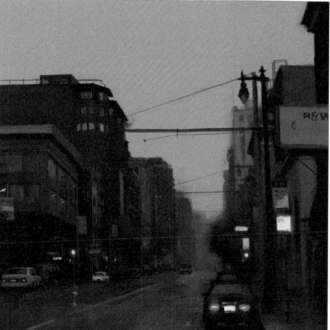

Fig.19

painterly feel, and not something that looked too photorealistic. You can
see from the detailed shot that the cars are pretty loose, especially the
ones that are further away from the viewer (**Fig.18**). Even when I am
painting something this small I still paint zoomed out to about 25%. This
allows me to keep things looser, and I can also judge what it will look like
zoomed out at the same time.

I think the hardest thing that I battled with in this illustration was the sign
on the right (**Fig.19 – 21**). Adding lettering to any illustration is tricky,
because people like to read things in paintings, and often they take a lot

Fig. 20

of focus away from the rest of the piece. I didn't want the sign to be too much of a focal point, and I had been avoiding finishing the rest of the text. In the end I finished the text, but I tried to keep the value range between the letters and the background fairly similar so as to not call too much attention to it (**Fig.22**).

Fig 21

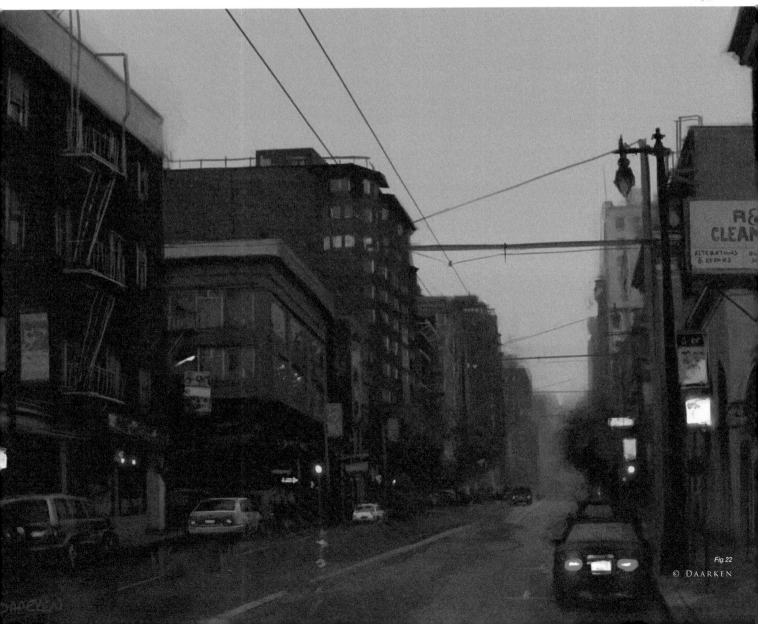

Fig.22

© DAARKEN

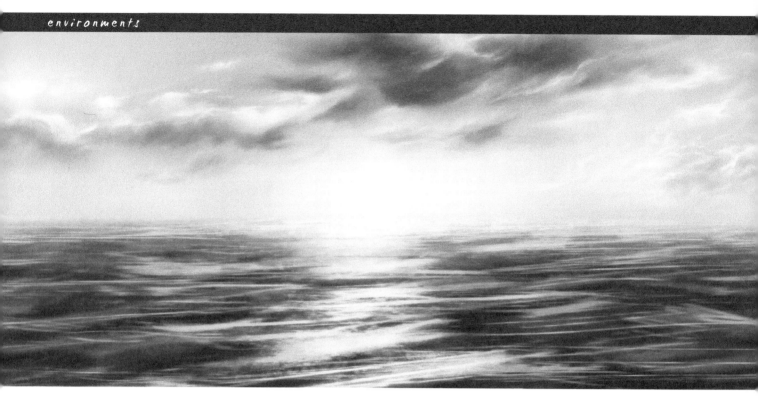

PAINTING A WATER SURFACE/WAVES
BY RICHARD TILBURY

SOFTWARE USED: PHOTOSHOP

During this tutorial I will try to outline one way to go about painting water that is representative of a calm sea. Now, this is a subject that varies greatly and is dependent on so many factors that it is almost impossible to lay down strict rules and guidelines. Water by nature is highly fluid and transformable, and therefore does not have a particular form to it. It is both transparent and at the same time very reflective, and so is always at the mercy of its environment and surroundings in the way it is perceived by the human eye. It is also affected by light, weather conditions and gravity, and so can appear in an infinite number of ways. A

waterfall or fast flowing rapids look white and opaque compared with a still pool for example, and the color of the ocean always reflects the sky above it. Therefore the way we go about painting water is always reliant upon a number of issues and aspects in our scene, and all of these must be considered before we begin. As I have already mentioned, this particular tutorial concerns a relatively calm sea and so the only real issue to be mindful of is the sky. If we were to include land masses or trees, for example, then these elements would undoubtedly have a bearing on our painting.

STEP 01

So the first thing to do is block in our horizon line and color of the sea. I have decided to start with a dull gray blue, but this can easily be changed later on. On the background layer fill in the whole picture with a white, and then, using the Rectangular Marquee tool, create a selection area at the base of the image. Then go to Select > Feather, enter about 10 pixels and fill in with a blue color, as seen in **Fig.01a – b**. With this done, select the entire image and go to Filter > Blur > Gaussian Blur and enter around 6.7 pixels. This will sufficiently soften our horizon line and lessen the transition

Fig.01a

Fig.01b

between the sky and sea (**Fig.01c**). This of course is not always how we perceive the horizon – sometimes it is very crisp, but for the purposes of the tutorial we shall create a bit of atmospheric perspective.

STEP 02

With the two colors blocked in the next thing to do is start to create the reflections across the surface, which will define the motion of the water. I decided to make a reasonably calm

Fig.01c

Fig.02a

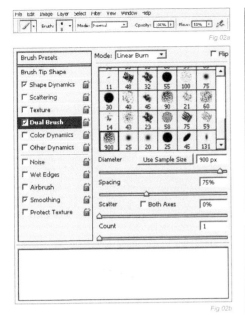

Fig.02b

Fig.02c

Fig.02d

Fig.03a

sea without too much turbulence, but enough
to create a pattern. For this I started with a
standard soft round Airbrush, and under the
Brushes tab added a sample tip as a Dual
Brush with settings similar those shown in
Fig.02a – b. I then created random strokes
across the blue on a separate layer using a
variety of brush diameters and using a pure
white (**Fig.02c**). I then set the layer Opacity to
50% (**Fig.02d**).

STEP 03

The next stage involves creating a new layer
and doing exactly the same thing, except
creating marks in different areas (**Fig.03a**). Set
the blending mode of this layer to Pin Light and
turn the Opacity down to around 70% – you
can see the two layers combined in **Fig.03b**.

STEP 04

In this exercise I am going to have a setting
sun in the center of the image, just above
the horizon line, and so will need stronger

Fig.03b

Fig.04

reflections at this point. So again, on a new
layer, using the same process as before, add
in some extra highlights below the position that
the sun will occupy, as seen in **Fig.04**. You
will notice that my marks are quite rough, but
do not be worried about that at this stage as
we are far from finished. When you are happy
with the layer, set the blending mode to Linear
Dodge and leave it at full Opacity.

STEP 05

Make a copy of this layer and then add a Gaussian Blur, similar to the amount seen in **Fig.05**. Keep this layer set to Linear Dodge.

STEP 06

So far I have only used one brush to paint the highlights, but to give the water a shimmering

Fig.05

Fig.06a

Fig.06b

quality I will need to use a different brush – in this case a standard Chalk brush (**Fig.06a**). This will break up the edges of the light reflecting on the surface and help create the impression of a sun low on the horizon. Concentrate the brush marks near the horizon where perspective reduces the visibility of the waves, as seen in **Fig.06b**. You will also notice that I have added in a simple sky to help contextualize the water and show how the two are codependent.

STEP 07

Using the Chalk brush I have added some marks across the water, but concentrating around the central section of the image on two separate layers, similar to the way I made the initial highlights. I then blurred both layers slightly to soften the effect, and the result can be seen in **Fig.07**.

STEP 08

There is no need to really add too much more detail on the water now. We have reached a stage where we have enough information to interpret the brush marks but have not labored over them too much. The overall image remains very blue and suggests an almost early afternoon light, but as the sun is low in the sky it seems as though an Overlay would help imply an evening light. The first thing to do is select

Fig.07

Fig.08

a dull pink with an RGB value of 146, 134, 136, and fill a new layer entirely. Then set the layer mode to Lighten and erase areas near the base of the image and across the clouds (**Fig.08**). This will produce the subtle impression that more light is bouncing off the water in the mid-distance from a low sun, which will help the sense of perspective. On the left of Fig.08 you can see the line where the layer has been added, compared with the right side which is as it was after the previous step.

Fig.09

STEP 09

We are now going to add a warmer Overlay across our sky and the lighter areas of the water. We can limit the areas we apply the color to by going to Select > Color Range, and using the eyedropper to select the highlights. Once done, feather the selection by no more

than 2 pixels, and again, on a new layer, fill in with an orange yellow and set the blending mode to Color at around 25% Opacity. In **Fig.09** you can again see the before and after effects of this, and how the yellow has been limited to the lighter areas.

STEP 10

Last of all we are going to add one more Overlay to the water only, so that the sun is the brightest area in the picture. Choose a pale orange and fill in an area across the whole of the water, and then set the blending mode to Multiply at around 20% Opacity. In **Fig.10** you can see how this looks before we change the blending mode, and how it looks afterwards. On this layer I have erased some of the color across the sky so there are some cooler blue tones remaining, in order to avoid too much uniformity.

That about concludes this tutorial; as always refinements could be made but hopefully it will prove useful to many people wishing to paint seascapes. The final image can be seen in **Fig.11**.

Fig.10

Fig.11

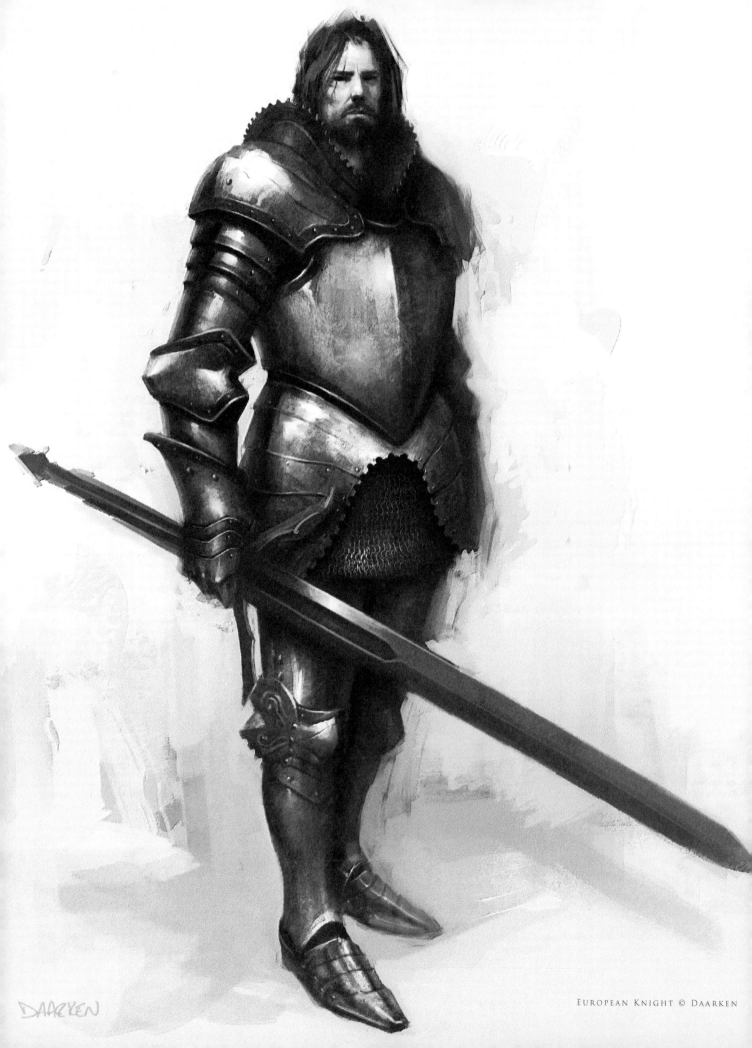

sci-fi & fantasy

These subjects are two of the most popular themes explored by modern digital artists today, and together form a large proportion of popular artwork adorning desktops around the globe. More than any subjects, these two allow an expansive base for creative freedom, and thus have attracted and inspired many artists who have become well respected within this field. Over the next few pages we take a look at how three very different artists approach varying subjects and exploit their tools to good effect. Ranging from the ancient through to the futuristic, we see how each has been inspired by this genre to produce imaginative pieces.

 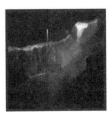

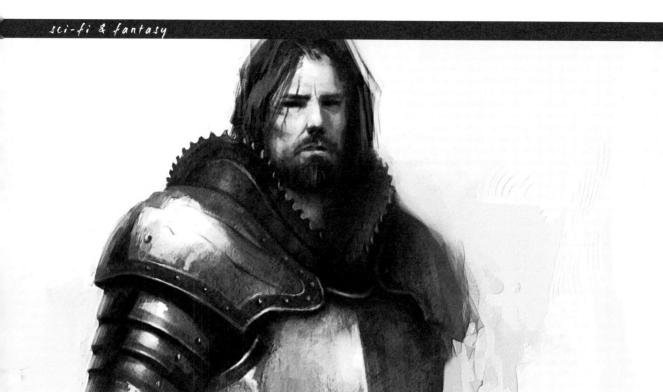

© Daarken

Painting Armor: European Knight
By Daarken

Software Used: Photoshop and Painter

Gather Information

The first thing I usually do when I get a project is to collect all of the reference material that I am going to need. Most of the time you can find everything you need by just Googling it. For this project I gathered some images from different museum websites. It is a good idea to start building up a large reference folder on your computer so that the next time you need some armor references you will already

Fig.03

Fig.01

have them. Now that we have our reference material, we can start the illustration.

Get Ready

This painting is going to be done primarily in Photoshop CS2, with a little bit of Painter IX at the end. If you want to try out my CS2 brushes (available for free download from **www. focalpress.com/digitalartmasters**) simply

Fig.02

click on the Brush tool, and then right-click on the canvas. Your Brush menu should now open. In the top right corner is a small triangle button – click on it and go to Load Brushes, then select the file that you have downloaded. As for what size of a file you should work in, I always paint at 300 dpi and usually around 3000 pixels wide. This artwork is 2404 by 2905 pixels.

THE BLOCK-IN

Start by blocking in the main shapes of the figure (**Fig.01**). At this point you are just trying to get the basic shapes of the figure, so don't worry about the details just yet. Next, lay in the basic color and shapes for the face (**Fig.02**). I felt the need for some more colors in the background, so I added some yellows to the ground and brought them up behind the character, and also onto his legs (**Fig.03**).

ADD DETAIL

Usually I block in more of the armor shapes before I work more on the head, but this time I am going to finish up the head first so that I can focus more on the armor (**Fig.04a**). I want this guy to be a rough and tough knight, not just another big brute but one that is proud and charismatic. Another way to make someone look more heroic is to elongate their proportions. Usually I make them around 8 – 9 heads tall. Now that I have the head down, I can start blocking in the armor. I wasn't really sure what the armor was going to look like, so I just started throwing down paint (**Fig.04b**). The shape I put down for the pauldron didn't really make any sense, so I start cutting away pieces and trying to give it some more form and function (**Fig.04c**).

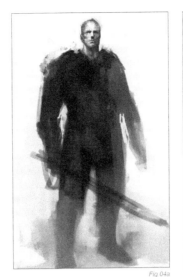
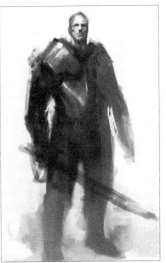
Fig.04a
Fig.04b

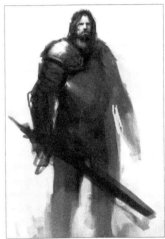
Fig.04c
Fig.04d

One thing you always need to be aware of when designing a character is whether or not they could actually function. It's nice to make them look cool, but a lot of the time, especially in the gaming industry, the character will need to be able to animate. This is where your references come in handy. Study how real armor is put together and try to figure out why it was designed a certain way and how it works. I felt like the character was leaning too much, so I rotated him a little counter-clockwise, and gave him hair and a beard (**Fig.04d**).

There are many ways to paint in the highlights, one of which is to use the Color Dodge tool (**Fig.05a – b**). I know people always say avoid

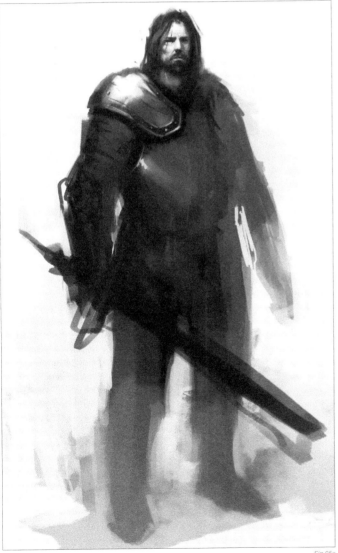
Fig.05a

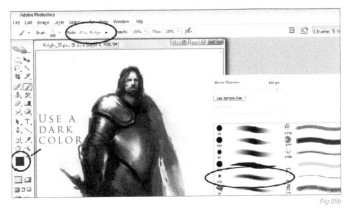
Fig.05b

using Color Dodge, but when used correctly it is a great tool. First you need to pick a dark color. If you pick a light color you will overexpose the illustration very quickly. Next, click on the Brush tool and go up to the Mode pull down and select Color Dodge. You can use any brush you like, but I find it easier to use a soft brush. Sometimes the area you paint will become very saturated, so just go back in with the desaturate brush.

For the plates on the arm, I first paint in the curved shadows that they create (**Fig.06a – b**). Then I put in some specular highlights, the core shadow, reflected light, and a highlight to the rim of the plates (**Fig.06c**).

A lot of people ask me how to get textures in their paintings (**Fig.07**). Most of the time I just paint my textures in manually with my brushes, but sometimes I will overlay a texture from a photo. For this particular piece, I found a texture by Barontieri (**http://www.barontieri.com**) which works really well. The easy way to add texture to a painting is to take the texture, copy and paste it onto your illustration, and set the layer property to Overlay. You can then knock down the opacity to whatever looks good. In this case I lowered the Opacity to 45%.

I wasn't really feeling that his pose was fitting with what I had in mind, so I changed around his stance to a more confident pose (**Fig.08 – 09**).

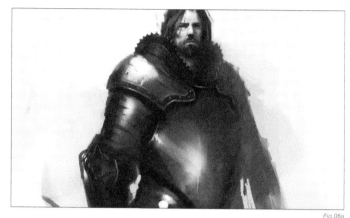
Fig.06a

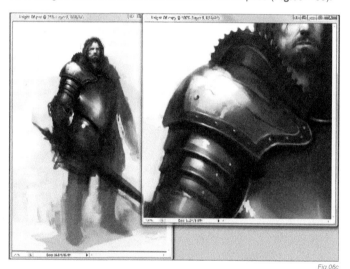
Fig.06b

Fig.07

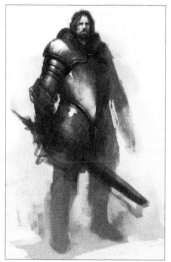
Fig.08

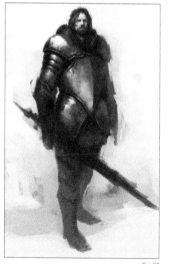
Fig.09

Fig.06c

Again, whenever you are painting something, be sure to remember that there are several parts to describing form, such as the core shadow, reflected light, and the highlights (**Fig.10**).

Another really cool part of armor to paint is chain mail. Painting chain mail is really easy and looks cool when you are zoomed out. This time

I decided to make a Chain Mail brush for the purpose of this tutorial. Open a new document and draw a few "C" shapes. Make that into a brush and go to the brush controls. Click the box next to Shape Dynamics and under Angle Jitter set the control to Direction. Doing this will cause the C-shapes to follow the direction of your brush. Also click the box next to Other Dynamics so that you can have opacity control with your stylus. First lay down one row of chain mail by painting from left to right, then you can paint the next row simply by painting from right to left. The reason we can do this is because we set the Angle Jitter to Direction, allowing us to paint the C-shapes in both directions without having to rotate the brush. This will let you get the basic idea down. Now go back in and pop in some highlights and darken the edges (**Fig.11 – 13**).

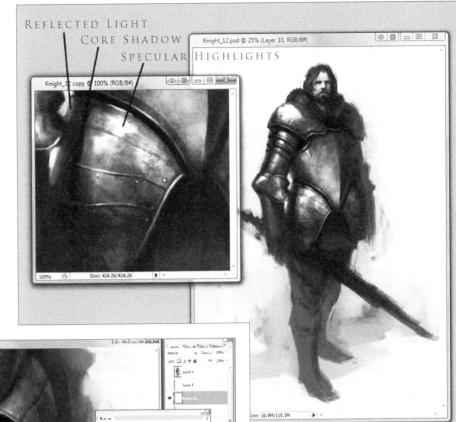

REFLECTED LIGHT
CORE SHADOW
SPECULAR HIGHLIGHTS

Fig.10

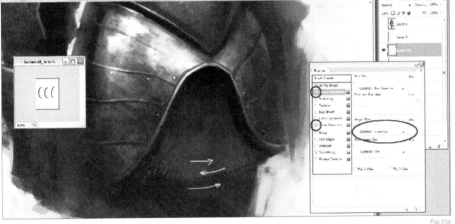

Fig.11a

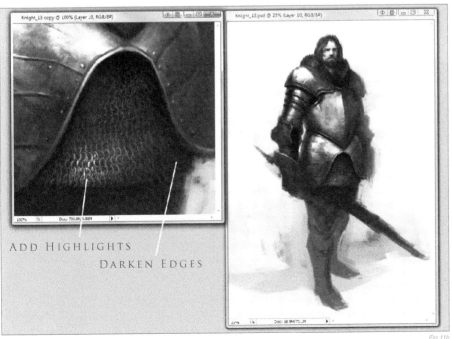

ADD HIGHLIGHTS
DARKEN EDGES

Fig.11b

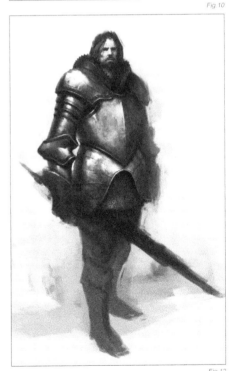

Fig.12

The armor on the arm is going to be handled the same way I handled the chest armor. First paint in the basic color, then add in the shadows and highlights (**Fig.14a**). After that I drop in a Texture Overlay layer (**Fig.14b**). On

CHAPTER 07

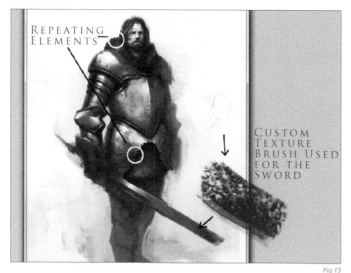

Fig.13

Fig.14a

Fig.14b

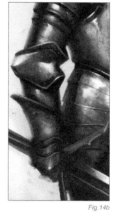
Fig.14c

top of that I use the Color Dodge brush to pop in some more highlights (**Fig.14c**). Go through the same process on the legs as we have used with the arms (**Fig.15a – f**).

It is a good idea to occasionally take breaks from your painting so that when you come back to it you can see mistakes you have made more easily (**Fig.16**). You should also regularly flip the image horizontally to see any flaws. I felt like his head needed to be a little bit bigger, so I enlarged that and changed his left arm as well (**Fig.17**).

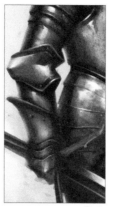
Fig.15a

Fig.15b

Fig.15c

Fig.16

Fig.17

Fig.15d

Fig.15e

Fig.15f

Fig.18

FINAL TOUCHES

Now I am going to move to Painter IX to add in some final textures (**Fig.18**). Open the image. It is better to add the texture to another layer so that you can erase out parts you don't want. To do this you will need to make a copy of your illustration. Select the entire canvas (Ctrl + A) and then, with the Move tool selected, hold down Alt and then left-click. This will create a duplicate layer. Now go to Effects > Surface Control > Apply Surface Texture. A dialog box appears with the different settings. Change the Using drop down to Image Luminance (**Fig.19**). Now go down and make sure that Shine is set to 0% Adjust the Amount to an amount that looks good to you, and then click OK. Finally, just erase out the parts that you do not want, flatten the image, and you are done (**Fig.20**).

You can download a custom brush (ABR) file to accompany this tutorial from **www.focalpress.com/digitalartmasters**

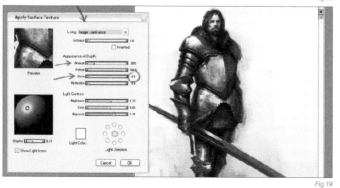
Fig.19

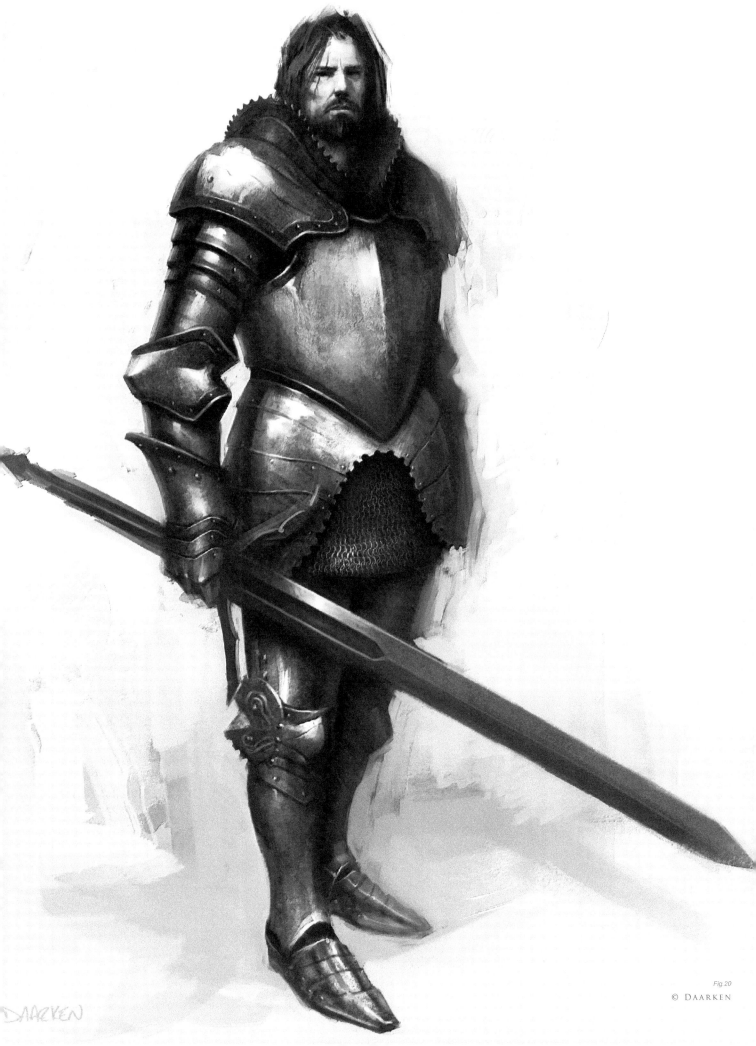

Fig.20
© Daarken

DAARKEN

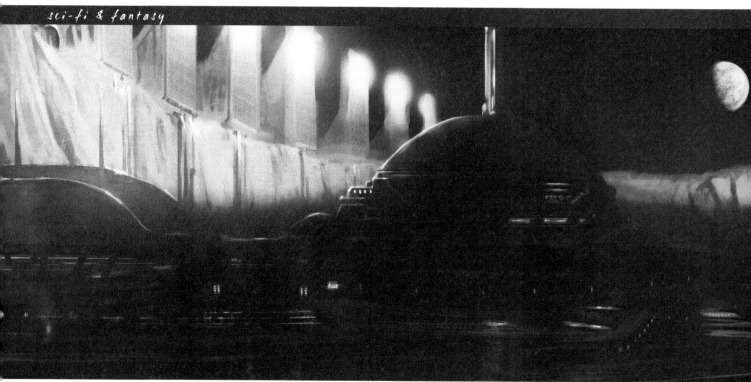

PLANETS AND STARFIELDS
BY CHEE MING WONG

SOFTWARE USED: PHOTOSHOP

NEBULAS

Space and the vast firmament of the heavens have always inspired. Like a vast bespeckled canvas stretching across the night sky, mankind has long dreamed about reaching forth and imagining life amongst the Gods. So let us begin with the jeweled clouds in the night sky: the nebulas.

As an oversimplification: if you can paint clouds, you can paint nebulas! The way to approach painting nebulas is to think of them as multicolored layered clouds (an interstellar cloud of dust, hydrogen gas, and plasma) that represent a birthing pool of stars. Most famous of all is the Eagle Nebula and the Pillars of Creation image.

When one is painting nebulas you tend to be less constrained by reality, and you are able to paint as abstractly or creatively as you wish. As such, nebulas and clouds are one of my favorite types of images to paint. For where else can one paint a rainbow cloud and get away with it as reality-disguised-as-fantasy-disguised-as-abstract art?

SMOKE AND CLOUDS

Studies of clouds and smoke will suggest that there is a hard and soft edge to each form (**Fig.01**). Similarly, nebulas can be likened to space clouds, with a few things to note:

- Dense areas tend to glow brightest or eliminate all light (darkest) as dark matter
- Only the brightest stars or spiral galaxies will shine through within or in front of a nebula.

Nebulas have hard edges (that tend to be brightest/denser) with an adjacent darker area and a soft opposing area (**Fig.02**). As a simple experiment, try pouring a moving viscous fluid into a lesser one, e.g., cordial into water. Alternatively, observe the smoke that trails from a lit cigarette or from burning incense.

In this tutorial, we are going to recreate similar images to that seen in the Eagle and Crab Nebulas, and our color palette choices are as follows:

- **Primary:** red – green complementary as the main color palette
- **Secondary:** orange/yellow – blue/green.

Fig.01

Fig.02

PAINTING A NEBULA

The Initial Rough-In: Start the initial canvas with purely the rough colors worked in. Any hard brush will do. For personal preference, an ideal brush that has a mix of a hard edge with some soft elements would be useful to act as a Cloud brush.

Basic Lighting and Detail: Apply a brighter area of color and establish your lighting so that it recedes into a darker area; a simple method is via establishing a gradient (in order to stimulate the way in which light falls off from bright to dark). In addition, this also helps to establish a good range of values to work with (**Fig.03**).

Lighting: Subtle use of the Color Dodge in areas where your main light emissions are will help provide a brighter overall source of light. Imagine a global light emerging just behind a cloud layer. A nebula is similar in principle. A secondary complementary light source is included to help provide contrast and accentuate a subtle difference (**Fig.04**).

Transform to Your Ideal Composition: To establish a larger and wider shot, we should

Fig.03

Fig.04

Fig.05

Fig.06

consider how the nebulas themselves form an aesthetically pleasing composition. Simply duplicate and apply the Free Transform tool (Ctrl + T) to rotate and shrink the overall image. You can repeat this step a few times, until you reestablish a more pleasing overall image (**Fig.05**).

Dark and Light: To ensure a realistic feeling, ensure various colors and values from the foreground are mixed into the background, and vice versa. Repeat this until you achieve an overall, even blending.

Stars: On a new layer, add a few bright stars in by hand across the whole image (**Fig.06**). As a simple rule of thumb, areas which are the lightest (well lit and bright) have the highest density of stars. And in a nebula region, only the brightest stars are prevalent.

CHAPTER 07

The resulting image is a rough composite. It is by no means finalized, but some people may choose to stop here (**Fig.07**).

CLEANING UP A BACKGROUND ILLUSTRATION

Critical to improving the overall image is the understanding and observation of edges. From here on, the whole process is about tidying up, correcting basic shapes and applying hard and soft edges, whilst subtle colors tweaks are added, as follows (**Fig.08**):

- **Whorls and Edges:** Tidy up the whorls and observe the edges of clouds as having a hard form
- **Movement of Forms:** Sinuous forms (that follow the movement of a heavier gas within a lighter gas form) should be observed
- **Soft and Hard Light:** Ensure only certain stars shine brighter than other focal points of light.

IT'S A LOVE-HATE THING!

Often, when working on an image, an artist may find themselves starting to overanalyze and dissect the image worked upon umpteen times. With this illustration (see **Fig.07**), I stared at it long and hard and decided that the overall image was lacking spontaneity and had become sterile. Working the image from left to right (**Fig.09**), here are a few approaches to loosening the overall illustration:

- **Topsy-Turvy:** Rotate the image at 90 degree increments. This allows us to

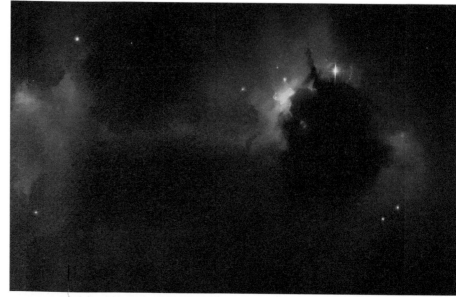

Fig.07

Fig.08

analyze the image in a new perspective and pick out errors or differences not seen before. Sometimes expanding the canvas frees up new compositional opportunities

- **Go Large:** Now paint everything out with a hard brush; do not worry about being tight or precise – use the biggest size you think you're comfortable with and then make it even bigger and paint in big, large strokes.

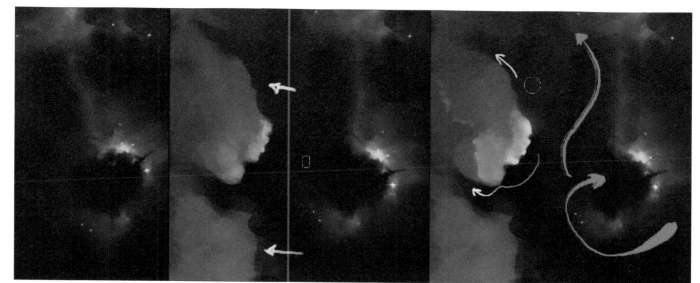

Fig.09

OBJECT FOCUS: USING A NEBULOUS BACKDROP

To complete the illustration, a small manmade object is utilized containing elements of a retro early space pioneer – effectively translated into large, chunky and cylindrical shapes (**Fig.10 – Fig.11**).

Block in: Use a large brush and project some rough shapes. Subsequently, select out areas to add more blocks of shapes.

Dark-to-Light Side: Lock the transparency on your new layer. This will allow you to paint freely within the blocked-out shape without worrying about straying beyond into the background. Ensure your strokes are parallel to the planar surface being described.

Fig.11

Fig.12

Fig.10

Blend: Now soften everything by working those two values back and forth to gradually show only the stronger light source (from the left), and faintly add a rim light (from the far right). To accentuate the overall form, you can lighten the immediate background around the derelict vessel in order to make it read better.

This should hopefully tie in all the various new elements of science, aesthetic and color visuals to allow you to produce your own fabulous and nebulous backdrops limited only by your own imagination and creativity.

BARREN WORLDS

Knowledge of atmosphere, and the lack of, accounts for how accurate and realistic our depiction of any Earth-like (blue) environment versus an alien unknown climate (for example an atmosphere with high methane content resulting in a green sky). As such, we will focus primarily on our companion, the moon, to provide a basis and working understanding for us to transfer to other exotic environments.

LUNAR LANDSCAPE

The lunar landscape is firstly said to have generally no atmosphere (actually, contrary to popular belief, there is a very thin atmosphere; however, it is insufficient to block out solar radiation, wind and cosmic rays). For the painter this translates as a minimal atmospheric perspective, i.e., a thin, transparent haze. There are traces of

gasses, such as radon, from out-gassing or micrometeorites. In addition, the solar wind can charge (a photoelectric effect) fine layers of moon dust that may present as electrostatic levitated dust. Coupled with exposure to cosmic rays, solar flares and solar wind, and the frequent impact of micrometeorites, this presents a hostile and relatively harsh, demanding condition. Closer inspection of the lunar landscape shows:

- A gray-colored surface
- Loose overlying debris covering most of its surface, otherwise known as "regolith"
- A fine scattering of lunar dust
- Dark patches (maria/mare) of ancient solidified lava to form the "sea"
- Light patches (terra) containing highlands with pockmarked craters.

THE DARK SIDE OF THE MOON: THE SOUTH POLE AITKEN BASIN

The initial objective of lunar colonization is to find a suitable location. For mankind, it will probably be easiest to locate a base within an area that is protected from sunlight, but within easy reach of solar radiation (for solar-based power) and study/research on the transition zone between light and dark. For this, the lunar south pole of the Aitken basin is ideal; it contains a small number of illuminated ridges within 15 kilometers of the pole, each of them much like an island of no more than a few

CHAPTER 07

Fig.13

hundred meters across in an ocean of eternal darkness. Of particular interest is the almost perfectly circular Shackleton crater, which NASA plans to colonize in the near future. The key features of the Shackleton crater are:

- A band of PELs (Peak of Eternal Light) on its crater rim which describes a point on a body eternally bathed in sunlight, therefore allowing for external power generation and studies of solar activity
- A low-temperature interior functions as a cold trap that may capture and freeze volatile sheds during comet impacts on the moon
- A permanently dark central core which is ideal for building a semi-covered base in (to account for radiation and exposure).

PAINTING A LUNAR CRATER
Bleak and Gray: Painting craters is an excellent study in defining a shallow, fairly elliptical shape using low contrast, and low value styled painting techniques (**Fig.12**).

Relative Perspective: As a general rule, craters form oval-shaped depressions which are more circular nearer the viewer and more elliptical the further away they get.

Lighting: Lighting (of the moon) is quite uniform, and in this instance comes from the top right, hitting the inner rim of the crater to recreate the (bright) band of PELs (**Fig.13**).

Why a Dark Side?: In contrast, everything within the crater rim is otherwise a uniform dark shadow (as the moon is tidally locked in relation to the Earth; i.e., there is always only

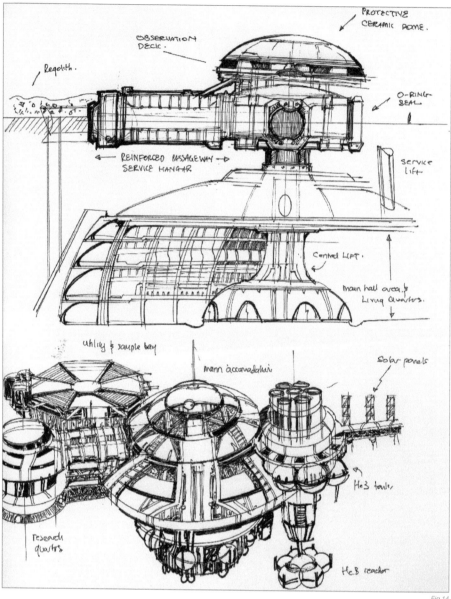
Fig.14

one side facing the Earth permanently, and all other areas facing away are known as the "dark side of the moon").

BUILDING A LUNAR BASE
Once a base is established, the key economy provided will be lunar colonists mining for Helium 3 (He3). Used within fusion reactors, this is an alternative, cheap, abundant and lucrative energy source (estimated to be a net profit of $300 – 400 USD billion per 100 tons of He3). Extraction would involve heating up lunar soil to above 600 degrees Celsius and therefore evaporating other volatiles in the soil.

The lunar base is fleshed out on pen and paper (**Fig.14**). It is depicted as semi-cylindrical living quarters being slowly installed within the dark

center of the Shackleton crater. Each cubicle is interlocked by short, sealed rings. I also took the liberty of considering an external power source/reactor that relies on He3 Deuterium fusion, assuming that the shielded reactor cores on the far right were relatively safe. In the main quarters, habitation is serviced by a dome-like structure with a central lift system to connect all levels of the base together. And finally, on the far left of the drawing, both a research and advanced propulsions works unit is coupled with the external hangar bay/ transport bay area.

MOON BASE: VERSION 2
Using the base schematics, we use this opportunity to refine the moon base design further (**Fig.15**).

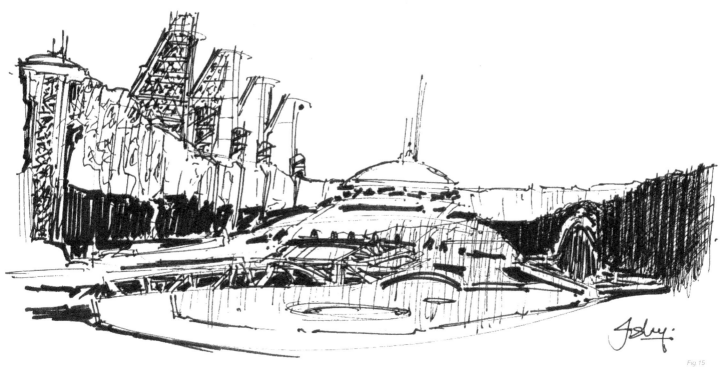

Fig.15

Initial Set-up: This rough thumbnail (see **Fig.15**) aims to simplify and tackle composition, form, and lighting all in one pass, utilizing a simple two-point perspective and focusing on the main dome which is protruding from the crater floor.

Retro Design: In the design, a marriage of the best elements of retro space and futuristic designs are merged, namely the white featureless planes and curves accentuated with angular tones; these few things bring a certain familiarity whilst still providing an evocative composition.

Perspective: Using a simple one-point perspective I aligned the main horizon and various objects with the main vanishing point (located slightly off center, to the left) (**Fig.16**).

Color Pass One: For a basic color pass, I separated the image into four basic values, showing a hierarchy of values to project depth and distance (**Fig.17**). The initial composition should resemble a simplified graphic shot that the eye can interpret easily. This will allow you to now work on various areas, according to tone.

Fig.16

Subtle Hues: In this instance, we know that the lunar surface is not entirely a bleak gray, but is variants of gray with streaks of maroon, copper, green, gold, and dark orange. In this respect, it might perhaps be advisable to take a more artistic license and use a deep saturated blue to suggest areas of shadow.

Fig.17

Lighting: The far rim of the crater, stretching from the far left to the middle, suggests light through the use of a warm tone, complementary to the blue (**Fig.18**). This unfortunately breaks up the lovely values which we established early on, but if you keep in mind the value structure established then you can try to work back to the original as much as possible.

CHAPTER 07

Ground Texture: A good and simple way to apply ground texture is to initially paint your desired surface in a rectangular shape. In this instance, we simple scatter a few dots with a dirt brush. Apply the Transformation tool (Ctrl + T) and manipulate it into the correct perspective (**Fig.19**).

From here on we'll consider two final outcomes: a lunar realistic-type rendition and an impressionistic space art style rendition.

Detailing: Well, this part can get a bit tedious; however, now that the values, composition, layout and lighting have all been established, you can really take the image to town by rendering every nut, rivet and bolt according to your needs! Here is a simplified checklist that I try to tend to adhere to (hopefully it can simplify and make your life easier during this stage) (**Fig.20**):

Note: Desaturate does not accurately depict a grayscale value, but can be used as an approximate.

SOLAR ARRAY LOCAL LIGHTING

Fig.18

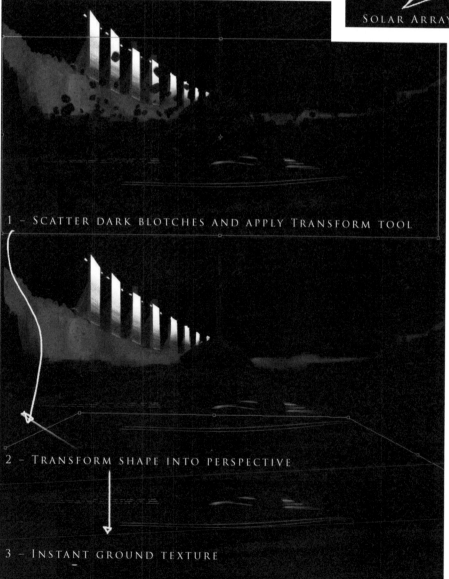

1 – SCATTER DARK BLOTCHES AND APPLY TRANSFORM TOOL

2 – TRANSFORM SHAPE INTO PERSPECTIVE

3 – INSTANT GROUND TEXTURE

Fig.19

• **Panels:** Neon lighting and subtle mixtures of angular and sweeping forms make for a simple and retro sci-fi image
• **Lights:** To ensure the glows are soft and project through mist, dust or clouds accordingly
• **Bounced Light:** Gives that extra special magic from local light sources and is a good way to describe a form moving within a shadowed/darkened area if you have no focal light source
• **Object Interests:** The main challenge of adding detail, I find, is that you can add too much hyper-detail throughout the canvas. More often than not if you add detail in the key areas, the mid-ground and background can have large simplified forms that can be left loose and the mind's eye will automatically fill in further details
• **Forms:** Ensure the large forms read and don't conflict with one another; a good method to check this is by squinting at your image frequently, or having a second monitor set up with the image size set to 50% or less.

And there you have it. I have also taken the liberty of adding a few more details, such as piping from the solar arrays and additional antennae. It is these small details that help to make your image look that much more convincing.

PANELS LIGHTS BOUNCED LIGHT OBJECT INTERESTS FORM

Fig.20

Finally, we will end our exploration of barren worlds here with two alternate images (**Fig.21 – 22**). **Fig.21** shows a final monochromic illustration which is more suited towards a lunar-styled environment and projects a more brooding, cold feeling. Ultimately, I love color and have also produced a more impressionistic space art version in **Fig.22**, blending in the main primaries of gold and deep blue/violet. And here is the final image for this part of our tutorial (**Fig.23**).

BARREN PLANETS

In this third part of the tutorial, we'll take a planetary-wide look at how planets are formed, depict the destruction and death of planets,

Fig.21

Fig.22

and explore the farthest regions of our known solar system. But first of all, let's take you back to the beginning ... to the birth of the solar system.

THE SOLAR SYSTEM – A FIERY BIRTH AND ITS DESTRUCTION

Imagine going back roughly 10 billion years after the Big Bang. A large star is about to die, having expended all its fuel, and from this its core eventually collapses inwards until it explodes as a supernova – sending a shock wave through the galaxy. It is from the remnants of this long distant star, and many others, that eventually a new star is formed – our sun – via the fusion of hydrogen atoms in a process called "nucleosynthesis".

Fig.23

ILLUSTRATING A DYING STAR

For our first painting we will look at illustrating the last moments of a dying star, transitioning before it explodes in a spectacular nova (which in the case of a large star is a supernova), for it is from the remnants of a dead star that the raw matter of a new star and solar system can come into being. In this instance it is probably more interesting to take a more impressionistic approach to space art, whilst working from a position of informed knowledge (**Fig.24**).

Colored Approach: We start by depicting a loose bluish-green background with flat washes over the canvas. Incorporating a circular styled composition, the illustration is planned to spiral outwards from its point of origin – the dying sun.

Level 1 Details: You can start to consider various aspects like stars and local objects at this juncture (as they are easy to forget later on in the process). Remember that the background stars will probably be very faint and only the brightest will shine through.

Blending: The next part brings the illustration to life as it allows the establishment of mid-

BLENDING BRINGS THE IMAGE TO LIFE

Fig.25

Fig.24

tone values, allowing various colors to bleed into one another and providing a softer, more realistic feel of an expanding cloud of gases (**Fig.25**).

Level 2 Details: Once the general disparate colors are blended, the next step to consider is the level 2 details. This means taking that extra care and taking additional attention to ensure that the key areas of the illustration harmonize and "sing" together. In this image,

Fig.26

Fig.27

it means adding a subtle blend of gold, jade, and turquoise with faint highlights and glows to make it all work together (**Fig.26**).

ILLUSTRATING THE BIRTH OF A SOLAR SYSTEM

Following the death of a star, a vast and widespread cloud of raw material is scattered across a region. When sufficient interstellar clouds (giant molecular clouds) of raw elements collapse under gravity, the center gets heavier and heavier and the rotation also gets faster and faster. Eventually, clouds of hydrogen become fused together until sufficient mass is reached to form a proto sun disc in a process called "Stellar Accretion". It is this process, through which a star is born, that a stable solar system forms. And it is this transition between the formation of a stable Stellar Accretion and a proto sun that we will try to illustrate in this tutorial, at this point (**Fig.27**).

In the initial stage we start with a rough layout of the proto stellar disc, using just pure deliberate color choices on the main canvas.

Using similar principles to those before, we can continue.

Flat Washes: Paint in a background of deep saturated blues and greens initially, and then sprinkle a scattering of faint stars.

Work Briskly: Then, very quickly and loosely, just paint in the basic layout of a central red and orange clump of clouds that spiral outwards in a ring.

Technical Data: Different artists depict this – the proto sun – as a geometric ring, and others as faint arms within a red disc. For the purpose of clarity here, we will first depict the thin edges of the arms, and subsequently lay in the red proto disc.

The Problem of Establishing Highlights Early On: Other issues to consider are the use of Color Dodge and brighter glows. I would like to stress that, in the initial stages it is often

too easy to use Color Dodge or add highlights straight away. If you do wish to do this here, try to limit these actions purely to the central portion only.

Contrast to Make Things "Hotter": This is due to the fact it is very hard to add further information/pixel data onto a white value. This illustration has almost pure white in the center but, due to the contrasting red surrounding it, it appears even hotter (in fact, it is merely a light desaturated yellow).

Minor Details: The ends of the disc should be depicted as wispier clouds (of raw elements). Using the method of blending as shown previously, establish your mid-tones early on. If all of these points have been considered, the early draft of your image should look pretty impressive (**Fig.28**).

MATURING THE ILLUSTRATION

The next stage to consider is to "work up" the initial composition into something respectable. Thereafter, one can spend an indeterminate amount of time perfecting every tiny detail or star, perhaps even adding a foreground element like an asteroid or some space transport of sorts – basically working till your heart's content. The following stages refer to the **Fig.28** sequence:

- **A:** The foreground elements of the edge of the stellar clouds have more color and mid-tones applied. Moving inwards, brighter

SEQUENCE: DEPICTING THE DETAILING OF A GROWING PROTO SUN FROM A LOOSE PAINTING TO A SEMI-FINISHED PAINTING

Fig.28

Fig.29

glows – with judicious use of Color Dodge –
can be applied closer to the center
- **B:** The central disc is thickened, with a
 more nebulous ring of circular globes that
 cumulatively form a rough spherical aspect
- **C:** The mid-range of the disc has more
 orange blended within. This lends a bit
 of an aspect of atmospheric perspective,
 however it does detract from the brightness
 of the original draft
- **D:** Additional details and blending are
 added to harmonize the overall feel. A faint
 wisp of red is eventually seen to emanate
 from the central aspect.

To finalize, the edges of the illustration are
color balanced and lightened to provide relief
and contrast to the final illustration (**Fig.29**).

A SPACE PROBE OVER A DEAD PLANET

For the purposes of object interest, let us now
design a space probe that can look to the stars.
And perhaps, to project it even further, one
that could look at past events or travel back in
time! Often, the challenge of producing space
imagery is the lack of providing relative scale
between the viewer and the main object of
interest. This will often be a large astronomical
object, such as a planet, star and asteroid field,
or the heavens above.

For our design, we end up with a simple robust
space probe that has a few additional features
(**Fig.30**) in addition to the beneficial features
listed above:

- The ability to deploy solar sails
- Multiple probe modules – allowing easy
 deployment to explore different planets for
 various scientific endeavors.

DSP PROBE

RETRO THRUSTERS

HEAT SHIELD

DSP PROBE: ENGINE AND STORAGE COMPARTMENT

MAIN MODULE: MAIN THRUSTERS

DEEP SPACE PROBE: MAIN MODULE STARGAZER II

Expendable Solar Sails.

DSP STARGAZER II: WITH SOLAR SAILS DEPLOYED

Fig.30

EXAGGERATED DEPICTION OF CIRCULAR CRATERS

Fig.31

As a backdrop, let's use our own natural satellite, the moon, in full
color, to depict a barren planet. Often, the lunar surface is depicted in
a bland gray, or a false desaturated blue color. However, the advent of
webcams and improved technology now show that the moon is indeed
more colorful than previously thought (color photography provided from
the 1994 DSPE [Deep Space Program Science Experiment] Clementine
satellite).

CRATERS ON THE MOON

The key issue to consider when drawing any large circular object on
a curved body, such as a planet, moon or asteroid, is the perspective.

In contrast to the other aspects throughout the tutorial, perspective is the key primary determinant when drawing craters (**Fig.31**). In general:

- The closer (or more perpendicular) a crater is towards the viewer, the more circular it appears
- The further away a crater is, the more elliptical It appears.

Lastly, nature is random, and thus, to achieve both aesthetic and an accurate rendition of the moon, try to vary the size, depth and discoloration of the craters.

ILLUSTRATING THE MOON

Some things to consider when illustrating the moon are that there is a nearside and a far side. Because our moon is tidally locked to the Earth's gravitational pull, the view of the moon is always fixed relatively to Earth. In the example of the moon, it is said to be tidally locked to a larger body of the Earth. The dark patches seen on the moon by the eye are said to be called the "Lunar Mare/Maria" (dark

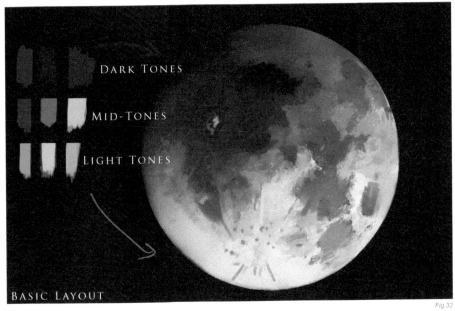

Fig.32

regions made of basalt which give a dark green-blue color cast).

INITIAL LAYOUT AND COMPOSITION

Initial Layout: Using the Circular Marquee tool, paint a base of light yellow/gray in large flat washes to represent the base of the moon.

Palette: A color palette of dark, mid and light tones will help in the overall production of the image using only color. Optionally, one can choose to start out in grayscale and work out the base values based on the reference of the near and far side; however, it will take some work to make it appear painterly and naturalistic in the final outcome (**Fig.32**).

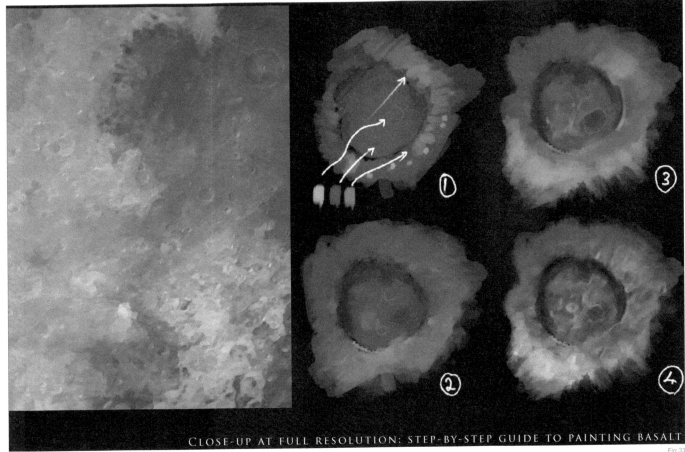

CLOSE-UP AT FULL RESOLUTION: STEP-BY-STEP GUIDE TO PAINTING BASALT

Fig.33

Base Shapes: Using the dark tones, lay down the dark basaltic mares, tempered with the mid-tones of pink and yellow. Finally, the lighter tones can be used to inscribe the edges of large and small craters. For a naturalistic feel, do not describe the whole shape of the crater, but rather just the edges that may catch light (**Fig.33**).

ADDING DETAILS

Work Big: For this piece, the overall image is at 6000 pixels wide. This allows many tiny details to be "faked" by using purely color complementaries.

Painting Basalt: Using a base of sea green, mix in a desaturated pink to suggest crater edges and highlands, and mix it in with the base green and yellow to get a good blend.

Craters: Try adding long light streaks emanating from some large craters. These can be thought to be leftover trails from micro meteorite impacts or smaller showers (**Fig.34**).

FINAL DETAILS

Fig.34

Fig.35

For that final finish, try adding various foreground elements, such as the space probe previously designed, or the whole illustration can be color-graded to a more traditional monochromic look (**Fig.35**).

In Conclusion

Well, this has been a quick 'whistle stop tour' of the life and death of the solar system and its constituents and stars. I hope you have found the various processes and workflow approaches informative and relatively concise. To round up this final part of the workshop you can see the final moon painting variations created for this tutorial (**Fig.36 – 37**). All the information provided here has been researched as best as possible and any factual errors rest solely on my shoulders.

Fig.36

Fig.37

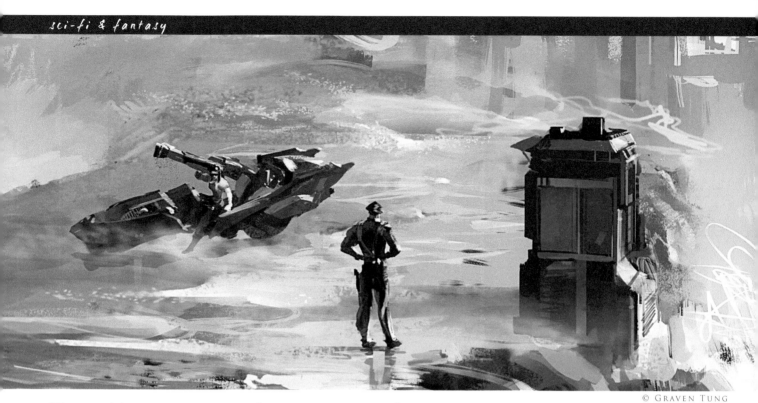

© GRAVEN TUNG

THE MAKING OF "PIER DUTY"
BY GRAVEN TUNG

SOFTWARE USED: PHOTOSHOP

This particular tutorial is a simple study that will hopefully explain some of the thoughts and techniques I use during my painting process. I'm usually not in the habit of questioning myself on why I do things a certain way; in fact, this is the first time I've been asked to paint for a tutorial, so bear with me here.

I started off by Googling for some ideas. I try to avoid jumping into a painting without at least having a general direction. This is to prevent myself from falling into the "safe zone" and repeating similar subjects over and over. So I dug up a few interesting shots after some random image searches. There's something cool about those waves crashing on the pier. I haven't done anything like that before, and it looks like fun.

Before we start, here are the two brushes I often use, especially for blocking in rough sketches. As you can see they're simply the two

Fig.01a

default Chalk brushes that come with Photoshop CS, with a little change in settings (**Fig.01a – b**). Some people ask why I only have the Opacity Jitter set to Pen Pressure and not the Size as well. It's simply a personal preference. I tend to adjust the brush size with the [and] keys anyway, so it all works out!

I open up a random canvas and loosely sketch in something that looks like a pier leading into a washed-out, misty background (**Fig.02**). Now, I'd be lying if I said I know exactly what I'm going for at this point; the purpose of this step is to quickly establish a value range while testing the scene to see if it actually captures the right mood. It's almost like giving me an inkblot test. I just push and shove shapes around till I see something I like. This is where I like to spend as much time as I want to make sure a shot works (assuming there's no deadline, of course). In this case I kind of like the dark shapes on the sides; they can easily

Fig.01b

be some manmade structures or even rocks; the warm highlights seem to suggest a side-lit situation which can work out nicely in this shot. The shape at the far end of the pier could be a building or small island, so we have something in the background as well.

Continuing on with the block-in (**Fig.03**), I extend some rock formation to the left to balance out the composition, and I also scatter some warm highlights across the background sky. I figure the cloud/wave/moisture in the air would likely catch the sun here and there. It also helps to emphasize the light source. At

Fig.02

WAVE

Fig.03

Fig.04

this point that shape jutting out to the right is starting to look like a tall wave going over the pier, which is good.

Next I plant a building on the left to give it some focus (**Fig.04**). It also serves as something that leads us from the foreground to the background. I'm not worried about its details yet. At this point it's better to focus on the right palette than trying to work out any specific designs. Right now the building is nothing more than a bulky shape with a touch of highlight, which is all we need.

CHAPTER 07

Fig.05

Fig.06

The composition is starting to take shape, but we're still missing something in the foreground. Since it's already looking a bit military, I'll go along with that theme. Here you can see a couple of attempts to work in some figures and maybe a vehicle (**Fig.05 – 07**). I eventually settle on the bike because I want to paint a biker chick carrying a big bazooka. I wish there were other deeper reasons, but sometimes you've just got to go with your gut instincts!

Now is a good time to clean up the background building on the far right; I put in another building on the left to give it more depth (**Fig.08**). I spend some time working out a simple design of the main building. Again, it still looks rough but we'll get back to it later (**Fig.09**).

Fig.07

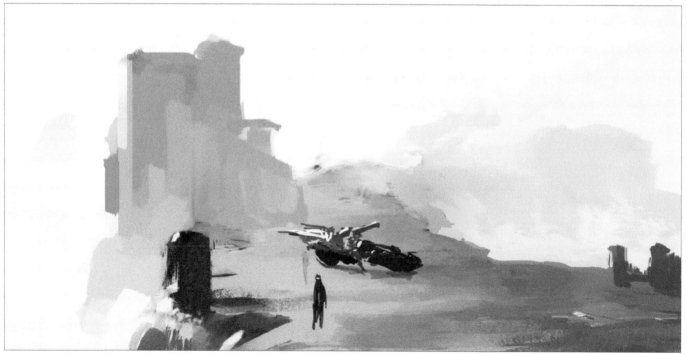

Fig.08

Time for some weather effects; this place needs a good, strong side wind. I open up a new layer and quickly indicate some moisture being blown across in front of the main building, as well as adding some puddles on the ground (**Fig.10**). The good thing about doing this on a layer is that I can still use a big textured Chalk brush to lay down a large shape, and come back with a small Eraser and erase into that shape to carve out the details. I also throw in a little bit of highlight on the building in the back to make it look like that wave is casting a shadow over the structure. Perhaps the wave is getting a little off scale here? I mean, that thing is like, 250 feet tall now! We'll have to fix that later on…

Fig.09

Fig.10

Fig.11

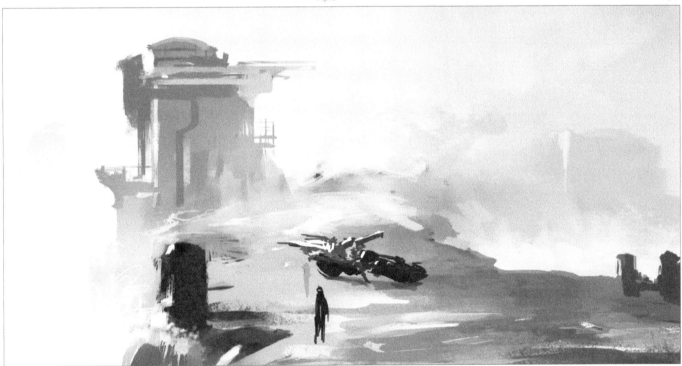

Fig.12

Fig.13

The sketch is coming along nicely for the most part, but the sky still seems a little too flat. I was hoping to keep it simple and have everything blending into the misty atmosphere, however right now it's just not creating enough eye movement. To fix this I open up a new layer and put down a subtle gradient using a large Airbrush (**Fig.11**). I change the layer option to Multiply (**Fig.12**). This helps to tone down the background value and emphasize the light source.

Next I flip the canvas to check the composition (**Fig.13**). I also decide to crop in on the two characters, to sort of bring them closer to the center

CHAPTER 07

and making them the focus (**Fig.14**). The standing figure can be a guard; the shape to the right can be his booth or something, and I sort of like the potential drama between him and the biker chick. Of course, the composition will have to be adjusted since cropping in has kind of killed some of the depth the piece had before, but at this point the basic "staging" is done. From now on it's just a matter of detailing it out till I can call it done.

Here's the image after some polishing (**Fig.15**). The actual rendering process can seem quite dull, even on a loose piece such as this one. I was pretty much moving all over the place, sampling colors and working on things in no particular order. But it's really nothing special, just the same old things I did during the block-in only repeated on a finer scale. I'll do my best to sum up some key steps:

Fig.14

- I simply raised the structure and added some minimum details. I indicated a path leading up to the building to add some interest. If you look closer at the waves at the bottom you can see I actually used the default Maple Leaf brush to mimic scattered waves, and went back in with a Smudge tool to kill a few hard edges here and there (**Fig.16**).

Fig.15

Fig.16



Fig.17

- I toned down the killer wave. It still looks tall, but at least not like some tsunami from hell. Other than that I simply laid down patches of textured shapes with a large brush on a layer, and carved out the details with a small Eraser (**Fig.17**) (as mentioned before).

• I further detailed out the main structure, added windows and a flag, and also threw in a soldier on the balcony to make it more interesting. I refined the building in the back, and popped that flying thing up there just for kicks (**Fig.18**).

• I made the booth larger so it looks like the guard can fit in there. The rest was pretty straightforward, just detailing out the characters and the bike with a small brush. The chick must have some insane strength to lift that cannon, but I actually like it that way. Who knows, maybe she's a cyborg (**Fig.19**)?

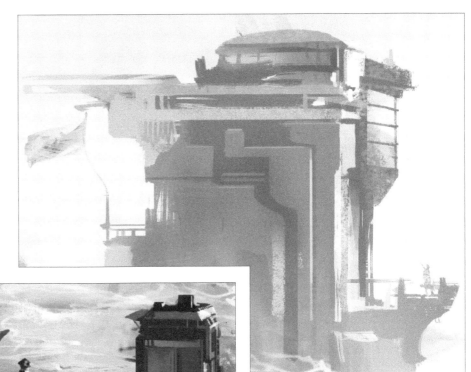

Fig 18

The painting is almost done now. I give it a once over just to clean up some minor areas that were still bugging me; throw in a layer of smoke effect in front of the bike; adjust the Levels; sharpen it with a filter, and the thing is finished (**Fig.20**). Of course there is always room for improvement and revisions, but for now the piece does what it needs to do.

Fig.19

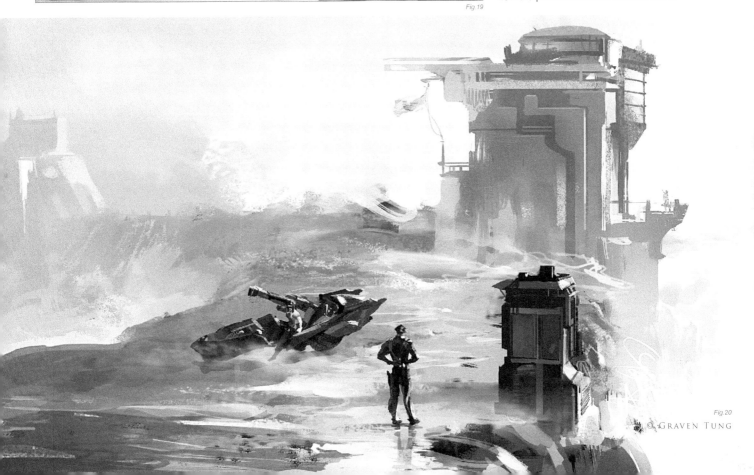

Fig.20

© Graven Tung

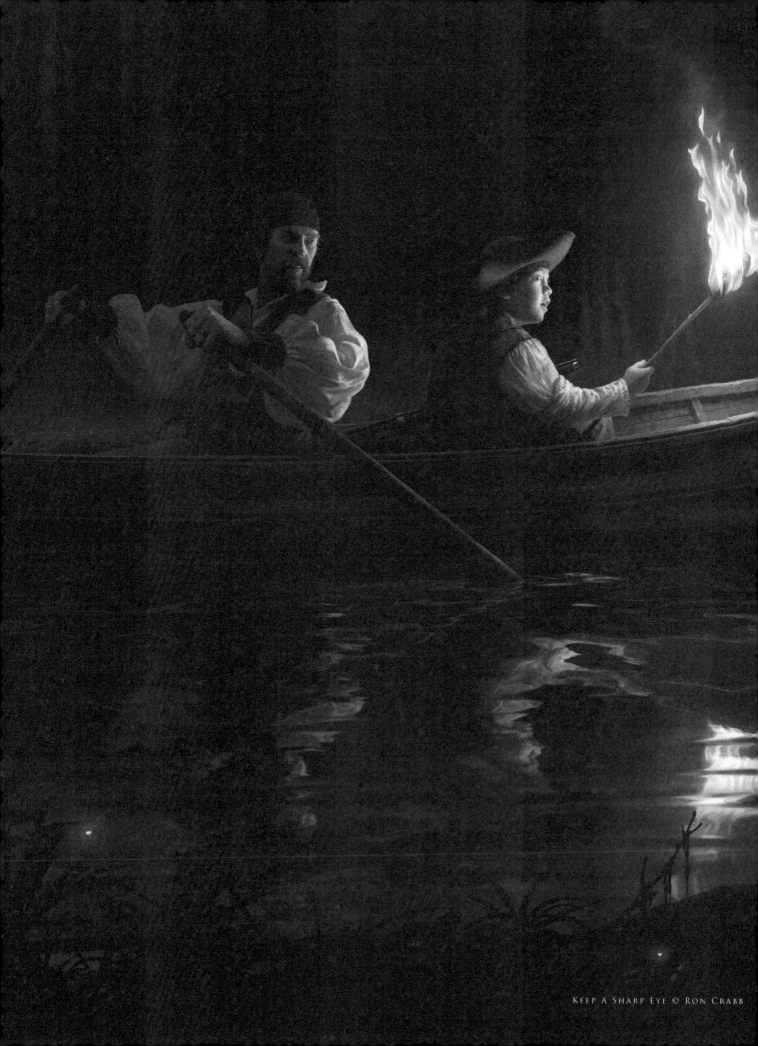

complete projects

This part of the book is perhaps the overture to what has preceded, and allows a glimpse into the thought process and creative approach behind three artists. Each addresses the human condition in diverse ways and hopefully, through comparing the different stylistic approaches, we will gain an insight into both the technical and emotive aspects that run through their work.

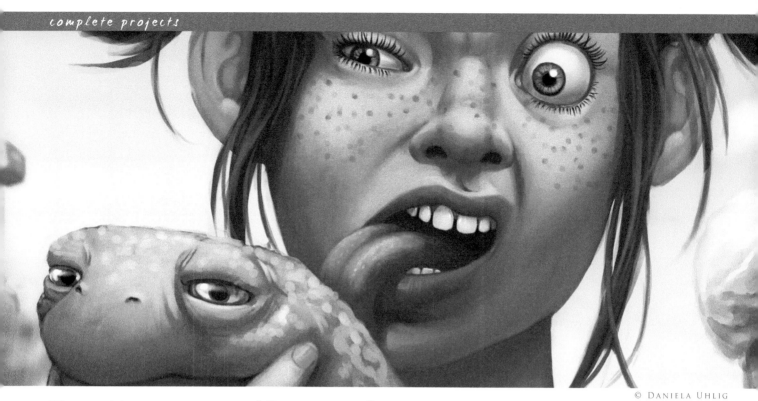

© DANIELA UHLIG

THE MAKING OF "FUNFAIR"
BY DANIELA UHLIG

SOFTWARE USED: PHOTOSHOP

I like my pictures to describe funny or strange situations, such as in my picture, *Funfair*. The idea for *Funfair* came about when I was sitting in the park on one of my lunch breaks. A friend and I were eating ice-cream when a small insect landed on hers ... her face instantly turned into a funny grimace, and I just had to hold onto that facial expression by drawing it.

STEP 01

As a starting size, I use around about a 3000 by 3000 pixel canvas, at 300 dpi. First I

Fig.01b

Fig.01a

draw the sketch in Photoshop using a small, pressure sensitive paintbrush (**Fig.01a**). The background and the sketch both have their own layers. I then set up the basic colors that

I think I might use for the sketch (**Fig.01b**). I always try to use very loud colors in order to enhance the surreal situations that you find in my pictures.

STEP 02

I create a layer behind the sketch layer and fill it roughly with my chosen basic colors (**Fig.02a**). The lighting and shading are set up with the chosen basic colors, again using a new layer (**Fig.02b**). For this piece I choose a daylight situation, in order for a summery, sunny ambiance to be achieved. I use a hard round brush; to get a smooth transition between the colors, the Other Dynamics and Pen Pressure settings were used (**Fig.02c**).

STEP 03

At this point I have the basic frame upon which I can start adding all the details. By creating a new layer I make sure that the sketch layer will still be there. On the new layer I just start drawing over the sketch lines – ignoring them completely. I start with the face because this is the main point of focus. By creating a general idea of the face, I am then able to work on the details such as the nose, mouth, eyes, teeth, and of course – very importantly for my nasty

Fig.02a

Fig.02b

Fig.02c

Fig.03a

red-headed teenage girl – some freckles, using the same settings as before but working more precisely this time. For the detailed parts, for example the eyelashes or other fine lines, you can use the helpful setting, Shape Dynamics (**Fig.03a – c**). The hard round brush gives us

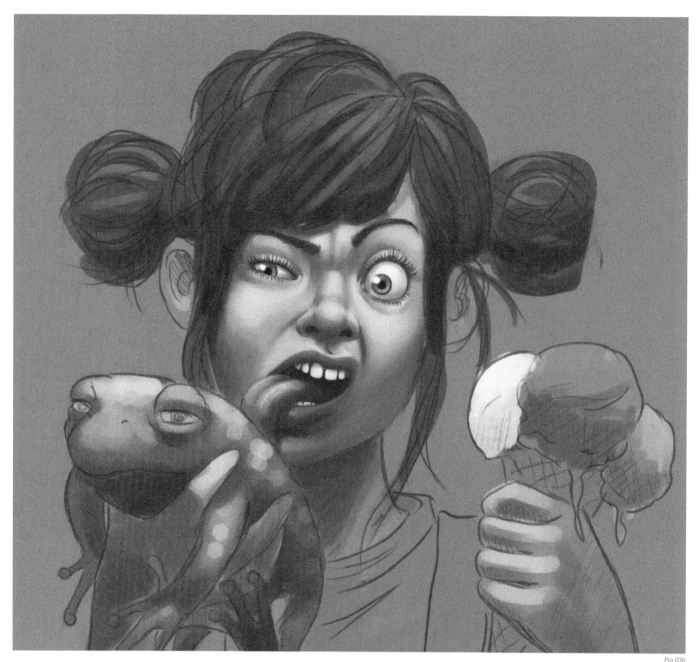

Fig.03b

a nice, painterly character, unlike when using Airbrush, as this feature always looks a little cleaner. After finishing up her face I then start work on the rest…

STEP 04

The next step is the hair. Earlier on I set up the basic colors, one of which was chosen for her hair color. I enhance the lighter and darker shades of red in her hair using single wisps. I don't want my character to look all prim and boring, and so for this reason I paint single wisps sticking out of the hair. This way her hair looks less combed and more out of order, which also gives her a cheeky look. The more

Fig.03c

Fig.04

luminous spots you apply to the hair, the more
it will shine and the silkier it will look. This time
I didn't want to use effects like that because I
wanted the hair to look a bit shaggier, for the
reasons I mentioned before (**Fig.04**).

STEP 05

Moving on to detail the frog, I paint bright
yellow colored spots where the light is to be

Fig.05a

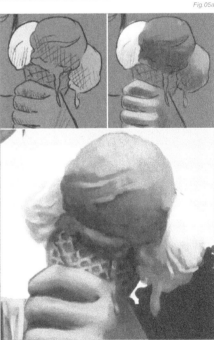

Fig.05b

Fig.05c

hitting his body. This way the frog looks all
wet and slippery, and you also get that typical
pimply skin effect that frogs have (**Fig.05a**).
I then work on the ice-cream cone; to get
that characteristic ice-cream surface, the line
management has to be more inaccurate and
I finish up with the Unsharp filter (**Fig.05b**).
Looking at a real ice-cream cone would also
help here.

I then work on the hands and clothes; you
could either do these both on one layer, or

CHAPTER 08

each one on a separate layer, on top of the sketch. After finishing all this, the sketch is now barely visible (**Fig.05c**), so I hide the sketch layer and everything else is merged into one layer. You should always merge layers together when you finish working on each layer – this way you can save a huge amount of calculating capacity. However, in order to have some kind of back-up, I also save jpeg files every couple of steps – but it's up to you if you wish to do the same.

STEP 06

The background needs to support the picture, whilst not becoming a key focal point. The

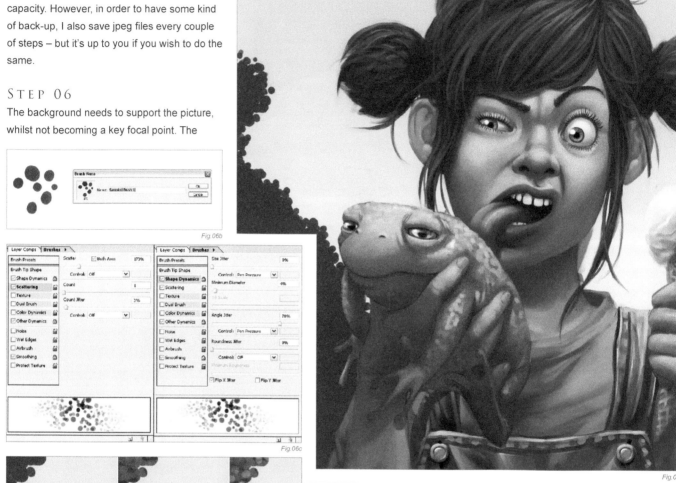

Fig.06b

Fig.06c

Fig.06a

Fig.06d

coloring has to be bright and strong to achieve that summery look for the whole scene which I described earlier. So I start with a rough green area that is to later on display trees and bushes (**Fig.06a**). I fill this area with darker and lighter shades of green, using a brush I created myself very easily (**Fig.06b – c**).

I erase some parts of the edge of the green area using the same brush, and to achieve depth of field I use the Gaussian Blur filter on the trees (**Fig.06d**). Behind these trees a Ferris wheel is depicted to signify the name and action of the picture. Of course, the Gaussian Blur also has to be applied here, as well. The lowest layer of the background holds the sky and a few clouds – both were sketched only roughly.

STEP 07

I can never really stop working on a character – there is always something to improve or change. A useful way to do this is to create a "correction layer". On this I can then, for example, change the light beam in the corner of an eye, or change how the T-shirt falls. For a nice finish I also give her hair bands with green dice on them, which creates a nice contrast to her red hair (**Fig.07a – b**). And we're done.

Fig.07a

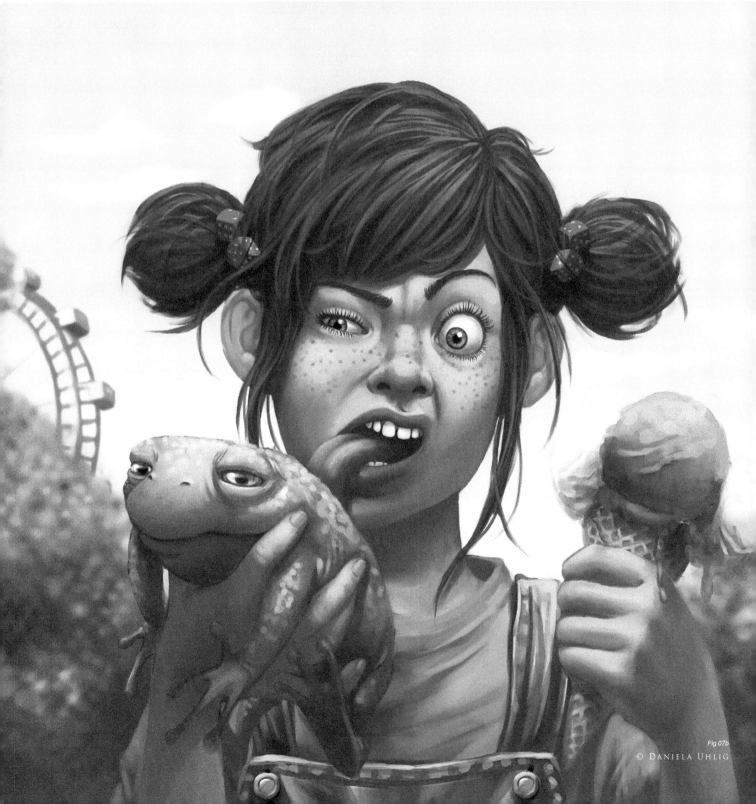

Fig 07b

© DANIELA UHLIG

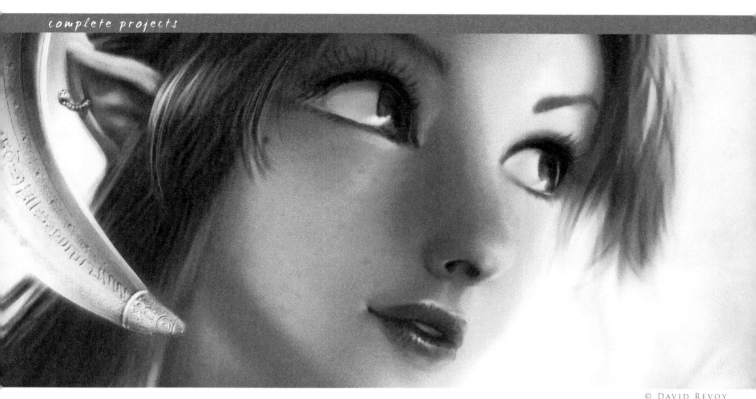

© DAVID REVOY

CREATING A 2D IMAGE FROM SCRATCH
BY DAVID REVOY

SOFTWARE USED: PAINTER, PHOTOSHOP, ARTWEAVER, GIMP

Here I have tried to create a simple step-by-step tutorial on the creation of my image, *Collar of Magic Pearls* (**Fig.01**). I originally intended to write the article as a "making of" for TDT3D.com; however, whilst writing I realized that a lot of the techniques and software used, and quickly developed it into a tutorial (later published on TDT3D.com). The painting was made using a combination of software: Corel Painter IX and Photoshop CS2; however, most of the techniques explained in this tutorial will also be applicable to other 2D programs. I have reserved space at the end of this tutorial for the conversion of the following programs: Artweaver and GIMP – both free and open source software.

SETTING UP IN PAINTER
Firstly, I begin by launching Painter. I prefer this software for global creation as there are a

lot of pre-made tools here to satisfy my needs, and it helps me to remember my old work as a traditional artist. I often start with a simple black marker on a warm, light-gray canvas. The size I use is always around 2000 by 2000 pixels. I usually start with a 3000 by 3000 pixel square canvas, and crop it to suit my requirements. Here, I directly enter the value 2970 by 2100 pixels to be sure to have a ratio equal to A4 – normal-sized European paper (almost equal to the Legal standard for the rest of world).

Tip: If I want to make a 16-9 ratio, I simply enter 1600 by 900 pixels. For my workflow organization, I like to work with the Hue/Saturation/Light, a panel of custom tools (more short-cut tools than custom) and a standard color selector. I like to keep the layer panel reduced next to my toolbox, to keep an eye on whether I need to add or change an effect if I'm

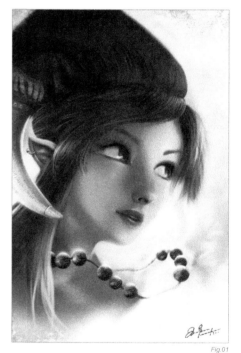

Fig.01

not too sure about a layer. Normally, however, I like to work without layers, as I would with a traditional drawing.

BLACK AND WHITE DRAWING
(**Fig.02**) I start with a simple line drawing, using thin marker tools. I try to start out working

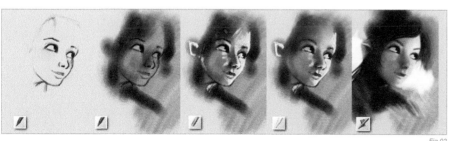

Fig.02

with good shapes, and then enlarge my tool to quickly create shadowed areas. Setting the background to white, I take the Eraser and add some highlights; taking the Blender tool, I then start to smooth the light/shadowed areas and, with an Airbrush, I make my shadows darker and my light areas glow more brightly.

See **Fig.03** for a close-up detail of the work. I continue the same process; adding details with the Marker/Airbrush/Eraser and blending my shapes. The main idea progresses gently. At first, I want to add a skull ring, and to represent dark elves; however, I decide that violet skin and red eyes would be too "disco" for my color preferences. Even when I'm working with black and white colors, I try to imagine the color values. It is necessary not to have the colors too dark or too light, which is why I try to keep neutral zones that will be the best places to express the colors (lips/skin, etc.).

Fig.04 is a mirror image of the work, which is a good way to refresh your eyes and spot any mistakes. During the process, I mirror the

drawing a lot (I even have a short cut on my Wacom express keys, as I work with an Intuos 3), as this is the best way to catch mistakes. It wakes up tired eyes and self-criticism (your brain believes it's a new picture, and instantly starts to analyze it differently).

COMPOSITION ENHANCEMENT AND RESIZING

The arrows in **Fig.05** show that a part of the face is too large, and the mouth is slightly out of alignment, so we need to work on the composition now to correct these flaws. Firstly, save your work and go to Photoshop. I always prefer to do any modification, moving of areas/ resizing of the drawing, etc. in Photoshop. With practice, it has become easier this way. I aim for good composition using three simple methods: (1) draw lines from corner to corner – the "big cross" – to show the dynamic axis of reading pictures; (2) 1/3; 1/3; 1/3 – cutting the image into nine frames – to show where to align the vertical-horizontal main lines (not in a boring way); (3) two circles, drawn to show

Fig.03

Fig.04

a representation of the two circles of the eyes and the focal point in the middle where detail will be observed first.

It can be interesting to place circular main lines around shapes to make the effect more efficient. Of course, I don't usually draw these compositional lines, I simply imagine them when I need to, but if you are used to drawing then you will subconsciously build your picture in this way. For now, it is best for cropping and resizing your picture, which is why I added a soft pink area to the picture, to achieve better composition (**Fig.05 – 06**). The hand-drawn details are done using a digital Airbrush with Painter, so I save the work and go back to Painter where, with a thin Airbrush, I simply define the main details; most of them are made using a simple black or white line, using a mixture of different pressures on my pen.

BEVEL AND EMBOSS

(**Fig.07**) From left to right: the horn without bevel and emboss; the horn with one layer;

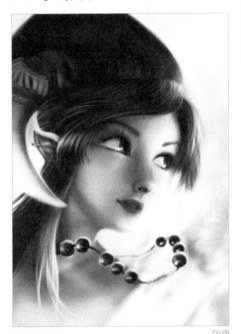
Fig.05

Fig.06

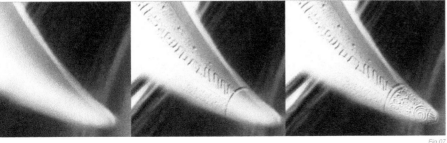
Fig.07

and the horn with the final layer. My prefered method for adding these cool details is an easy technique which I have learnt from forums and websites: Save and go to Photoshop, and duplicate the background layer; apply a Bevel and Emboss effect on the new top layers; draw with the Eraser ... easy! You can change the parameters of the effect to have colored shadows/light, and alter their direction (**Fig.08**). The only thing to take care of is the frame on the border that appears around the second layer (square, embossed appearance). At the end of your engraving work, apply the effect and erase the border of the top layer. You can now collapse your layers and repeat the process to include a lot more detail.

Fig.08

BUMP UP YOUR TEXTURES!

The complexity of this effect warrants a brief tutorial in itself (**Fig.09**): (1) in Photoshop, draw a rock on a new layer using a basic brush; (2) draw

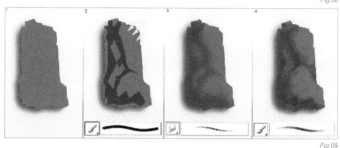

Fig.09

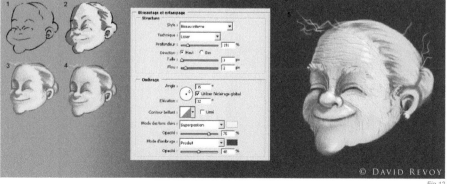

Fig.10

some solid shadows; (3) blend them using the Smudge tool (increase the value of the Smudge tool to make it work faster and better); (4) use a brush to add some finer details, such as the material color. Now for the effect (**Fig.10**): (5) duplicate the layer of your rock by dragging and dropping onto the Create a New Layer icon; (6) double-click on the right part of the layer to add an effect, choose Bevel and Emboss, and play with the Blending Options; (7) on the top layer, use an Eraser and set a good sparkled "grunge" shape; erase, and the relief appears!

Here are two other quick examples which I have painted to help understand when and where to use this technique I've just described (**Fig.11 – 12**). This little touch always adds a little more life, and doesn't take too long when you think of the amount of detail generated. There are other examples as well, such as flat textures; this will also be of interest to 3D

Fig.11

Fig.12

artists. Step 1 for **Fig.13**, **14** and **15** is without a bump map, and steps 2 and 3 use different bump maps (**Fig.13a – 15c**).

Back to the *Collar of Magic Pearls* painting; the bump map for this work was made using 3 – 4 layers to give different levels of engraved details. The lowest layer utilized a lot of line, using a 1-pixel wide tool to create grungy lines on the materials. The largest use of this effect was using a large Eraser to write inscription on the horn, on the left of the painting (**Fig.16**). You can see the Bevel and Emboss effect layers in action here.

COLORS

The color steps are made on a separate layer, which will incrust color onto the gray painting.

Fig. 13a

Fig. 13b

Fig. 13c

Fig. 14a

Fig. 14b

Fig. 14c

Fig. 15a

Fig. 15b

Fig. 15c

Fig 16

Fig. 17

Fig. 18

To add color, we create – on the top of our layers (I collapse them all, so I keep only one black and white layer open) – a layer with the Color layer blending mode. This layer will transform the gray value in the color tone applied to that value. I start to apply a green color over all colors, and add additional colors to the painting step-by-step (**Fig.17**). I first discovered this technique used in a 2D painting tutorial by Steven Stahlberg.

To explain color schemes, I have used tones/colors and arrows to demonstrate (**Fig.18**). A good trick for skin tone is: (1) add a little blue/violet on the eyes; (2) give a touch of a warm, red/blood color on the cheek; (3) apply a little violet around the corners of the nose; and (4) add more red and saturation to the nose and ears.

LAYERS AND DETAILS

See **Fig.19** for a screenshot of my working method in Photoshop. As usual, my favorite tools are the palettes of Hue/Saturation and Brightness/Contrast. Details of my layer composition for the artwork can also be seen here (**Fig.20**). I keep the two layers (in the example shown "Calque" is the default French term for "Layers" in Photoshop, which means "copy") and add as many layers as I need to get my picture as I want it. The layers enforce some color simply by using an Airbrush, adding

highlights, and adding some grain to the skin and texture to the pictures – which is all fairly easy to do (**Fig.21**).

TIPS AND TRICKS

Two tips which you can try after finishing an artwork, to make your picture even better (for publishing, etc.) are: (1) go to a 3D online gallery, browse your favorite artists' pictures, analyze their artwork and try to comment on their images constructively. After this, return to your 2D painting; (2) it's always good to have insight from another person, so post your final image in a WIP forum – experts and hobbyists will happily give you precious advice on how to enhance the quality of your artwork, and in turn you can help them with their own art.

REFERENCES

Most photographs are already the artworks of a photographer/artist, so you mustn't copy them – even if you like the shadows/characters, it would still be a derivative of an original artwork. Another way is to become a drawing master and to have a mental image in mind. The last way is to use your own reference material, from your personal photos. It's not easy to ask all of your friends to pose for your artwork, which is why I find my working method most efficient: using 3D software which is distributed freely, for example DAZ Studio with Mike and Victoria models

Fig.19

Fig.20

(**http://www.daz3d.com**), which is likely to have models with the ability to move their arms, change their pose, change lighting and background, etc.

For this artwork I didn't actually use this method, but I have simulated the method for you here, as I would have done it if I had needed to (personally, I use DAZ Studio for my hand and feet poses, and for an idea of general lighting). I have included some screenshots to demonstrate the helpfulness of such software (**Fig.22 – 23c**). The interface is full of great things, but the best way to learn is by reading the Help section of the software. **Fig.24** shows the wireframe render

Fig.21

Fig.22

Fig.23a

Fig.23b

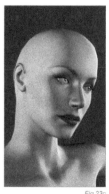

Fig.23c

Fig.24

Fig.25

Fig.26

Fig.27

Fig.28

Fig.29

inside the 3D viewport. Rendering is perhaps not as realistic as a photograph; however it's a good base to start an artwork with an idea of how the light will move on a face. This job was approximately 15 minutes quicker than undertaking a big internet search for photos, or asking a friend to pose for me.

CONVERSIONS

I have detailed some conversions for you here, which are useful if you desire to use other software to create your work. This will not reproduce the Tool effects of Painter and Photoshop, but will help you to achieve a similar method when working with software such as GIMP (free and open source) and Artweaver (freeware), and will concern only the important points:

1. Using the Smudge tool/Blender tool – to mix the colors;
2. Applying a bump map;
3. Applying a color layer to color your grayscale artwork.

For a Windows user, the ideal method is to work with Artweaver; I work with Painter and tend to use GIMP in the same way I would use Photoshop on my Mac. It is ideal to begin your

investment in your 2D digital painting studio with a purchase of a graphics tablet before even thinking about software, because you can find software such as GIMP and Artweaver which are completely free and legal to use.

CONVERSION FOR GIMP

GIMP is surely the most famous free and open source 2D editor, and can be downloaded for all systems – Win/Mac/Linux – and is still in use by a large community. The version which I like to use is a portable version of the 2.2. This version can be on a USB key, as well as your drivers for your graphics tablet display. It's ideal to have all of this on a USB key ready to work with anywhere on a computer. GIMP is free and open source, so it is legal to install it on another computer or to execute it from the USB key anywhere. That's why it's such a powerful 2D tool to consider in professional work.

Use the Smudge tool configuration to blend artwork efficiently – see **Fig.25** for a screenshot of the general organization. Bump is supported by GIMP but is not as efficient as the Photoshop method. A sphere is airbrushed onto the base layer (**Fig.26**), and then a new transparent layer is added (**Fig.27**). Draw onto it with a hard brush to engrave a pattern

(**Fig.28**). To apply a bump map to your image, go to Filter > Map > Bump Map (**Fig.29**); **Fig.30** shows the Bump Map filter in action. The result, with 70% Opacity set to Overlay mode, can be seen in **Fig.31**. See **Fig.32a – b** for the color layer, where I experimented with a 5-minute color test, made using GIMP, with some saturation tones (apologies for the colors used here – I randomly selected them to illustrate this example).

Fig.30

Fig.31

CONVERSION FOR ARTWEAVER

Artweaver is a Windows freeware program by Boris Eyrich, which simulates natural brush tools, such as Painter from Corel (**Fig.33**). This software is excellent and will have everything that you need to work through this tutorial. What I personally like is: (1) the color selector – the turning pyramid; (2) many natural tools; (3) an incredible computing speed for brushes; (4) imitation of Painter and Photoshop mixed – so if you learn this one you will never be lost in other standard commercial and professional software; (5) the history, start-up launching speed, filters and extensions – AWD (Artweaver), BMP, GIF, JPEG, PCX, TGA, TIFF, PNG, and PSD (has no layer support); (6) the pen tablet support for a realistic feeling and a lot of language support.

For tool compatibility, select in the tools Airbrush > Digital Airbrush. All of the tools are almost the same as in this tutorial (icons), so it will be easy for you to follow the same steps. For Smudge/Blend tools, use the Artweaver brush editor (**Fig.34**), which can configure any tool as a Smudge tool. Brushes can be transformed to become a good Smudge/Blend tool using the Smear option in the Method menu. In Fig.34 you can see the blending of half of the face, made quickly in Artweaver using a 2970 by 2100 pixel canvas. A good tip is to keep the height Spacing value at just less than half of the brush size; so, for example, if using brush size 80, the Spacing for the smear should be optimal between 30 and 40. If using brush size 30, the Spacing for the smear should be optimal between 12 and 15.

Bump maps are not supported, but a trick is to quickly airbrush a sphere onto the base layer (**Fig.35**). On a separate new layer, add some

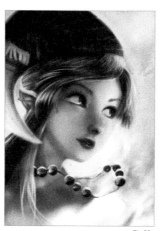

Fig.32a

Fig.32b

Fig.33

Fig.34

Fig.35

Fig.36

Fig.37

Fig.38

Fig.39a

Fig.39b

patterned engravings (**Fig.36**). See **Fig.37** to see the Emboss filter in action with an Angle selector; see **Fig.38** for the result, after a little blur.

For the color layer, create a new layer in Artweaver, where it is easy to change the color mode. See **Fig.39a – b** for a 5-minute color test made with some red/violet/peach colors, which are blended extremely well on the gray tones. Color layers in Artweaver are great – it may, in fact, have the greatest existing color layers! In other software, color layers are often made too unsaturated by mixing them too much with gray layers underneath. This is why yellow and orange are sometimes poor in this working method, but with Artweaver the problem is solved. This proves just how much the software has a future place in the 2D professional industry.

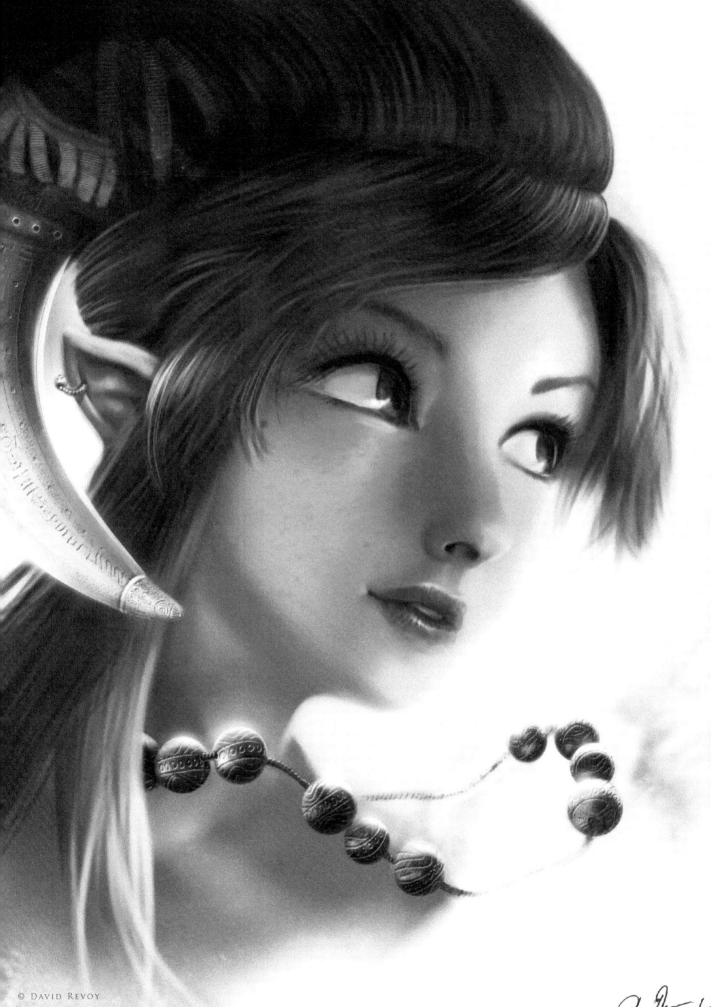

© David Revoy

THE MAKING OF "KEEP A SHARP EYE"
BY RON CRABB

SOFTWARE USED: PHOTOSHOP (AND CINEMA 4D)

INTRODUCTION

The digital painting, *Keep a Sharp Eye*, had its genesis in my desire to return to my roots as an illustrator. Most of my recent commercial work consisted of matte painting work for film and television, which has occupied a lot of my time for a number of years now. More recently I've found myself longing to get back to some figurative work and do some storytelling with my illustration abilities (it's the variety of things I get to do that makes me love being an artist). To that end, I came up with an idea to create images that feel like they have a great story behind them, even though that story hasn't been written yet. *Keep a Sharp Eye* is the first in the series that I'm calling "Illustrations from Untold Stories".

THE CONCEPT

I had a number of ideas that had been in my mind for quite some time, but the one that jumped to the front of the line was a concept that developed during a trip to Louisiana. I've traveled most of the United States looking for artistic inspiration (and good location photos) for fine art, and I once found myself on a swamp tour boat in the bayous west of New Orleans. It was daytime, and I was on

Fig.01

a pontoon boat sitting comfortably above the water (and alligators), but I instantly imagined going back in time and being there on a small skiff, gliding through those spooky waters at night with nothing but lamplight. That basic idea is the one I expanded upon for this digital painting.

All the work was done in Photoshop with just a little assistance from Cinema 4D; I'll talk you through now how it all came together.

THE SKETCH

Normally, for a paying client, I would do a pretty good concept sketch. Since I was the client for

this piece I already had a good idea of what I wanted to do, so I just did a very quick, rough sketch – just to know what problems I might need to solve. This process allowed me to figure out lighting positions, model poses and prop requirements (**Fig.01**).

GATHERING REFERENCES
I then began collecting references from a number of sources, as well as online. I needed swamp images, period boat references, pirate costume details, and water ripple patterns. Once I decided to switch from lamplight to torchlight, I also needed flame references. This all came together quickly and I was then ready to photograph some models.

Fig.02

THE MODEL SHOOT
For the older pirate I needed a rough-looking old guy with nice scars. Since there aren't many pirates in my neighborhood, I decided to use myself as a model (a lot of artists do this), and I could then roughen and scar myself to an appropriate degree in the painting process. I also found two very willing children close by who were happy to help out.

A note about model shooting: I don't go overboard in trying to get everything just perfect in the photo shoot because I find that the process of correcting things during the painting phase allows for quite a bit of creativity. It forces me to think hard about lighting conditions and shapes, as well as final poses. I take many photos and often end up combining elements from a number of them to get exactly what I want (**Fig.02**).

Fig.03

STARTING THE PAINTING
With all my photos and references in hand, I began the painting process. I created a quick background just to get a base going, using simple, hand-painted tree silhouettes (**Fig.03**). I also did a quick boat model in Cinema 4D (you could use any 3D software application to do the same), just to make sure I got the shape right. I then placed the basic boat into the picture, which gave me the platform to position my characters (**Fig.04**).

A note about 3D: While not traditionally thought of as an illustration tool, 3D is becoming more commonplace as just that. It can really enhance your options as an artist

Fig.04

　　　　　　　　　CHAPTER 08

and fuel creativity. Free programs such as Google SketchUp can get you started on it, should you decide to add 3D to your toolbox. I know I'm glad I did!

I pieced together my model references, combining body positions with preferred facial expressions, and did some color correcting to get close to the desired lighting and coloring. During this process I decided to make a slight change in lighting and to get rid of the bright moonlight that I had indicated in the rough sketch. I felt that having it darker, without an overly bright rim light on the characters, would make it moodier; more like a classical painting than a movie poster. I would still add some ambient moonlight, but much less pronounced than originally planned. I wanted that torch to really pop.

Fig.05

Fig.06a

Fig.06b

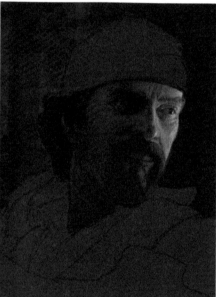

Fig.06c

Fig.06d

I positioned the corrected photo layers and roughed some quick positioning sketches over them. I then moved the photo reference off to the side and began sketching in more details (**Fig.05**). I did this for two reasons: one, it's more fun to draw than trace; two, it allows me to make the changes I want to make and be creative. For instance, I often make a man's head slightly smaller in relation to his body size and his hands slightly larger. It's a common illustrator tip I picked up from a Norman Rockwell book ages ago. I also make kids' eyes slightly larger – it adds to expressiveness. None of it is dramatic, but I think it helps the storytelling.

Tip: All through this process I keep all my elements separated into many Photoshop layers. I combine as I go, once I'm satisfied with each layer.

PAINTING FACES

I seem to always start with faces. That's because that is where the story is, and the rest supports the mood that is captured there. Plus it's the most fun part. Once I had the line work in (as a separate Photoshop layer), I painted a new layer that was a silhouette of the characters as a base to work on (**Fig.06a**). I chose the medium level value of the ambient moonlight color as a starting point (**Fig.06b**).

That way, when I started painting, I was thinking about the torchlight; how it would hit the shapes and where the resulting shadows would be. Even when copying from photo references, it is good to really understand what is going on with shape, lighting and color.

CONTINUING THE FACE

I created a new Photoshop layer under the line layer and above the character base layer. I set the transparency for the line layer to around 50% and started blocking in color with a custom brush that has a chalk pastel kind of feel to it (**Fig.06c – e**). I find this brush gives me results similar to those I get when oil painting with worn sable brushes. I worked

Fig.06e

quickly and started reducing the size of the brush as details emerged. It was a pretty straightforward painting at this point, but I constantly kept in mind the underlying bone structure and my two light sources (torch and ambient). I also made the character change by making the nose more chiseled than my own rounder one. I enhanced the cheekbones a bit, and weathered and scarred the face considerably. I also gave him a better goatee than I have. Artistic license is a great thing! As I neared the detailed work, I turned off the line drawing layer, or made it very transparent, and merged it down. I then fine-tuned the sharper details.

Fig.07

THE KIDS

I continued in the same way with the kids. During this process, I decided to age the girl from a nine-year-old into a young teen. I felt this would add a better range of character ages and complicate the potential story a little. It also replaced cute with beautiful, again making for a broader range of emotional appeal. I now had a cute boy (**Fig.07**), a young and beautiful girl (**Fig.08**), and a rough-looking pirate – all in the same boat. There has to be a story there!

MOVING ON

I got the people to an almost finished point and moved on, knowing I would return to them later for final adjustments and detail additions. I painted a quick torch to establish its exact location for lighting purposes, and then began the boat by painting on a layer above the 3D base. Compared with the people, this all went fairly rapidly and I moved quickly from boat to torch, and then to the background.

Fig.08

THE BACKGROUND

Back when I used oil paints, I almost always did the background first – just for the practical reason of working back to front. In the digital realm this is not necessary, and in this case it allowed me to determine just what I wanted to do with the environment, based on the look of the characters. I decided to leave the trees in the distance somewhat graphic in style, with overlaying transparency levels. I think this gives it a ghostly appearance and fits with the mood. It also leaves the underlying texture visible, which adds suggested detail without the need for a lot of painting. I only enhanced areas on the tree trunks that would pick up light from the torch. It was also at this point that I started defining foreground elements and decided to make them detailed in shape, but silhouetted in nature. I then added some fog layers.

Fig.09a

Fig.09b

Fig.09c

Fig.09d

DETAILS

After getting the background just about right, I went back and added some details to the boat and everything inside it. I added the tattoos on the girl's arm, the sword and baldric (scabbard) on the pirate, a rifle, some jewelry, stitching and other small details (**Fig.09a – e**).

Fig.09e

THE WATER

Since everything in the upper half of the image needed to be reflected in the water, I naturally had to do the water last. But it wasn't as easy as simple copying and flipping the image. The reflection would have a slightly different angle on the people in the boat and the boat itself,

Fig.10a

Fig.10b

Fig.10c

so after making separate copies of the people, the boat and the background, I cut and pasted elements and shifted them so that they would have the correct perspective – or at least a reasonably close one (**Fig.10a – d**). I then flipped the image and used a combination of Photoshop smudging and painting (**Fig.10e – g**).

MORE DETAILS

At this point I was almost there, and just went around adjusting details and doing slight color corrections. Once I considered the painting part done, I made some overall Color Correction layers to fine-tune the focus on the people.

Fig.10d

AFTER SOME FEEDBACK

Here's where the global community of artists came in nicely. Once this image was posted I got some great critiques that I went back and applied. They included better rendering of the flame and some lighting adjustments to the boy and girl to account better for light fall-off. I had knowingly cheated the lighting (artistic license again), but apparently a bit too much (it's great to have the whole world of artists available to give you some good advice – use them!).

Fig.10e

Fig.10f

Fig.10g

REFLECTION FINE-TUNING

After it was all done, I discovered that I didn't like the water reflections and could improve it a bit more (so it wasn't done after all). I decided to take advantage of 3D to get a more detailed rendering of water reflections. I took the image that had been adjusted for the reflection perspective and mapped it onto a plane in Cinema 4D (again, you could use any 3D application of choice). I loaded it into the illumination channel so that the image itself would be the only light source. I then rendered a number of water reflections at different scale settings. I could then take them into the Photoshop file and combine them – very

much like the hand-done version – so that the reflection represented the correct water flow dynamics (or was at least close). I ended up combining some of the original hand-painted with the new 3D to get exactly what I wanted (**Fig.11a – b**).

THE FINAL IMAGE

The whole process took about four days – maybe five (I was working on this in the midst of commercial jobs). The final resolution was 6000 by

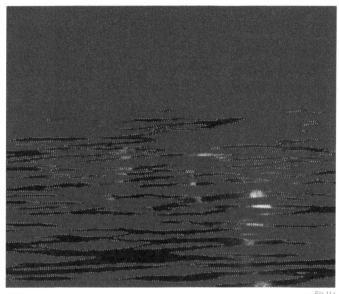
Fig.11a

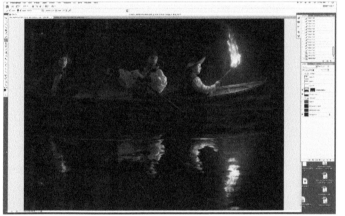
Fig.11b

4496 pixels. I'm planning on doing giclée prints of this image and hope to do more in my *Illustrations from Untold Stories* series. I hope you can glean something valuable from hearing about the creative process that went into the production of this image (**Fig.12**).

the gallery

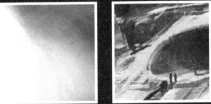

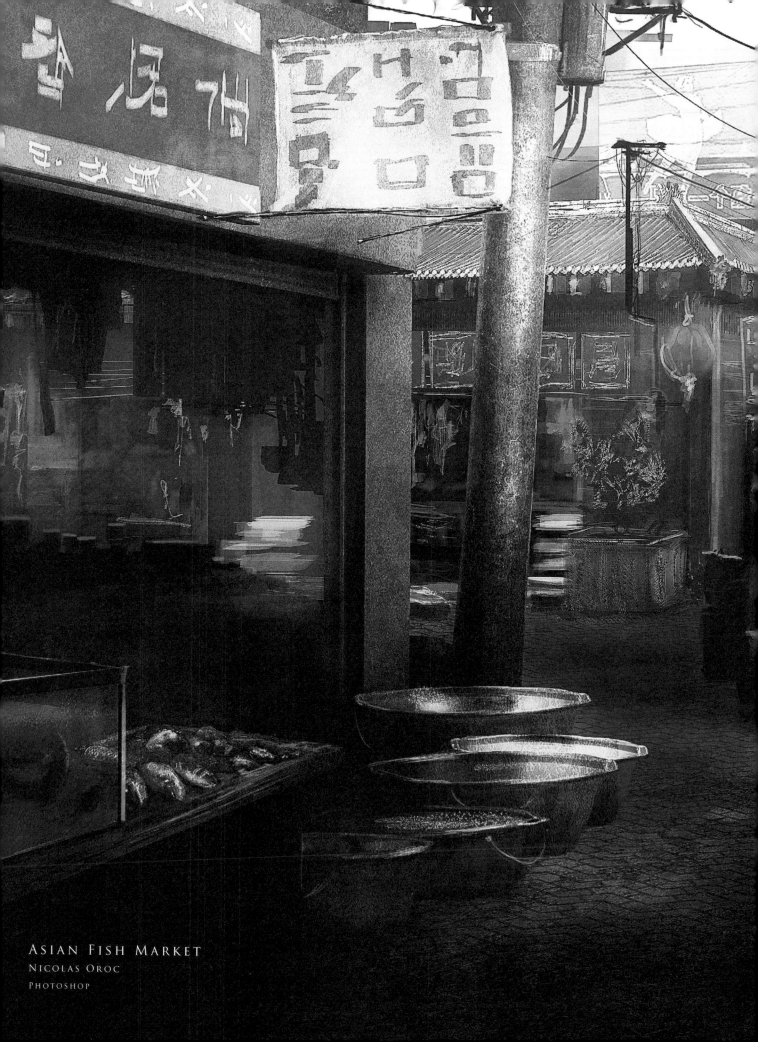

Asian Fish Market
Nicolas Oroc
Photoshop

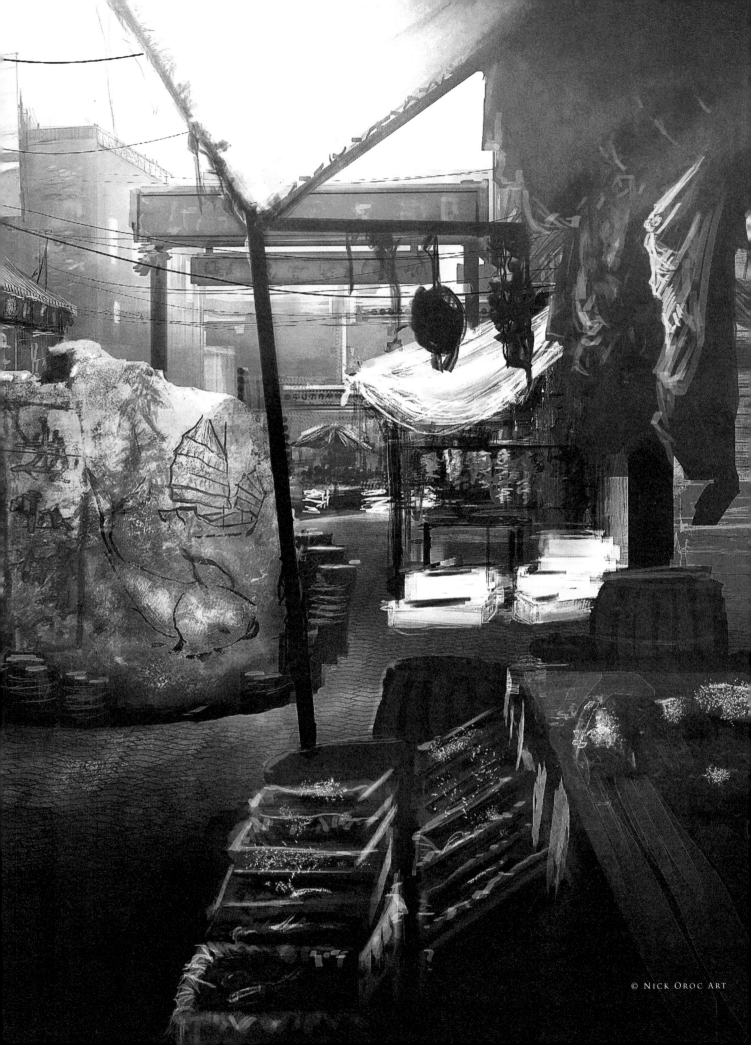

© Nick Oroc Art

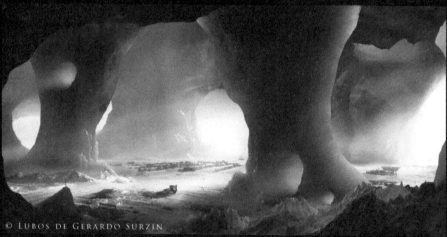

© Lubos de Gerardo Surzin

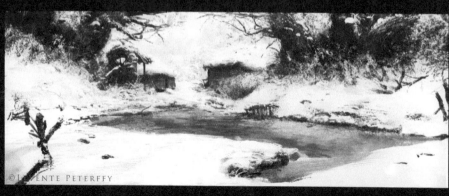

©Levente Peterffy

Guild Wars 2 "Mole Tunnels"
Daniel Dociu
Photoshop
(Above)

Ice Cave Base
Lubos de Gerardo Surzin
Photoshop, 3ds Max, ZBrush
(Left)

Winter Tranquility
Levente Peterffy
Photoshop
(Bottom Left)

Street Corner
Jaime Jones
Photoshop
(Right)

252

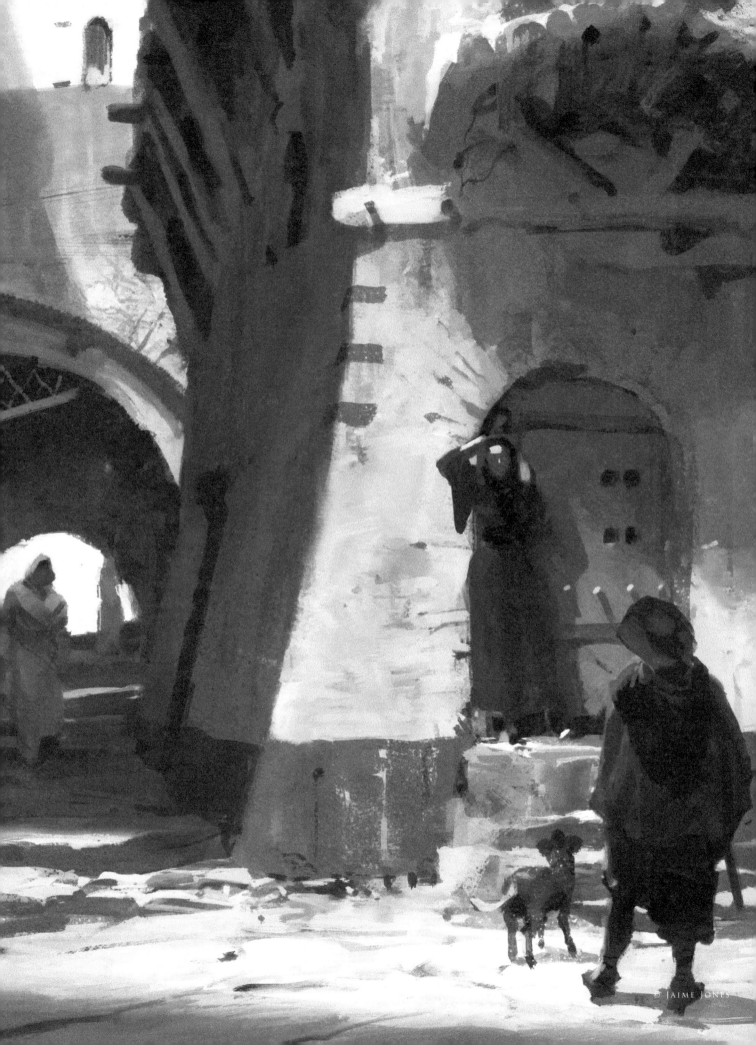

© Jaime Jones

LUX LUCIS
CHRIS THUNIG
PHOTOSHOP & MAYA

STURMGRUPPE DAHL
JOHN WALLIN LIBERTO
PHOTOSHOP & ARTRAGE

© John Wallin Liberto

© MICHAEL KUTSCHE

© NYKOLAI ALEKSANDER

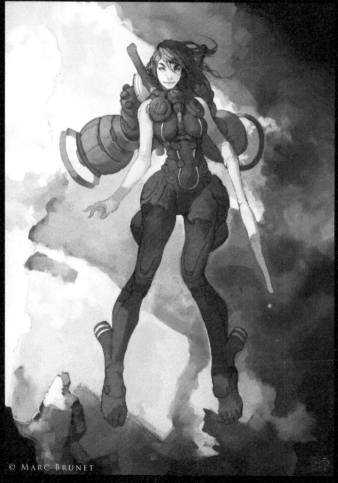

© MARC BRUNET

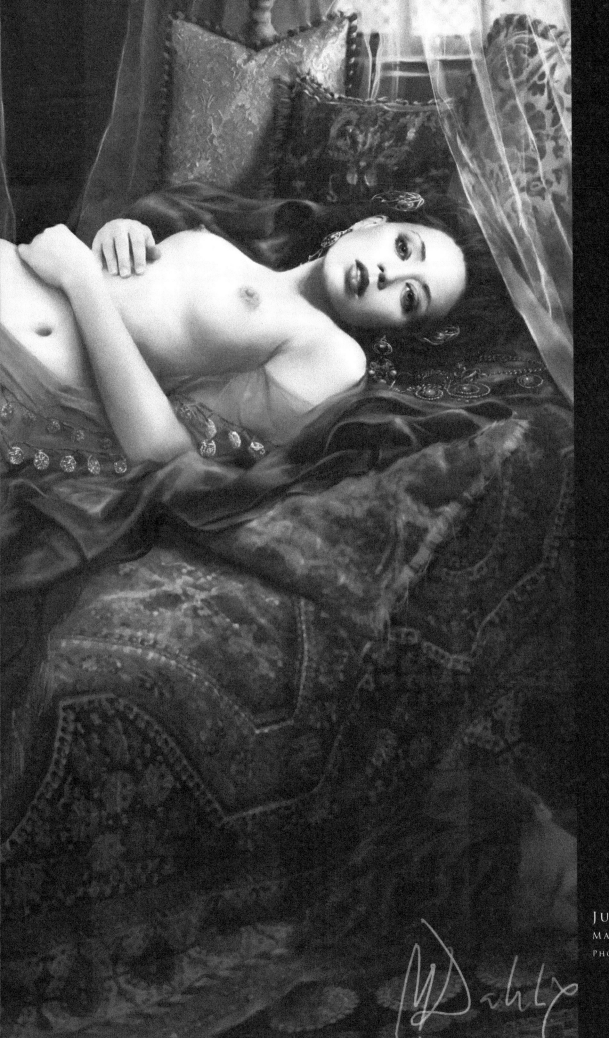

JUDITH
MARTA DAHLIG
PHOTOSHOP

© Loïc e338 Zimmermann

© Jaime Jones

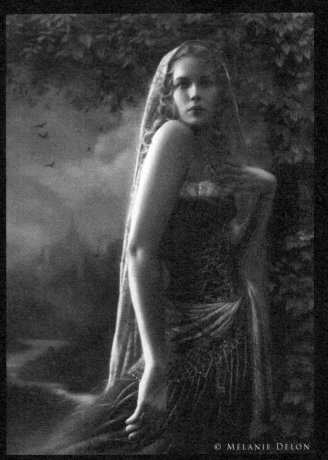

© Mélanie Delon

PATIENCE
Loïc e338 Zimmermann
Photoshop & Painter
(Above)

THE OLD KNIGHT
Jaime Jones
Photoshop
(Top right)

BRUME
Mélanie Delon
Photoshop & Painter
(Right)

VAGO
Carlos Cabrera
Photoshop
(Left)

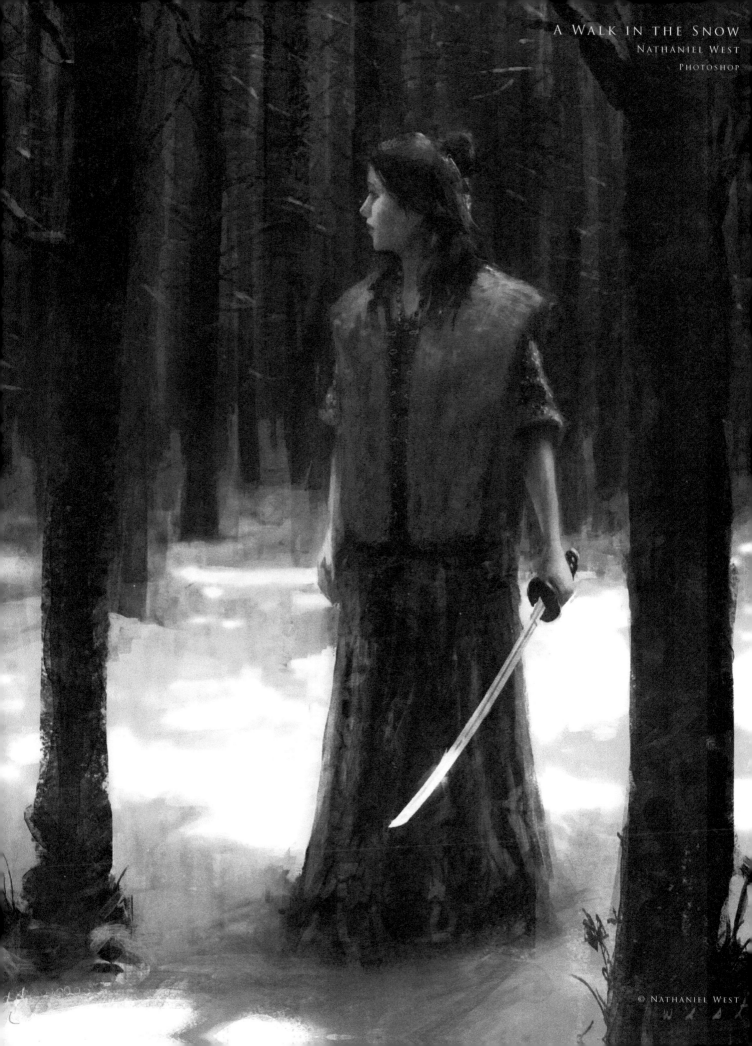

A Walk in the Snow
Nathaniel West
Photoshop

© Nathaniel West

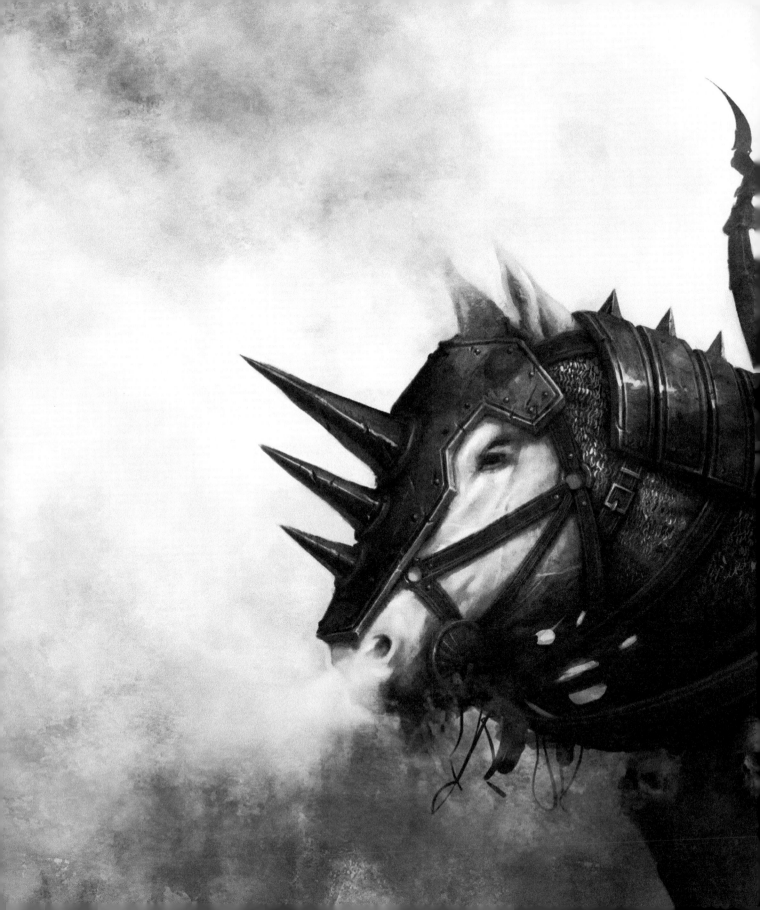

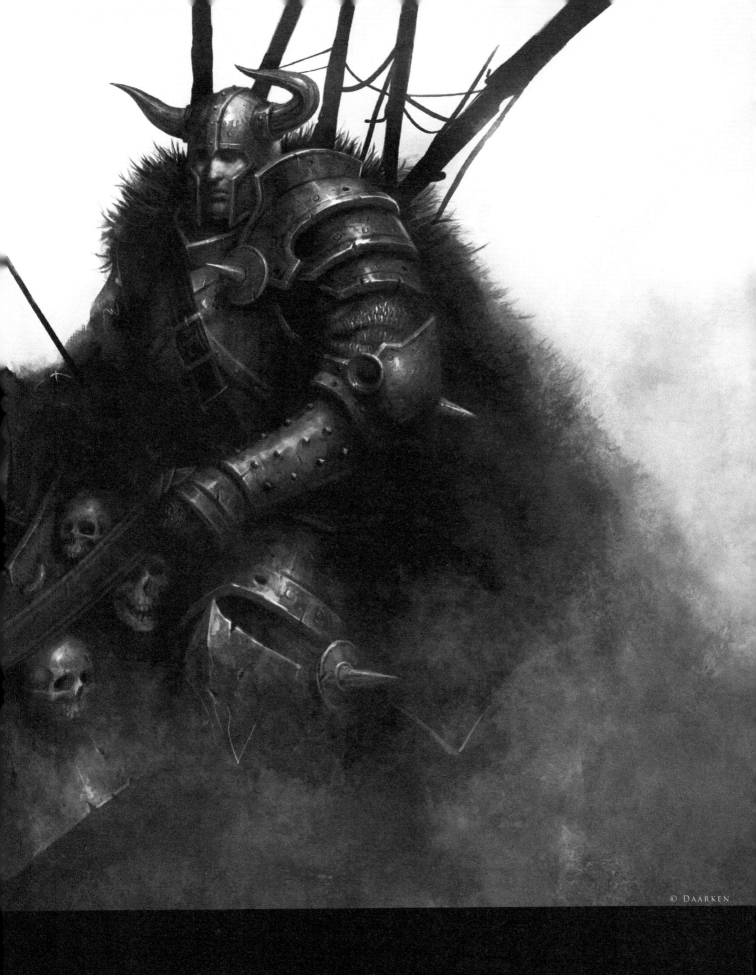

© Daarken

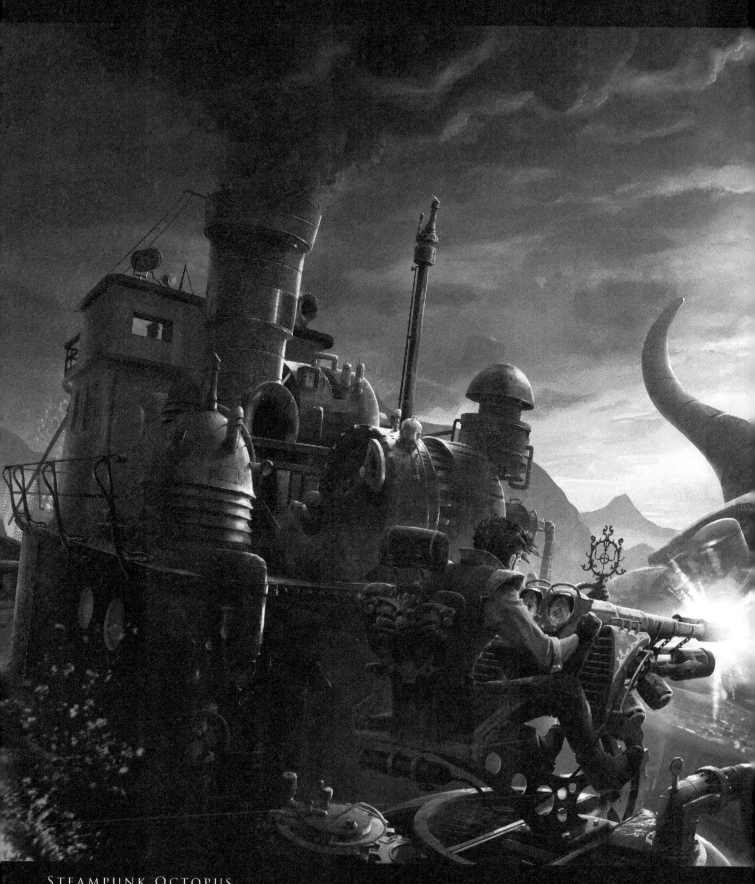

STEAMPUNK OCTOPUS
ALEX BROECKEL
PHOTOSHOP

© Alex Broeckel

ARCTIC EXPRESS
Raphaël Lacoste
Photoshop & 3ds Max

© Raphaël Lacoste 2007

270

© Ron Crabb

He's out There Somewhere
Ron Crabb
Photoshop
(Above)

Army of Scorpions II
Tomasz Jedruszek
Photoshop
(Below)

© Tomasz Jedruszek

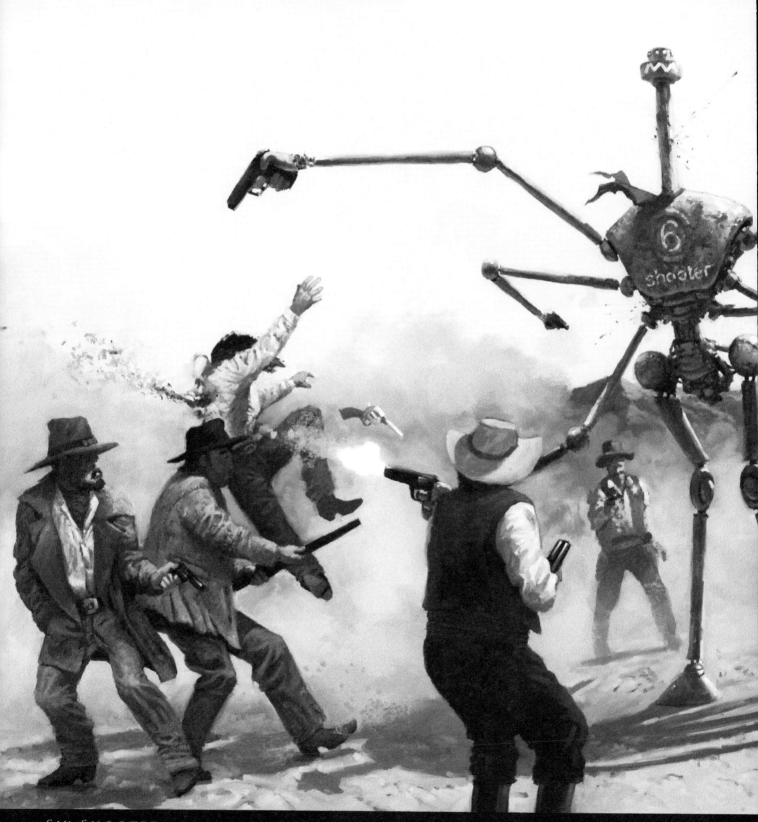

SIX SHOOTER
SIMON DOMINIC
PAINTER

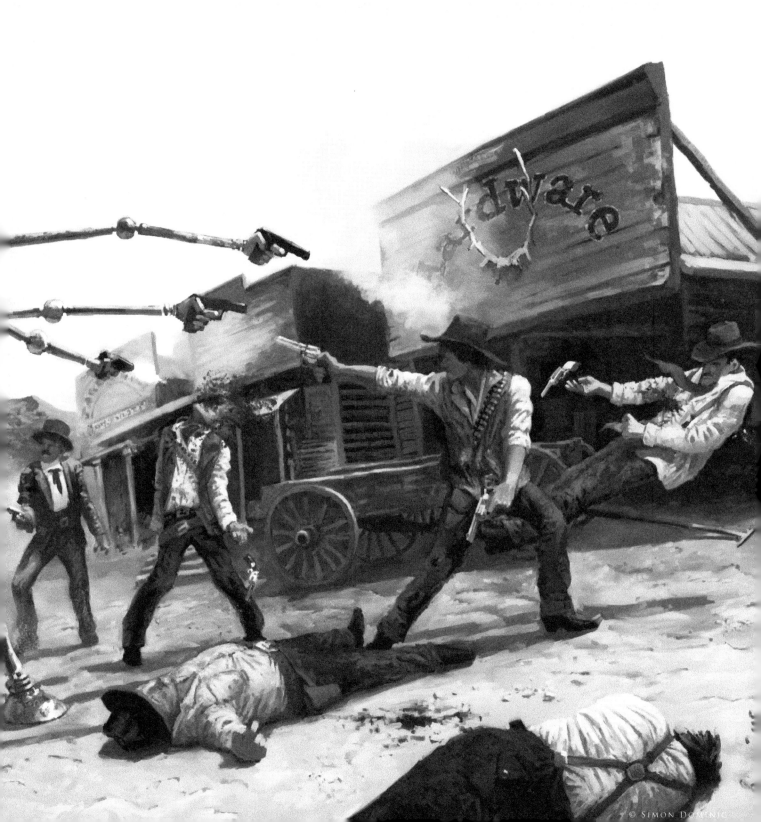

© Simon Dominic

© JAN DITLEV CHRISTENSEN

© LEVENTE PETERFFY

MORNING OF THE BATTLE
JAN DITLEV CHRISTENSEN
PHOTOSHOP
(TOP)

ARRIVAL AT THE STATION
LEVENTE PETERFFY
PHOTOSHOP
(ABOVE)

URIEL 9
JESSE VAN DIJK
PHOTOSHOP & 3DS MAX
(RIGHT)

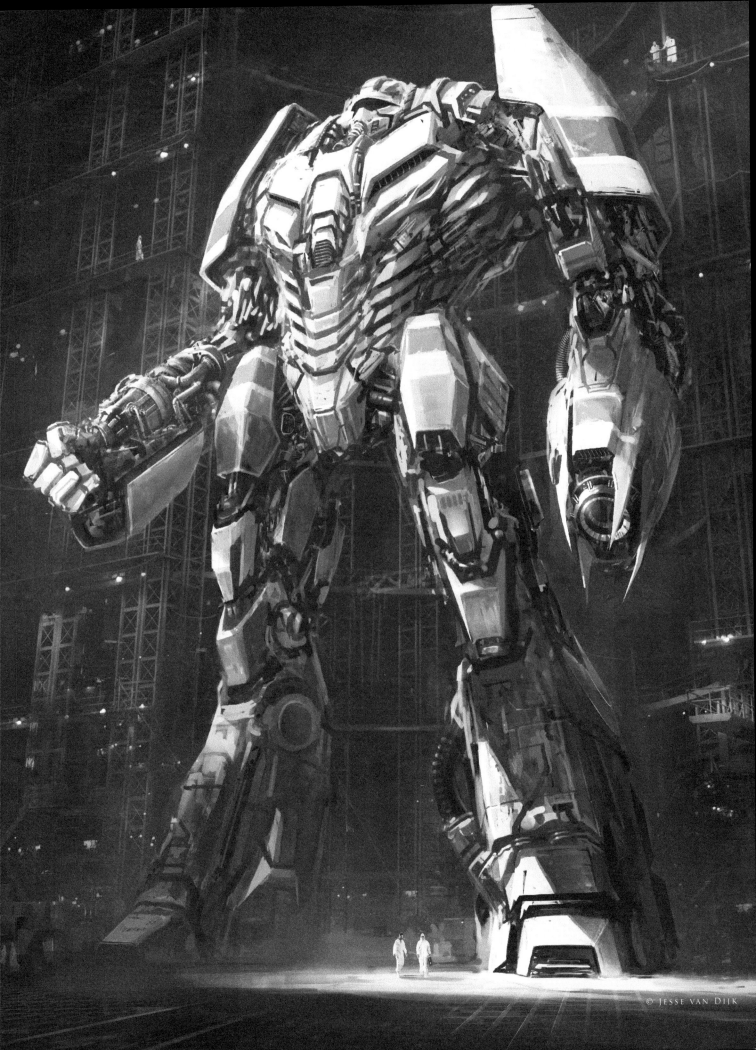

© Jesse van Dijk

GUILD WARS 2 "CHARR SPHERE"
Daniel Dociu
Photoshop

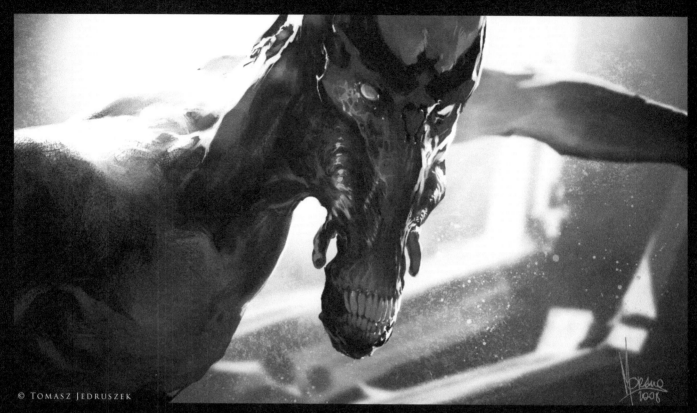

© Tomasz Jedruszek

ANGEL
Tomasz Jedruszek
Photoshop
(Above)

TERRA-STOMA
Dr. Chee Ming Wong
Photoshop
(Below)

THE SCULPTOR
Simon Dominic
Painter
(Right)

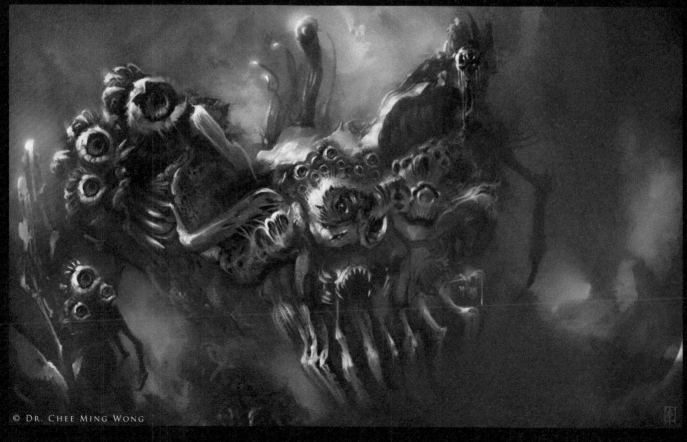

© Dr. Chee Ming Wong

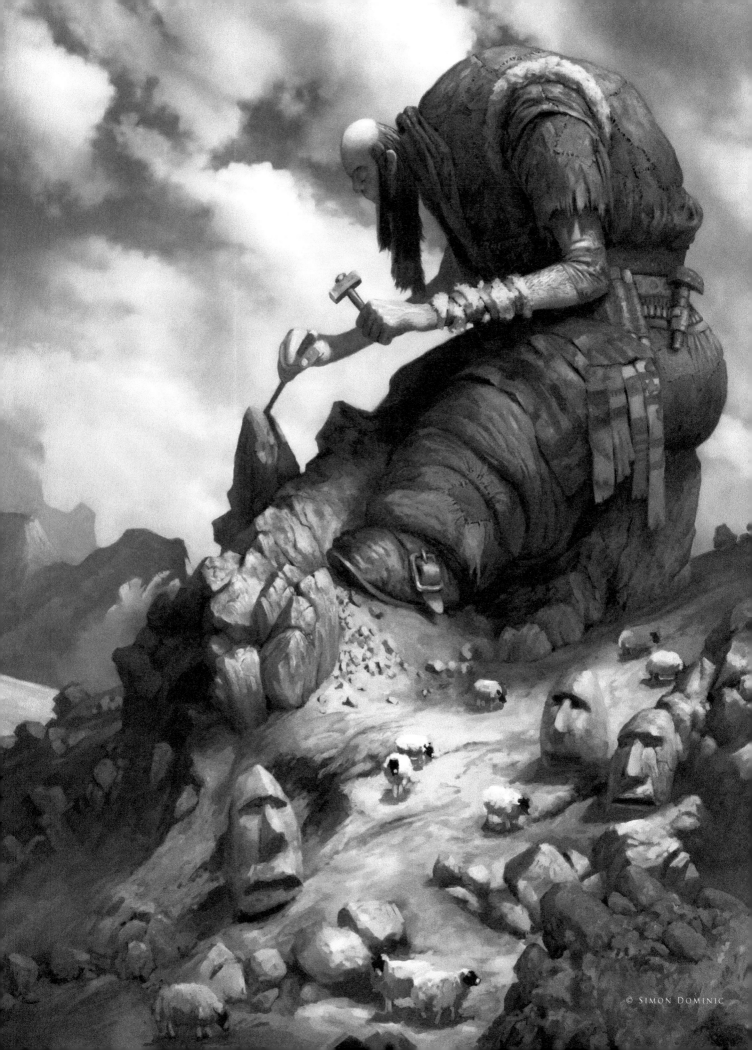

© Simon Dominic

ACTIVIST 23 (WITH MRO ROBOTIC SUIT)
KAI SPANNUTH
PHOTOSHOP

THE TUTORIAL ARTISTS

ANNE
POGODA

wpwebmasterin@web.de

http://www.darktownart.de

GRAVEN
TUNG

gtung@artofgt.com

http://www.artofgt.com

PASCAL
RAIMBAULT

raimbaultpa@gmail.com

http://pascalr.cgsociety.org/gallery

BRIAN
RECKTENWALD

breckten@gmail.com

http://barproductions.com

LEVENTE
PETERFFY

lp@leventep.com

http://www.leventep.com

RICHARD
TILBURY

ibex80@hotmail.com

http://www.richardtilburyart.com

CARLOS
CABRERA

sayhi@carloscabrera.com.ar

http://www.carloscabrera.com.ar

MARC
BRUNET

finalxii@msn.com

http://bluefley.cghub.com

http://bluefley.cgsociety.org/gallery

RON
CRABB

ron@crabbdigital.com

http://www.crabbdigital.com

CHEE
MING WONG

chee@opusartz.com

http://www.opusartz.com

MARCO
BAURIEDEL

mail@marcobauriedel.com

http://www.marcobauriedel.com

SERG
SOULEIMAN

sergdls@gmail.com

http://www.artofserg.com

DAARKEN

daarkenart@daarken.com

http://www.daarken.com

MATT
DIXON

mail@mattdixon.co.uk

http://mattdixon.co.uk

SERGEY
MUSIN

musinart@aol.com

http://www.samfx.com

DANIEL
LJUNGGREN

daniel@darylart.com

http://darylart.com

MÉLANIE
DELON

contact@melaniedelon.com

http://www.melaniedelon.com

STEPHANIE
R. LOFTIS

glddaisy@gmail.com

http://daisy7.deviantart.com

DANIELA
UHLIG

info@du-arwork.de

http://www.du-artwork.de

MIKE
CORRIERO

mikecorriero@gmail.com

http://www.mikecorriero.com

TIBERIUS
VIRIS

suirebit@gmail.com

http://www.tiberius-viris.com

DAVID
REVOY

info@davidrevoy.com

http://www.davidrevoy.com

NATHANIEL
WEST

nathaniel@nathanielwest.net

http://nathanielwest.net

EMRAH
ELMASLI

hello@emrahelmasli.com

http://www.emrahelmasli.com

NYKOLAI
ALEKSANDER

x@admemento.com

http://www.admemento.com

THE GALLERY ARTISTS

ALEX BROECKEL

alexbroeckel@gmail.com

http://www.alexbroeckel.com

JOHN WALLIN LIBERTO

info@johnwallin.net

http://www.johnwallin.net

MICHAEL KUTSCHE

mk3000@gmx.net

http://www.mistermk.de

CARLOS CABRERA

sayhi@carloscabrera.com.ar

http://www.carloscabrera.com.ar

KAI SPANNUTH

kai.spannuth@dpi-graphics.com

http://www.dpi-graphics.com

NATHANIEL WEST

nathaniel@nathanielwest.net

http://www.nathanielwest.net

CHEE MING WONG

chee@opusartz.com

http://www.opusartz.com

KIERAN YANNER

kieran@kieranyanner.com

http://www.kieranyanner.com

NICOLAS OROC

nickoroc@gmail.com

http://www.nickorocart.com

CHRIS THUNIG

contact@thunig.com

http://www.thunig.com

LEVENTE PETERFFY

lp@leventep.com

http://www.leventep.com

NYKOLAI ALEKSANDER

x@admemento.com

http://www.admemento.com

DAARKEN

daarkenart@daarken.com

http://www.daarken.com

LOÏC e338 ZIMMERMANN

info@e338.com

http://www.e338.com

RAPHAËL LACOSTE

raphael.lacoste@gmail.com

http://www.raphael-lacoste.com

DANIEL DOCIU

daniel@arena.net

http://www.tinfoilgames.com

LUBOS DE GERARDO SURZIN

gerardo_de@yahoo.co.uk

http://www.degerardo.com

RON CRABB

ron@crabbdigital.com

http://www.crabbdigital.com

JAIME JONES

cicinimo@gmail.com

http://www.artpad.org

MARC BRUNET

finalxii@msn.com

http://bluefley.cghub.com

http://bluefley.cgsociety.org/gallery

SIMON DOMINIC

si@painterly.co.uk

http://www.painterly.co.uk

JAN DITLEV CHRISTENSEN

janditlev@gmail.com

http://www.janditlev.blogspot.com

MARTA DAHLIG

marta@marta-dahlig.com

http://www.marta-dahlig.com

TOMASZ JEDRUSZEK

info@morano.pl

http://www.morano.pl

JESSE VAN DIJK

jesse@jessevandijk.net

http://www.jessevandijk.net

MÉLANIE DELON

contact@melaniedelon.com

http://www.melaniedelon.com

DIGITAL ART MASTER

VOLUME 4

THE FOURTH BOOK IN THE **DIGITAL ART MASTERS** SERIES FEATURES 50 OF THE FINEST 2D AND 3D ARTISTS, INCLUDING

Alexey Kashpersky, Andrée Wallin, Andrei Kashkin, Andrew Hickinbottom, Andrius Balciunas, Andrzej Sykut, Blaz Porenta, Bradford Rigney, Bruno Melo de Souza, Cesar Martinez Alvaro, Craig Sellars, Daarken, Daniel Lieske, Denis C. Feliz, Eduardo Peña, Fabricio Moraes, Gerhard Mozsi, Gregory Callahan, Hao Ai Qiang, Iker Cortázar, James Paick, Jelmer Boskma, Jonathan Simard, Kekai Kotaki, Leonid Kozienko, Loïc e338 Zimmermann, Maciej Kuciara, Marc Brunet, Marek Denko, Marek Okoń, Martin Carlsson, Michal Kwolek, Nicholas Miles, Nykolai Aleksander, Piotr Luziński, Roberto F.Castro, Rudolf Herczog, Ryohei Hase, Sarel Theron, Sönke Maeter, Stefan Morrell, Sebastien Haure, Thibaut Milville, Till Nowak, Titus Lunter, Tomáš Müller, Tomáš Král, Viktor Fretyán, Viktor Titov and Weiye Yin

VOLUME 1

THE FIRST BOOK IN THE **DIGITAL ART MASTERS** SERIES FEATURES **48** OF THE FINEST 2D AND 3D ARTISTS, INCLUDING:

Drazenka Kimpel, Fred Bastide, Robert Chang, Natascha Roeoesli, Patrick Beaulieu

VOLUME 2

THE SECOND BOOK IN THE **DIGITAL ART MASTERS** SERIES FEATURES **58** OF THE FINEST 2D AND 3D ARTISTS, INCLUDING:

Benita Winckler, Daarken, Daniel Moreno, Emrah Elmasli, Glen Angus, Jonathan Simard

VOLUME 3

THE THIRD BOOK IN THE **DIGITAL ART MASTERS** SERIES FEATURES **60** OF THE FINEST D 2D AND 3D ARTISTS, INCLUDIN

Damien Canderlé, Eduardo Peña, Frederic St Arnaud, James Paick, Joh

WEB RESOURCES

WWW.3DTOTAL.COM

3DTOTAL.COM – DAILY CG NEWS AND FREE RESOURCES VISITED BY 50,000 ARTISTS EVERY DAY

FORUMS.3DTOTAL.COM

CHALLENGES – DISCUSSION – TECHNIQUES – SHOWCASE

WWW.FOCALPRESS.COM/DIGITALARTMASTERS